# Technology and Rural Women:

## Conceptual and Empirical Issues

edited by
IFTIKHAR AHMED

A study prepared for the International Labour Office
within the framework of the World Employment
Programme

London
GEORGE ALLEN & UNWIN
Boston          Sydney

**George Allen & Unwin (Publishers) Ltd,**
**40 Museum Street, London WC1A 1LU, UK**

George Allen & Unwin (Publishers) Ltd,
Park Lane, Hemel Hempstead, Herts HP2 4TE, UK

Allen & Unwin, Inc.,
Fifty Cross Street, Winchester, Mass. 01890, USA

George Allen & Unwin Australia Pty Ltd,
8 Napier Street, North Sydney, NSW 2060, Australia

First published in 1985

**British Library Cataloguing in Publication Data**

Technology and rural women: conceptual and
empirical issues: a study prepared for the
International Labour Office within the framework
of the World Employment Programme.
1. Women—Developing countries. 2. Technological
innovations—Social aspects—Developing
countries
I. Ahmed, Iftikhar   II. World Employment Programme
305.4'2'091724      HQ1870.9
ISBN 0-04-382043-3

**Library of Congress Cataloging in Publication Data Applied For**

Set in 11 on 12 point Plantin by Columns of Reading
and printed in Great Britain by Biddles Ltd, Guildford, Surrey

# Technology and Rural Women
Conceptual and Empirical Issues

The World Employment Programme (WEP) was launched by the International Labour Organisation in 1969, as the ILO's main contribution to the International Development Strategy for the Second United Nations Development Decade.

The means of action adopted by the WEP have included the following:

– short-term high-level advisory missions;
– longer-term national or regional employment teams; and
– a wide-ranging research programme.

Through these activities the ILO has been able to help national decision-makers to reshape their policies and plans with the aim of eradicating mass poverty and unemployment.

A landmark in the development of the WEP was the World Employment Conference of 1976, which proclaimed inter alia that 'strategies and national development plans should include as a priority objective the promotion of employment and the satisfaction of the basic needs of each country's population'. The Declaration of Principles and Programme of Action adopted by the Conference will remain the cornerstone of WEP technical assistance and research activities during the 1980s.

This publication is the outcome of a WEP project.

# Contents

Preface                                             *page* x
Editor's Acknowledgements                                xii
List of Contributors                                    xiii
List of Abbreviations                                     xv

1  Introduction *by Iftikhar Ahmed*
   Background                                              1
   Objectives                                             2
   Methodology and design                                 5
   Summary and highlights                                 6

Part I  CONCEPTUAL APPROACHES

2  Technological Change and Rural Women:
   A Conceptual Analysis *by Amit Bhaduri*
   Relevance of traditional analysis                     15
   A relevant analytical framework                       19
   Social acceptability of technological change
   among rural women                                     25

3  Effects of Technological Change on Rural
   Women: A Review of Analysis and Concepts
   *by Ann Whitehead*
   Introduction                                          27
   Women and technological change: some pointers
   from the literature                                   29
      Evidence from the Green Revolution                 30
   Technological innovation and the intensification
   of women's work within the peasant household          36
      Some characteristics of unremunerated labour
      within the peasant household                       37
      Factors affecting the intensification of
      women's work: the sexual division of labour        41
      Further implications for technological
      change and women                                   49

Gender hierarchy and the rural production
system: women and access to resources                    51
  How to conceptualise women in the rural
  production system?                                      51
  Gender hierarchy in access to productive
  resources: land                                         52
  Gender hierarchy in costs and access for women          57
Concluding remarks                                        62

Part II  EMPIRICAL OVERVIEWS

4  Women and Technological Change in
   Agriculture: The Asian and African
   Experience *by Bina Agarwal*
   Introduction                                           67
   Some conceptual issues: intra-household
   distribution of work, income and consumption           69
     Distribution of work burden                          70
     Control and sharing of household income              74
     Sharing of household food                            76
   The impact of technological change in
   agriculture by class and gender                        78
     The Asian experience                                 80
     The African experience                              103
   Forms of survival                                     109
   Concluding comments                                   111

5  Technologies for Rural Women: Impact
   and Dissemination *by Marilyn Carr*
   Introduction                                          115
   Current situation                                     117
     Role of women and division of labour                117
     Technologies relevant to rural women's tasks        120
     Impact and dissemination of technologies            124
   Major problem areas                                   142
     Limited impact                                      143
     Limited dissemination                               144
     Limited access                                      145
   A new approach                                        150

Part III   PROGRAMMES AND PROJECTS

6   Modernisation, Production Organisation
    and Rural Women in Kenya *by*
    *Vivianne Ventura-Dias*
    Introduction                                          157
    Outline and analytical approach                       161
    Historical overview                                   163
        The division of labour between sexes              163
        Social differentiation and technical change       165
    Rural women in modern Kenya                           172
        Rural women and the agrarian structure            172
        Access to sources of capital formation and
        credit                                            178
        Employment alternatives for rural women           180
    Alternative technologies for rural women              184
        The nature of female tasks                        184
        The household unit of production                  192
        The nature of technological change               194
        Reallocation of labour time                       197
    Summary and conclusions                               205

7   Technologies for Rural Women of Ghana:
    Role of Socio-Cultural Factors
    *by Eugenia Date-Bah*
    Introduction                                          211
    Potential for technological improvements in
    rural women's traditional activities                  213
        Farming                                           214
        Agricultural extension services                   220
        Land tenure system                                221
        Food processing                                   223
        Domestic chores                                   226
        Other activities                                  230
    Constraints to technological improvements in
    rural women's activities                              234
        Food processing                                   235
        Other improved technologies                       237
    Strategies for technology diffusion                   242
    Conclusions                                           247

8  Innovation and Rural Women in Nigeria:
Cassava Processing and Food Production
*by Tomilayo Adekanye*
Introduction                                          252
Objectives                                            253
Survey design                                         253
Technology of *gari* processing                       255
Traditional processing                                255
Mechanised processing                                 258
Time spent in processing                              258
Traditional processing                                259
Mechanised processing                                 261
Costs and returns                                     264
Traditional processing                                264
Mechanised processing                                 269
Innovation, women and development                     270
Alternative technologies                              270
Impact of innovations                                 272
Conclusions and policy implications                   279
Conclusions                                           279
Policy implications                                   280

9  Improved Technologies for Rural
Women: Problems and Prospects in Sierra
Leone *by Yvette Stevens*
Introduction                                          284
Technology spectrum for rural women's
tasks – review and appraisal                          289
Cooking                                               295
Water collection and storage                          296
Farming                                               298
Rice processing                                       298
Food preservation                                     300
Food processing                                       301
*Gari* (tie) dyeing                                   306
*Lubi* and 'black' soap production                    307
'Soda' soap preparation                               308
Handicrafts                                           308
Shallow water fishing                                 309
Conditions for the widespread adoption of
improved technologies                                 309

Flow chart for the introduction of
improved technologies 312
Examination of 'improved' technologies
developed in the light of the conditions
for widespread adoption 315
Problems of generation, production and
diffusion of improved technologies in
Sierra Leone 315
Improved technologies to increase production,
relieve boredom and save women's labour time 319
Cooking stoves 319
Problems of water supply 320
Farming and rice processing 321
Food preservation 322
Food processing technology 323
Improved technologies in income-
generating activities 324
Conclusions 324

10 Conclusions *by Iftikhar Ahmed*
Introduction 327
Traditional macroeconomic theories 327
Prediction of impact 327
Labour and production processes 328
The institutional basis of female labour input 329
Are women a homogeneous group? 330
The household as a unit of analysis 331
Mechanisms and causes of female labour
displacement 331
Factor price distortions 331
Scale of production and commercialisation 332
Rural factor market imperfections, technology
choice and the institutionalisation of sexual
discrimination 333
Diffusion of innovations 334
Technology and welfare 336
Areas for future research 336

Bibliography 342
Index 370

# Preface

The subject of technological change still requires careful handling and remains complicated despite several years of economic research on processes of innovation. The issue of its impact on a particular socio-economic group like rural women is an even greater area of darkness. What accounts for this eclipse is a relative neglect of this group as a distinct class until perhaps the ILO World Employment Conference (1978c), which recommended in its Programme of Action of Basic Needs that 'special emphasis be placed in developing countries on promoting the status, education, development and employment of women' and 'that the work burden and drudgery of women be relieved by improving their working and living conditions and providing more resources for investment in favour of women in rural areas'. Similarly, the 1980 World Conference of the United Nations Decade for Women (Copenhagen) expressed concern about the frequently negative impact of technological advances on women's employment opportunities and living conditions. The Conference recommended that all organisations of the United Nations System should encourage and support governments and non-governmental organisations, including research institutions, in elaborating appropriate technology projects and in identifying ways in which women can participate in and contribute to the effectiveness of development projects and improve their own economic and social condition. Finally, the United Nations Conference on Science and Technology for Development (UNCSTD), 1979, recommended that United Nations bodies dealing with science and technology, like the ILO, should continually review the impact of their programmes on women. The present volume edited by Iftikhar Ahmed of the ILO World Employment Programme is a modest response to this call.

There are two ways of approaching the problem of technical change, namely, to formulate a conceptual or

theoretical framework and then test it with available empirical facts, or to observe facts as they are and try to draw conclusions about the nature and character of the underlying analytical and conceptual framework. The present volume follows both approaches, although it tends to opt for the second approach rather than the first.

The volume contributes to work on technology and rural women essentially at three levels. First, it attempts to establish a theoretical and conceptual framework for research relating to this field. Secondly, it helps to formulate an analytical framework on the basis of a review of cross-country data. Thirdly, it provides policy insights and guidelines for the formulation of concrete programmes and projects for promoting technologies for rural women in the Third World countries.

This research was mostly financed by a grant from the Swedish government. Parts of it were also financed by grants from the governments of Norway (Chapters 6, 7 and 9), the Federal Republic of Germany (Chapter 4) and the United Nations Fund for Population Activities (Chapter 8). The ILO World Employment Programme, within the framework of which this work was undertaken, has endeavoured to establish a close integration of research and operational activities. Research initiated in innovative areas is intended to provide a sound basis for new operational activities in individual countries. Initially, this research was undertaken parallel to an ILO African regional project on technological change, basic needs and the condition of rural women funded by the Norwegian government. Subsequently, the results of this work led to a technical co-operation project on technologies for rural women of Ghana, which is financed by the Royal Government of the Netherlands and executed by the ILO in response to a request for assistance from the Ghana National Council for Women and Development.

A. S. Bhalla
Chief
Technology and Employment Branch
International Labour Office

Geneva
January 1985

# Editor's Acknowledgements

This volume reflects the efforts of a number of individuals who have contributed in various ways at different stages of the work. Martha Loutfi, Christine Oppong, Armand Pereira and the publisher's anonymous reviewer provided many useful comments. I am greatly indebted to Ajit Bhalla without whose encouragement and guidance this research could not have been completed.

I am very thankful to Hazel Cecconi and Michèlc Bhuunoo who helped with the typing of the initial drafts. The tedious work of placing the entire final typescript on word processor was undertaken by Heather Kelland. I am also very grateful to her for the long hours of strenuous proof-reading. I greatly benefited, too, from Pierrette Dunand-Rosso's careful verification of the presentation of the bibliography and footnotes.

In the final stages of the preparation of the typescript for printing, Liz Paton painstakingly scrutinised the typescript for remaining errors, factual inconsistencies and the completeness and accuracy of the bibliographical references. She also made a valuable contribution in improving the style and presentation of the text. To her we owe a very special debt of gratitude.

# List of Contributors

TOMILAYO O. ADEKANYE is an agricultural economist who has worked extensively on agricultural marketing and agricultural and rural development, particularly in West Africa. She is currently Reader, Department of Agricultural Economics, University of Ibadan, Nigeria. She also worked at the Department of Economics, University of Lancaster, United Kingdom.

BINA AGARWAL is a development economist who has worked on farm mechanisation, choice of technology, tenancy, rural energy and women's questions. She has been a visiting fellow at the Institute of Development Studies, Sussex, United Kingdom, and a research fellow at the Science Policy Research Unit, University of Sussex, United Kingdom. She is currently Reader, Institute of Economic Growth, University of Delhi, India.

IFTIKHAR AHMED is a development economist who has worked on a wide range of issues including farm mechanisation, the Green Revolution, farm equipment innovations, forestry technology and technologies for rural women, primarily covering Asia and Africa. He has worked previously as a Post-Doctoral Associate at the Iowa State University, United States, a Visiting Fellow at the Institute of Development Studies, Sussex, United Kingdom, and Associate Professor of Economics, Dhaka University, Bangladesh. He is currently responsible for the rural technologies component of the Technology and Employment Programme of the International Labour Office. He is the author of *Technological change and agrarian structure: a study of Bangladesh* (Geneva, ILO, 1981) and an editor of *Farm equipment innovations in eastern and central southern Africa* (Gower, 1984).

AMIT BHADURI is a versatile development economist who has contributed significantly to the theoretical and conceptual aspects of agricultural and rural development. His broad-based work has covered areas like agrarian structure, participatory development and theories of agricultural growth. He is the Chairman of the

Centre for Economic Studies and Planning, Jawaharlal Nehru
University, New Delhi, India.

MARILYN CARR is a development economist who has worked
extensively on technologies for rural development. She has
undertaken field work in many Third World countries, particu-
larly in Africa. She is currently with the Intermediate Technology
Development Group, London.

EUGENIA DATE-BAH is a sociologist who has undertaken surveys
among several sectors of the Ghanaian population and has
worked on the technology-related problems of rural women at
both the conceptual and empirical (Africa) levels. She was a
senior lecturer in the Sociology Department at the University of
Ghana and is currently working as a senior programme officer
with the International Labour Office.

YVETTE STEVENS is an electrical engineer who was involved in the
design and development of village technologies. While at Fourah
Bay College, Sierra Leone, she began her work with technologies
and income-generating activities for rural women, which was
later broadened to cover the themes of energy and new
technologies. She has undertaken field work in Africa while
working in the Technology and Employment Branch of the
International Labour Office, Geneva. She is currently with the
Office of the United Nations High Commissioner for Refugees,
Geneva.

VIVIANNE VENTURA-DIAS is a development economist who has
worked on both rural and industrial development in Latin
America and Africa. She worked for the International Labour
Office on a research project dealing with technologies for rural
women. She is currently with the United Nations Conference on
Trade and Development, Geneva.

ANN WHITEHEAD is an anthropologist who has worked on the sexual
division of labour and rural production systems in Africa, and
has carried out field research in Northern Ghana. She is
particularly interested in the effects of monetisation and
changing kinship structures on gender relations. She lectures in
social anthropology at the University of Sussex, United
Kingdom, and is a member of the *Feminist Review* collective.

# List of Abbreviations

| | |
|---|---|
| ADC | Agricultural Development Council |
| ATRCW | African Training and Research Centre for Women |
| BARD | Bangladesh Academy for Rural Development |
| BSA | British Sociological Association |
| CIRDAP | The Centre on Integrated Rural Development for Asia and the Pacific |
| FAO | Food and Agriculture Organisation of the United Nations |
| GATT | General Agreement on Trade and Tariffs |
| IBRD | International Bank for Reconstruction and Development |
| IDS | Institute of Development Studies |
| IEA | International Economic Association |
| IILS | International Institute for Labour Studies |
| IITA | International Institute of Tropical Agriculture |
| ILO | International Labour Organisation |
| IPPF | International Planned Parenthood Federation |
| IRRI | International Rice Research Institute |
| ISSER | Institute of Statistical, Social and Economic Research (Ghana) |
| JASPA | Jobs and Skills Programme for Africa |
| NCWD | National Council on Women and Development (Ghana) |
| NORAD | Norwegian Agency for International Development |
| OECD | Organisation for Economic Cooperation and Development |
| TPI | Tropical Products Institute (UK) |
| UNCSTD | United Nations Conference on Science and Technology for Development |
| UNCTAD | United Nations Conference on Trade and Development |
| UNDP | United Nations Development Programme |
| UNECA | United Nations Economic Commission for Africa |

| UNESCO | United Nations Educational, Scientific and Cultural Organisation |
| UNFPA | United Nations Fund for Population Activities |
| UNICEF | United Nations Children's Fund |
| UNITAR | United Nations Institute for Training and Research |
| UNRISD | United Nations Research Institute for Social Development |
| USAID | United States Agency for International Development |

# 1

# Introduction

*IFTIKHAR AHMED*

## Background

This volume builds on the pioneering work by Boserup
(1970) over a decade ago who attempted a global review of
the effect of modernisation on rural women. This has been
followed by a flood of papers and articles on this subject.
However, on the one hand little effort has been made to
synthesise the fragmented empirical evidence to arrive at
credible generalisations on which policy decisions could be
based and, on the other hand, no coherent conceptual and
analytical framework has been developed from the growing
literature in this field. The present volume attempts to fill
this gap in both these respects.

A number of generalisations, often quite sweeping, have
been made and conclusions drawn under rather simplistic
assumptions (for example, that women constitute a homo-
geneous group) based on sketchy data and on analysis that
lacks penetration. For example, it is concluded that changes
in technology that accompany 'modernisation' have, for the
most part, led to a female concentration in domestic and non-
market roles and in labour-intensive activities. While this is
no doubt true, little light is shed on why this has occurred
and what policy measures need to be adopted to improve
women's position in this respect. Similarly, it is repeatedly
established by the literature that men take over responsibility
for women's tasks as soon as they are mechanised or when
they are transformed from a subsistence into market
production. Not much diagnosis is offered on the causes of
such a trend, so the necessary policy insights are not
provided. The existing studies on rural women also conclude

1

that technological change leads to harder work for longer hours with less appropriation of the economic returns to their own labour. Such broad generalisations would not apply to all technologies and every segment of women's work.

Two books have recently appeared that attempt to analyse the role of women, technology and development (Dauber and Cain, 1981: D'Ononfrio-Flores and Pfafflin, 1982). Both these volumes try to cover too much ground by extending their analysis to all spheres of developing countries' economies, and one of the volumes includes empirical coverage of industrialised countries and touches on the international dimension of the problem. This volume, in contrast, focuses specifically on women in rural areas and, as a result, is able to treat the issues in much greater depth. The generalisations arrived at here are more meaningful for policy-making and for the formulation of programmes and projects of concrete operational activities.

## Objectives

Current literature points to gender-based inequalities in access to resources, knowledge, skills and modern means of production, but no rigorous analysis (or theoretical explanation) is available on the implications for choice of techniques and allocation of resources. Similarly, existing studies lament the low rate of adoption of improved technologies among women but shed little light on the multi-disciplinary character of the constraints to their wider dissemination. This volume was designed to deal with such issues on the conceptual, analytical and empirical plane.

The first basic question is whether traditional macro-economic theories of technological change, which are primarily concerned with analysing the impact of technological change on the class distribution of income, can be extended to gender-based distributional questions. If these are not adequate, what modifications are necessary in order to make these more applicable to studying the impact of technological change on rural women?[1]

Difficulties in predicting the impact of technological change on rural women arise from a number of intricacies of

the labour process. Interrelationships between tasks (multiple tasks simultaneously undertaken by women at a single location),[2] sex-sequential nature of the work[3] and a team of participants in a single labour process[4] make it difficult to trace the direct and indirect consequences of technological intervention in any segment of the rural production system. Another problem (especially in agriculture) arises from the institutionalisation of the female labour input (i.e. whether it is a mode of production based on female family labour or on female wage labour). Such problems are made more difficult when a given task performed by rural women is designated as 'unproductive' because it is unpaid and non-monetised (producing 'use value' for subsistence consumption) but becomes 'productive' as soon as it is commercialised ('exchange value'), mechanised or employs hired labour. For example, when water collection is commercialised, male hired labour replaces female household members. Further, fuel wood collection and water collection are non-monetised tasks performed by women even though these could serve as inputs to poultry and animal husbandry raised for the market. Even a cooked meal provided by the farmer's wife to farm labourers hired for crop harvesting is classified as unproductive.

Although it has been established empirically that men take over tasks performed by rural women as soon as they are mechanised or commercialised, existing literature does not provide a satisfactory analysis of the causal factors. This volume not only confirms this trend but, more importantly, it attempts a rationalisation of this phenomenon on the basis of economic factors and of the results of gender-based inequalities in the agrarian structure that in turn contribute to the institutionalisation of discrimination. In particular,

[1] In the analysis of the impact of technological change, some have raised the question, in very simplistic terms, of why women should be treated differently from men. Did the process of development include all men?

[2] For example, a rural woman in Bangladesh concurrently undertakes work of cooking, child care and rice processing within the seclusion of her compound.

[3] Palm fruit provided by men serves as raw material to palm oil processed by women in Africa.

[4] Children and female members of household participate in water collection (intricacies in the household division of labour).

this volume examines whether the principles of economics (for example, distortions in relative factor prices) that contributed to the emergence of capital-intensive industries in Third World countries despite the availability of a pool of unemployed labour have contributed to higher capital-intensity (which is detrimental to incomes and employment) in the rural production system relying on female wage labour.

One principal contribution of this volume is the attempt (at the conceptual level and in empirical applications) to extend current theories of rural factor market imperfections, which are designed for class-based analysis, to gender-related questions, and to assess their implications for choice of techniques and resource allocation in rural women's production processes. This could provide the clue to why rural women are left in labour-intensive sectors characterised by low productivity and low returns.

Easing the time disposition with respect to arduous and non-monetised activities is often assumed to be the major constraint to women's adoption of income-generating technologies. This volume examines empirically whether the time budget is in reality a binding constraint where economic opportunities are available (taking due account of the size of household and operational holdings). In particular, the volume tries to determine whether time budget (through reallocation of time) or resources constitute a more binding constraint to increasing the productivity of women's existing work and to the undertaking of income-earning activities. A related question is whether technologies intended to improve women's time disposition are frustrated by intricacies in the labour process. For example, as a result of improvements in the provision of water supply, help previously received from other members in water collection is withdrawn or the availability of additional water generates more work for women in washing or for provisions of water to the household's economic activities.

The volume indentifies the social, economic and technical constraints to the diffusion of technologies relevant to rural women's tasks. In assessing the appropriateness of technologies, a multidisciplinary approach is adopted. In particu-

lar, the volume examines factors that favoured the adoption of improved technologies. While most of the diffusion questions are considered at the micro (household) level, macro (national) level policies are also reviewed for their consistency with micro-level measures.

Undertaking a disproportionately large share of the family's work burden does not necessarily give women access to or control over a proportionately larger share of the household cash income (and consumption).[5] This is important because the way in which cash income actually gets spent (that is, in whose interests it gets spent) could vary according to who controls it within the household. Therefore, an attempt is made in the volume to identify appropriate organisational forms that would help women retain control over their increased incomes brought about by investments and improved technologies.

**Methodology and design**

In the light of the background and objectives outlined above, the volume brings together conceptual and empirical analyses undertaken by economists, sociologists and engineers. The rest of the chapters in this volume encompass an interesting number of approaches with somewhat varying emphases. The authors, not surprisingly, tailored their approaches to the nature and availability of data and documentation. Although the authors belong to different disciplines, because of the multidisciplinary character of the issues covered it was not uncommon for an engineer to utilise socioeconomic data supplied by an economist or sociologist or for an economist or sociologist to use data from technical engineering studies. The country case studies (Chapters 6–9) were undertaken only after the overview and conceptual chapters (Chapters 2–5) were completed.

The book is divided into three distinct parts. Part I deals with conceptual, analytical and theoretical approaches

[5] One common recurring theme in the background statements of virtually all the chapters in this volume is women's high work burden in relation to that of the men in both absolute and relative terms and irrespective of whether it is measured on a daily or an annual basis.

(although the empirical overview and the country case studies also attempt conceptualisations to different degrees on the basis of *a priori* reasoning and analysis of evidence). It begins with a theoretical piece (Chapter 2), which attempts the formulation of a macro-quantitative model for analysing the impact of technological progress on rural women. This is followed by the formulation (Chapter 3) of a conceptual framework for analysing the effect of technological change; it relies exclusively on empirical evidence and analytical arguments.

Part II consists of two empirical overviews of the impact of technological change on the condition of rural women. The first focuses on women in the agricultural sector and attempts conceptualisations, based on a comparison of the Asian and African experience, about the effect of technical change on women engaged in crop production. This is followed by a regional overview of the problems involved in the introduction, evaluation and dissemination of technologies to rural women in Africa.

Part III contains four country case studies from Africa (Chapters 6–9), which help to articulate the analytical arguments and reinforce the general conclusions drawn in Parts I and II through in-depth country-level data. These case study chapters are more operational and project-oriented.

The concluding chapter (Chapter 10) does not list the conclusions arrived at by individual chapters (which are available at the end of each chapter). Instead, it discusses analytically the highlights of the major themes of the volume at both the conceptual and empirical levels. In the summing up, the approach followed was to further refine analytically the broad conclusions so that the contribution made by the volume to both theory and policy-making in this field is clearly brought out. Finally, this chapter identifies some areas of future research based on suggestions made by authors of some of the chapters.

### Summary and highlights

This introduction is concluded with a preview of the substantive points raised by individual authors.

Chapter 2 analyses how the traditional macroeconomic theories of technological change, which have primarily been concerned with analysing its impact on the class distribution of income, are inadequate in providing a framework for analysing the question of technological change and rural women. They nevertheless offer some valuable clues, on the basis of which the author suggests some modifications in order to make these more suitable for studying the impact of technological change on rural women. A mathematical expression is formulated for measuring the change in time disposition that results from technological change affecting both rural women's gainful economic activities and their unpaid household work. Two important indices of rural women's welfare in terms of income earned and leisure time consumed are introduced. A four-fold classification is presented for quantitatively capturing the impact of technological change on the welfare of rural women in terms of the two indices. This involves income comparison and time disposition comparison, before and after technological change. A set of conditions have been established that help identify whether the likely direction of the impact of innovation is 'labour-using', 'labour-saving' or 'neutral'. In the light of the conceptual analysis, the chapter derives and discusses the specific conditions under which innovations become socially acceptable to rural women. Finally, a set of general hypotheses regarding the impact of technological change on rural women by various socio-economic groups is generated using the logic of the previous sections and modified to make them suitable for empirical testing.

Chapter 3 argues that the relative positions of men and women vis-à-vis the benefits of rural development have an institutional basis from which are derived forms of sexual hierarchy that lead to greater exploitation of women. It conceptualises some aspects of this institutional basis and examines why the issue of gender is so markedly absent from much of the traditional theory and framework of analysis of the impact of technological change. It empirically demonstrates the interaction between biochemical and mechanical innovations on the one hand and institutional sources (wage

and family) of women's labour input on the other. It qualitatively evaluates the impact of this interaction on women's work burden and income. Another institutional aspect brought out by this study is that some technological change has the effect of reinforcing the patriarchal or entrepreneurial role of men in the household to the detriment of women. On the conceptual plane, the study draws the analogy between class and gender as a system of inequality and hierarchy in rural societies and postulates that techno-logical change is not 'indifferent' to gender any more than it is to class. Just as one manifestation of the rural factor market imperfection is higher labour-intensity on small farms, so also rural women tend to be confined to labour-intensive sectors characterised by low productivity. Chapter 3 also analyses the differential impact of technological change on rural women on the basis of sex-sequential tasks (labour inputs required from each sex at different times to produce a single product – as, for example, cocoa in Africa) or sex-segregated tasks (one or the other sex performs all the operations to produce a given product, such as cotton cloth in nineteenth-century Mexico).

Chapter 4 traces the impact of agricultural modernisation on rural women in the Third World. Women, by virtue of their gender, are typically left worse off than the men of their culture and socioeconomic class. In the Asian context, one can often assume that the direction of the effect would tend to be the same for women and men of the same class of households, even if the relative levels and forms of impact would be different; in the African context, on the other hand, even this usually cannot be assumed to hold true: here, schemes that clearly have been beneficial to the men of a household have often been detrimental to the women of that household. The consequences of the unequal distribution of the costs and benefits of technical change between the genders can be particularly severe for women belonging to the poorer households. More often than not, the problem cannot be located in the technical innovation *per se*, since what is inappropriate about the innovation is frequently not its technical characteristics but the socio-political context within which it is introduced. This gives the innovation its

specific class and gender bias. This chapter further stresses the need for greater control over productive resources and the product of their labour by women from poorer rural households if the adverse effects of technological change on rural women are to be reduced or eliminated. It also considers structural changes aimed at reducing socioeconomic inequalities as a prerequisite for a more equal sharing among households and between the sexes of the benefits and burdens of technological change.

Chapter 5 undertakes an in-depth review of the impact of technological change in a few selected activities important to rural women in the African context. The empirical analysis of the chapter provides some links to the methodological framework developed by the preceding conceptual chapters. Recognising that the issue of dissemination of technologies is important, this chapter identifies the economic, technical, social and cultural constraints to the diffusion of technologies relevant to rural women's tasks. Based on empirical evidence and on evaluation of some operational pilot projects, it emphasises the need for a package approach to rural development under which beneficial equipment innovations for rural women are introduced together with adequate institutional, financial, organisational and extension support. It suggests the need for the creation of alternative income-earning opportunities for rural women as an incentive to the adoption of labour-saving devices in their arduous tasks.

The basic premise of Chapter 6 is that technologies conceived for or adapted to tasks traditionally performed by rural women are likely to maintain and reinforce a given division of labour between sexes. This division of labour assigns to women tasks related to the maintenance and growth of their households over and above whatever work for which they may be responsible outside the home. The chapter argues that technological solutions that leave the scale of domestic production unaltered tend to keep women in the semi-subsistence sector while commercial production of the same set of goods and services remains in the male domain. This chapter further suggests that a lasting improvement in rural women's income and employment opportunities in Kenya cannot be brought about by short-run solutions

based on small-scale technologies; it has to be accompanied
by long-run policy measures to increase women's access to
training, skills, education, credit, extension services, off-farm
employment opportunities and, most importantly, the modern
means of production. Finally, this chapter reveals the critical
importance of focusing on the technological needs of the two
most vulnerable groups of rural women in Kenya – operators
of small agricultural holdings and female-headed households.

Chapter 7 points to the need to take into account social and
cultural factors in assessing the appropriateness of tech-
nologies in rural women's tasks and draws a number of
conclusions: Ghana's current economic predicament, with its
associated acute shortages of food and other essential items,
is quite conducive to the stimulation of rural women's
activities through the application of improved technologies; a
holistic approach needs to be adopted in planning and
introducing the improved technologies, in which due atten-
tion is given to the linkages between the women's activities
and those of others in their families and communities; the
women's accustomed tastes, beliefs, taboos and modes of
behaviour combine with economic and technical factors in
determining their acceptance or rejection of improved
technologies; and reliance on traditional channels for the
dissemination of improved technologies to rural women is
likely to be more effective.

Chapter 8 reveals that the major problems faced by rural
women in Nigeria were the use of old technologies in
traditional processing, cassava shortages at peak periods and
overcapitalisation and underutilisation of modern or mechan-
ised processing. The most significant finding of this chapter
is that the traditional *gari* processing system is more efficient
than the mechanised system, in terms both of costs and
returns and of its relevance to the needs of the village
economy. However, it also shows that innovations can have
positive and beneficial effects in increasing agricultural
productivity and rural incomes and in reducing costs. By
conserving the advantages of the traditional system while
introducing a preferred technology to overcome the dis-
advantages of the traditional system, agricultural development
and rural transformation in Africa could be made to walk on

two legs. Small-scale technologies are particularly significant for favourable costs and returns. It has also been observed that the strategy of selective rather than complete mechanisation is often the answer, particularly in the early stages of agricultural development. Only the difficult aspects of agricultural processes need to be mechanised to break bottlenecks in rural women's manual operations, thereby increasing productivity while maintaining the essentially labour-intensive nature of the processes.

Chapter 9 reviews available evidence from Sierra Leone on the range of technologies relevant to rural women's tasks, such as farming, water collection and food processing. It also examines the constraints on the adoption of suitable innovations and points to the need for studies in greater depth of traditional methods of production.

# PART I
# *Conceptual Approaches*

# 2

# Technological Change and Rural Women: A Conceptual Analysis

*AMIT BHADURI*

## Relevance of traditional analysis

Traditional macroeconomic theories of technological change have primarily been concerned with analysing the impact of technological change on the class distribution of income. Division of income between profits and wages – or, within the neoclassical framework of an aggregate production function, the 'functional distribution' of income in terms of the relative share of 'labour' and 'capital' – has been the central variable to be analysed in this context.

Economists' preoccupation with this link between techno-logical progress and the functional or class distribution of income has a long and distinguished history, going back at least to Ricardo's famous and controversial chapter 'On Machinery' where Ricardo (1951) was concerned with analysing the consequences of the introduction of machinery into production processes and its resulting impact on the working class. Marx's ideas on labour-saving technological change resulting in the maintenance of a 'reserve army of labour' to keep down the real wage rate under capitalism also essentially centre around the same set of issues.

Although the conceptual tools and methods of analysis have changed in recent times, contemporary economists dealing with technological change have also been motivated to consider technical change mostly from the point of view of its consequences in terms of the functional or class

15

distribution of income. J. R. Hicks (1932) was one of the first contemporary economists who tried to classify technological innovation in accordance with its impact on the functional distribution of income. Using an aggregate neoclassical production function as his point of reference, he considered technical progress to be neutral if, in effect, it left the ratio of profit rate to real wage unaltered at a given capital–labour ratio before and after technical change. Thus, neutrality of technological change essentially implied an unaltered functional distribution of income. This criterion for neutrality was also adopted by Roy Harrod (1948), although he defined it in terms of a new set of variables to suit the requirements of modern growth theories. According to him, technical progress could be deemed neutral if the rate of profit remained unaltered before and after technical change at a constant capital–output ratio, thereby leaving the share of profit in national income unaltered. (Harrod's definition was inverted by Joan Robinson (1956), who defined technical progress as neutral if, at a constant rate of profit, the capital–output ratio remained constant. The inversion was intended to overcome some capital–theoretic problems.)

Following the same line of analysis, non-neutral technical change occurs when the class distribution of income alters as a consequence of technological change. Thus, if, at a constant capital–labour ratio, the ratio of profit rate to real wage rate goes up as a consequence of technical change, then this must entail a corresponding change in the relative distribution of income in favour of profits. Hence, technical progress will be said to have a bias in favour of 'capital'; in accordance with Hicks' definition, it may be termed 'capital-using' technical progress. Using this simple idea of defining 'bias' in technological change in terms of its corresponding impact on the relative income distribution among classes (or on the functional distribution of the neoclassical scheme), one could now easily classify technological innovations as 'capital-using' (or labour-saving), 'labour-using' (or capital-saving) or neutral, in accordance with Hicks' or Harrod's definition.

This general way of classifying technological change in terms of its impact on income distribution appears also to be

a useful way of examining the economic consequences of technological change in several particular contexts. Thus, in a discussion of the impact of technological change on rural women, one could perhaps proceed on the basis of a preliminary classificatory scheme along the same lines. We shall thus define technological change as neutral if it leaves the pattern of income distribution among relevant groups unchanged, and, in line with the preceding discussion, technological change will be said to have a bias in favour of a particular group, if the pattern of income distribution is shifted in favour of that group.

All this is in direct accordance with traditional economic theories of 'disembodied' technological change in a macro-economic context.[1] An important difference arises as soon as one begins to characterise the attributes of the 'relevant groups' whose pattern of income distribution is being considered. One or two specific examples will suffice to make this point clear. Thus, one may be concerned with the problem of sexual division of labour between men and women. It has been observed that in many traditional societies the work roles of both men and women are fairly strictly defined, so that certain types of work obligations are considered to be almost exclusively male or female domains of work. Under such circumstances, in order to study the impact of technological change on income distribution, one may define male and female workers as the two relevant groups (as well as child workers, if that be a significant third group) and see how technological change affects the traditional shares of these particular groups. But one could also take an alternative example, where traditional work roles according to sexual division of labour are not the most important point of analysis. Thus, the brewing of beer in certain parts of Africa is almost exclusively a women's job (see Chapters 5 and 9), but is done both as a subsistence domestic activity as well as on a commercial basis in factories. Under such circumstances, it may be quite useful to analyse the impact of change in the technology of brewing

---

[1] 'Embodied' technological progress reflected through the higher productivity of later 'vintages' of machines is not relevant for our purpose here. See Salter (1960) for pioneering work on 'embodied' technical change.

on self-employed women compared with women employed as factory workers in terms of the relative distribution of income among them.

These examples seem to make two rather important general points for the purpose of the present analysis. First there is no *a priori* basis for choosing the 'relevant groups' or group characteristics. The groups among whom income distribution is to be analysed may vary considerably, depending on the particular type of technological change being considered. This can be contrasted with the traditional macroeconomic theory of technological change, where the income-receiving classes like capitalists and workers (or 'profits' and 'wages' as categories of income under capitalistic production) are more or less invariant, thereby offering a greater cohesion to the analysis. This cohesion may often have to be sacrificed for relevant empirical studies in the present context. Secondly, there is a more fundamental problem, which will recur over and over again in the context of the present analysis. Before the impact of technological change on the group distribution of income can be systematically studied, there is a serious conceptual problem of defining 'income'. The problem arises (as in the case of the brewing example given above) primarily because very often we shall find in our analysis that some of the women or one of the relevant groups are dominantly or even exclusively engaged in subsistence household activities, whose purpose is mostly self-consumption and 'use-value'. Since they are not involved in 'exchange-value' and commercial production, it becomes difficult to impute monetary values to their work time. Consequently, it also becomes difficult to study the pattern of relative income distribution, because the lack of a common monetary unit or numéraire makes comparisons almost meaningless. (This problem of measuring 'opportunity cost' in imputed money value in a use-value economy has been beautifully discussed in Kula, 1976.)

Consider again my previous example of technological change in brewing as a specific illustration of this general point. If labour time in brewing is reduced by 20 per cent in commercial factory production and by 10 per cent in domestic production for self-consumption, how are the two

to be compared in terms of income distribution, since the latter has no direct monetary implications? In a different context, several economists have often suggested imputing going market values to such domestic work for self-consumption but this seems to be a hopelessly circular argument in the present context (see Kula, 1976). For, if the two relevant groups are women engaged in factories and women working at home, one may lose precisely their relevant group attribute or characteristic by imagining that everybody was a factory worker. Rather than imposing this kind of assumption of uniformity, which blurs the important distinction between domestic 'unpaid' work for use-value and 'paid' work for exchange-value, it is important in this study to devise methods and definitions by which such an important distinction can be clearly captured, rather than being lost sight of. And this is one of the very important reasons why conventional macroeconomic theory of classifying technological innovations in terms of income distribution is rather inadequate when one comes to apply that framework to the problem of technological change and rural women.

## A relevant analytical framework

One of the most direct ways of analysing the impact of technological change on rural women is to consider its overall welfare implications in terms of the 'quality of life' of the women involved, rather than simply the income changes brought about by technological evolution. As the argument of the last section showed, the overall welfare criterion involves not only income but also the pattern of time disposition of those working women. In order to grasp the problem more concretely, we can start by dividing the entire woman-day (or woman-year) into three specific time components:

(i) The amount of time spent in 'gainful economic activity' resulting in income. This relates to commercial activities in the sphere of 'exchange-value' and, given the average earning rate per hour (or per day), the total income ensuing from such activities is known. Let us denote by

$H_c$ the total amount of time spent in such commercial activities and let $w$ be the corresponding earning rate per unit of time so that,

$$Y = w.H_c \qquad (1)$$

yields the total amount of income, measurable in money terms, resulting from such commercial activities.

(ii) For the broad category of rural women, a significant proportion of their time is spent on unpaid household activities. This relates to activities in the sphere of their own family consumption or self-consumption for 'use-value'. As I have already indicated, this is a special, but important, feature in analysing the impact of technological change on rural women. No direct income measure of these unpaid household activities is possible and indirect measures by imputing values based upon opportunity costs may lead to misleading calculations in most cases (see Kula, 1976). Let us denote by $H_u$ the time spent on unpaid household activities.

(iii) There is a residual amount of time, $H_r$, spent on sleeping, eating, recreation, leisure, etc.

As a matter of definition, it must now be true that the total time $H$ (measured in a relevant unit like hours or days – for the present analysis hour-unit is most directly suited) is composed of these three forms of activity, i.e.

$$H_c + H_u + H_r = H. \qquad (2)$$

(Since the total time per day is fixed, if hour is the relevant time unit then $H = 24$ hours in equation (2).)

The importance of this three-fold division of total time disposition can be seen by considering specific forms of technological change. Consider, for example, technological change affecting economic or social overheads and infrastructural facilities like easier availability of drinking water: it will reduce the amount of time spent on unpaid housework ($H_u$) to make the 'time budget' for rural woman less stringent. Thus, $H_u$ reduces to $H'_u = (H_u - \Delta H_u)$. Whether this

additionally reduced time for unpaid household activities is now spent on personal 'leisure' – so that $H_r$ increases to $H'_r = (H_r + \Delta H_r)$ – or is alternatively spent in gainful employment – so that $H_c$ becomes $H'_c = (H_c + \Delta H_c)$ – will depend among other things on available gainful job opportunities. In general, we can say:

$$-\Delta H_u = \alpha.\Delta H_c + (1 - \alpha)\Delta H_r, \quad 1 \geqslant \alpha \geqslant 0. \qquad (3)$$

If $\alpha = 1$, then the entire released time is spent on gainful employment; $\alpha = 0$ implies that the entire released time is spent on residual activities, thus slackening the time budget of rural women. In between these two extremes are various possibilities where part of the released time is spent on gainful employment and part is spent on residual activities, with $\alpha$ taking the value of a positive fraction.

I have illustrated my argument only with a specific form of technological change affecting unpaid household work, but the argument is perfectly general in so far as release of time in one direction or activity results in corresponding gain in time for other activities, including leisure time. Thus, the change in time disposition caused by technological change can be captured in each case by an equation corresponding to (3).

There is, however, an important element of asymmetry in this change in time disposition as a result of technological change. If, at a given earning rate, time spent on gainful employment is reduced, then, by (1), a fall in income is entailed. Thus, mechanised harvesting, say, may cause time disposition to move in favour of unpaid household work and residual work, including leisure, only at the cost of a drop in income. This is 'involuntary unemployment' caused by substitution of more efficient machine-hours and it will indeed be odd to call it just an increased consumption of leisure.

The foregoing discussion should be sufficient to highlight an extremely important point in the analysis of the overall welfare implications of technological change for rural women. As a first approximation, there are two important indices of welfare: an index in terms of income earned, and an index in

terms of leisure time consumed. It should also be noted here that 'leisure time' is a rather hazy notion in the present context, as it may involve time spent on both residual activities $(H_r)$ and unpaid household activities $(H_u)$, the two being not always mutually exclusive. But again as a first approximation, one may treat the increase in leisure as equivalent to an increase in time spent on residual activities, $H_r$, at a constant level of $H_u$ in order to show the overall welfare implications of technological change on rural women as a two-dimensional (vector) comparison.

Thus, let $Y^i$ be the income of group $i$ of rural women and let $H_r^i$ be the time they spent on residual work before technological change. Let $\bar{Y}^i$ and $\bar{H}_r^i$ be the corresponding data after technological change. Then the two ratios,

$$\frac{\bar{Y}^i}{Y^i} = R_1^i \quad \text{and} \quad \frac{\bar{H}_r^i}{H_r^i} = R_2^i,$$

give an indication of the impact of technological change on income and time disposition. We can now have the following classification:

(1)  $R_1^i > 1$ and $R_2^i > 1$ implies income- as well as leisure-augmenting technological change for group $i$ of rural women.
(2)  $R_1^i > 1$ and $R_2^i < 1$ implies income-augmenting technological change that is leisure reducing.
(3)  $R_1^i < 1$ and $R_2^i > 1$ implies leisure-augmenting technological change that is income reducing. This includes situations of 'involuntary technological unemployment' discussed above.
(4)  Finally, $R_1^i < 1$ and $R_2^i < 1$ implies that technological change is both income reducing and leisure reducing. This may well be the case if, as a result of technological change, the earning rate per hour is decreased more than proportionately in relation to increased number of hours spent in gainful employment for group $i$ of rural women.

This four-fold classification is a broad way of capturing the impact of technological change on the welfare of rural women

belonging to a particular group $i$ in terms of two broad indices involving income comparison and time-disposition comparison. However, its validity is based on the assumption that, during the process, the time spent on unpaid household work, $H_u$, remains constant. In actual empirical studies, this may raise two distinct sets of problems. First, it may indeed be found in specific case studies that there is a considerable overlap between unpaid household activities and residual personal activities, so that the time spent on each may not be easy to demarcate. Secondly, the actual time disposition before and after technological change may in general be expected to affect all the three elements – $H_c$, $H_r$ and $H_u$ – mentioned above, so that notional comparisons based upon a constant level of $H_u$ become difficult to apply.

In spite of these serious difficulties in empirical applications, the essential common sense underlying an analysis of technological change that tries to combine income considerations with time-disposition considerations should not be lost sight of. Indeed, to highlight this procedure we can, alternatively, have the following classificatory scheme of innovations in terms of their impact on rural women's leisure time:

(a)  If, at a constant level of income (i.e. $R_c = 1$), leisure hours of rural women increase as a result of technological change, then it will be considered 'labour-saving'.
(b)  If, at a constant level of income, leisure hours of rural women decrease as a result of technological change, then it will be considered 'labour-using'.
(c)  If, at a constant level of income, leisure hours of rural women remain constant, then it will be considered 'neutral'.

On general welfare considerations, with income considerations held constant for analytical purposes, it appears that case (a) is most advantageous for any particular group of women considered.

In order to see the full implications, it is useful for a moment to return to my algebraic formulation. Identifying 'leisure' ($L$) with time spent on personal activities (which seems to be the most concrete way of proceeding), from

equations (1) and (2) one obtains by definition,

$$L \equiv H_r = H - \frac{Y}{w} - H_u,$$

or, taking changes,

$$\Delta L \equiv \Delta H_r = \frac{Y.\Delta w}{w^2} - \Delta H_u, \qquad (4)$$

where $H$ is constant, so that $\Delta H = 0$, and $Y$ is constant, by the nature of my definition of classifying innovations.

On simple manipulation, one gets

$$\Delta H_r = \frac{\Delta w}{w} \cdot \frac{Y}{w} - \Delta H_u$$

or,

$$\Delta H_r = \frac{\Delta w}{w} \cdot H_c - \Delta H_u. \qquad (5)$$

The interesting economic implication of (5) can now be seen. An increase in leisure entails, from (5), $\Delta H_r > 0$, i.e.

$$H_c .\Delta w > w.\Delta H_u. \qquad (5a)$$

Condition (5a) is easy to interpret: the increase in income from a change in the earning rate must over-compensate the decrease in the opportunity cost of income loss through additional hours spent in unpaid household activities. This happens because an increase in leisure hours at constant income level is possible either through a rise in earning rate per hour, so that fewer hours have to be spent to earn the same level of income, or through a reduction in hours spent on domestic activities. Condition (5a) ensures that the hours released from gainful employment through a rise in the earning rate per hour must exceed the hours lost through a rise in domestic unpaid activities – an evident enough condition, when viewed from this angle.

It is needless to add that, corresponding to my earlier definitions of 'labour-using' and neutral' innovations, there are conditions corresponding to (5a). Thus, when innovation is 'labour using',

$$\Delta H_r < 0 \quad \text{and} \quad H_c.\Delta w < w.\Delta H_u, \qquad (5b)$$

while strict equality holds in the case of 'neutral' innovation in the above condition.

Theoretically, one can proceed along the above line of argument to integrate, to some extent at least, the time-disposition criterion with the income criterion in judging the impact of technological change on rural women, but it should be pointed out that the time-specific operations of agricultural activities will often make this difficult. For example, it is possible to imagine technological changes that are 'labour saving' in one operation (e.g. sowing) but 'labour using' in another operation (e.g. harvesting). Since these specific agricultural activities are typically sequenced in time, special care has to be taken to look at the aggregated net effect of an innovation whenever it affects more than one such activity. This net effect then has to be judged both by the income criterion and by the time-disposition criterion to arrive at a meaningful evaluation of technological change.

## Social acceptability of technological change among rural women

One important consequence of an attempted integration of the two criteria of time disposition and income is that it brings out the enormous variations in costs and benefits of technological innovations depending on the socioeconomic characterisation of various groups of rural women. It would thus seem valid to formulate the problem of social acceptability of an innovation in two analytically distinct but interlinked steps:

(i) Its implications for the time budget of various socio-economic groups of rural women. For this purpose, it may be necessary to perform a thought experiment by which, on the assumption of a constant level of income, it is found out whether the innovation does actually release time by making the overall time budget less stringent;

(ii) How this released time (at constant income level, by

assumption) is actually used – in gainful employment, in greater leisure or in longer hours of unpaid household activities. It may generally be presumed that only when gainful employment opportunities exist for the additional hours released will they impute monetary opportunity costs on the released labour time of rural women; the more real and significant are those opportunity costs, the stronger may be the incentive to accept technological change socially.

Another aspect of the question of social acceptability of technological change is the ability privately to bear part or whole of the cost of introducing technological change. Unless a particular socioeconomic group has this financial ability, both the process of social acceptability as well as the diffusion of technological change will essentially be exogenous to it. This is an obvious but important consideration in the present context. For, in relation to the poorest sections of rural women in developing countries, even when certain types of technological change are decidedly to their advantage on the basis of time-disposition and income criteria, their actual introduction depends on other social groups who can bear the cost. Thus, in the final analysis, social acceptability of privately introduced technological change does not depend on its consequences on all groups that are broadly in a position to bear the cost of new technology. Therefore, both the time-disposition and the income criteria of social acceptability of technological innovation should be interpreted as class-related criteria where only the decisions of the more advantaged and powerful social classes matter. This consideration is more relevant in private introduction of technology than in public efforts directed towards technological change in the rural society.

# 3

# Effects of Technological Change on Rural Women: A Review of Analysis and Concepts[1]

*ANN WHITEHEAD*

## Introduction

It is often argued that, in the abstract, technological change could have both favourable and unfavourable effects on the position of rural women. Although the field is lamentably under-researched, this chapter starts with the judgement that, overwhelmingly, the evidence from empirical studies is less contradictory and ambiguous in its general trends than this neutral stance would suggest. In recent years a substantial number of writers have pointed out the ways in which women are suffering negatively from technological and socioeconomic changes brought about by the development process. (Dey, 1975; Palmer, 1975a; Germain, 1975, 1976; Olin, 1977; Zeidenstein, 1975; UNRISD, 1977.) The purpose of this chapter is to examine some of the reasons why, despite the potential benefits that rural women could derive from both planned and unplanned technological innovation, the impact of such innovations has been largely 'unfavourable'.

There is a very large gap between the major types of problem tackled in the literature dealing with technological change in general and those in the relatively few sources

[1] This chapter is a shortened and revised version of Whitehead (1981b). The themes are dealt with in greater length in Whitehead (1980).

27

dealing specifically with technological change and women. The former contains a number of well-developed focuses and themes. These include discussions of the political economy of technological change (including those implied in research and development transfer); problems of technological choice; appropriate technology; delivery systems and implementation strategies; the neutrality or non-neutrality of forms of innovation; and employment, labour-demand and income-distribution effects. Some of these are discussed with a good deal of analytical rigour, which provides the scaffolding for further research. The much more recently developed literature on technological change and women, in contrast, is more or less forced to rely on descriptions of specific situations and on relatively low-level generalisations about an empirical association of men with advanced technology and of women with backward technology. Few general surveys of the kinds of technological change that affect women's work are available, and little or nothing has been done to determine the relationship of women's work to technological change, except in so far as there has been stress on the fact that rural Third World women do play an important part in production, and that their work should be seen to include domestic and reproductive work. There is not much that can be directly inferred to serve as a conceptual framework for the issue of rural women and technological change.

This state of affairs has led me to abandon any form of review of research findings on women and technological change, and rather to make a highly restricted selection within this literature to illustrate the problems, and then to go on and seek to conceptualise the issues by reference to findings in other development fields.

The underlying argument is that the relative positions of men and women vis-à-vis the benefits of development have an institutional basis from which are derived forms of sexual hierarchy. The objectives of the study are to conceptualise some aspects of this institutional basis and also to examine why the issue of gender is so markedly absent from much of the traditional theory and framework of the analysis of the impact of technological change. In stressing that the most significant forms of technological change affecting women are

not innovations aimed directly at them, but rather are the indirect consequences of planned and unplanned innovation in the rural production system as a whole, the study shows how these are fed through the sexual division of labour and family relations into far-reaching consequences for women. The chapter concentrates its discussion of these in two main areas: first, that of the social relations under which women's work is performed, examining especially the work that women do without remuneration as household members and dependants; secondly, it addresses the question of how the inequality in the effects of technological innovation between the social categories of women and men can be conceptualised, and suggests that there are parallels between the effects of gender and the effects of class.

## Women and technological change: some pointers from the literature

In the literature on technological change in general, an influential and important paradigm is what could be called the employment, productivity and income-distribution paradigm. A major example of work of this genre is to be found in a detailed study of the known evidence of the labour-demand effects of different combinations of technological packages for cereal production in Asia (Bartsch, 1977).

Studies of employment and labour-demand effects of this kind, although extremely important, have a number of serious inadequacies. Among these are conceptual and analytical problems that derive from the fact that the Third World economy is not a fully wage employment one. Wage employment coexists with other forms of production of various kinds so that there are demands on labour time that do not necessarily operate according to the principles of the labour market and wage employment. Differences in the forms of production and their coexistence affect how the technical demand for greater human effort is transformed into the hours of work, intensity of effort and forms of reward for a given set of workers. The narrowly defined employment and productivity economic analysis necessarily treats labour as abstract labour. Bartsch, for example, points

out that: 'No differentiation is made between type of labour input, either by sex and age characteristics, or by class of worker, such as family, unpaid, permanent wage employee, casual wage employee' (Bartsch, 1977, p. 8). He suggests that there is evidence from field studies that changes in technique have a different impact on various classes of workers. Given the extent to which women's work, especially in the Third World, is as unpaid workers or as family labour, this hidden problem of the actual labourer working within a specific set of institutionalised social relationships is especially important when considering the effects of technological change on women. This, therefore, is the first theme taken up in this chapter.

*Evidence from the Green Revolution*
Palmer (1978) summarises the effect of the introduction of high-yielding variety (HYV) technology on women with a view to examining the processes of widening gender inequality set in train and the reasons why many studies within the previous paradigm fail to pick up significant gender differences. She points out that HYV innovations affect all points of a crop cycle, which includes land preparation, pre-harvest, harvest and post-harvest tasks, in which both men and women engage at various points. On the basis of the United Nations Research Institute for Social Development (Pearse, 1974; Palmer, 1976) and other studies, she summarises the demands of HYV technology as extra effort required in the following men's and women's tasks: for men – more careful and more frequent land preparation; harvesting a thicker crop; for women – increased trans-planting and weeding work; applying chemicals; increased harvesting and processing work. She points out that, although women as a whole undertake the day-to-day cultivation tasks and take part in the harvest, the hard and seasonally peaked post-harvest tasks for which they are largely responsible are often done by women of the landless classes in the form of casual wage labour.

In highlighting a number of definitional problems relating to measures of productivity, Palmer stresses the importance of the time unit over which productivity is measured. The

effect of an increased labour demand on a rural worker's welfare may well depend on whether s/he is having to work at greater intensity during the agricultural season or for a longer period of the year. Her analysis also refers implicitly to the widely recognised problem of measuring women's work within the family. She argues that the translation of the labour-augmenting demands of a technological change into changes in the annual spread or daily intensity of work effort, as well as into employment loss and creation, depends on a number of factors – for example, whether the task is being mechanised, and the time period over which increased demand is spread. She also emphasises that the class to which the woman belongs affects her employment mode.

Palmer argues that land preparation, harvesting and some processing are the easiest tasks to mechanise, and that, where mechanisation is introduced, female tasks become male tasks. Rice milling employing male labour is replacing hand-pounding in Sri Lanka, South India, Bangladesh and Java and is thus decreasing employment for landless women. (Female labour displacement through the introduction of mechanised food processing is a major concern elsewhere – for Java, see Collier *et al.*, 1974, and Timmer, 1973; for South India, see B. Harriss, 1977.) The greater effort that the HYV technology objectively requires in all the tasks performed by women does not create jobs for women since, if not met by mechanisation, it is mainly met in peasant farming classes by the more intensive use of female 'family' labour. She documents increases in the use of family labour and argues (1978, p. 7) that this demonstrates 'the ability of patriarchal authority in the peasant household to extract more labour from family members'.

In addition to the loss of jobs and income for landless women, Palmer describes the effects of the introduction of HYV technology on women compared with men in the following terms (1978, p. 8):

The new technology has probably led to men doing some work on more days of the year – a fall in seasonal unemployment or a fall in underemployment on an annual basis. Hence men's greater labour effort would entail a

more even spread of work throughout the year with no extra physical strain. On an annual basis employed men would have experienced an increase in productivity, and if they use some machinery an increase in hourly pro-ductivity.

Peasant household women's greatest effort has to be seen in more hours in the fields on the days they do go into the fields, and probably more days in the week that they go into the field. Combined with their household tasks, peasant women do not usually experience seasonal un-employment (or any unemployment) and their additional fieldwork would mean longer work-days or more over-employment. Certainly their annual productivity would rise but this, as with men's, would be due to more work effort. On an hourly basis there is no reason to believe there is any increase in women's labour productivity.

Three important conclusions could be drawn from the overall analysis contained in Palmer's paper and the studies on which it is based. First, the findings suggest that the most significant forms of technological change affecting women may not be aimed directly at them; indeed, they are not necessarily those changes that are built into the first stages of large-scale development projects. The problem area of technological change and women cannot be confined to those planned developments in which it has been clearly seen that intervention is being made in the kind of work that women do and the way they do it. Rather, for large numbers of rural women the most significant forms of technological change are more likely to be the indirect consequences of both planned and unplanned innovations in agriculture as a whole. In many cases, far-reaching effects on women's work derive from the powerful drive to commercialise the potentially profitable sectors of women's work. Persistently operating and widely spread unplanned technological innovations often accompany modernisation in agriculture as well as widespread changes in the socioeconomic system. The range and complexity of the conceptual issues raised in any empirical situation vary with whether the technological change is the single type of technical innovation that directly changes the

way in which a particular task is carried out, or a complex form of interlinked sets of technological change, whether catalysed by discrete development projects or not.

A second generalisation arising from Palmer's account concerns the importance of carefully conceptualising the manner in which women's work is done, and in particular the social relations that surround it. It is now a commonplace to describe women's work as characteristically embedded in a division of labour in which gender differentiation marks the allocation of social agents to work tasks and to the processes of work (see Whitehead, 1980, for further discussion). It is less often stated that such sexual divisions of labour differ in a number of important features. Among these, the form of social relations under which work is done is very important. It cannot be argued that women's work is all characterised by the same set of employment relations, nor do the social relations of work take the same forms for women as they do for men. Important differences in the effects of technological change on women and men and on different categories of rural women derive from this aspect of the sexual division of labour. So, throughout her account, Palmer examines empirically demonstrable differences in the effects on women's work according to whether that work is done for wages or within the family. Palmer maintains that discussions of the employment effects of HYVs took place largely in terms of male employment because female labour in the crop cycle was invisible in two senses. First, women's wage work was regarded as economically insignificant in relation both to their own welfare and to the total income and budgets of the families of landless classes. Second, a woman's work as a member of the peasant household – as 'family labour' – is socially and politically invisible; in so far as it is part and parcel of her responsibilities as a wife and is unremunerated there is no employment effect and its intensity is determined by non-economic forces.

The significance of examining the social relations under which women's work is performed is brought out very clearly if one considers the case of the growth of paddy processing by custom huller that has accompanied the utilisation of HYVs in parts of Bangladesh. Paddy processing is women's

work, done within the confines of the homestead (*bari*), using a *dheki* – a modified pestle and mortar technique.[2] Women work in seclusion in the *bari*, and, although middle-income households use female family labour for this range of tasks, richer households hire poorer women to perform this arduous work on a client basis. A recent Bangladesh government report (Bangladesh Ministry of Agriculture, 1978) found that HYV innovation was accompanied by an accelerated informal (including smuggled) diffusion of a custom miller. In this context the custom miller may be regarded as a form of appropriate technology as there are two other forms of rice-milling technology available, which are much more capital intensive and large scale. The report estimated that, although 90 per cent of pre-milling processes were still being done by women in the *bari*, only 65–75 per cent of the paddy was being *dheki* husked, and an increasing proportion was being sent to the mill. It is estimated that, hour by hour, the average custom husker is 330 times more productive than the *dheki*. The very high profits ('the average custom mill pays for itself in one and one-third years') mean that the mills are spreading rapidly. The cost differential between the dheki technology and the huller technology is of the order of 12:1, so that it is entirely rational for an agricultural family with cash to switch to mechanised milling wherever it is available.

However, the report makes some important points that are relevant to gender differences. First, the productivity differentials between the two techniques lead to massive overall labour displacement. Less work is required to husk the paddy, and such new employment as is created is for men – the mill employs a male driver and occasionally another male helper. Secondly, the effects of this reduced labour requirement on rural Bangladeshi women vary according to whether the women are working as hired labour or as family labour: where most of the original home-based technology has been used by women working as family members, this would represent a considerable reduction of women's unpaid work; for women who did *bari* work as clients, however, this work is lost. We may conjecture that

[2] Detailed descriptions of the techniques are to be found in Bangladesh Ministry of Agriculture (1978); Martius von Harder (1975); Khatun and Rhani (1977).

employment in *bari*-based rice processing in other households is a highly significant source of subsistence and income for some women of poor and landless peasant households, especially as it is a form of work that does not involve public appearances. The report's suggestion that there has been massive displacement of this category of female labour foreshadows more recent work that has highlighted the contribution that this kind of female employment makes to the overall budget in poor families in Bangladesh (Greeley, 1981).

The fact that the effect of innovations varies according to whether women work as wage (client) labourers or as family labour creates important policy dilemmas that are well illustrated in the Bangladesh literature. In so far as the massive female labour displacement adversely affects those women employed on *bari*-based *dheki* milling,[3] and for whom there are no alternative income-generating opportunities, a number of influential policy discussions of women and work in Bangladesh call for the curbing of the spread of mechanised rice milling (see, for example, MacCarthy, 1974; Lindenbaum, 1974; Germain, 1976; Chen and Ghuznavi, 1978; Zeidenstein and Zeidenstein, 1973; Halpern, 1978.) On the other hand, *bari*-based paddy processing is enormously hard work, it consumes a large amount of already over-burdened time, and it provides pitifully small incomes. It is thus a form of work that is highly suitable for technological innovation to raise rural women's income and improve their welfare. Above all, this example indicates the need to be fully aware that rural women are not an undifferentiated category when it comes to the negative, or positive, effects of technological change. (This point is discussed in Whitehead, 1984.)

The third perspective to be derived from Palmer's account concerns ideological conceptualisations of male–female relations. Palmer does not assume that the interests of all family members, particularly those of husband and wife, coincide. On the contrary, as the above summary makes

---

[3] Ellickson (1975) and Halpern (1978) attribute the growing numbers of homeless and pauperised women who have been abandoned by male relatives to this and other loss of income for rural women.

clear, she conceives of the marriage relation as a labour relation containing the potentiality for exploitation. In much the same vein, Palmer also points out that the essence of many HYV packages is immeasurably to strengthen the dominant position of the male head of household, since monetisation involves both market and credit incorporation, giving rise to new institutions like co-operative or market agencies. The implication that the family or household has to be deconstructed into its constituent members is very important for considering women's work.

### Technological innovation and the intensification of women's work within the peasant household

One of the reasons for the lack of empirical and conceptual work on the effects of technological change on rural women is the fact that much of the productive work of women is as members of peasant families, for whom the household is a farming enterprise producing some of its own subsistence and also selling for the market. The direction of the processes affecting rural women that it has been argued accompany much of the relevant technological innovation derives from many of the overall development policy objectives in relation to this household production. These are summed up in the phrase 'increasing their productivity'. The desire to increase the productivity of household production has the dual objective of increasing both the real incomes of rural producers and the amount of marketed agricultural products from such rural producers.

Here again, despite the increasing attention to the workings of such household-based enterprises, which derives from the realisation of their importance in many national economies, little existing economic literature is helpful in looking at factors affecting women's work within them. Hart (1978, p. 10) has argued that neither the neoclassical approaches to peasant family farming deriving from Chayanov nor the work of the New Household Economics School are able, on the basis of the model they adopt, to make distinctions based on gender in relation to such things as decision-making about the allocation of labour and the

intensity of work in household-based production:

> Both models are based on extremely simplistic assumptions
> as to the nature of the productive and distributive
> relationships among different age and sex groups within
> the household, and the manner in which this is related to
> the intra-household allocation of labor and consumption
> and welfare.

In support of this argument, Hart notes that household
labour is treated as homogeneous in Chayanov's theory, with
the only distinction being that between workers and
dependants. She also argues that, although the New
Household Economics model apparently takes into account
the division of labour by sex and age, it does so only in a
limited sense. A major stumbling block is that the ways in
which preferences of household members are built into the
model implies that 'a household manager or decision maker
will internalise these preferences through a high level of
concern or caring for other members' (Evenson, 1976,
quoted in Hart, 1978; see also Nerlove, 1974).

*Some characteristics of unremunerated labour within the peasant
household*
A major characteristic of the peasant household as an
enterprise is its use of the labour of all its members for its
production objectives. This is familiar to us in the category
'family labour', which is used by economists to describe
informal work that members of a household put into the
household enterprise. The economists' formula for 'family
labour' tacitly implies a household structure comprising a
head of household or family (the peasant farmer or tenant)
who works on the farm and whose dependants or family
members provide 'additional' labour. A more accurate term
might be 'unremunerated labour of family members' to
describe the work that is done for other family members
where no direct reward is calculated or where the effective
possession of the product or reward for the labour accrues to
the user of the family labour.

The most obvious examples are the work that is done
inside the household by dependants. Work by wife and

children for the husband/father is very often an important labour relation in the household, but there are others too – for example, the work of daughters for their mothers. An ideology of collective interest and non-calculative behaviour surrounds the relationship between family members, and this is often particularly true of the normatively defined relationship of marriage. The performance of work for the husband for no di. ·t reward is often part of the wife's role obligations in marriage, but it should not be assumed either that this obligation is open-ended, or that it is not subject to cultural variation.

Unremunerated labour within the household agricultural enterprise is a widespread category of women's work in the Third World. Examples include the work oi harvesting coffee in Mexico, which is done by women, the work on cocoa farms by Yoruba and Beti women, as well as the major categories of women's unremunerated labour in rice growing and rice processing that have been affected by the Green Revolution. It would be fair to say that, in many cases (but not all), when development literature draws attention to the often unrecognised ('socially invisible') but productive economic contribution of women, it is work performed as unremunerated labour for family members. That the availability of this labour may be critical is indicated by Abdullah and Zeidenstein's (1975) finding that farmers in Bangladesh were marrying extra wives when harvests had increased as a result of technological innovation.

Another important category of unpaid female labour is the work that women do as female dependants of a husband as part of the husband's work input outside the household. Examples are the sex-specific work that women do as part of the tribute labour from tenants in Peru (Deere, 1977) or the work that women do on coffee plantations in Brazil (Stolke, 1981). Plantation work often involves the *de facto* obligation of the entire family of the worker to work especially at times of seasonal demand (Caulfield, 1974). An International Labour Office (1966) report of a survey in twelve countries in Asia, Africa and Latin America suggests that the employment of wives of plantation workers is most widespread in Asia, especially Sri Lanka, India and Malaysia, where their income

is a significant contribution to the family income. Palmer (1976) argues that the term 'sharecropping' has long been a euphemism for the hired family labour arrangements between landowners and the indebted landless in Java. Examples are also widespread in nineteenth-century England (Hostettler, 1978). Indeed, so widespread is the assumption that the work of family members, especially wives, will be available in this way that it is almost certainly grossly under-reported in the literature.

Most analysts for whom the family is a 'black box' have failed to treat family labour as either an analytical or empirical issue, although Jain (1976) argues that the failure to take account of the contribution in the form of family labour to household production when new techniques are introduced often leads to the effective unemployment of some household members, and more importantly a drop in household income. In addition, one may conjecture that, in so far as a wife's rights to sustenance are predicated on the work she performs, removing this work may give her less claim to household income.

In the few studies that have addressed the question of what happens to family labour in changing circumstances or according to the socioeconomic situation of the family, family labour emerges as an important labour resource because of its flexibility. For example, in a study of a West Javanese village it was found that 'The average days worked per family is lowest for the large size, high liquidity group. Large farmers have the most family members available, yet they use them the least' (Alexander and Saleh, 1974, quoted in Hart, 1978, p. 6). Palmer's studies show that 'Before the advent of the new technology tenants were known to have higher yields than owner cultivators because they used a more intensive (family) labour technique in order to be able to provide sufficient income to cover rent (1976, p. 86). Under the impact of the new technology, 'tenants use family labour as a substitute for cash inputs, such as weedicides where that is possible' (p. 86). It is also reported that in the Philippines the use of family labour increased with the new technology: 'Hitherto it appears that the debt-dependence of the landlord on the tenant discouraged the use of family labour on the

tenant's own farm and encouraged its sale off-farm' (Palmer, 1976, p. 83). All this suggests that family members work more or less hard for 'the household' according to the changing nature of the work demands, the availability of capital and so on, and emphasises that family members may be the source of extra unpaid labour when the demands for labour for the household enterprise change in innovating situations. This was shown in response to the changing demands that the Green Revolution placed on women's agricultural tasks discussed earlier.

Traditional employment models fail to examine the processes affecting the working conditions and work burdens of family labour for two reasons: first, they lack a model for the propensity to work of household labour, and secondly they are unwilling (or unable) to take account of the fact that family labour is primarily the labour of wives and children. Hence Bartsch's (1977) comment (typical of many) that rises in seasonal peak demands may pull into economic activity those who are otherwise 'unemployed' (e.g. women and children). To apply this category to the labour of women and children unless they are pulled into employment that is economically remunerated conceals the fact that this work exists when not remunerated and is done simultaneously with a large number of other women's economic activities that are essential to the households' well-being and maintenance. Those who are 'unemployed' for Bartsch are precisely those who are 'overemployed' and 'overburdened' for Palmer (1978) and I. Ahmed (1978). The propensity to use women as family labour without reducing the burdens on them of other kinds of economic activity is likely to lead to intolerable work loads.

It is clear that a major range of issues that are significant for the effect of technological change on rural women concern the factors affecting the use of women as family labour. The next section therefore addresses the question of how external demands on the household as a work unit are translated into women's extra work burden within it.

*Factors affecting the intensification of women's work: the sexual division of labour*
One of the strongest themes to emerge from the general literature on the implementation of technological change is that the innovation has to be seen in the context of an entire set of production techniques and constraints. However, in treating the domestic-based economy as a total system, two points need to be borne in mind in relation to women's work: first, the significance and nature of the work sharing between the genders, which goes under the label of the sexual division of labour, needs to be carefully examined; secondly, the output and 'product mix' to be considered should include the domestic and reproductive work that women do.

Two case studies that deal with the changing sexual division of labour illustrate these features (Guyer, 1978; Hart, 1978). They cover different historical spans, different geographical areas and different kinds of economy, but in each case what is being described is not women's work in isolation, but how the work that men and women do fits together and the way in which this 'fitting-together' changes as economic and other circumstances change.

One point that emerges from both studies is the importance of considering the whole domestic economy, including 'off-farm' activities, and furthermore the total demands on women's time that their reproductive responsibilities make. Guyer's examination (1978) of the Beti and Yoruba shows clearly that the response to the introduction of cocoa farming in West Africa can only be understood not in terms of the traditional responsibilities of the sexes for such tasks as land preparation and weeding but in terms of what other economic activities the sex-divided agricultural work is linked with – specifically men's and women's traditional work in the sector of trade and marketing. The same point is made at a different level of abstraction in Hart's findings in a study of household allocational behaviour in the area of the commercialisation of agriculture accompanied by technological innovation in Java (Hart, 1978). She demonstrates considerable difference in the strategies with regard to labour allocation, income and consumption between three 'asset classes' – basically large landowners, small landowners and

the near landless. Her most important findings concern differences between small landowners and the near landless, which she argues are based on the extent to which they have to purchase rice. She argues that the 'trade-off between income and non-income earning time undergoes important changes as households move to higher levels of security and welfare' (p. 270), and she sees the poorest households adopting a survival strategy in contradistinction to the normal welfare-maximising strategy.

A rather different point in relation to the totality of the domestic economy emerges from a case study from Mexico (Young, 1978a). Her analysis emphasises the significance of the changing reproductive work of women, as commercialisation proceeds. Young makes it apparent that reproductive work is not an unchanging burden for the women of peasant households, and this is especially significant in so far as this work provides some of the labour for expanding output. Family labour that is not wife's labour for peasant cash cropping has to be borne and bred, as does the potential wage labour for the household. Her analysis points to a reproduction/production 'scissors effect' in commercialising peasant households, with both increased productive and reproductive work leading to the intensification of women's work.

In addition, however, the case studies point to the importance of certain technical, economic and social aspects of the sexual division of labour that have not been much discussed. Comparisons of the material from Mexico (Young, 1978a) and West Africa (Guyer, 1978) bring out the significance of the extent to which the labour processes being examined are what may be termed either sex-sequential or sex-segregated. The distinction is between techniques requiring labour inputs from each sex at different times to produce a single product – in Guyer's case study, cocoa requires the sequential input of both men and women – and production systems in which one or other sex performs all the operations necessary to produce a given product – as in the weaving of cotton cloth in nineteenth-century Mexico (sex-segregated). This aspect of the sexual division of labour has been mentioned by Pala (1976a):

Although sources heretofore reviewed concur that women were major food producers in traditional pre-colonial economies [African] they do not explain the work linkages performed by men and women within specific crop cycles. It would be particularly useful to know for instance that in the yam cycle only women do farm work, or that in the millet men do tasks A and women do tasks B in a given sequence.

Thus, although unremunerated family labour is often associated with a set of labour processes in which tasks are sequentially allocated such that both husband and wife have to play their part in the total process, this is by no means always the case, and women's unremunerated labour may be in activities for which they are wholly responsible.

Both sex-sequential and sex-segregated labour processes imply the need for decision-making in the production process, but the implication for gender relations in the two cases may differ. There may well be parts of a production process or a crop cycle for which only women understand the detailed requirements, and these may well be statistically important areas of decision-making for them. However, the decisions that are most significant in terms of workload and risk to household food supply may have been made in the earlier and male segments of the production.

So, too, different kinds of command and control may be implied in these different forms of the sexual division of labour. Young, for example, has argued that, in the household-based economy in which they were contracted as independent workers to weave cotton at home, women controlled the quantity and pace of work, as well as the proceeds. In coffee production, the woman's role in harvesting was beyond her control in the sense that it formed part of a sequence of activities that had to be done at a particular moment and in amounts determined by previous decisions made by the initiator of the overall production cycle.

The significance of the form aspect of the interlocking of men's and women's work is abundantly clear in the literature, although rarely is it explicitly brought out. Many of the adverse effects of technological change associated with

the Green Revolution discussed above were the effects on women linked to men's products in sex-sequential labour processes in which, effectively, technological change was acting on a different and earlier part of the production cycle. Indeed, one can generalise that technological change very rarely acts equally on all parts of a technical division of labour, and that insufficient attention has been paid to the changes brought about in the pace and balance of the sequences in the labour process. Much technological change also alters the division of labour in the direction of ever-increasing complexity so that the work of different categories of rural worker becomes more and more intermeshed.

Clearly the very notion of labour for others, even within family relationships, carries with it the potentiality for the control and command of work to lie with the uscr of the labour rather than its provider – a potentiality over and above the technically implied control discussed above. There is very little information on the extent to which family dependants do or do not control their own work and can or cannot resist additional work being imposed upon them by the household head. Factors affecting the ability or inability of the husband and/or household head to intensify the work of wife and child dependants or to invest in cash crops at the expense of their health and nutrition are many. They include the range of alternative income sources for women, the ease of divorce and its legal and social consequences, the temporary waxing and waning of religious fervour, and so on. This is obviously an important area for future research since there is little or no empirical material or discussion of it in the literature.

Nevertheless, the obligations of family members are not open-ended. On the contrary, the sexual division of labour in any culture specifies the kind of unpaid labour for a husband that a wife should perform. In a fascinating discussion of the details of a complex system of household production in the Gambia, Dey (1979) describes a situation in which there is a distinction between the collective farms and farming of the household and the individual plots of household members. The cultivation of household farms produces food for collective consumption, whereas individuals have the right to

dispose of the products of their own farms. There is also a sexual division of labour in that men are associated with groundnuts and sorghum and women are associated with rice. Several development programmes have tried to introduce into this production system double-cropped irrigated rice as a male crop, primarily to produce rice surplus to the household requirements. Dey argues that these development programmes have been unsuccessful partly because, although it is women and not men who transplant and weed rice, women do not have any obligation to perform unremunerated labour for their husbands' private farms; rather they have an obligation to work in rice fields that are designed for collective household consumption. In the wet season, there is competition for women's labour in the agricultural system. Women prefer to cultivate their own rice, and there appear to be no effective ways in which men can gain control over their wives' labour. In the dry season, women are not occupied with their farming, and Dey finds a number of different arrangements whereby men obtain the necessary female labour. In some cases, traditional forms of unremunerated labour use continue; in other cases, a man employs his own wives and female dependants as well as other women; in yet others, women do not work for their husbands at all, but as wage labourers for other men.

This example makes it clear that obligations to do unpaid labour may be either strictly controlled or the subject of negotiation. It is noteworthy that this example is from Africa, where in general the labour rights and obligations between husband and wife are often fairly strictly defined, and there may well be tasks that are remunerated. Thus the Guyer (1978) case study mentions that the labour of Yoruba wives involved a complicated system of remuneration, which was subject to negotiation. Assumptions about the availability of the labour of a man's dependants are often built into development programmes but these may be directly contrary to the woman's obligations in the household sexual division of labour. It is not clear to what extent these aim deliberately to change the nature of the rights and obligations of the sexual division of labour and the economic responsibilities in marriage, or to what extent there has been an assumption of

the universal right of husbands to command their wives' labour. Either of these has interesting implications.

These examples raise the implications of the use of the term 'unremunerated' to describe family labour. Labour for others in the household is unpaid in the sense that there is no notion of direct return for work done, either in kind or in cash, nor is there any necessary legal or effective possession of the goods produced. Under most circumstances, unpaid work for others would be seen as exploitative, but the unpaid work for other household members is not seen as such. Indeed, the very absence of direct connection between work done and reward gained is of importance in so far as marriage is not a simple work relation. Rather the distribution of the products from the household division of labour is part of the complex of rights and responsibilities of a broadly economic nature within marriage (and family relations in the household) that has been referred to elsewhere as the conjugal contract (Whitehead, 1981a; discussed in greater detail in Whitehead, 1980).

This broader context suggests that, as well as labour input, one should simultaneously examine the forms of the distribution of the rewards for productive effort to the spouse. Intra-household distribution and consumption relations are based on various notions of sharing and need. Family exchanges are often thought to be based on non-calculative behaviour stemming from the view that a couple have interests in common. However, there is a growing literature pointing out the inadequacies of this approach in a number of fields (see, for example, Papanek, 1977; Rapp *et al.*, 1979; Whitehead, 1978, 1981a; McIntosh and Barrett, 1980; Lim, 1978; Heyzer, 1980; Harris, 1981). Indeed, some of the literature referred to earlier points out that there is no necessary correlation between women's increased effort and output/income. Thus, although a family's annual income and annual productivity may be increased by women's greater work burden as family labour, Palmer (1978) dismisses the idea that this will necessarily benefit the women household members by pointing out a number of alternative ways in which women's work could contribute to family well-being or husband's income without benefiting them. Agarwal's detailed

cases from Asia (Green Revolution) and Africa (tubewell irrigation) are also revealing and relevant (see Chapter 4 below). In general one may hypothesise that in sex-sequential labour processes, where women's labour is put into specific tasks in a crop cycle that includes the labour of her husband and/or is initiated by him, it may be more difficult for her to increase her share of the rewards for the extra effort implied by technological change since the basis on which she is rewarded for this work may be unclear.

By and large the issues in actual domestic economies are much more complex. In their detailed configurations, forms of conjugal contract may differ in the rules and mechanisms for the division of the products of joint labour, and in the basis on which other goods and services are exchanged. They should be treated as an independent variable, and I have already illustrated some ways in which they can be culturally specific. The inability of Gambian men to command their wives' labour for some economic activities is associated with a conjugal bond in which husband and wife do not pool their income and products to form a common marital fund. Separate budgets imply the possibility of selling goods across the marital bond, as well as payment for labour (and other) services. This would be unthinkable in some definitions of the budgetary implications of marriage – for example, the Hindu conception of women's place in the joint family.

These different forms often link with wider aspects of the economic system, for example with dowry systems, but little work has been done on this. Arguably, the distribution system within the household is based on at least four factors:

- the sexual division of labour as discussed above;
- culturally specific social definitions of need;
- concepts and ideologies of ownership;
- power – in the sense of all that makes it possible for differential possession of product.

In situations where the sexual division of labour is changing, these intra-household relations of exchange and distribution, in so far as they are to some extent an independent variable, need not change to correspond with a changed profile of economic activity. In the literature on

Africa there are several examples where cash cropping and more extended monetisation appear to be superimposed on the former rights and obligations that make up the ways in which household members provide for each other. This may result in considerable inequity in the capacity to meet normative responsibilities. The most widely known example is probably that of the Mwea Development Scheme (Hanger and Moris, 1973). In this case, numerous mistakes were made in relation to the division of work responsibilities between men and women, the way in which the household was provisioned by husband and wife, and their rights in relation to each other's cash incomes. In effect, the form of the development scheme prevented women from maintaining their subsistence production, while men had no obligation to spend cash on provisioning the household to fulfil their self-provisioning part within the sexual division of labour and household provisioning.

It is thus fairly clear that one needs to bear in mind the intra-household exchanges and distributions as a factor constraining women or affecting their ability to benefit from change. The form of budgeting, together with women's relatively weak social position, prevent her from gaining indirect access to the benefits of economic change. In other situations, her labour input may be changing without any compensatory changes in the distribution of rewards. Women in direct producing households may be unwilling to innovate if they know they will hardly benefit from the increased production. (See the discussion in Roberts, 1979.)

The form that intra-household distributional mechanisms may take and the factors that affect them may also be very significant in seeking to identify strategies for change. In addition to providing constraints, they are certain to contain points of leverage and contradiction, which may be of great importance in supporting those aspects of women's household and economic position that provide her with a basis for greater access to income and resources. Correct identification may also guard against introducing new resources in such a way that already existing mechanisms enable husbands to cream off the benefit, thus reducing women's willingness to participate in the changes.

*Further implications for technological change and women*

In the first section, in which I examined some of the findings from a limited range of literature on women and technological change, several significant trends emerged. First, the tendency for large-scale technological innovations that increased output to be accompanied by further, and possibly unplanned, technological change, notably the mechanisation of some women's work. Secondly, the tendency for technological innovation to lead to changes in the social relations under which work is performed, notably movements of work activities into or out of the category of family or hired labour. Thirdly, the tendency for labour-displacing innovations to occur in women's work activities performed as wage labour, with a relative absence of adoption of technological innovation for the same activities performed as family labour. A fourth theme, which did not emerge very clearly from that discussion but that is nevertheless apparent from the literature as a whole, is the relative difficulty in promoting adoption of technological innovations aimed directly at women. In addition to providing some pointers for research into the factors affecting the intensity of women's work as family labour, the preceding discussion seems to shed some light on some of the issues surrounding these four generalisations.

The findings in the first section, which are based on Palmer's (1978) accounts of the effects of HYV technology, differ from those of Agarwal (Chapter 4 below). Agarwal argues that income-earning opportunities of hired labour would increase. More female labour would be demanded for female-performed operations, and some hired female labour may be substituted for the work of women who withdraw from farm work because of its low prestige. Examining a wide variety of HYV innovating situations, Palmer points out the strong tendency for women's post-harvest operations to be mechanised whereas the operations performed by female family labour tend to remain unmechanised. Overall, women's employment decreases and their work burdens increase. One thing that is not clear from Palmer's account is why the operations performed by casually hired female labour (post-harvest operations) happen to be those that are mechanised

(an attempt at answering this question has been made in Chapter 10).

The preceding discussion has suggested possible conflicts of interest between husbands and wives that are created by the form of sexual division of labour. It is abundantly apparent from the examination of family labour that the person who does the extra labour may not make the decision on technological innovation. However, the unremunerated nature of the work relations within the family carries a number of other implications. The failure to mechanise some cultivation techniques, such as sowing and weeding, may be because the extra burden of work on unpaid family labour does not carry with it sufficient extra economic (or social) cost, over and above the overhead annual 'costs' that their membership of the household already implies, to make the purchase of alternative inputs worthwhile, whereas the purchase and use of mechanical substitutes for hired female labour is presumably profitable to the farmer in cutting costs.

The issue may not be as simple as this, however, and it is necessary to reassert the importance of profitability as a determining factor in innovation. An illustration of this is the spread of the custom rice huller in Bangladesh discussed earlier. The main reason for the spread of the mill is its enormously increased productivity and profitability. Thus, by moving post-harvest processing out of the family labour category into wage labour, commercial profits can be made. So, too, centralised processing technology has the potentially welcome effect of moving the product off the farm, and thus potentially increasing the amount that enters the market. Nevertheless, compared to technologies associated with cultivation practices, processing technology has a particularly enhancing effect on productivity in reducing work burdens. Milling/husking certainly seems to be a work task for which women are particularly anxious to utilise mechanical aids: African studies report women walking quite long distances to use diesel mills (see Chapter 5).

The importance of profitability, with or without the subsidising effects of public policy, is also an important aspect of the adoption of technological innovations by women. In discussions about innovations in women's dom-

estic work, there is a tendency to abhor the distinction between productive and non-productive work of women. Epstein (1976) long ago pointed out the futility of expecting a male head of household to prefer to install a house water supply or other improvements simply to lighten the workload of the women of the household, over several other ways of spending the same amount of money, for example, invest-ment or personal consumption. This also has to be borne in mind when women say that what they want is an improved water supply or a nearer source of fuel. The crude question is: can they pay for it and, if not, what leverage do they have to encourage men to provide the resource? Once provided, are there ways of recouping the cost in increased output? This raises the questions of who gets the extra income, what is it used for, and who decides how it will be used?

The adoption of domestic technology appropriate for women's work, or the introduction of innovations in other aspects of their work, are likely to be affected by the degree to which women lack access to cash resources and the degree to which the economic interests of husbands and wives do or do not coincide.

## Gender hierarchy and the rural production system: women and access to resources

*How to conceptualise women in the rural production system?*
The discussion in the preceding section had its origin in the apparent inability of approaches to technological change based on the employment, productivity and income-distribution paradigm to put 'women' into the model. By and large, it focuses attention on sociological and economic aspects of the relations between men and women who are members of peasant farming households, as an area that determines some of the effects of technological change on women. In this section, I want to go beyond the focus on the internal relations of the peasant household and look at aspects of the interaction of women with the agrarian system as a whole. The underlying *raison d'être* derives from the persistent way in which the processes of socioeconomic change occurring in the countryside appear both to affect

men and women differently and to promote a gender 'gap' rather than gender equality. This implies the need at least to try to theorise gender as a system of social relations at the level of the rural production system as a whole. As this notion of gender as a system of hierarchy is a fairly unfamiliar one in policy-oriented literature, I first explore in more detail what may be implied in the approach by referring, by analogy, to analyses of class as a system of hierarchy in some of the literature on the Green Revolution.

One of the characteristics of the employment, productivity and income-distribution models of technological change is that they do not discuss specific historical processes within which technological change is occurring in the contexts of particular places or of forms of rural economy. That this relatively strict drawing of the parameters of relevance limits their predictive value is amply demonstrated by the example of the Green Revolution. Although, technically, the essential HYV technology was of the desirable rural employment-creating kind, it nevertheless had substantial, though un-sought-for, effects in promoting inequality, landlessness and proletarianisation where it was successful (Pearse, 1974). There is widespread agreement that unpredicted employment and income-distribution problems have appeared with the use of the new technology (see Griffin, 1974).

It is very striking that current empirical work on the impact and dissemination of the Green Revolution technology is largely confined to the analysis of class-based inequalities and does not deal with gender-related questions. In particular it does not cover issues like the failure of women to benefit from increased production, the problems of uptake and of reaching women, and the apparent intractability of the increasing differentiation between men and women in relation to the modern sectors of the economy. In order to conceptualise these issues, we have to consider the position of women as potential independent producers rather than as family members.

*Gender hierarchy in access to productive resources: land*
Whereas, sociologically, the capacity of women to be independent producers depends on a number of factors,

unimpeded and secure access to productive resources is regarded by many economists as an essential requirement if farmers are to have incentives to invest in land and other capital assets to develop this productive potential. Thus the first variable to examine for gender hierarchy should be that of access to the major economic resource, that of land.

In most Third World situations, women's preponderant rights in land are use-rights rather than outright ownership rights. Where full rights to ownership of agrarian resources exist in traditional legal codes, a woman's share is not usually equal to that of a man. Thus, she is often entitled to part of the inheritance, which is specifically a proportion of that which her brothers receive (USAID, 1979b, c). Chlora-Jones (1979) also notes that new codes and legal rulings may reduce women's rights to succession. Thus, the Colombian land reform law, which ignored women's needs by confining land redistribution to married males over 18, contained a new inheritance law in which the land may be inherited only by married males over 18.

Even where a woman has rights to own land in theory, there are a number of factors that reduce her real access to it. Custom may take away rights enshrined in law. Thus, it is extremely widespread for women's inheritance rights under Islamic law to be over-ridden in practice in favour of her close male relations. There are many instances of competing claims for land, especially land that has had any productive investment, or land in a prime place, or where land is extremely scarce. Both the assessment of women's competing claims as against those of other relatives and the interpretation of law and custom as a whole are often in the hands of a male family head or male members of the kin group. Chlora-Jones reports that priority tends to be given to men (e.g. sons) over women (e.g. widows and daughters), both where women's rights to inherit land are adjudicated by consensus decisions within the kin group and where they are adjudicated by formal court rulings dealing with competing legal rights.

What is striking about women's access to use-rights in land is that they come most often through an individual relationship with a kinsman. These include links with primary kin (e.g. a brother or a father) but, depending on the

nature of the kinship system and the degree of development of the economy, may extend beyond this. Perhaps the commonest way for women to get rights to use land is through their husbands: that is, by virtue of being married to a particular man they are given land to farm that belongs either to him or to his kin group. It may indeed be an obligation on a woman's husband to so provide her some land for farming use. Receipt of land through kin-defined domains, as distinct from the market, is relatively common for both men and women in Third World agrarian economies, but the determination of a woman's access to land by her position in a kin-defined domain tends to persist long after men have entered the land market.[4] The way in which kinship status determines her access is in any case rather different from that of men, for men's rights to land are mainly inherited, whereas women's depend on an extant relationship with a living individual. Thus, in so far as this relationship is liable to dissolution (through death, divorce or separation) and her residual claims may be non-existent or difficult to enforce, her rights are often insecure.

Although good studies of women's access to land and other productive resources and the factors that affect this are few, the bald generalisations that emerge are that the size of women's landholdings is less than that of men; their occupancy of it tends to be insecure; and the socially dominant position of men is critical in determining access where there is competition for land. However, it is exceptionally difficult to elucidate the factors that give women greater or lesser access or leverage in situations of scarcity. If the issue of land ownership in the Third World is of itself a minefield of complexities,[5] land ownership in relation to women is a particularly entangled web. In addition to raising such problems as the factors that limit usufructory rights and the problems of trusteeship, it also raises the ramifications of the property component in marriage, and of systems of inheritance. Although a vast body of anthropological data exists on traditional property

---

[4] This point was also made by Hill (1979).

[5] Jannuzi and Peach (1977) contains a meticulous discussion of the complex methodological problems raised by numerous types of land holding in Bangladesh.

rights and on land rights and their disposition in marriage, at death and at the setting up of new households, relatively little work has been done on the way in which any one system of marriage payments and of inheritance affects women's access to productive resources in situations of changing agricultural practice involving technological innovation. Certain broad differences in areas with different cultures are, however, apparent.

In many African societies, the husband's family makes a substantial ritual payment to the bride's family upon their marriage, and in doing so agrees to feed, clothe and support her in return for rights over the children she bears within the marriage. Bringing no property with her, it is then perhaps natural that her rights to the lands of her husband's kin group are minimal. She often does farm, on land to which her husband has rights, but her needs are usually met after those of the rest of the kin group, and she may never get prime land. Although she has a farm, the 'contract' concerning which land may be 'renegotiated' each year; thus developing the land as a productive resource may not be worthwhile. Roberts (1979) reports that Niger women spirit manure (to which they have no right) out of the compound to improve their plots of land, and, having raised the fertility, the plots are taken away from them by the men of the family. The amount of land that women farm is often greater in systems of matrilineal inheritance or of low brideprice, and in these systems there are examples of women developing land for cash cropping, including export cropping independently. (Specifically, see Okali's, 1976, and Hardiman's, 1977, accounts of women cocoa farmers in Southern Ghana.) However, with Pala (1976a), one could stress women's overall mediated and dependent position in African agrarian systems.

In contrast, as Goody (1976) has discussed in detail, in many societies in the rest of the world, and especially Asia, both husband and wife contribute property on marriage and such property forms a conjugal estate out of which both husband and wife expect to be maintained over a lifetime, even where a husband predeceases a wife. However, even where women own property and contribute it to the joint

estate on marriage, it is rare in these societies for women to have independent effective possession of the land or other resource. Since the aim enshrined in law or custom is usually the woman's support over a lifetime, her disposal of land in terms of succession is restricted. What is at issue is not ownership in the sense of disposal rights that can be upheld against others, but claim to effective though temporary possession in the sense of use-rights. In this sense, too, women's land is often managed for her by a father, husband, brother or son, in such a way that she rarely receives proceeds from it directly, but only indirectly as part of the obligation of her husband, his family and his heirs to support her.

These very different situations lead me to the view that women's access to productive resources is mediated by men precisely because of the dependency enjoined upon her in marriage and in the family-based household. Thus a principal source of gender hierarchy is the way in which the household positions (and specifically their asymmetrical positions in the family and marriage) of men and women interact with the institutions that provide access to the major economic resource of land in the wider economy.[6]

Although the family-based household may be regarded as a unit with collective interests, 'households' are rarely collectives that possess productive resources. Some form of individual ownership is much more common, and this is especially true of the primary productive resource, that of land, even though it may be in the form of individual use-rights rather than rights to full ownership. The ability of Beti and Yoruba husbands to profit from cocoa farming, as discussed earlier, is dependent on concepts of individual ownership to the extent that it is as individuals that they have access to land in such a way that they possess the product to which their wives' labour has also contributed. Similarly in the Mexico case, men have effective ownership of use-rights over the land to produce the cash crop, with the help of their wives, that the husbands sold. Wives could not enter into cash cropping because they lacked any effective possession of

[6] O. Harris (1981) discusses this and related themes in examining the link between gender relations in the household and the wider society.

land. That few present-day or traditional legal codes treat household members equally with regard to land is part and parcel of treating the household as a unit in which the rights of some can be subsumed under the rights of others. What is true of land is equally true of access to other kinds of resource. The household is, by and large, a set of social relationships for allocating resources differentially to its members who occupy different positions within it.

*Gender hierarchy in costs and access for women*
In arguing that women's access to land and other productive resources is not only limited but is mediated by her dependent position in the household, I am in effect arguing for the importance of putting gender into the agrarian economic and social relations that determine access to resources. Seen in this light there are a number of more complex implications for the relation of women as independent producers to technological change. Again, the most relevant sources of data about the effects of agrarian social and economic relations on the effective economic costs of innovation and what determines access to resources are the general Green Revolution studies. Those studies that have concentrated on elucidating the economic mechanisms by which inequality is increased appear to have important implications for women. As I can find no explicit account drawing attention to the implications of these mechanisms for the relation between women and new technology, they will be considered in some detail here.

The pattern of innovation in the Green Revolution was very uneven, with profitable innovation closely associated with position in the rural class structure. Small and marginal cultivators by and large failed to innovate, while large- and middle-sized farmers both took up the new technology and became increasingly prosperous as the effects of the enhanced profitability worked themselves through. This was especially important because the technology of the Green Revolution had, on the face of it, a number of extremely desirable attributes. A biological and chemical revolution, rather than a mechanical one, it was supposedly scale neutral in that seeds and water are almost infinitely divisible. An initial

finding was that the requirements for HYV innovation were not nearly as divisible as was originally thought. The optimum situation for the new technology to be substantially profitable needed an additional package of material input, which included fertiliser, a controlled water supply and other chemicals. From this more substantial requirement flowed quite a lot of consequences.

In the first place individual farmers have to have a source of cash income to purchase the innovatory inputs, and the extent of the ability to innovate depends on the amount of surplus already being generated by the farm or on having another source of cash income. The more non-monetised a farmer, the more likely s/he would be unable to purchase inputs. It is often very difficult (especially for anyone who is used to purchasing most of life's requirements) to appreciate what very small sums of money may be passing through the hands of a person, especially a woman, in self-provisioning economies. It is also difficult to appreciate just how hard it is to obtain such tiny sums of money, and how many different necessities need to be bought, such as clothes. Simple absence of cash surplus to the purchase of necessities may well mean that women are quite unable to afford the apparently quite modest amounts of input that are part of an improved technology. Roberts (1979), for example, reports that, in a scheme that was particularly designed to deliver inputs to women, suitable for the kind of activity for which they were responsible in the domestic economy, the women were unable to purchase the inputs (which were modest in cost) and the men of the community snapped them up.

However, the problem of unequal adoption was made much more complicated by the unforecast dependence of the success and profitability of the HYV technology on the degree of development of the rural economy, rather than on the cash income of individual farmers. The underdevelopment of the rural infrastructure and rural markets meant that, in many places, the innovation depended on the public provision of some of the inputs. For a number of reasons these were almost always in the form of large-scale projects, such as massive irrigation schemes, or the provision of a programme of credit, or an extension programme for

fertiliser and chemicals, or a system of guaranteed prices, and markets for the output. Several studies have argued that it is the combination of the form of administration of these public policies with the agrarian class structure (and, I would argue, with the structure of gender relations) that affects a farmer's ability to utilise and profit from the technological innovation.

It is in relation to this that the issue of scale sometimes became directly relevant, with large farmers benefiting from economies of scale and small farmers suffering diseconomies. Griffin (1974) argues that this is the case in relation to the economies of getting water from some irrigation schemes. Pearse (1974) points out an often overlooked overhead in the time spent managing and servicing inputs. Time is a scarce resource for peasant producers and, in relation to increased returns, decisions have to be made about its best use. If a day in town may be an expensive overhead for the small-scale farmer, it may be even more expensive for his wife. In so far as women's farms are limited in size by the kind of land tenancy arrangements discussed above, it may not make much economic sense for her to try to operate her small plot using all the apparatuses of the modern sector. So, too, women's time tends to be more limited than men's because of the lengthy nature of food preparation tasks, which confine her to activities that can be accomplished within sight of the cooking pot, or because of the need to look after young children. She may be confined in another sense too, in that journeys away from the village may be frowned upon.

The class system creates other inequalities of access:

Small cultivators lacked the time, influence, literacy and social affinities . . . to be in touch with government programmes and facilities and receptive to technical information. Peasants may find themselves competing for credit or irrigation facilities with agriculturalists who have city houses and political connections, poor villages may have to compete for institutionalised credit with the local elite who make up the village communities which allocate credit; illiterate, illclad cultivators must argue their case in town offices with status conscious officials. (Pearse, 1974, p. 77)

Pearse refers to this as the 'contractual inferiority' of the small cultivator in the factor market. Once again, if this is true of small farmers in relation to larger ones, how much may it also be true of women in relation to men. As global statistics show, a woman is more likely to be ill-clothed, illiterate and poorly educated compared to her brother. She also faces institutions and decision-making bodies peopled by men whose attitudes towards women's independent activities may, to say the least, be unencouraging. The association of women with the private rather than the public domain amounts in some cases to their restriction to the domestic world and the denial of a place for them in public institutions. By whatever mechanisms they are maintained, all such restrictions amount to conditions of 'contractual inferiority' vis-à-vis men. If she has learned behaviour and skills suitable for the home, how does she learn to assert herself in the office, field station or bank, or a public meeting? It is for these reasons that properly funded women's programmes linked to production of items for which there is a competitive market are in some circumstances desirable.

Probably the most important effect of public policy was to enter a factor market that was already markedly imperfect: 'A multiplicity of fragmented markets, within a single locality for a single factor of production may mean that there is no such thing as the price of an input' (Griffin, 1974, p. 190). Thus, great stress is laid by some authors on the mechanism of the factor market as promoting the inequality that accompanies the technological revolution. As there is no single market and no single price, some groups have easier and cheaper access than others to the major factors of production. In terms of its effects on the profitability of farming as a whole and on agricultural innovation in particular, rural capital is an extremely important factor market. The cost of obtaining credit varies widely according to its source, with the organised credit market of state institutions and large-scale banks often the cheapest source. 'Large landowners pay less than the opportunity cost of capital, while small peasants pay substantially more' (Griffin, 1974, p. 191) because it is often only those with security, or

other criteria, who gain ready access to the cheapest sources of credit. Others pay the highest rates in the more risky lending market of the indigenous trader/farmer network. Griffin suggests that the relation between class position and the relative cost of major factor inputs also extends to labour costs. In relation to the economics of innovation, then, farmers at different positions in the class structure facing different sets of relative factor prices will find different techniques of farming production profitable.

There are very significant parallels in this analysis with the effects of the nature of gender relations on the economics of innovation. Although no coherent study has been attempted, there are some *a priori* points to be drawn from the preceding discussion, and relevant points are to be found scattered in the literature. A woman's status in the household creating an indirect and mediated relationship to the land market has been fully commented on above. As far as women are concerned, the factor market is not just fragmented and imperfect but broken into distinct sex-related divisions. Land is effectively allocated between men and women not on economic criteria at all, but on social criteria. In relation to the other inputs, very few women indeed ever gain access to the cheap sources of credit. Many schemes hardly ever consider that women might be able to utilise credit (Ward, 1970); yet others stipulate conditions that they could not even fulfil. Again there are on record monotonously numerous cases of government agencies, extension schemes and co-operatives that insist on providing credit to the household head without regard to the sexual division of labour within the household. They insist on treating the household as a unit, with the husband as the economically active member and his family as helpers, so that he represents them to the outside world, and it is him that they deal with. That is, he is treated as the gatekeeper. Equally there are development schemes that go badly wrong because of the assumption that the husband is responsible for the targeted activity (Hanger and Moris, 1973; Dey, 1975; Sridharan, 1975; Alamgir, 1977; Palmer, 1979).

Together with the 'contractual inferiority' discussed earlier, these are briefly sketched examples of the way the social

structure creates inequality between women and men in relation to the factor market. As regards discussions of the effect of the price of production factors on choice of technique, it is apparent that, in comparison to men, many women are in the position of small cultivators compared to large. That is, it will make more economic sense to them to utilise labour-intensive techniques rather than others, since they have to get other production factors in the most expensive market. It is in this light that women's association with the 'subsistence' or low-productivity sector should be seen.

## Concluding remarks

At the start of this chapter, an attempt was made to take some of the disparate and scattered indications of the inadequacies of current conceptual approaches in the analysis of technological change, and to pull together what they have in common. My conclusion is that these approaches all have difficulties in finding a place for women and for sex differences in their conceptual frameworks. They are all, in one way or another, sex-blind. This difficulty in moving from the empirical category of women to an appropriate conceptual category is one of the serious problems underlying policy-making and prediction within any area of development and women. It seems to be particularly the case that no analytical framework exists that can deal with the complexities of the social institutions that mediate technological changes and the distribution of gains and losses as between men and women.

The last section has elaborated some of the implications in relation to women of the view that technological change is not indifferent to the already existing inequalities and systems of hierarchy in the agrarian system. In addition to being aware of class as a system of inequality and hierarchy in the countryside, we should also be aware of gender as a system of inequality and hierarchy. Gender hierarchy does not have the same analytical base as class hierarchy, but it does have a production and distribution component, with its own institutional bases, and it is for this reason that technological change is not 'indifferent' to gender any more

than it is indifferent to class. What has emerged from that discussion is, on the one hand, how many aspects of the way in which the family-based household orders relations between men and women determine the terms on which women (and men) enter into wider economic political and social relations, and, on the other hand, how highly critical the perspective adopted by the policy-making and policy-implementing institutions and their agents is. Normative conceptions of the relations between men and women in the family and household are a recurring element in policy packages. One major model of husband–wife relations to be found in public policy stresses the dependency of the wife within the conception of the family as based on joint interests.

In these regards the themes that emerge from considering gender in the wider system of agrarian social relations link up with those dealt with previously, when the focus was ostensibly much narrower, covering women's work and its rewards in peasant producer households. Here, in order to simplify the discussion, I ignore the fact that these households frequently engage in wage work, often of a casual kind, and examine the kinds of factors that may affect the intensification of women's work within household production. Implicitly, this account is a critique of currently existing economists' models of household labour allocational behaviour. What I have laid out is, in effect, a discussion of some of the factors affecting the relative power of household members vis-à-vis each other, and especially of husbands and wives. The discussion of what affects the husband's capacity (or otherwise) to intensify his wife's work efforts in direct production is also highly relevant to the kinds of wage employment situation that are commonly found in Third World rural economies where some household members may be sent out to wage work. One area, among a number of others, of further work highlighted by this chapter then is 'household allocational behaviour'. However, this work would need to break out of the straitjacket imposed by many economists' approaches to this issue. A primary aim in this chapter has been to argue that relatively little is known about the factors affecting the ways in which women allocate their time and labour, and it is precisely changes in the disposal of

time and labour that are implied by technological change. This is not to suggest more 'time-allocation' studies, which are often rendered useless by an absence of analytical focus and by being almost wholly descriptive, but rather to suggest work that examines the operation of some of the factors that have emerged as potentially significant variables in this discussion.

PART II

*Empirical Overviews*

# 4

# Women and Technological Change in Agriculture: The Asian and African Experience

*BINA AGARWAL*

## Introduction

This chapter seeks to examine the ways in which, over the past several years, the introduction of agricultural modernisation schemes, including new inputs and practices, have affected rural women in the Third World. Underlying the focus on women rather than on the household alone is the consideration, and the concern, that technological changes that benefit the men in a household may not always benefit the women, and may even be detrimental to them, or that changes that adversely affect the men may have a worse effect on the women. That is, the popular assumption of the household as a unit of convergent interests is questioned and it is argued that, in addition to the effect of technological change on a particular socioeconomic class of households and hence on women as members of that class, there would be a differential effect by gender within each class. The way in which the effects of class and gender become manifest may, of course, be expected to vary in different parts of the Third World, depending on the degree of class differentiation and variations in the factors (especially cultural norms) governing the sexual division of labour in agricultural production and other activities.

The actual issues are posited here in terms of three types of

67

effect on women and men: (a) on their absolute and relative workloads; (b) on their absolute and relative access to and control over cash income; (c) on their absolute and relative access to consumption. These aspects, especially the latter two, have largely been ignored in existing studies. Hence, direct evidence on them is often lacking. This inevitably places limitations on the ability of the present chapter (which relies essentially on available studies and secondary data sources) to provide complete answers. Nevertheless, it is imperative to pose these issues at the level of problem formulation as areas of concern, and as a first step to piece together whatever evidence does exist and to identify the gaps that need to be filled.

In the following sections of the chapter an attempt is first made to spell out why, in terms of the three criteria, the interests of women and men within a household cannot automatically be assumed to be complementary. The evidence from recent literature relating to the non-socialist Third World countries, especially those in Asia and Africa, is considered here. The chapter then looks at the impact of technological change by class and gender, focusing first on the Asian experience and then on the African experience. The discussion on the Asian experience is based both on an empirical case study for two Indian states and on the overall Asia-related evidence to be found in the literature.

Some details about the availability of such evidence are relevant here. To begin with, information on the male/female division of labour at home and in the fields is much more commonly available than is information on intra-household control over cash or consumption. Few studies address themselves to the latter issues. Again, direct evidence cannot always be found for ascertaining the effect of specific technological changes on an existing pattern of inter-household and intra-household sharing of work, cash or consumption. In the Asian context, for example, while a large number of studies seek to assess the impact of agricultural innovations on different classes of households, very few consider the effects specifically on the women of such households. In the African context, on the other hand, gender-related implications are more commonly focused on,

but the studies rarely indicate (except in indirect terms through related information) the economic class of the households to which the women belong.

Where such direct evidence is lacking, greater dependence has had to be placed on inference and on *a priori* reasoning; and an attempt has been made to present a set of possibilities of the likely effect of various types of technological changes on women in particular socioeconomic circumstances, by drawing upon more general information on the status of women in different classes of households, in particular communities.

### Some conceptual issues: intra-household distribution of work, income and consumption

The three types of effects I mentioned as being of primary concern are those on women's work burden, on their control over cash income and on their consumption. In the discussion that follows, it will be seen why any given impact of agricultural modernisation on these three variables is likely to have different implications for women and men even of the same class of household. It will also be apparent that there is no straightforward association between these three variables; for instance, an increase in women's workload cannot automatically be assumed to increase her control over cash income or her consumption.

To help locate the problem, consider the women in the agricultural sector as belonging to three different socio-economic classes (classes admittedly drawn on very broad criteria but that suffice for purposes of illustration):

- women belonging to landless households or households with insufficient land to fulfil, on its basis alone, the family's subsistence needs: in addition to their roles as childbearers and as family domestic workers, these women would need to hire themselves out as wage labourers to help provide an adequate income for themselves and their families;[1]

[1] This would not apply in the special instances where women of all classes might be physically secluded. In some Muslim countries such as Tunisia, Libya and

- women belonging to small cultivator households, which have adequate land for subsistence but which have to depend essentially on family labour for cultivation: again in addition to their reproductive roles and domestic tasks, these women would also need to do some manual work on the family farm, although they would not have to hire themselves out as wage labourers;
- women belonging to large cultivator households where much of the work in the fields is done by hired labour: women of such households would have reproductive roles in common with poorer women, but the burden of domestic work would be less in so far as help could be hired for such work; also, they would not usually need to do manual work in the fields, although they may perform some supervisory functions on the farm.

*Distribution of work burden*

Women of landless and small cultivator households (who warrant our primary concern) are found, in virtually all parts of the Third World, to have high workloads, often higher than those borne by the men. In addition to their work contribution in the fields, the primary burden of child care, cooking and cleaning, and of tasks such as water carrying, firewood gathering and grain grinding, tends to fall on women; often even the selling of agricultural products in the market is done by them. Water carrying and firewood gathering, in particular, are activities that consume much time and energy. To illustrate, in parts of the Sudan, women have to walk a mile to fetch water three times or more a day (UNECA, 1975); sometimes the distance travelled is 8

Algeria, for example, only 2 per cent of the total agricultural workforce is female (Youssef, 1974). Even extreme economic necessity may not break down such social taboos, except perhaps for women with no man to support them economically (Chakravarty and Tiwari, 1977). However, under-reporting of women workers is a worldwide phenomenon (Agarwal, 1979); hence, it is often difficult to assess, especially from census statistics, the extent to which the reported low participation rates for women are due to statistical biases, and to what extent they reflect the actual situation. Also, such low female participation is not common to all Muslim countries. In Morocco, for instance, women form 10.5 per cent of the total agricultural labour force, and in Pakistan they form 14.2 per cent by official statistics (Youssef, 1974).

kilometres or more, a trip that takes from dawn to noon (see White, Bradley and White, 1972). In Tunisia, some women have to walk up to 5 kilometres to draw water (USAID, 1980). In Zaire, for a family of seven, women have to make three to four trips over a distance of up to 4 kilometres, carrying 10–15 litres of headload on each trip (Mitchnik, 1972). In Ethiopia, in one survey, the time taken ranged from 30 minutes to 4 hours per day in the lowlands and 30 minutes to 1½ hours per day in the highlands (Kabede, 1978). White, Bradley and White (1972) observed that in many parts of Africa there is a strong prejudice against men carrying water on their heads and backs, although it is interesting to note that water vendors are usually men, who often use donkeys, wheelbarrows or carts to carry water for sale. Again, in the Asian context, in one study based on Haryana (India), the village women were noted to walk over three-quarters of a kilometre to fetch water, carrying a total of ten matkas (earthenware pots) during the day (Chakravorty, 1975). Firewood gathering is also highly human-energy intensive. In parts of the African Sahel, women have to walk about 10 kilometres per day, taking an average of 3 hours to gather wood (Floor, 1977). With deforestation, this task is becoming increasingly time-consuming and strenuous (Arnold and Jongma, 1977).

Studies that have looked at the tasks done by women in landless and very small cultivator households note that the hours worked by them usually exceed those worked by the men. In the Asia-related literature, for instance, in one study based on a sample of rural Javanese households (whose plots of land were too small – less than 1 hectare – to sustain the family, so that members had to hire themselves out as wage labourers), it was noted that women of 15 years and over in age worked an average of 11.1 hours per day, compared to 8.7 hours put in by the men; of this time, 5.9 hours for women and 7.9 hours for men went into what the study terms 'directly productive work', that is, excluding firewood collection, child care, food preparation and other domestic chores. In annual terms, the total hours worked (including time devoted to domestic activities) came to 4,056 for women and 3,173 for men (White, 1976). Similarly, a survey of

Philippine rural households revealed that, among small-farm families, men put in an average of 8.50 hours per day and women 8.95 hours per day, while in non-farm families men put in 8.77 and women 9.98 hours per day for farmwork plus household chores (Quizon and Evenson, 1978). Other studies from the Philippines have also found that women put in more total work time than men do, both in rich and in poor rural households (King, 1976). Similarly, detailed data by age and sex on the daily workloads of the rural population in Nepal indicate that female members of rural households put in longer hours of work than male members among all age groups from 6 years upwards into old age (Nag *et al.*, 1977). In the Pakistan Punjab, women from small peasant households are observed to work for an average of 15 hours per day, even in the non-peak periods (Khan and Bilquees, 1976).

In the African context, examples of the high workload borne by women are numerous. The evidence from Ghana, from parts of Malawi, from the United Republic of Tanzania and from Nigeria all indicate that women tend to contribute more labour than men, especially when domestic work is taken into account (Dasgupta, 1977a). For example, the study relating to Ghana gives a figure for work time in farming households of 35.39 hours per week for men and 46.97 hours per week for women; of this time, 23.83 and 16.59 hours per week, respectively constituted time put in for farming alone. In a Tanzanian study, men are noted to have worked an average of 1,829 hours per year and women, 3,069 hours per year. Evidence from Zimbabwe, Nigeria and Uganda also clearly shows that rural women put in longer hours than men when housework is taken into account, and in the case of Uganda and Zimbabwe this is seen to hold true even when the comparison is based only on the work done on the farm (Cleave, 1974). A similar pattern emerges from a survey undertaken by Wilde (1967) of a number of African studies. In one, relating to Nigerian cocoa farms, women were found to be putting in 17 per cent more work time than the men; in another, based in the Central African Republic, men were found to be working only 67 per cent and 72 per cent as long as the women in the two villages surveyed.

Although in a few of the studies reviewed by Wilde men are noted to work longer hours than women, in most such cases this is because the time devoted by the women to domestic work had been ignored. (For additional evidence on Africa, see Table 5.1 in Chapter 5.)

So far I have considered only typical average hours of work over the year. But there is evidence to indicate that the peak season workload is also heavier on women than men. For example, in the African context, at peak activity the men are observed to work on crops no more than 30 hours a week when planting and harvesting groundnuts, whereas for the women the urgency of harvesting swamp rice in January includes a 45-hour working week in the fields (Cleave, 1970; quoted in Schofield, 1979). In the Asian context, it has been observed that in the peak wheat harvest season adult women in Haryana (India) spend an average of 15–16 hours or more a day on arduous manual work at home and in the fields and get little time to rest, whereas the men do no housework and are able to take some rest in the afternoon, and perhaps even have a game of cards (Chakravorty, 1975).

All in all, there is substantial evidence to indicate that women, especially of the poorer (agricultural labourer and small cultivator) rural households in the Third World countries, usually work longer hours than men when all work (including activities listed as 'housework') is taken into account. Further, even if domestic work is not counted, there are many communities where women are still found to work longer hours than men.

It is important to recognise, however, that the delegating of an inferior status to 'housework' is not really justified, since activities related to housework and to what is counted as 'directly productive work' are often closely interdependent, and usually crucial for family survival. For example, the absence of fuel can be as much a cause of malnutrition as a shortage of food: in parts of Nepal and Haiti, a shortage of firewood has caused people to shift from two cooked meals a day to one (Arnold, 1978). Yet tasks such as this continue to be excluded from the list of 'productive activities' in academic studies (White, 1976).

*Control and sharing of household income*
Undertaking a disproportionately large share of the family's
work burden, however, does not necessarily give women
access to or control over a proportionately larger share of the
household cash income. In both the Asian and the African
contexts, existing studies indicate that it is usually men who
have primary control over the family's cash income. For
instance, in South Gujarat (India), the wages paid for work
done by women and men of agricultural labour households
are usually handed to the male members alone (Breman,
1981). The same is observed in the context of Malaysian
plantation workers (Heyzer, 1980). Further, evidence from
three Indian states reveals that, even where the wages are
initially paid to the women, they are taken over and
controlled by the men (Chakravarty and Tiwari, 1977).
Similarly, the earnings from rice cultivation in small peasant
households in Korea are observed to be controlled by the
men (Palmer, 1980). Case studies relating to African
countries also document male control over the earnings from
women's labour (see Bukh, 1979, for Ghana).

It could of course be asked why the issue of who controls
the cash income and makes decisions on how it is spent is
important. Why can we not argue for instance that, in so far
as cash income is a means of providing for the consumption
needs of the household members, even if the cash initially
went into the men's hands, the consumption benefits would
flow to the women as well? Again, in so far as cash provides
access to the means of production (land, new inputs, etc.),
would not all household members, irrespective of gender, be
expected to benefit?

One reason why this argument may not hold is that the
way in which cash income actually gets spent (that is, in
whose interests it gets spent) could vary according to who
controls it. While the documentation on the way decisions
regarding the sharing and spending of cash income are made
in rural households is extremely scanty, the few existing
studies provide crucial pointers. They indicate that, to the
extent that women have some discretion and control over
cash expenditure, they tend to spend the money essentially
on family needs, whereas men tend to spend it largely on

their own needs. This has been observed especially in the African context (Consortium for International Development, 1978; Hanger and Moris, 1973; Bukh, 1979). For instance, in the irrigated rice resettlement villages in Mwea (Kenya), the women not only produce food for the family on their individual (and separate) plots, but also try to generate a surplus for sale to meet essential housekeeping expenses, as it is not usual for the men to contribute towards such expenses. Men, on the other hand, spend the income from the sale of their cash crops (for which women, too, provide some labour) largely on beer and to hire supplementary labour for their own fields (Hanger and Moris, 1973). In Ghana, it has been observed that the money earned by the man from his cash crop, cocoa, is usually controlled entirely by him and often spent on drink and clothes for himself, while the family's subsistence needs are met by the woman (Bukh, 1979).

In the Asian context, too, a number of studies note this divergence between women and men in their pattern of spending. In rural India, it is commonly found that men spend a part of their earnings on liquor and cigarettes, whereas women usually spend the money on family needs alone (Gulati, 1978). This factor can frequently be a source of conflict in the family (Chakravarty and Tiwari, 1977). In Bangladesh, it has been observed that money earned by poor peasant women is used by them to buy food for the family, rather than spent solely for their own benefit (Arens and Van Beurden, 1977).[2] However, unlike the African context, cultural/social norms in Asia would usually dictate that the man shares some responsibility for the family's subsistence needs, and that the produce from the land (where the household has some land) or any cash earned be used, if not entirely, at least substantially, for the family members. The relative sharing of the food and cash between different members of the household could nevertheless still favour the

---

[2] Women in Latin America do not seem to be any better off. For instance, it is noted that women in poor rural households in Mexico try and find work wherever possible, and '. . . although it is often argued that women only spend frivolously, in fact women could not waste the family's small stock of cash on alcohol and cigarettes as did the men, rather they invested in necessities' (Young, 1978b, pp. 209–10).

men over the women. This becomes apparent when one considers women's access to food, irrespective of whether or not they have access to cash income.

*Sharing of household food*

Documentation on the sharing of food between women and men in the household is again limited, but nevertheless adequate to show that the actual distribution of food and nutrients tends to favour the household men relative to the women in large parts of the Third World. Evidence from Asia, Africa and Latin America reveals that the senior male members of the household are frequently given the best diet in terms of both quality and quantity, and that boys often have priority over girls (Schofield, 1979).

The favouring of male members in the sharing of food cannot be justified *a priori* on the grounds that men expend more energy than women, especially in the context of poor peasant households. First, the minimum energy requirements per unit of body weight are usually higher for women relative to men during periods of pregnancy and lactation, even with an equal amount of energy expended in work. Secondly, in many instances the energy expended in work alone is higher for women than for men. For example, in a study of male and female farmers in Gambia, it was found that the total calories expended per day in working and walking were higher for women than for men in six out of the nine months of the agricultural season studied (Fox, 1953). Another study, which meticulously compared energy intake with energy expended in rural Nigeria, found that women's intake fell much short of their needs while the men's intake was much more than their needs (Longhurst, 1980b). A case study of a typical agricultural labour household in Kerala (India) noted that on working days the man's caloric intake fell short of the Indian Council of Medical Research recommendations by 11 per cent, while the woman's fell short by 20 per cent; on unemployed days the shortfalls were 26 per cent for the man and 50 per cent for the woman (Gulati, 1978). In another Indian study for rural Karnataka, on comparing daily caloric intake with energy expended

during the day, it was found that, on average, the women's intake had a deficit of about 100 calories and the men's had a surplus of about 800 calories per day (Batliwala, 1983). Also, some general inferences can be drawn from the fact (already noted) that in most communities women in poor households work longer hours than men, both on an average over the year and often during peak periods as well.

Differential male–female status in the household that leads to sex-selective feeding, particularly (but by no means exclusively) in scarcity situations, is likely to lead to a differential distribution, by gender, of income for other needs as well.

So far, my focus has been on women as members of male-headed households. In fact, female-headed households, where women have sole responsibility for their own upkeep and often for their children, are not uncommon. By one estimate, 15–25 per cent of households in many under-developed countries of the non-socialist Third World today are likely to be *de facto* female-headed: 20 per cent on average in the Caribbean and Central America, 22 per cent in sub-Saharan Africa, 16 per cent in North Africa and the Middle East, 15 per cent in South America, 18.7 per cent in India, and so on (Buvinic and Youssef, 1978; for some country-specific estimates of *de facto* female-headed households in the African context, also see Chapters 5 and 6). The incidence of poverty is found to be much higher among such families than among those headed by men. Many of these women are widows or have been divorced or deserted by their husbands and they often get little or no financial support from their male relatives (see Chen and Ghuznavi, 1978, for Bangladesh and Visaria and Visaria, 1983, for India).

It is against the background of these varied considerations that one needs to view the implications of technological change for women. In other words, the initiation of a new agricultural modernisation scheme, including the adoption of new inputs and practices, needs to be viewed in the context of a situation where usually:

• there is already an unequal (often highly unequal)

distribution of the ownership of and control over material resources between households;

- women in the poorer households already have a high work burden both in absolute terms and relative to the men;
- the division of cash and consumption within the household tends not to be in women's favour;
- a number of the poorer households are headed by women who have the sole responsibility for the upkeep of their families, and who often have no ready access to land or capital.

The question then is: are the current forms and directions of technological change in agriculture likely to exacerbate the problems for women or alleviate them? It will be seen from the discussion that follows that answering this question needs consideration of a complex combination of possible effects: for instance, a given technological change that increases, decreases or has a neutral effect on a woman's work burden may be accompanied by effects in a different direction as regards her control over cash income or her consumption. These combinations could vary by socioeconomic class. Further, there may be a shift in the location and content of a woman's work (say a shift from 'visible' work in the fields to 'invisible' work at home, or vice versa) that may not affect her total work time, but would affect the social valuation attached to that work time. These aspects will become obvious when concrete examples are taken up in the next section, which considers the observed and likely effects of specific technologies and modernisation schemes in agriculture on women of different socioeconomic classes in the context of different farming systems.

### The impact of technological change in agriculture by class and gender

In recent years, agricultural modernisation has been associated with a variety of technological and other innovations, which in very broad terms can be classified into four categories:

- those that are land saving, labour using and yield increasing: into this category would come biochemical inputs (high-yielding variety (HYV) seeds, chemical fertilisers, etc.) and the introduction of modern forms of irrigation such as tubewells and pumpsets, where previously reliance was only on old forms such as canals and tanks;
- those that are essentially labour saving, such as combine harvesters, wheat threshers, maize shellers, rice mills, maize mills – in other words, the post-production innovations;
- those whose effect on the use of land or labour or on output cannot be stated categorically, since the impact can vary under different ecological and sociological conditions: into this category come tractors;
- other changes associated with agricultural modernisation in the Third World that strictly cannot be termed technological innovations in the sense that the first three can, but that are of significance in the present discussions: into this category would come the introduction of cash cropping in areas where previously crops were grown for subsistence.

I shall consider each of these changes in turn, drawing examples first from Asian agriculture and then from African agriculture. The separate consideration by region is useful for the following reasons. First, there are some differences in the agriculture of the two regions that would influence what effect the same technological innovation could have. In very broad terms, one can say that Asian agriculture is typified by a high labour–land ratio, and a fairly high percentage of the agricultural population that is landless; family units tend to be monogamous, and women and men both tend to cultivate the same crops on the same plot(s) of land – with some operations being done mainly by the women and others mainly by the men. In African agriculture on the other hand, the labour–land ratio is relatively low, landless agricultural labour is relatively scarce, family units are often polygamous, and women and men often cultivate different crops on separate plots of land. Secondly, the more typical forms of

agricultural modernisation scheme undertaken in Asia and Africa are somewhat different in nature. In the Asian context, agricultural modernisation over the past decade and a half has been associated largely with the introduction of HYVs, especially for rice and wheat, as part of a package along with chemical fertilisers and an assured water supply. The adoption of HYVs has either followed the introduction of new irrigation schemes on previously unirrigated land, or been accompanied by an improvement in the technique of irrigation through investment in tubewells, where only traditional sources of water were used previously. In some areas it has also been accompanied by the introduction of harvest and post-harvest mechanisation and by tractorisation. In the African context, agricultural modernisation has been associated mainly with new irrigation schemes on previously unirrigated land, and with the introduction of cash cropping. The advent of irrigated farming has generally gone hand in hand with cash cropping. Although tractors have begun to be used in some places, in overall terms their use in most African countries is not common (Cleave, 1974); where used, they have generally been introduced along with cash crops – serving as a means of clearing new land for the latter. There appears to have been no significant adoption of the Asian type of HYV package: Cleave (1974), whose study relates to a number of regions in Africa, notes that there are few records of fertiliser application or of the use of improved seeds, insecticides, herbicides, etc.

*The Asian experience*
As mentioned earlier, virtually all the studies relating to the impact of agricultural modernisation in Asia have focused on the household as the unit of analysis; few deal with the intra-household inpact by gender. Hence, relatively more can be said about the effects on women as members of particular classes than about the gender-related effects. However, an attempt will be made to interpret the evidence in relation to the gender implications.

Further, a separation has been attempted between the effects of biochemical inputs in the form of HYV seeds and chemical fertilisers with an assured water supply (including

tubewell irrigation) – the HYV–irrigation 'package' – and the effects of mechanical equipment in the form of tractors, combine harvesters and threshers. These two components of the so-called Green Revolution need to be separated because their effects on labour use often move in opposite directions: the former is generally associated with an increase in the demand for labour time, and the latter (especially harvest and post-harvest mechanisation) with a decrease. In the discussion that follows, such a separation has been made, although it is recognised that in practice the two components often go together.

To begin with, I shall present some of my empirical results relating to two predominantly paddy-growing states of South India. The scope of my empirical analysis is modest. It is confined to the implications of technological change in agriculture on work done by women in the fields since the available data do not allow a consideration on the effects of women's domestic workloads or on the inter-household or intra-household distribution of income or consumption. Some of these wider issues will be taken up in the subsequent, more general, discussion of the evidence from available literature relating both to India and to other parts of Asia.

*Some India-specific empirical results*   The attempt here will be to trace the effect of the spread of HYVs on the use of female labour in the fields. The effects of mechanised techniques will not be discussed because the degree of tractorisation or mechanical threshing was extremely limited among the sample farms. (These effects will be considered later in the more general Asia-related discussion.) The present analysis is based on secondary (unpublished) data that have not previously been used for similar work. The data relate to samples of principally paddy-growing farms drawn from the Andhra Pradesh and Tamil Nadu states of India, for the crop-years 1974/5 and 1976/7 respectively.[3] These two states

---

[3] The data were collected for the Directorate of Economics and Statistics, Ministry of Agriculture, under the 'Comprehensive Scheme for Studying the Cost of Cultivation of Principal Crops' by the Agricultural Universities of the two states. The Andhra Pradesh sample consisted of ninety-nine farms spread over ten *tehsils* in

were chosen because the level of female labour participation here is higher than in most other states of the country, and because they are among the principal HYV-rice-adopting states. First the Andhra Pradesh and then the Tamil Nadu results will be presented. Subsequently, the implications of both samples taken together will be highlighted.[4]

*Andhra Pradesh*  Table 4.1 gives the percentage use of labour time by type of labour and operations. The predominant use of female casual labour is strikingly apparent. It contributes 45.9 per cent of total labour time over the crop-year, while male casual labour contributes another 25.3 per cent. (Casual labour thus accounts for 71.2 per cent of the total annual labour time on the farm.) However, the use of female casual labour is not distributed evenly over all operations. In fact, there is a distinct task-specificity in its use (as there is in the use of each type of labour). The significant contribution of female casual labour is in sowing, interculture and harvesting. It is also quite important in threshing, but there is very little involvement of women in other operations, such as ploughing, manuring or plant protection. Female family labour contributes only 2.1 per cent of total labour time. Women are usually not hired as permanent labourers.

The effect of HYVs on female labour (casual and family) is indicated in Table 4.2, which gives the annual use of labour per hectare of net sown area on farms with different proportions of their gross cropped area[5] under HYVs. (Most

---

ten districts. The Tamil Nadu sample consisted of eighty-seven farms spread over nine *tehsils* in seven districts.

The information was obtained by the cost-accounting method, namely, on the basis of day-to-day observation of the selected cultivators by whole-time fieldmen residing in the selected villages. This method has special advantages over the 'recall method' often used for farm surveys by researchers, in terms of the accuracy of the information obtained, since it does not rely exclusively on the memory of the respondent.

[4] The tables presented here help provide a descriptive picture. For a more rigorous statistical analysis of the impact of HYV rice on female labour use in Andhra Pradesh and Tamil Nadu, based on the same data as used here, and in Orissa, see Agarwal (1984).

[5] Gross cropped area is the total area under all crops grown during the crop-year, as opposed to net sown area, which constitutes the area that is cultivated at least once over the crop-year.

Table 4.1  Andhra Pradesh: percentage use of labour time by type of labour and operations

| Operation | Female labour | | | Male labour | | | | Child labour | All labour |
|---|---|---|---|---|---|---|---|---|---|
| | Family | Casual[a] | Total | Family | Permanent[b] | Casual[a] | Total | | |
| Ploughing[c] | 0.3 | 6.8 | 7.1 | 45.5 | 22.2 | 25.0 | 92.7 | 0.1 | 100.0 |
| Sowing | 2.0 | 67.4 | 69.4 | 7.8 | 3.9 | 17.8 | 29.5 | 1.2 | 100.0 |
| Manuring | 4.2 | 4.0 | 8.2 | 44.8 | 25.6 | 20.7 | 91.1 | 0.6 | 100.0 |
| Interculture | 3.5 | 69.0 | 72.5 | 7.9 | 3.7 | 14.4 | 26.0 | 1.6 | 100.0 |
| Irrigation | 0.3 | 0.2 | 0.5 | 57.1 | 19.4 | 23.0 | 99.5 | n | 100.0 |
| Plant protection | 0.8 | 1.6 | 2.4 | 51.2 | 24.8 | 21.5 | 97.5 | – | 100.0 |
| Harvesting | 1.6 | 61.6 | 63.2 | 6.2 | 3.5 | 25.8 | 35.5 | 1.2 | 100.0 |
| Threshing | 2.3 | 22.6 | 24.9 | 15.3 | 6.9 | 52.4 | 74.6 | 0.5 | 100.0 |
| Miscellaneous | 3.2 | 4.0 | 7.2 | 74.8 | 7.2 | 10.8 | 92.8 | – | 100.0 |
| All operations | 2.1 | 45.9 | 48.0 | 17.8 | 8.0 | 25.3 | 51.1 | 0.9 | 100.0 |

Notes:
n = negligible
[a] Casual labour is that hired for specific tasks, often on a daily basis.
[b] Permanent labour is that hired on a long-term basis, usually for a year or more.
[c] This covers total labour time used for seed-bed preparation, including functions other than ploughing, e.g. ground levelling, etc.

Table 4.2  Andhra Pradesh: annual use of labour by type of labour and percent area under HYV

| Percent area under HYVs | Female labour | | Male labour | | | Child labour | | All labour | No. of cases in each category |
|---|---|---|---|---|---|---|---|---|---|
| | Family | Casual | Family | Permanent | Casual | Family | Casual | | |
| | *Absolute values: hours per hectare of net sown area* | | | | | | | | |
| 0 | 46.9 | 804.6 | 241.8 | 132.1 | 356.4 | 1.5 | 5.1 | 1,588.4 | 37 |
| >0 – ≤40 | 60.9 | 581.6 | 323.2 | 94.8 | 172.8 | 3.8 | 15.6 | 1,252.7 | 17 |
| >40 – ≤70 | 40.4 | 831.2 | 322.9 | 172.2 | 501.2 | 0.6 | 13.8 | 1,882.3 | 20 |
| >70 | 6.0 | 963.7 | 407.6 | 159.6 | 725.8 | 1.3 | 29.3 | 2,293.3 | 25 |
| All | 37.7 | 811.8 | 314.0 | 140.7 | 447.4 | 1.7 | 14.8 | 1,768.1 | 99 |
| | *Percentages* | | | | | | | | |
| 0 | 3.0 | 50.6 | 15.2 | 8.3 | 22.4 | 0.1 | 0.3 | 100.0 | |
| >0 – ≤40 | 4.9 | 46.4 | 25.8 | 7.6 | 13.8 | 0.3 | 1.2 | 100.0 | |
| >40 – ≤70 | 2.1 | 44.2 | 17.2 | 9.2 | 26.6 | n | 0.7 | 100.0 | |
| >70 | 0.3 | 42.0 | 17.8 | 7.0 | 31.6 | n | 1.3 | 100.0 | |
| All | 2.1 | 45.9 | 17.8 | 8.0 | 25.3 | 0.1 | 0.8 | 100.0 | |

*Note:*
n = negligible

of this HYV area is occupied by HYV rice.) Note that about 37 per cent of the farms use no HYVs at all, another 45 per cent have over 40 per cent of their area under HYVs, and the rest fall in between. *A priori*, one would expect an increase in the demand for labour with HYVs relative to traditional crop varieties, since HYVs need greater care in sowing/trans-planting, interculture (if pesticides and weedicides are not also introduced) and irrigation; and because of their positive crop yield effect they would also need relatively more labour for harvesting and threshing (if the operation is not simultaneously mechanised). This is broadly borne out by the results. From the table, note that, with the exception of farms with no HYVs,[6] the use of total labour per sown hectare increases with an increase in the percentage of area under HYVs. This labour consists mainly of female and male casual labour and to a lesser extent of male family labour, as measured in absolute terms. In percentage terms, however, the use of female casual labour decreases slightly while that of male casual labour increases, with no consistent increase or decrease in male family labour use.

These conclusions were found to hold true even when the effects were disaggregated further by farm size (see Agarwal, 1981a). In addition, the disaggregation revealed two interest-ing features about female family labour: first, that its use was confined largely to farms of 4 or less hectares in size, and second that even on the smaller farms, as the percentage of area under HYVs increased, the use of female family labour decreased both in absolute and in proportionate terms.

The explanation would appear to lie in the fact that, in a cultural setting where women's participation in manual work outside the home is seen as lowering the family prestige, women would usually not undertake such work if their families could afford to do without their labour and use hired help instead. This would generally be true of the larger farms (here farm size serves as a broad proxy for the household's economic position). On the smaller farms, the noted results

---

[6] The majority of these farms are in the smallest size group of less than 2 hectares. Since small farms usually have a higher cropping intensity than large farms, they would tend to have a high input of labour per hectare even without HYV (Agarwal, 1983).

are a function of two divergent tendencies: on the one hand, HYVs increase the requirements of total labour input on the farm, which would encourage the greater use of family women; on the other hand, HYVs usually lead to higher farm incomes, which would encourage the withdrawal of family women from field work as a result of prestige considerations. In the above instance, the tendency of family women to withdraw because of the 'income effect' of HYVs appears to have offset the tendency towards a greater involvement of family women as a result of the 'labour-need effect'.

A further illustration of this aspect is provided by Table 4.3. Note that in sixty-five of the ninety-nine farms there are

Table 4.3   *Andhra Pradesh: characteristics of farms using female family labour and those not doing so (mean values)*

| Characteristic | Farms not using female family labour (No. =65) | Farms using female family labour (No. =34) |
| --- | --- | --- |
| Farm size (net sown area) | 5.47 | 2.71 |
| Output per hectare of net sown area (rupees) | 5,222.50 | 3,527.80[a] |
| Output per hectare of gross cropped area (rupees) | 3,225.80 | 2,371.00[a] |
| No. owning a tractor | 4 | — |
| No. hiring a tractor | 18 | 3 |
| No. and % owning a tubewell or pumpset | 5 (7.7%) | 2 (5.9%) |
| % of gross cropped area under HYVs | 41.8 | 28.6 |
| Cropping intensity | 167.6 | 142.6 |
| Casual male labour as a % of total labour | 28.3 | 19.2 |
| Casual female labour as a % of total labour | 47.2 | 43.4 |
| Family male labour as a % of total labour | 13.4 | 26.5 |
| Family female labour as a % of total labour | — | 6.4 |

*Note:*
[a] Data on output were missing for one of the farms; hence these averages were computed for 33 rather than 34 farms.

no family women engaged in crop production activities. These farms tend to be larger (twice as large on average) than those where family women work in the fields. They also produce a higher value of output per hectare, have a higher cropping intensity in spite of their larger size, devote a larger proportion of cultivated area to HYV crops, have a higher percentage of tubewell/pumpset owners, and include all the tractor owners. Additionally, they tend to use a higher percentage of casual labour (both female and male) and a smaller percentage of family labour. These factors serve as indicators of the family's economic position and level of farm modernisation, and are of course related to one another; together, they indicate that farms not employing family women in the fields tend to be economically better off and more modernised than those where the family women work in the fields.

*Tamil Nadu* The picture presented by the Tamil Nadu sample is similar to that for Andhra Pradesh. As can be seen from Table 4.4, female casual labour again constitutes the most important labour input, providing 49.5 per cent of total labour time. Also noticeable again is a consistent increase in total labour time over the year with an increase in the area under HYVs. In absolute terms, the type of labour affected is once more female and male casual labour, although, unlike Andhra Pradesh, there is also a slight increase in the use of female family labour. In proportionate terms, the share contributed by different types of labour shows no consistent increase or decrease.

When a further disaggregation by farm size groups was undertaken, the finding that there is an increased use of female and male casual labour with HYVs was found to hold true for all size groups. However, an interesting feature emerged with regard to male and female family labour: on the smaller farms of 1 hectare or less, their use increased with the use of HYVs, in both absolute and proportionate terms. Unlike Andhra Pradesh, therefore, in the Tamil Nadu sample the burden of fieldwork on women in the smaller farm households appears to have increased with HYVs, and any positive income effect of HYVs has not been able to

Table 4.4   Tamil Nadu: use of labour by type of labour and percent area under HYV

| Percent area under HYVs | Female labour | | | Male labour | | | | Child labour | All labour | No. of cases in each category |
|---|---|---|---|---|---|---|---|---|---|---|
| | Family | Casual | Exchange | Family | Permanent | Casual | Exchange | | | |
| | *Absolute values: hours per hectare of net sown area* | | | | | | | | | |
| 0 | 30.9 | 841.5 | 33.8 | 265.4 | 74.0 | 283.0 | 0.2 | 0.3 | 1,529.1 | 17 |
| >0 – ≤40 | 85.8 | 708.0 | 5.5 | 281.9 | 150.9 | 328.0 | 6.9 | 6.3 | 1,573.3 | 28 |
| >40 – ≤70 | 80.2 | 1,220.8 | 0.3 | 233.7 | 162.3 | 617.8 | 2.5 | 0.3 | 2,317.9 | 21 |
| >70 | 144.0 | 1,167.9 | 2.6 | 397.3 | 96.4 | 639.5 | 9.4 | 3.1 | 2,460.2 | 21 |
| All | 87.8 | 968.9 | 9.1 | 294.9 | 125.4 | 464.3 | 5.1 | 2.9 | 1,958.5 | 87 |
| | *Percentages* | | | | | | | | | |
| 0 | 2.0 | 55.0 | 2.2 | 17.4 | 4.8 | 18.5 | n | n | 100.0 | |
| >0 – ≤40 | 5.5 | 45.0 | 0.3 | 17.9 | 9.6 | 20.8 | 0.4 | 0.4 | 100.0 | |
| >40 – ≤70 | 3.5 | 52.7 | n | 10.1 | 7.0 | 26.6 | 0.1 | n | 100.0 | |
| >70 | 5.8 | 47.5 | 0.1 | 16.1 | 3.9 | 26.0 | 0.4 | 0.1 | 100.0 | |
| All | 4.5 | 49.5 | 0.5 | 15.1 | 6.4 | 23.7 | 0.2 | 0.1 | 100.0 | |

*Note:*
n = negligible

offset this. On the larger farms the tendency for family women's work participation to decrease with an increase in income was still apparent (Agarwal, 1981a).

Table 4.5 further illustrates these relationships. It can be seen that only thirty-nine out of eighty-seven farms have family women working in crop production activities. As in Andhra Pradesh, farms using no female family labour, compared to those that do, tend to be larger in size, have a higher incidence of tubewell owners and tractor users, a higher percentage of casual (male and female) to total labour use, and a higher value of output per cropped hectare. However, their percentage area under HYVs and cropping intensity (which affects output per sown hectare) are lower than on farms where family women are working in the fields. This is at variance with the Andhra Pradesh results, but is in

Table 4.5  *Tamil Nadu: characteristics of farms using female family labour and those not doing so* (*mean value*)

| Characteristic | Farms not using female family labour (No.=48) | Farms using female family labour (No.=39) |
|---|---|---|
| Farm size (net sown area) | 2.67 | 1.67 |
| Output per hectare of net sown area (rupees) | 4,734.50 | 4,809.40 |
| Output per hectare of gross cropped area (rupees) | 3,957.70 | 2,885.00 |
| No. owning a tractor | 1 | — |
| No. hiring a tractor | 5 | 3 |
| No. and % owning a tubewell or pumpset | 15 (31.3%) | 9 (23.1%) |
| % of gross cropped area under HYV | 0.33 | 0.53 |
| Cropping intensity | 134.9 | 164.6 |
| Casual male labour as a % of total labour | 26.9 | 20.4 |
| Casual female labour as a % of total labour | 50.3 | 47.3 |
| Family male labour as a % of total labour | 9.9 | 20.4 |
| Family female labour as a % of total labour | — | 8.2 |

keeping with my observations that in Tamil Nadu the higher labour requirements associated with HYVs (as also with cropping intensity) tend to keep family women in the fields, despite the opposing influence of any income effect of HYVs or of a higher cropping intensity.

*An overview of the Andhra Pradesh and Tamil Nadu findings*
From the Andhra Pradesh and Tamil Nadu results taken together, some general conclusions emerge. In both samples, female casual labour is a major contributor of labour time, constituting about 45–50 per cent of total labour time on the farms over the year. The effect of HYVs on the demand for total labour time over the crop-year as a whole is positive for both states; again in both samples, the increase is most noticeable in terms of female and male casual labour time. This would suggest an increase in the employment opportunities for casual labour with the spread of HYV paddy. Whether or not this leads to an increase in the agricultural income of such labour would depend on the movement of real wage rates, an aspect that will be discussed later.

In small cultivator households, the implications of modern inputs for women are found to vary. In Tamil Nadu there is an increase with HYVs in the time put in by family women, implying an increase in their work burden. In Andhra Pradesh, however, no such increase was observed. These results reflect the net effects of two divergent tendencies associated with HYVs – one stemming from the increase in overall labour requirements and the other from the increase in household income.

In large cultivator households, family women are generally not found to participate in manual work in the fields.

*The overall Asian evidence*   Having looked at some of the field-related, labour-use effects of technological change in agriculture in the context of the two Indian states, let us now consider both the Indian experience more generally and the overall Asian experience. In keeping with the categories demarcated at the beginning of this paper, I shall discuss, in turn, the effects on work, income, etc., for women in

agricultural labour, small cultivator and large cultivator households.

*Agricultural labour households*[7]    Women of agricultural labour households constitute a major focus of concern since economically they are amongst the worst off and in many Asian countries they constitute the largest percentage of rural women workers. In India, by the 1981 census, approximately 50 per cent of all rural women workers were employed as agricultural labourers, and another 37 per cent as cultivators, i.e. they worked on the family farms. Rural women constituted 38 per cent of all rural agricultural labourers at the all-India level and for some states the percentage is much higher. In Andhra Pradesh, for instance, 51.5 per cent of all rural agricultural labourers are women, and in Tamil Nadu the percentage is 47.8. Also, the number of such workers has been increasing over time. According to the Rural Labour Enquiries (RLE) data, between 1964/5 and 1974/5 – that is, broadly the pre-Green Revolution period and the period subsequent to the introduction of the HYV-irrigation 'package' – the number of agricultural labour households in India increased from 15.3 million to 20.7 million, and the numbers of agricultural labourers increased from 30.8 to 46.4 million. Disaggregated by sex for adult workers, the increase was from 11.5 to 18.3 million for women and 17.5 to 25.2 million for men (Government of India, 1979, pp. 19, 62–3).

However, agricultural modernisation does not appear to have provided an equivalent increase in the demand for such labour. Table 4.6 gives the average number of days worked for wages and the number of days not worked owing to want of work by women, men and children of rural agricultural labour households, both for selected HYV-adopting states[8] and at the all-India level. The table indicates that, except for Uttar Pradesh where the number of days worked increased for both women and men, and Andhra

[7] Agricultural labour households are defined in this study as those households that derived over 50 per cent of their total income in the year preceding the inquiry from wage-paid manual labour in agricultural operations.

[8] Punjab, Haryana and Uttar Pradesh were selected as illustrative of the principal HYV wheat-adopting states, and Tamil Nadu, Andhra Pradesh and West Bengal as illustrative of the principal HYV rice-adopting states.

Table 4.6  *India: employment and unemployment of usually occupied members of agricultural labour households in selected states, 1964/5 and 1974/5*

| State | Women 1964/5 | 1974/5 | Men 1964/5 | 1974/5 | Children 1964/5 | 1974/5 |
|---|---|---|---|---|---|---|
| | *Average no. of full days[a] worked per year in agricultural operations[b]* | | | | | |
| Andhra Pradesh | 102 | 136 | 194 | 185 | 186 | 160 |
| Haryana | ⎫126 | 95 | ⎫272 | 191 | ⎫266 | 122 |
| Punjab | ⎭ | 82 | ⎭ | 217 | ⎭ | 136 |
| Tamil Nadu | 143 | 114 | 185 | 141 | 177 | 115 |
| Uttar Pradesh | 83 | 104 | 177 | 191 | 110 | 114 |
| West Bengal | 167 | 110 | 264 | 206 | 251 | 198 |
| All India | 138 | 129 | 208 | 186 | 167 | 145 |
| | *Average no. of full days not worked during the year owing to want of work* | | | | | |
| Andhra Pradesh | 98 | 101 | 16 | 60 | 47 | 57 |
| Haryana | ⎫50 | 65 | ⎫27 | 85 | ⎫21 | 23 |
| Punjab | ⎭ | 51 | ⎭ | 61 | ⎭ | 36 |
| Tamil Nadu | 152 | 138 | 103 | 96 | 83 | 71 |
| Uttar Pradesh | 90 | 99 | 34 | 57 | 45 | 58 |
| West Bengal | 66 | 146 | 36 | 88 | 15 | 58 |
| All India | 91 | 119 | 47 | 74 | 51 | 72 |

*Notes:*

[a] Full day means three-quarters or more of the normal working hours.

[b] Wage employment in agricultural operations is undertaken within agricultural labour households by (a) agricultural labourers (i.e. those household members whose main source of earnings is agricultural wage work); (b) non-agricultural labourers; (c) others. In the above table, state-level information for 1964/5 on the average number of days employed in agriculture could be gleaned only as regards agricultural labourers, i.e. for (a) and not for (b) and (c). At the all-India level, however, information for all three was given.

For 1974/5, the figures available, even at the state level, included agricultural work done by all members of the household and not merely by agricultural labourers. The 1964/5 state-level figures are thus a slight overestimate of the average number of days for which all members of the agricultural labour households found work during the year. This does not, however, alter the conclusions that have been drawn from the table.

*Sources:* For 1964/5 data: Government of India (1973), Tables 3.4, 3.6, 8.5, 8.7, 9.5, 9.7, Appendices V, IX, X. For 1974/5 data: Government of India, (1980), Tables 3(a)1.1, 3(a)1.2 and 3(a)1.3.

Pradesh where the work-days increased for women alone, in all the other 'selected' states there has been a decline. Also, with the exception of Tamil Nadu, there has been an increase in the days not worked during the year owing to want of work for both women and men. At the all-India level, the average annual work-days declined for both men and women, and the days of 'involuntary' unemployment increased. These data indicate that, by and large, agricultural modernisation between 1964/5 and 1974/5 did not help to provide employment (even at the 1964/5 work-days rate) to all those seeking agricultural wage work in 1974/5.

These overall results, however, hide the divergent effects of the HYV–irrigation 'package' and mechanisation. Table 4.7 gives some indication of this divergence. On the one hand, there was an increase in the days worked by both women and men in transplanting, weeding and harvesting, i.e. in the three main operations that were noted earlier as likely to need more labour with the introduction of the 'package'. On the other hand, there was a decrease in the use of hired labour in ploughing and 'others' (which would

Table 4.7 *All India: employment of usually occupied members of agricultural labour households in agricultural wage work in 1964/5 and 1974/5*

| Operation | Average full days[a] worked during the year | | | | | |
| | Women | | Men | | Children[b] | |
| | 1964/5 | 1974/5 | 1964/5 | 1974/5 | 1964/5 | 1974/5 |
|---|---|---|---|---|---|---|
| Ploughing | 7 | 1 | 46 | 34 | 14 | 4 |
| Sowing | 4 | 5 | 5 | 5 | 4 | 2 |
| Transplanting | 10 | 13 | 7 | 8 | 8 | 5 |
| Weeding | 21 | 31 | 12 | 21 | 18 | 20 |
| Harvesting | 42 | 45 | 39 | 44 | 31 | 31 |
| Others | 44 | 34 | 82 | 74 | 80 | 83 |
| Unclassified | 10 | — | 17 | — | 12 | — |
| All operations | 138 | 129 | 208 | 186 | 167 | 145 |

*Notes:*
[a] Full day means three-quarters or more of the normal working hours.
[b] Under 15 years of age.
*Sources:* For 1964/5: Government of India (1973), Tables 3.4, 8.5 and 9.5. For 1974/5: Government of India, (1981), Table 3.4(a).1.

include threshing, transportation, etc.). It is these very operations that, in a number of areas, have been mechanised through the use of tractors and threshers. This suggests that the decline in overall terms, i.e. for all operations taken together, is likely to be due largely to such mechanisation. The positive labour demand effect of the HYV–irrigation 'package' taken on its own appears to have been unevenly shared between women and men. Table 4.7 shows that, although there was a rise in the demand for both female and male hired labour time in the operations linked with the 'package', the increase was greater for female hired labour. Unfortunately, the RLE reports provide information only in terms of labour time effects and not in terms of the numbers of labourers affected. Hence it is not possible to say how any increase or decrease in labour time requirements has been shared between people.

Studies relating to other parts of Asia present a mixed picture in terms of the employment effects of the HYV–irrigation 'package'. For the Philippines, for instance, some studies clearly indicate that the demand for hired labour time has increased with HYVs (e.g. Barker and Cardova, 1978). Other Philippine-based studies, however, suggest that the numbers of hired labourers employed would not necessarily have increased, and may well have decreased, because of the changes in institutional arrangements for labour hiring that have become widespread after the introduction of HYVs. For instance, under the *sagod* system, which is now spreading, the payment to labour for weeding and harvesting is tied: only those who do weeding can participate in harvesting and thereby get a right to the harvest share (which is a joint payment for both tasks). Earlier, all comers could participate in harvesting for a share of the harvest. Under the *sagod* system, therefore, not only may the labourers employed receive no effective payment for weeding, but also a restriction is put on the numbers who can get such employment (Whythe and Whythe, 1982). The Indonesian literature provides similar pointers. Here the *kedokan* system under which payments for transplanting and harvesting are tied, which earlier existed only in some parts of the country, is observed to be spreading more widely in the post-HYV

period. This is noted to have specially negative implications for women's employment and income (Sajogyo, 1983; White, 1983). Another related aspect is that, in both the Philippines and Indonesia, the shift to HYVs has been accompanied widely with a switch from the hand-knife to the sickle in harvesting, and this in turn has been accompanied by the displacement of hired female labour by male labour hired on a contract basis (Res, 1983; White, 1983; Stoler, 1977).

In addition, mechanisation in various forms is observed to have negative implications for female labour, although the extent can vary depending on which operations are mechanised. Here a distinction needs to be made between the mechanisation of operations such as ploughing, through the introduction of tractors, and the mechanisation of post-production operations such as harvesting and threshing, through the use of combine harvesters and threshers.

A critical review of the evidence (mainly cross-sectional) from a number of studies in South Asia indicates that the use of tractors (which in South Asia are mainly being used for ploughing and transportation, although technically they can perform many diverse functions) reduces the requirements of labour time (Binswanger, 1978). However, as in India-based analysis (Agarwal, 1983) indicates, the use of tractors does not necessarily lead to a significant decrease in the numbers of persons employed. This is because the kind of labour affected is mainly male family or male permanent labour, since ploughing is rarely done by casually hired labour. A reduction in the time for which permanent labour is needed in a particular operation would not automatically displace the worker, since he would still be needed in other operations. The direct effect of tractorisation for hired labour in general, and casually hired labour (female and male) in particular, would thus be small, so long as tractors are used mainly for ploughing.

In contrast, the introduction of combine harvesters, wheat threshers, maize shellers, etc., clearly displaces hired labour. Harvesting and threshing on Asian farms are generally done jointly by female and male labour, and there is usually a high dependency on casually hired labour (as noted in my Andhra Pradesh and Tamil Nadu results), particularly on the larger

farms. The use of combines (which mechanise both oper-
ations) thus has a significant displacing effect for casual
labour, especially as it mechanises harvesting, which is
traditionally done manually and is a highly labour-intensive
operation. In parts of Asia where combines have been
adopted, they have been noted to have displaced a large
number of labourers. In one study for West Malaysia, for
instance, nine combines introduced in 1974 displaced 2,000
workers (Asian Development Bank, 1978). In India, the use
of combines is still limited, but it is not unlikely that this will
change in the future. This would mean taking away one of
the principal sources of employment for female casual labour.
Threshers are already widely in use in the HYV wheat areas
of India, and their negative effect on employment has been
noted in a number of studies (Agarwal, 1981b; Billings and
Singh, 1970), although there is no clear evidence on whether
it is male or female agricultural labourers who are primarily
displaced. In the Philippines, too, threshers are found to
displace hired labour; as a result, women are noted to be
working longer hours per day for a lower hourly wage (Illo,
1983).

In the case of non-farm, post-harvest mechanisation
represented by grain processing mills, there is clear evidence
that it is essentially women from the poorest rural households
who have been displaced. This has been noted, for instance,
in Bangladesh, where manual de-husking of rice is the most
important source of female wage employment in the rural
areas, and often is the only source (Greeley, 1981). The
mills, in contrast, tend to employ mainly men. Many of the
women who have been so displaced were the sole supporters
of their children and have now become destitute (Abdullah
and Zeidenstein, 1975; Halpern, 1978). A similar situation
has been noted in Java (Indonesia), where the mechanisation
of rice processing through the introduction of rice hullers has
thrown many landless women, who were employed in the
handpounding of rice, out of work. The estimated reduction
in women's work-days is 12 million (Collier *et al.*, 1974). In
India, where traditional rice mills employed women on a
casual or semi-permanent basis, the modern mills employ
mostly men (B. Harriss, 1977).

Table 4.8 *India: average daily real wage earnings from agricultural operations for members of rural agricultural labour households in selected states, 1964/5 prices (rupees)*[a]

| State | Women 1964/5 | 1974/5 | Men 1964/5 | 1974/5 | Children 1964/5 | 1974/5 |
|---|---|---|---|---|---|---|
| Andhra Pradesh | 0.85 | 0.76 | 1.21 | 1.03 | 0.65 | 0.62 |
| Haryana | )1.45 | 1.63 | )2.13 | 2.00 | )1.04 | 1.06 |
| Punjab | ) | 1.41 | ) | 2.65 | ) | 1.42 |
| Tamil Nadu | 0.85 | 0.79 | 1.39 | 1.24 | 0.70 | 0.53 |
| Uttar Pradesh | 0.93 | 1.07 | 1.10 | 1.39 | 0.83 | 1.00 |
| West Bengal | 1.36 | 1.14 | 1.81 | 1.40 | 1.03 | 0.84 |
| All India | 0.95 | 0.88 | 1.43 | 1.26 | 0.72 | 0.71 |

*Note:*
[a] Money wage earnings in 1974/5 have been deflated by the consumer price index for agricultural labour households to give real wage earnings.
*Source:* Government of India (1979), Tables 3.1(a).1 and 3.4.

The gloomy picture on the employment front is further darkened when one considers the question of the earnings of agricultural labourers. The Indian evidence (taken from the RLE Reports) reveals that between 1964/5 and 1974/5 in all the 'selected' states there was a rise in daily money wage earnings[9] from agricultural wage work, although the large cultivators seek to stem wage increases by various means, such as procuring the labour on contract from areas where wage rates are lower. However, as can be seen from Table 4.8, the increase in daily money wage earnings has not been in keeping with the rise in prices. In real terms, in West Bengal, Tamil Nadu and Andhra Pradesh, there was a decline in daily wage earnings for both women and men. The exceptions were Uttar Pradesh, where there was an increase for both sexes, and the Punjab, where there was an increase for men but a decrease for women.

Of course, a labourer can lose in terms of daily earnings and yet gain in annual terms if the number of days of employment over the year increases (or vice versa). However, when one considers the employment information along with

[9] Computed by dividing the aggregate earnings from each of the agricultural activities in which the labourer was engaged during the reference week of the survey by the corresponding number of 'full days' of employment.

the daily earnings information to get the annual real earnings from agricultural wage work, one notes that Uttar Pradesh is the only state where there was an increase in both the average annual days of employment and real wage earnings, for both sexes (see Table 4.9). In Andhra Pradesh there was an increase for women alone, while in all other selected states there was a decrease for both sexes. Moreover, the annual real wage income of an average agricultural labour household, estimated in another study (again from the RLE data) by taking account of the income of all earning members (men, women and children) from farm and non-farm work, was found to have declined between 1964/5 and 1974/5 in all states of India except Uttar Pradesh (Bardhan, 1981).

Evidence from parts of Asia other than India presents a similar pattern as regards the wage earnings of agricultural labourers. In Java, for example, as a result of a decline in real wages, all members of the labourers' families had to work longer hours to earn a living wage (White, 1976). In rural Bangladesh, a strong downward trend in real wages in agriculture is noted since 1964, accompanied by increased landlessness and poverty (Begum and Greeley, 1979). They found that, because of this, in an increasing number of

Table 4.9   *India: annual real earnings from agricultural wage work of usually occupied members of agricultural labour households in selected states for 1964/5 and 1974/5 (rupees)*

| State | Women | | Men | | Children | |
|---|---|---|---|---|---|---|
| | *1964/5* | *1974/5* | *1964/5* | *1974/5* | *1964/5* | *1974/5* |
| Andhra Pradesh | 86.7 | 103.3 | 234.7 | 190.0 | 120.9 | 99.2 |
| Haryana | ⎫ 182.7 | 154.7 | ⎫ 579.4 | 382.8 | ⎫ 276.6 | 129.0 |
| Punjab | ⎭ | 115.5 | ⎭ | 575.1 | ⎭ | 193.9 |
| Tamil Nadu | 121.6 | 90.3 | 257.2 | 175.2 | 123.9 | 61.2 |
| Uttar Pradesh | 77.2 | 111.7 | 194.7 | 264.9 | 91.3 | 114.5 |
| West Bengal | 227.1 | 125.0 | 477.8 | 288.7 | 258.5 | 167.0 |
| All India | 131.1 | 113.9 | 297.4 | 234.5 | 120.2 | 102.7 |

*Sources:* For 1964/5: based on Tables 4.6 and 4.8.
   For 1974/5: based on Table 4.6 and Government of India (1979), Tables 3.1(a).1 and 3.4.

agricultural labour households where earlier the men's wages were sufficient for the family's subsistence, women now have to seek wage work to enable the family to survive. Both these examples suggest an increase among agricultural labour households in women's work burden and a decline in their absolute income and consumption in these two countries, to which agricultural modernisation in the form of mechanisation is likely to have been an important contributory factor.

*Small cultivator households* The impact of the HYV–irrigation 'package' on small cultivator households is found to be a mixed one. On the one hand, there are those who have been able to take advantage of the new 'package' of inputs and practices: in the Indian subcontinent these are essentially concentrated in the wheat-growing regions, especially of the Indian Punjab. On the other hand, there are also many small cultivator households that have been left worse off. They have lost out not merely in relative terms, in that they have been unable to take advantage of the 'package' while others have done so, but also in absolute terms, in that there has been a tendency for the large landowners to evict tenants because they now find it more profitable to resume personal cultivation. This has been noted in the context of Pakistan (Hussain, 1980), India (Bhalla, 1976; Dasgupta, 1977b; Bardhan and Rudra, 1978), the Philippines (Griffin, 1972) and Indonesia (Sajogyo, 1983). This would also mean a decrease in the amount of land available for pure tenancy in the HYV areas. The Indian evidence further indicates an increasing tendency for rent to be asked for in cash and for cash rent to be rising. All this has meant that many of those who could previously hire in land have now had to join the ranks of the agricultural labourers. Further, in both the Indian and Pakistan context, there appears to be a rise in the concentration of landownership, asset ownership and income in the HYV areas (Dasgupta, 1977b; Hussain, 1980).

For many small cultivator households, these effects have been reinforced by tractorisation. Tractors have been noted in parts of South Asia to be a significant factor enabling large landowners to bring bigger pieces of land under personal cultivation than was possible or profitable previously. This

has led to tenant eviction in some parts of South Asia, as for instance in Pakistan Punjab (McInerney and Donaldson, 1975; Hussain, 1980), and many of the evicted tenants have become agricultural labourers (Hussain, 1980).

Women in small cultivator households are affected not merely by the complexity of such factors operating at the household level, but also by divergent gender-related effects. In the case of households that have adopted the 'package', these divergences are especially apparent, and make it difficult to provide clearcut pointers regarding benefits or costs in net terms. As already noted, in such households there is usually an increase in the requirement of labour in the fields as well as an increase in farm output and income. The impact of this on family women vis-à-vis their fieldwork burden varies across regions. In some areas, the adoption of the 'package' has increased women's fieldwork burden, for example, in Pakistan Punjab (Khan and Bilquees, 1976), the Indian Punjab (Mamdani, 1972), the Philippines (Palmer, 1975b), and Indonesia (Manuaba, 1979).[10] In other areas, there is observed to be a withdrawal of family women from work in the fields, for example in Karnataka with the introduction of irrigated rice cultivation (Epstein, 1962, 1973), in Andhra Pradesh (Agarwal, this chapter) and in Bangladesh (Greeley, 1981).

It is important to note here that the withdrawal of women of small cultivator households from work on the family farms, and the consequent reduction in their fieldwork burden, is usually made possible by a rise in family income with technological change. This has different connotations from the involuntary unemployment and forced staying at home of women in agricultural labour households, for whom a reduction in the availability of work in another's fields simultaneously means a fall in income.

---

[10] The dwarf HYV rice introduced in Indonesia requires the additional operation of crushing the paddy stalks after harvest in the fields. This is because the paddy, owing to short stems, cannot be tied in bundles necessary for transportation. The stalk crushing has to be done by the women. Also, while the headload from the traditional variety of rice was 20 kilos for the women, the load with HYV rice is nearly 100 kilos because of the size of the available standard jute sacks in which the rice is carried (Manuaba, 1979).

However, there can be trade-offs, even for the small cultivator household women who have withdrawn from the fields. For instance, the decrease in the load of fieldwork may be countered by an increase in their workload at home, such as in areas where it is customary to provide meals for hired agricultural labour during harvest. In small cultivator households the burden of cooking these meals is likely to fall on the family women, since, even if hired help replaces their labour in the fields, it would not usually replace their labour at home (Randhawa, 1975). Further, withdrawal of women from 'visible' work in the fields to 'invisible' work at home may also negatively affect their household status and participation in decision-making (J. Harriss, 1979).

Again, the expected gain to small cultivator household women from the introduction of modern flour mills, in terms of relieving them of arduous hand grinding, cannot be taken for granted, since the household men who control the cash are not always willing to pay for the grain processing at the mills (Chakravorty, 1975).

Likewise, although the increase in farm output and income among the 'package'-adopting farms may usually be expected to add to women's absolute level of consumption (but not necessarily relative to the men's), this may not always follow. For example, irrigation often leads to a shift in cropping patterns in favour of cash crops and away from subsistence production; the extra income so obtained does not necessarily flow back to the family in terms of a greater quantity or better quality of food (Whitcombe, 1972).

All in all, agricultural modernisation appears to have had mixed effects on women in small cultivator households. Even among the households that have been able to adopt the HYV–irrigation 'package', one cannot say that women have unambiguously benefited, since many of the benefits of one kind could have been offset by costs of another kind. (More research on these non-farm effects is clearly needed.) For women of those small farmer households that have not been able to adopt the HYV–irrigation 'package', technological change in agriculture has brought little gain, and for those that have been evicted from their land it has brought further impoverishment. The imperatives of survival push the

women of such households into wage employment and/or other ways of contributing to family income. For instance, in Bangladesh, the impoverishment accompanying technological change in agriculture has been forcing women of such households increasingly into wage employment – mainly rice processing – in a country where social dictates on female seclusion are strong (Begum and Greeley, 1979). At the same time, as noted earlier, the possibility of finding such employment has been decreasing with the setting up of modern rice mills.

*Large cultivator households*  These households have clearly gained from the introduction of the HYV–irrigation 'package' and the women in such households would have gained in terms of their absolute levels of consumption and perhaps even of cash income, although not necessarily relative to the men. Since, in most cases, these women would not have been involved in manual fieldwork in any case, any possible adverse effects on women's household status as a result of their 'withdrawal' from fieldwork would not be a consideration here. However, it is possible (as also noted for the small farms adopting the 'package') that, with an increase in hired labour use on the farm, women's domestic work burden may have increased somewhat in terms of providing meals for such labour.

The evidence considered reinforces the need for concern over the differential distribution of the benefits and burdens of the so-called Green Revolution strategy, in terms not merely of the usually emphasised inter-class effects, but also of the intra-class, gender-related effects. The divergent implications of the HYV–irrigation 'package' and mechanisation (especially in the form of post-harvest equipment) for labour use are also noteworthy. The most obvious negative implications for the employment of hired labour in general, and female hired labour in particular, stem from the mechanisation of threshing and the setting up of modern mills for grain processing. As a result, many of the positive employment effects of technological change associated with the HYV–irrigation 'package' appear to have been lost.

*The African experience*
In the African context, agricultural modernisation has been associated essentially with two types of change: the initiation of new irrigation schemes, and the popularisation of cash cropping. Since African peasant agriculture is based largely on family labour (hired labour being much rarer than in Asia), the impact of modernisation on women is felt essentially through the effect on family labour use. Here, typically, agricultural modernisation has tended to increase women's work burden, without necessarily any increase, in fact in some cases even an absolute decrease, in their incomes. The effects often work through a complex set of socio-cultural factors. Let us first consider the effect of introducing irrigation.

*The impact of new irrigation schemes*   An illustrative example is provided by the Mwea irrigation settlement scheme undertaken in Kenya (Hanger and Moris, 1973). Under the scheme, families were moved onto new settlements where surface irrigation was made available. The purpose of the scheme was to raise the household income through the cultivation of rice both as a cash crop and as a food crop. In the old settlements, largely unirrigated maize, beans and coffee (the last as a cash crop on the men's plots) had been grown. As in many other parts of Africa, the women had been responsible primarily for cultivating food crops to feed the family, although they also put in labour on the men's crop. The women's food plots had been sufficient for subsistence and, at times, even for producing a surplus for sale, the income from which they could control and use for household expenses.

In the new villages at Mwea, since a diet of rice was disliked by the men, the customary food crops, maize and beans, still had to be grown by the women. However, the garden plots allotted to them were small and had poor soil; hence the output was inadequate to feed the family. In addition, the women had to devote time to their husbands' rice plots, and their workload, already high, tended to increase dramatically during the harvest. By and large, the total work commitment of women's time was greater than the

men's. Further, while in the pre-scheme situation the men rarely interfered with the women's allocation of their own time, at Mwea the labour of wives and children during peak periods was completely managed by the men. Yet the women had little direct claim to the cash income from their husbands' paddy plots. They were paid by their husbands in the form of rice, and the proportion could vary depending on the men's inclinations. They had to sell this rice (since it was rarely eaten) to obtain some cash for buying additional food for the family and for other household needs. The money was, however, generally insufficient for even these purposes. Thus, increasingly, the women had to depend on their husbands for financing the purchase of household necessities, and to economise where they could. Such economising often meant more work for them. For instance, in the scheme villages, firewood had to be bought, for which the men seldom provided adequate cash. To reduce expenses, the women sought out cheaper markets but this sometimes meant travelling long distances. To save on wood, they had to watch the fire more carefully while cooking, and they lacked the kind of wood that could be left on the fire for long periods while they did other tasks (as they could in the off-scheme villages). It is noteworthy too that, when labour was hired by the men, it tended to increase rather than decrease the women's workload, since the hired labourers worked only on the men's fields, while meals had to be cooked for the labourers by the women. The women's participation in all types of household decision-making was also lower in Mwea relative to the off-scheme villages.

Hence, on the one hand, women found themselves working harder, with much less independence and control over their use of time, and, on the other hand, there was a marked decrease in their subsistence output, their access to and control over cash income, and their say in decisions concerning the family. Not surprisingly, cases of women deserting their husbands and returning to the old settlements were not infrequent.

This is an uncommon study in that it explicitly considers the effect of an irrigation scheme on women's work burden, consumption and control over cash, in contrast to most

studies, which consider the effects of such schemes without addressing themselves to gender-related issues. However, the scheme it describes would not be untypical, being conceived of and implemented on the questionable assumption that the household is a unit of convergent interests where the costs and benefits of the scheme will be shared evenly by members of both sexes.

One kind of exception to this nevertheless needs to be noted. This relates to those African Muslim communities where (as I observed in the Asian context) prestige considerations cause household women to withdraw from work in the fields when household incomes rise. For example, in the Gezira region of Sudan, it was noted that the introduction of irrigation and the associated prosperity of cotton farming led to tenant farmers adopting the ways of life of the landlords: 'New rules of decency required a greater segregation of women than in the past, as much in the organisation of the household as for outside occupations. Strong resistance arose towards women going to the fields to work . . .' (Brausch, 1964, p. 352). Ironically though, when cotton prices fell and some of the newly prosperous households became poor again, they still continued to follow the practice of the landlord households of not allowing the women to work in the fields.

To the extent that this withdrawal from the fields would have decreased the women's work burden, it would be seen as a gain. However, if such withdrawal reinforces their subordinate status in the household, this could affect their consumption, because their influence over the distribution of family consumption items may well have decreased. In any case, in the African context, the above situation does not appear to represent a general pattern. The documentation that exists suggests that the example of the Mwea scheme would be more typical of the impact of irrigation schemes.

*The impact of cash cropping* The divergence of interests between women and men of a household again becomes apparent when one considers the impact of introducing cash crops. A useful example is provided by a study that has examined the consequences for women of the rapid expansion

of cocoa cultivation in Ghana from the 1920s (Bukh, 1979). The study notes that, in the earlier period, peasant households largely concentrated on foodcrop production. The principal food crop then was yam – although vegetables were also grown. Both men and women cultivated the same plot. The men generally cleared the land on their own, but the women shared the work of weeding, planting and harvesting. However, when cocoa cultivation became profitable, a new sexual division of labour emerged. Men took over the production of the cash crop and women were left to produce the food crops for subsistence. Land that earlier had been cultivated jointly by both sexes was gradually taken over by the men to cultivate cocoa, and the women were left with small, infertile plots. Men now devoted their labour almost exclusively to cocoa and stopped helping with the food crops. The money from the sale of cocoa did not contribute to the family's subsistence; rather it was used for larger investments either in the cocoa crop or in house-building, and occasionally on the children's education. Often the money was also spent by the men on their own clothes and on drink.

Where women managed to produce a surplus for sale, the cash they obtained could not be spent by them but was controlled by the male heads of households and used for the family's subsistence needs. In the absence of help from the men, the women found it increasingly necessary to shift out of yam and vegetable cultivation into the cultivation of less labour-intensive crops such as maize and cassava. These crops, however, had a higher starch content than yam and were less nutritious.

The desire to have control over some cash income, as well as the takeover by men of land previously used for food crops, caused the women to try and establish separate farms, in addition to the family farm. Women's access to independent plots, however, was severely constrained by a number of factors. An important one was the increased privatisation of communal land, and the confining of inheritance rights of this land to men. Hence, where previously women had the same rights to communal property as men, even though the social structure was patrilineal, now they had to ask

permission from male relatives for the use of the latter's fallow land. With an intensification in the competition for land this became increasingly difficult. Another problem related to the fact that women had no direct access to labour other than their own or that of their children, and hired labour was difficult to get (quite apart from problems of payment); hence they were constrained in the type of land they could cultivate. For example, they could not use forest land, which would need manual clearing, even though such land was usually the most fertile; rather they had to opt for a less fertile plot, but one that was locationally accessible and that they could prepare on their own or plough with a hired tractor (hiring a tractor was cheaper than hiring labour).

The difficulties of access to land and labour as well as to extension services and credit meant that survival became a battle for many women and their children. In short, the introduction of cash cropping in Ghana may be seen to have (a) significantly increased women's work burden; (b) led to a fall in the nutritional standard of their diets because it necessitated a shift from yam to cassava and, for some, even a fall in their absolute levels of consumption; and (c) brought no gain in terms of their control over cash, since the scale of their independent activities was usually so small as to make it very difficult to produce enough even for subsistence needs.

The above example is by no means a stray one. In fact it highlights some important features also observed in a number of other (though usually less detailed) studies relating to African communities. For example, it has been observed for a number of African countries that the introduction of cash cropping has meant an increase in women's work burden without them gaining from the extra income so generated (Mbilinyi, 1972; Wilde, 1967; UNECA, 1972, 1975). Similarly, in the Ivory Coast, with the introduction of cash crops, women's share of total family income (not just of the increase in income) fell drastically: in the traditional village, 50 per cent of the family income was allocated to the women, compared to only 10–35 per cent in the modernised villages. Here, the women are likely to have suffered an absolute decline in their incomes (Palmer, 1977). Again, women's loss of communal rights to land with the introduction of new

tenure systems accompanying attempts to modernise agriculture has been noted in Tropical Africa (Wilde, 1967), in the United Republic of Tanzania (Brain, 1976) and other areas (Boserup, 1970).

In addition to inequities relating to access to land and labour, women also suffer in their role as producers in terms of their unequal access to credit and information on agricultural innovations (see Chapters 5, 6 and 7 below). A bank loan, for instance, usually requires a surety in the form of a title deed to land, or the ownership of a house, etc. The women rarely have such assets in their names. Likewise, information on agricultural innovations usually flows only to the men. The extension personnel is typically male and visits are confined to meeting the male heads of households. This is justified on the grounds that: 'In the African way, we speak to the man who is the head of the house and assume he will pass on the information to other members'; and again, 'Being men, it is of course easier for us to persuade men' (Staudt, 1975/6, p. 91). This logic totally ignores the fact that if women are the producers it is they who need to be persuaded or given access to new information. Again, demonstration trials, which are often the most important means of disseminating new information, tend to be held at distant locations and the women usually cannot spare the time from housework and fieldwork to attend them. Such information as women obtain therefore tends at best to be second-hand, less accurate, and usually inadequate for enabling them to change from traditional to new methods. Farmer training programmes reflect the same bias. The sexual bias in extension and training is so deeply ingrained that there have been cases where foreign technical experts have trained men in activities that are entirely women's responsibility as, for instance, occurred in rice transplanting in Liberia (Tinker, 1977) and Senegal (Boserup, 1970). In the latter instance, instructors from East Asia taught the new techniques only to the men, who paid little attention because their wives were the cultivators. The women therefore continued to use the old techniques.

## Forms of survival

Although it cannot be argued on the basis of this review that women in all small cultivator and landless households have been left impoverished uniformly as a result of agricultural modernisation – I have noted situations to the contrary – nevertheless there are clear pointers to a deterioration in women's economic position, not merely as members of poor households but also by virtue of their gender, in a sufficiently large number of cases to make it a matter of immediate concern. These women, who by themselves or along with their families have been pushed to the margins of subsistence, now have to seek various means to survive.

For those who continue to function within the context of a male-headed household and where the living standard of the family as a whole has fallen, the imperatives of survival can in fact affect the way in which all members of the household (the men, women and children) allocate their labour time, although from the cases already discussed one would expect such 'joint' solutions to be more likely to be sought in the Asian households than in the African ones. An illustrative example is provided by White (1976), who noted how a fall in the real wages of agricultural labourers in Java in recent years has led to a breakdown of the traditional sexual division of labour in the interests of maximising household income. For example, during periods of the year when women can get a higher wage in agricultural work than men, they hire themselves out, and the men remain at home to cook and babysit; or young children herd the family livestock and cut fodder when there are wage labour opportunities for their fathers, and they even cook and babysit when their mothers are planting rice and their fathers cutting fodder, and so on. Women often alternate between working in the fields and producing handicrafts for sale. (In the Javanese context, small traders are usually women from landless and small landholding households whose trading activities provide a necessary and immediate part of the household's subsistence needs – Stoler, 1977.) In other words, the household attempts to allocate labour time to a variety of tasks to get the highest total return from family labour. Ultimately, though, the

higher burden of work is found to fall on the women, who, as noted earlier, work substantially longer hours than men, on a daily as well as on an annual basis. Moreover, the sharing by men of housework, even under conditions of poverty, is not likely to be a common feature. In most communities, women would have to bear the burden of a 'double day', even when seeking wage work.

An additional illustration is provided by Hart's (1978) study in which it was observed that in rural Java during the wet season women and girls in landless households had to accept very low wages and extremely arduous work in the sugarcane fields outside the village to provide a small but stable income for the household, thus enabling the men to attempt high-risk ocean fishing and avoid having to accept low-paid wage labour jobs. On average, the women spent nearly 80 per cent of their 'directly productive time in heavy physical labour, frequently at a considerable distance from home, in the slack periods of rice production' (Hart, 1978, p. 136). Hence, they bore a major part of the burden in helping to increase the households' chances of obtaining the highest possible average returns.

Women's contribution to income in such households is clearly crucial for the family's survival. In 50 per cent of the households of one Bangladeshi region, women's wage work provided over 60 per cent of total household income; and for all the sample households in the region taken together the average came to 40 per cent of total household income. With deepening poverty, an increasing number of the women seeking agricultural wage work in Bangladesh consist of married women and single girls, where earlier only the widowed, divorced or deserted would undertake such work (MacCarthy *et al.*, 1978; Begum and Greeley, 1979).

Increasing poverty and landlessness can have other implications, such as the weakening of the bonds of obligation on the part of male relatives, either within or outside a joint family set-up, to support women whose husbands are dead or have left them. For example, in one village study for Bangladesh it was found that only 54 per cent of all widows in the village had the security of being integrated members of their sons' households (Cain *et al.*, 1979).

Where men contribute little or nothing to the family income, the women are left to fend for themselves. In such situations, women might rely on the cultivation of small plots of land (where such land is accessible to them), or combine cultivation with minor trading (Bukh, 1979); or they may hire themselves out as wage labourers in agriculture (Chen and Ghuznavi, 1978) or work as domestic servants (Cain, 1977). In Bangladesh, a large number of the women who seek wage employment, either in others' fields or in the government's food-for-work programme, are the sole earners of their families (Chen and Ghuznavi, 1978).

## Concluding comments

This chapter has sought to outline the effect of agricultural modernisation schemes on rural women in the Third World, on the basis of available literature and an empirical study. There are, of course, gaps in this information, and on a number of points reliance has had to be placed on the findings of one or two studies, or on *a priori* reasoning alone. In spite of this, the pointers provided by the evidence considered here establish a sufficiently strong case for separately assessing the likely impact of technological change on women, prior to the promotion of particular technological innovations, and for taking action to mitigate expected adverse effects where the stemming of such innovations is not desirable on other counts. In practical terms, however, as elaborated below, the issue of mitigating the adverse effects of agricultural modernisation touches on a complex set of factors that do not lend themselves to simple solutions.

In the present review, I noted that, on the one hand, a wide diversity of experiences can result when any given innovation is located in different social, cultural and political contexts. On the other hand, what is also striking is the commonality in the experience of women who by virtue of their gender, in relative if not in absolute terms, typically are left worse off, or less well off, than the men of their culture and class. Although in the Asian context one can often assume that the direction of the effect would tend to be the same for women and men of the same class of households,

even if the relative levels and forms of impact would be different, in the African context even this usually cannot be assumed to hold true: here, schemes that clearly have been beneficial to the men of a household have often, at the same time, been detrimental to the women of that household. The consequences of the unequal distribution of the costs and benefits of technological change between the sexes, as we have seen, can be particularly severe for women belonging to the poorer households.

More often than not, the problem cannot be located in the technological innovation *per se*, since what is often inappropriate about the innovation is not its technical characteristics but the socio-political context within which it is introduced. This gives the innovation its specific class and gender bias and mediates the distribution of costs and benefits from its adoption. Thus, for example, the impoverishment of many rural households with the introduction of the HYV–irrigation 'package' would be traceable not to the 'package' in itself but to the pre-existing unequal distribution of land and of political power between households, which has enabled a privileged few to monopolise access to the new inputs and practices in many parts of Asia. Likewise, the fact that the introduction of rice milling in Bangladesh or in Java has led to destitution among women who depend on manual rice processing for their livelihood is not so much a function of the technology itself as of the form of its ownership and control, and of the fact that no alternative channels of employment are usually provided. The fact that it is women who often tend to lose more or gain less from a scheme than the men of their class again relates less to the technical characteristics of the scheme than to the ideology that legitimises and reinforces women's subordinate position, economically and socially, both in the household and in the larger society. This subordination manifests itself in inequalities in women's access to productive resources, especially land, in the roles they assume in the private and public spheres, and in the sharing of the burden of work and the product/income from such work between male and female household members.

Even to the extent that an inappropriate technological

choice is involved, – as for instance could be argued in the case of large multi-purpose tractors or combine harvesters, which have been promoted in many labour-surplus Third World countries in spite of their obvious labour-displacing (and no necessary output-augmenting) effects – the choice of that technology rather than another less-mechanised one may often be traced to the ability of a few economically and politically dominant groups to get their interests promoted at the cost of the underprivileged. Moreover, the fact that little attention is paid and few resources are usually allocated to developing and promoting technologies specifically to suit the poorer rural women's needs relates to their lack of political and economic control and thus their inability to influence the direction of technological change in their favour.

The complexity of the interacting factors that make it difficult to break existing biases is again highlighted when one considers attempts to introduce given technological innovations within alternative forms of organisation, such as co-operatives. Success stories are few and far between. An often-quoted one is that of the United Republic of Cameroon in Africa where a number of flour mills are now co-operatively owned by the women who earlier had laboriously hand-pounded the grain (*Focus*, 1975). Again, women's producer co-operatives have helped alleviate conditions of poverty among rural households in some South Asian countries (Dixon, 1978; Greeley, 1981).

Nevertheless, the rarity of such cases and the problems encountered even in these cannot be ignored. For example, in joint male–female co-operative societies, women are seldom observed to participate in actual management (Dixon, 1978); and women appear to receive a disproportionately small share of the resources generated by and through such ventures (Greeley, 1981). However, this is noted to occur in all-women ventures, too, if the women belong to different economic classes; here, the economically better-off women tend to dominate. The success of the co-operative can thus depend crucially on how homogeneous it is in terms of the economic class and gender of its members. Another problem relates to women not being readily accepted in roles that are not typical within a traditional setting. This creates difficulties

when they are managing the co-operatives in their interaction with outside, usually male-dominated, institutions. In Africa, a number of women's grinding-mill co-operative ventures are observed to be facing difficulties in getting major and minor repairs done. Women themselves receive little or no training in operation and maintenance, and the provision of credit for such purposes is rarely a part of the scheme (Chapter 5). Membership alone does not ensure that women get access to the income earned through such ventures, where the nature of gender-based power relationships within the household favour male control over cash. One solution could be 'group investment' as opposed to individual investment. Women themselves have been found to prefer group investment because it keeps their husbands' hands off their earnings (Greeley, 1981).

All in all, it appears clear that women of the poorer rural households need to have greater control over productive resources and over the product of their labour if many of the adverse effects suffered by them as a result of technological change are to be stemmed. However, what is also apparent is the difficulty of ensuring this control through localised attempts alone if the overall social structure of a country is highly inegalitarian. Wider-based measures to promote greater material and ideological equality between households, and between the genders, are thus likely to prove a necessary condition in most Third World countries for bringing about a fairer distribution of the benefits and burdens of technological change.

# 5
# Technologies for Rural Women: Impact and Dissemination

*MARILYN CARR*

## Introduction

The plight of women in the rural areas of Africa has only recently received the amount of attention it deserves. It is now recognised that women are responsible for a large and increasing proportion of the work and that they have usually been denied access to improved equipment and the facilities necessary to enable them to do this work efficiently. Attempts are now being made in many countries to collect statistics in order to record accurately the contribution of women to the economy. In Tunisia, for example, the 1966 census declared that only 3 per cent of working age women were in the work force, a total of 7,992 women nationally. A re-evaluation was undertaken that concentrated largely on measuring women's contribution to rural production. The revised statistics showed that 250,000 women were involved in production in rural areas – thirty-one times the original figure – and the adjusted female labour activity rate was 26 per cent of the total labour force as opposed to the 5.5 per cent estimated in the census (Mernissi, 1978). Similar results can be expected if the same exercise is carried out in other countries. This is an essential first step in the move to help rural women to help themselves, their families and the overall development of their countries. Once the women are recorded as workers, then the planners might start planning for them to work more productively.

Implementing the necessary changes is not as easy an exercise as altering statistics, and improvements cannot be expected to occur quickly. At the moment, we are still at the stage of trying to identify exactly what obstacles have been placed in the way of the women and what policies are necessary to give them the opportunity to participate more fully in rural development efforts.

One policy that is commonly advocated is to give rural women access to improved technologies that can relieve them of many back-breaking underproductive chores on the farm and in the home and help them to increase their labour productivity. Such technologies are undoubtedly of great potential benefit to rural women and their families but, if the realisation of these benefits is to be ensured, there is still much research to be done on the factors involved in their introduction, acceptance, use and impact. Various types of improved technologies such as water pumps and grinding mills have been introduced into rural areas in the past without noticeably improving the working and living conditions of the women; it is even proposed that these technologies have often had a negative impact on women. Many other types of improved technology such as solar stoves and hydram pumps have been developed but have never gained any degree of widespread acceptance in the rural areas. It appears, therefore, that the existence of improved technologies designed to help with land preparation, grinding, fuel and water collection and other women's tasks is not sufficient. A much closer look must be taken at the whole process of dissemination and impact. Undoubtedly, some policy and infrastructural changes will be necessary if the past trends are to be reversed. Before these changes can occur, however, it will be essential to identify what the problems have been in the past.

This chapter reviews the existing evidence and uses this to try to identify appropriate strategies at the policy and project levels. It also offers suggestions as to how and where such projects could be undertaken in the African region.

# Current situation

*Role of women and division of labour*

Women in Africa, especially in the rural areas, are fully involved in all aspects of social and economic life. They do most of the seeding and harvesting and often do the clearing, preparation of the fields and planting. They fetch water (at some seasons two or three times daily), walking 2 kilometres or more each way on each occasion. They collect and carry wood home. In addition, they look after children and old people, clean, wash, cook and preserve food for the family and frequently help with the storing and marketing of the produce of the farm.

The time spent on these activities varies according to season. In one survey in Kenya, it was found that women spend an average of 4.5 hours a day on the farm during low labour demand times and 6–9 hours a day in peak seasons, especially during the first and second weedings (Pala, 1976b). A study in Zaire estimated that women spend between 180 and 312 days in the fields and work 5–6 days per week. During periods of hoeing and weeding, their time in the fields averages between 4 and 5 hours a day. During the rainy season, when sowing is urgent and must be completed before the rains end, they spend on average 7–8 hours a day (Mitchnik, 1972). Studies in Lesotho (Development Alternatives Inc., 1974), Zambia (UNECA/FAO/Netherlands Government, 1973), Swaziland and the Gambia (Carr, 1976a) all reveal that women spend 9–10 hours a day in the fields during the busiest agricultural seasons. When all other tasks are added to this, it is not surprising to find that rural women work as many as 15 hours a day at the busiest times of the year.

The women's workload during off-peak seasons is only slightly less demanding. Estimates show that when the number of hours spent in the fields is lower, the number of hours spent on other activities such as collecting water and firewood, processing and preparing food and caring for children increases. In Kenya, it was found that women spend almost twice as many hours on water and firewood collection during the dry seasons as they do during the wet season

(Hanger and Moris, 1973). A study in Ethiopia showed that, although none of the households being surveyed spent more than 2.5 hours a day in water collection during the wet season, over 80 per cent did so in the dry season – with 20 per cent spending more than 4 hours daily on this activity (UNECA/ATRCW, 1978). In the Upper Volta, it was found that, whereas women devote the greater part of their work-day in the rainy season to farming, they spend at least 60 per cent of their work-day on processing food and fetching water in the dry season (Hemmings-Gapihan, 1981).

Thus, at any time of the year, women spend a great many hours every day on tasks that rarely have any monetary value given to them. Despite this already heavy workload, their need for additional income to pay for school fees and to purchase items such as sugar and salt means that they are obliged to find at least some time to spend on vegetable growing, poultry keeping, soap making, food processing, trading or other income-generating activity. These in themselves are time-consuming. For instance, poultry keeping involves collecting and carrying large amounts of clean water – every 100 chickens require 25 litres of clean water daily (UNECA/FAO, 1974). In the case of trading, the nearest market is often as far as 10 kilometres away and the women often have to stay most of the day in order to sell their produce (see, for example, International Labour Office, 1976a).

Women often participate fully in community projects such as building roads, schools, clinics, community centres and wells. In Lesotho, for example, women are estimated to build 90 per cent of the roads, and in Kenya they are responsible for about 80 per cent of all self-help labour (UNECA/ATRCW, 1975c).

In addition, in regions where there is a high rate of male migration to cities, mines or plantations, the women are often faced with the added burden of managing and operating the entire farm and household and of taking on tasks such as fencing and building maintenance that are normally done by the men. A survey in Mali showed that 16 per cent of families depend solely on a woman (UNECA/ATRCW, 1975b), and a study in Swaziland revealed that 30 per cent of

households had no adult males normally in residence (Fion de Vletter, 1978). The 1969 Kenya census indicated that one-third of rural households are headed by women; estimates for Lesotho are even higher (UNECA/ATRCW, 1978): almost 40 per cent of the male working age population is always away in the Republic of South Africa as migrant workers (International Labour Office, 1978a). Although male absentees may send part of their wages back to their wives to help with farm and domestic expenses, this is not always the case. A survey of Yoruba families in Nigeria showed that one-fifth of women received no support from their husbands (UNECA/ATRCW, 1975b), and a study in Swaziland found that only two-thirds of households with absentee males were receiving regular cash remittance (Vletter, 1978). In fact, women farmers often end up supporting their city-based husbands in the form of sending farm produce to them (UNECA/ATRCW, 1977).

By comparison, men in the rural areas spend relatively little time at work in the fields and at home. This can be seen in Table 5.1, which roughly estimates the division of rural labour into tasks for men and women.

Apart from the question of unequal work burden reflected by the prevailing sexual division of labour, the division of labour between men and women is seen to be class-specific (as in Ethiopia) in that, whereas women in landless households and those with small holdings assist in almost all stages of agricultural production, women in middle peasant strata and above consider agricultural production as exclusively men's work (often that of tenants) (Tadesse, 1982).

Children sometimes help out with the farming and domestic chores. One study in Ethiopia found that between 12 and 27 per cent of all children in the survey villages helped with collection and carrying of water and fuel (UNECA/ATRCW, 1978). Statistics from Kenya show that children helped their mothers with water collection in 40 per cent of all households being surveyed (Republic of Kenya, 1978a). However, the amount of help given by children may well have decreased as the emphasis on primary education has increased. In Kenya, for example, the decision of the government to accord highest priority to expansion of the

Table 5.1  *Division of labour between men and women*

| Task | % of total labour | |
|------|-----------|-------|
| | Men[a] | Women[a] |
| Land clearing | 95 | 5 |
| Turning the soil | 70 | 30 |
| Planting | 50 | 50 |
| Hoeing and weeding | 30 | 70 |
| Harvesting | 40 | 60 |
| Transporting crops from farm to home | 20 | 80 |
| Storing crops | 20 | 80 |
| Processing food crops | 10 | 90 |
| Marketing excess crops | 40 | 60 |
| Trimming tree crops | 90 | 10 |
| Carrying water and fuel | 10 | 90 |
| Caring for domestic animals | 50 | 50 |
| Hunting | 90 | 10 |
| Feeding and caring for children, men and aged | 5 | 95 |

*Notes:*
[a] With or without some help from children.
*Source:* UNECA/ATRCW, (1975b).

eduation system resulted in the proportion of enrolment of the eligible primary school age cohort rising from 37 per cent in 1962 to 87 per cent in 1976 (Republic of Kenya, 1978a). This must obviously have diverted some time – mainly that of male children – away from household and farm chores and resulted in an added burden on the women. The rate of female wastage at the primary school level is much higher than that for males in most countries. In Kenya, for example, there is a 26 per cent wastage rate for females as opposed to only 7 per cent for males. This has been attributed to greater demands being made on female children to assist with household chores, to care for younger siblings and fetch firewood and water (Monstead, n.d.). As a result, the future mothers and farmers in Africa have little more chance of being better educated than their own mothers.

*Technologies relevant to rural women's tasks*
When one considers the multitude of tasks that rural women

perform and the limited tools they use in performing these tasks, it is obvious that the introduction of improved technologies holds out the promise of considerable benefits – not just to the women but to rural families as a whole. Varying amounts of work have been done on developing or improving technologies related to crop production and processing, water supply, fuel supply, transportation and other activities that are important in the rural environment.

For most tasks, there is now a sizeable range of technologies available as alternatives to the traditional methods. For land preparation, for example, there are improved handtools, animal-drawn ploughs, power tillers and tractors. For weeding and fertiliser application, there are many devices of varying complexity and cost that can do the job more quickly and in a less back-breaking way than the traditional hand methods. For harvesting, scythes and little knapsack reapers that are powered by small diesel engines or by solar power are alternatives to the traditional penknife. For threshing and winnowing, there are hand-operated and pedal-, animal- or power-driven machines that can be used instead of the time-consuming and wasteful traditional methods. In addition, there is a whole range of equipment, powered in a variety of ways, designed to grind cereals, polish cereals, grate cassava, shell maize, extract oil from fruits, nuts and seeds, shell groundnuts and palm nuts, pit dates and scrape the flesh from coconuts. There is also a variety of new or improved technologies available to help with on-farm storage of crops and the preservation of surplus foods. For example, simple and cheap solar dryers have now been developed that can be used to reduce the level of moisture in crops prior to storage or to dehydrate surplus vegetables.

With respect to water supplies, there is a range of technologies that can help with the problems of collection, storage and purity of water. Wells can be drilled nearer to villages or can be dug manually on a self-help basis. Streams can be diverted and water piped to villages. Hydrams can be inserted in streams to pump water up to hillside villages. Underground catchment tanks can be built to collect and store rainwater, or water can be collected from roofs and

stored in various types of container. Constant experimentation is going on to find more appropriate and cheaper materials for lining wells, constructing pipes and making storage containers. Much work has also been done on development of water-lifting devices that are operated by hand, pedal power, wind power, solar energy, animal power, or run off engines. Such devices save considerable time and effort involved in pulling up bucket after bucket of water from a deep well. Water drawn from a well will normally be much purer than that taken from a muddy river or stream. The water from a fully enclosed well with a pump will be purer still, since the chances of contamination from refuse and dirty buckets are eliminated. Thus, the introduction of a well and a pump to a village will automatically improve the quality of the water available for drinking. In cases where water is still collected from contaminated sources, simple water filters made from traditional clay pots and containing layers of pebbles, sand and charcoal can get rid of many of the impurities.

To help with the fuel supply problem, there are now many technologies that can reduce the amount of firewood or charcoal needed for cooking or heating purposes. Improved stoves that use only two-thirds of the amount of wood needed with the traditional 'three-stones' method of cooking can be built very simply and cheaply from mud and other locally available materials. A whole variety of solar cookers and solar ovens are available that use no source of fuel at all except the sun's rays. Solar energy can also be used for heating water for washing purposes. Yet another alternative to wood is to use methane gas for cooking or even lighting purposes. A great deal of work is being done on the development of both methane digestors and stoves and other equipment that will utilise the gas once it has been produced.

In the field of transport, there are various types of animal-drawn carts, hand carts and wheelbarrows that can help women to carry more water, fuel and other commodities in less time and with less effort. There are also various developments taking place in respect of low-cost techniques of constructing rural feeder roads and bridges that can make the marketing of farm and other produce considerably easier.

To all of this, still further technologies can be added that can help rural women. Pit latrines, soak pits and sun-tables can make the women's tasks of keeping the home clean and hygienic much simpler. Low-cost refrigeration methods can enable rural health clinics – which can stock needed vaccines – to be located in fairly remote areas, thus allowing women the opportunity of giving their children adequate health care without the necessity of long journeys to the nearest town. Kick wheels and improved spinning and weaving equipment can help women to produce their traditional pottery, textiles and rugs more efficiently and raise more income from such work with less effort. Improved beehives and solar dryers can open up new sources of earning income to rural women through making bee keeping and food processing activities simpler and less time-consuming. Low-cost methods of storing rainwater and simple water-lifting devices can make activities such as poultry keeping and vegetable growing possible for women who could otherwise not afford the time to collect the quantities of water involved.

There is obviously no lack of equipment designed for use in, or designed to eliminate, almost every task in which the women of rural Africa are involved every day of their lives. The fact that the equipment exists, however, is obviously not sufficient. The most common sight in Africa continues to be that of women walking long distances with heavy loads of water, fuel or other goods on their heads and backs; and the most common sound in the villages is still the pounding of grain, which goes on and on throughout the early morning and evening. Women continue to be overburdened and overworked. Yields of food from subsistence agriculture continue to be low. Children continue to suffer from malnutrition and lack of sufficient care and attention. Women continue to be unable to engage in income-generating activitites to help out with family expenses because they are fully occupied in underproductive tasks.

The obvious question is to ask why the technologies that do exist are not being utilised to any great extent by the women who are largely responsible for the pace of rural development and who are unable to quicken the pace without access to these improved technologies. The next section seeks

to shed some light on this question by examining the limited data that are available on this subject in the African region.

*Impact and dissemination of technologies*
A few improved technologies such as ox-drawn ploughs, seeders, hand-dug wells, water pumps, grinding mills and oil presses have now achieved a limited distribution in rural Africa. This section reviews the available evidence on the impact of these technologies on women and the family as a whole. It also offers some suggestions on why a whole range of other types of improved technologies have not gained any widespread acceptance and use in the rural areas.

*Impact of technologies*   Improved technologies relating to land preparation, water collection and crop processing should, in theory, be very beneficial in respect of releasing women's time from underproductive tasks – time that can be diverted into income-generating activities, better child care and a general increase in the well-being of the whole family. In practice, however, it seems that a number of factors have prevented the potential benefits from being realised.

Conceptually, two important impact indicators ought to be simultaneously examined. The first is the ratio of rural women's income after technological change to that before technological change; and the second indicator is the ratio of time spent on residual work after and before technological change. (For an elaboration of the quantitative model and the derivation of a set of conditions that identify whether the likely direction of the innovation is labour-using, labour-saving or neutral, see Chapter 2.) Quantitative assessment is not possible because of a lack of sufficiently disaggregated and relevant time series data. However, the following sections attempt to examine the impact of technological change in some key activities such as crop production, water supplies and crop processing.

*Crop production*   In much of Africa, each adult farms his or her individual fields, but it is usually only the man who has access to co-operative and extension facilities. Having access to credit through the co-operative, the man is able to buy

equipment such as an ox-drawn plough, a seeder or a hoe, as well as inputs such as fertiliser and improved seed. Inevitably, the equipment is used first on the man's fields and, if women waited until late in the season for the use of this to work their fields, yields would be badly affected. This is well illustrated in the case of a study in Senegal, which stated that:

> Farming equipment is used first in the fields of the household head, then on those of his younger brothers or sons, in order of priority based on age. Finally, the women have use of the machinery. Thus, women who wait for the use of seeders and hoes are late in planting and weeding, significantly reducing their yields. (Loose, 1979, p. 18)

Given that women are normally responsible for providing the bulk of the family's food from their own fields, it is not surprising that they often choose to proceed with land preparation, seeding and weeding in the traditional ways, even when the household is recorded as possessing improved technologies that are designed to help with these tasks.

Thus, ownership of improved farming equipment by the household head does not necessarily result in any time-saving for women. However, one would expect other benefits to be realised by the family if the equipment leads to an increase in the acreage farmed by the man or an increase in yields per acre on his fields. Unfortunately, this does not necessarily follow. Since feeding the family is thought of as the woman's responsibility, the man often sells any extra crops he is able to grow rather than using the surplus to augment the family's diet. Similarly, the income received from the sale of crops is more likely to be spent on semi-luxury goods than on basic necessities such as food and clothing for the children. One author has noted that it is not uncommon for nutritional levels to fall while wrist watches, transistor radios and bicycles (all largely consumed by men) are finding their way into the household (Palmer, 1977).

The problem is especially worth attention in cases where equipment enables the man to enlarge the acreage under cultivation. This is likely to be the case with ox-drawn ploughs, for instance. In the event of this occurring, the

woman will be called upon to give extra assistance with planting, weeding and harvesting her husband's crops – thus leaving less time to devote to her own fields. The resulting fall in the supply of family food from the woman's fields will not necessarily be compensated for by a redistribution of gains from the husband to the woman and children. In a Northern Nigerian village, an inverse relationship was observed between proportion of planted area under cash crop and the proportion of planted area to household consumption (Longhurst, 1980a).

*Water supplies* Although the introduction of clean and conveniently located water supplies would seem to be a priority in almost every African village – from the point of view of both releasing women from the daily drudgery of collecting and carrying water and improving hygiene, health and nutrition – the potentially beneficial effects are not always forthcoming.

Wells often run dry after a few years and pumps frequently break down after a few months, so that women must resort to the traditional more distant water source. Although it is the women who stand to lose most if the water system breaks down, they are rarely involved in the construction of wells or trained in the operation and maintenance of pumps. For example, a project in the Upper Volta dug wells to inadequate depths because only men were involved in its designing and implementation. Village women were not consulted, although they were responsible for collection of water from wells and had better knowledge of the depth to which wells should be dug to retain water year-round. At the end of the wet season when the water table dropped, the wells naturally went dry (Atol, 1982). Women do not usually have the cash to pay for pumps to be repaired and often the men do not feel that repairs are their responsibility. For example, a recent study of water supplies in Lesotho stated that 'drawing water is a woman's task, and men are under little direct pressure to carry out repairs' (Feacham *et al.*, 1978, p. 61). As a consequence, the number of pumps in Africa at any one time exceeds the number that are in working order.

Even when the new water system is fully operational, there

are still factors to be taken into consideration. For example, if there are not suitable facilities provided at a well for bathing and washing clothes, the women will still find it necessary to travel to a more distant water source. In addition, even if a significant amount of the women's time is released from collecting water, this time may be diverted into doing more work on their husband's fields rather than into income-earning activities of their own or better childcare. A recent study in Ethiopia revealed that over 50 per cent of the men in villages awaiting improved water supplies expected that any time savings realised by their wives would be reallocated into helping them with their work (UNECA/ ATRCW, 1978). As explained earlier, the family as a whole is more likely to benefit if women can divert time savings into activities unrelated to their husband's work.

It is, however, important to find out whether the women are willing, through technical change, to trade off income-earning opportunities for securing relief from the burden and difficulty of work. For example, in the United Republic of Tanzania, replacement of the hired women carriers from a village supply point by diesel pump, which stored water in a tank, led to the loss of 2,531 women-days of work and a deprivation of income equal to 7,972 Tanzanian shillings (Macpherson and Jackson, 1975, p. 112).

With respect to better quality of water, it has generally been found that improved water supplies by themselves do not lead to any noticeable improvement in health since there is also a need for general hygiene and environmental improvements and better medical facilities (see, for example, Carruthers, 1970, and Feacham *et al.*, 1978). As was mentioned earlier, there is little hope of making much headway with better hygiene and home improvement pro-grammes while women are overburdened with the whole range of farm and domestic chores. It is possible that any time released from water carrying could be put to learning about health and hygiene and spent on making the home more hygienic. Normally, however, the women's need for cash income means that any released time is diverted (when possible) into learning new skills and expanding production of marketable commodities.

*Crop processing*   Grinding mills and oil presses can be highly beneficial in the African context since women spent a great deal of time and effort on handpounding of cereals and (in West Africa) extraction of oil from palm fruits. However, as with crop production equipment and improved water supplies, the introduction of these devices has rarely resulted in a significant and lasting improvement in rural life.

Power-operated grinding mills are now fairly common in rural Africa. The majority of these are owned by male entrepreneurs who earn substantial profits from their operation. Despite high milling costs and often inconvenient location of the mill, many women are prepared to make use of this facility rather than pound their grain by hand. For instance, in one part of East Africa, it has been recorded that women walk $6^{1}2$ kilometres and then take a bus for another 8 kilometres to reach the nearest mill. Transport costs plus the cost of grinding amount to two-thirds of the value of the cereal (UNICEF, 1974).

The economics of this need to be looked at in more detail. For instance: is it the women themselves or their husbands who provide the cash to pay for this expensive service? Also: what is the reason for paying to have cereals milled when the process could be accomplished at home with no monetary outlay? A recent study in Senegal (Loose, 1979) shed some light on these issues. Here it was found that users of the mechanical grinder fell into two general categories – those who used it regularly and those who used it irregularly. Paying for the service of the grinder was, in many households, the wife's responsibility. Thus, if she had some cash, she would have that day's millet ground by machine. If not, she would pound by hand. These women were the irregular users. Those women whose husbands paid for the use of the grinder were the regular users, and pounded by hand only on those days that the mill was not in operation. It was suggested in the Senegal study that the husband or wife will pay for mechanical grinding depending upon who can gain the value of the woman's labour time. Thus, if a husband can gain more from having his wife working on his field rather than pounding, it is in his economic interest to pay for the use of the machine. If a woman has a substitute

activity in which her labour time has more value to her than that spent in pounding, she herself will pay. Thus, the opportunity cost of women's labour is an essential factor.[1]

In cases where a commercial mill is the only alternative to handpounding, it would seem essential that its introduction should be coupled with new money-earning options for the women. Without this, they will be able to use the mill only infrequently or only by substituting work for their husbands for handpounding – work that brings them no monetary return.

One important factor to be kept in mind is that commercial mills normally run off diesel oil, whose price has increased drastically during recent years. This has put the cost of milling beyond the reach of many households. In one region of the Upper Volta it was reported that, when the cost of fuel rose by 33 per cent in 1976 and the miller raised his fees accordingly, many people could no longer afford to use the mill. As a consequence, the miller lost so many customers that he was forced to open the mill only twice a week, on market days, rather than every day as he had done in the past (Hemmings-Gapihan, 1981). A grinding mill is of very little use to rural women if they are unable to afford the cost of using it.

One alternative to private ownership of grinding mills is ownership by a co-operative. Unfortunately, this sort of scheme has not usually been successful or particularly beneficial in the long term. In one region of the Gambia, some grinding mills from East Asia were introduced to farmer co-operatives in the late 1960s. These worked quite well at first, but after eight years most were in need of major repairs and the co-operative had not sufficient money to pay for these. From the inception of the scheme, 10 per cent of the grain processed at the mills had been kept back to pay for operation, maintenance and repair costs, but when the need for a large sum of money arose it was not available. Most of the mills remained out of order and the women, who had greatly enjoyed the availability of a mill, had to go back to

[1] The Bhaduri model could quantitatively capture the impact of technological change on the welfare of rural women in terms of the two indices involving income comparison and time-disposition comparison (see Chapter 2).

pounding by hand. One reason put forward for the failure of this scheme is that the mills were too large (0.5 ton per hour) and therefore the co-operatives had to be large and were difficult to run properly. Another explanation was that it was the men who belonged to the co-operatives, whereas it was mainly the women who suffered when the mills were out of order (Carr, 1976a).

A scheme started in the Upper Volta in the early 1970s has also had its problems. Here, smaller diesel-powered grinding mills were introduced into selected villages. Each mill served a single village and was the responsibility of the community. Unfortunately, there was little or no training given in respect of operation or maintenance. By 1976, when a visit was made to four of the original thirty villages, only one mill was still in working order. Even in this village, the mill had frequently given trouble and had only recently been taken to Ouagadougou for major repairs. The cost of these repairs had left the village greatly in debt. The women had become used to the ease of a power-driven grinding mill and were anxious to have this facility restored to them, but they realised that repairs were costing more than they could afford (Carr, 1976b).

One of the few success stories about grinding mills comes from the United Republic of Cameroon in the 1960s (O'Kelly, 1973). Here, in order to alleviate the burden on women, a hand-operated corn mill was introduced into one village by community development workers. At first the women were reluctant to accept this technological innovation. They said that turning the wheels was too hard for them, but when persuaded to persevere they found it grew easier and preferred this type of movement to pounding. The cereal started sticking to the grinding plates, but this problem was overcome when it was explained to the women that the corn should be dried more thoroughly before grinding. Other problems arose and were solved by the community development workers, and eventually the women were using the mill happily and successfully. Very soon there were requests from women in other villages to set up 'corn mill societies'. Loans were granted and the women were expected to pay these back. By charging a fixed sum a head per month, thirty

villages had repaid the loans by the end of the first year and more mills were purchased. Eventually hundreds of villages had their own corn mill societies and most of these mills are still working almost twenty years later.

The impact of this new technology appeared to be very beneficial. Released time was spent in attending classes in such subjects as soapmaking and cookery, and eventually in the broader issues of child welfare and hygiene. With more time and more training, the health of the children and adults showed a marked improvement.

There are several factors involved in the success of this scheme. Women were given access to credit so that they could own their own mill. They were also given the training necessary to operate the mill themselves. In this way they were able to grind their corn when it was most convenient for them, rather than when it was convenient for the owner/ operator of a commercial mill. The mills were hand-operated so there were no problems caused by rising costs of diesel oil; they also had fewer moving parts than diesel mills so that maintenance and repair costs were lower. Finally, training was provided so that good use could be made of the time released from handpounding.

In much of West Africa, the women spend as much time in extracting oil from palm fruit and palm nuts as they do in grinding cereals. The oil is used in the family diet, or sold to supplement the family income. The introduction of modern, power-driven oil mills into this system has often led to chaos. In Nigeria, for example, women grouped together to demonstrate against the new mills since the whole fruit now went to the mill, and their husbands got the money for the oil. This deprived the women of the by-products of processing the fruit (e.g. the oil-containing nut), which they used to keep as payment for their labour (Kilby, 1969).

Another case study from Nigeria described the introduction of a hand-operated hydraulic oil press, which produced 4 imperial gallons of oil from only 15–20 heads of palm fruits, compared to thirty needed with the traditional method. So well did the press work that it was used 24 hours a day. The problem was that the press required a great deal of water, and as a result of its constant operation the well in the village

could not cope with both its needs and those of village
households. In addition, the press required the strength of a
man to operate it. Two farmers were employed to man the
press, but when they were away doing other things the press
fell idle (Spurgeon, 1979).

Work is now proceeding on developing much smaller
hand-operated oil presses that can be owned by a village
community or a co-operative and that can be easily operated
by the women themselves. A programme to introduce these
to women in several villages is now under way in Sierra
Leone. This contains many of the elements that made for the
success of the corn mill scheme in the United Republic of
Cameroon. Included, for instance, is the provision of credit
for women's groups, training for women in the operation and
maintenance of the presses, and training in soap making and
refining of oil for cooking purposes, so that time released
from pressing in the traditional way can be put to good use.[2]

Before leaving this section on crop processing, it should be
noted that, in areas where large farms predominate, improved
equipment may displace women working as casual agricul-
tural labourers. This could happen, for instance, if maize
shellers were introduced into the Central Province in Kenya.
Here, many families depend solely on the income earned by
the women from activities such as hand-shelling of maize
(Carr, 1976c). Situations such as this are not particularly
common and there are very few instances in Africa of women
earning wages from activities such as grinding, hulling,
threshing, shelling groundnuts or maize, and extracting oil
from fruits and nuts. In the majority of cases, therefore,
crop-processing equipment would be of great potential
benefit to rural women – providing it is cheap to run, can be
easily kept in working order and can be owned and operated
by the women themselves.

It has been observed for several Asian and African
countries that government loan, price support and investment
policies help the industrial (or large-) scale processing
establishments that threaten the processing of several food

[2] This project was being run by the Ministry of Social Welfare and Rural
Development with funding from the African Training and Research Centre for
Women of UNECA.

items like rice, maize, fish, cane sugar and bread undertaken by rural women. It has also been found that there is a choice of technology in the processing of such items; through the adoption of appropriate tariffs and excise taxes and preference in supply of raw materials, it would be possible to protect and stimulate processing activities pursued by women in rural areas (Baron, 1980).

*Dissemination of technologies*   The second issue to be looked at is why a large number of improved technologies other than those mentioned above have failed to gain acceptance outside of demonstration centres, university and government workshops or pilot villages.

*Fuel supplies*   One area in which very little headway has been made at the village level is that of the introduction of improved stoves that are designed to save the amount of firewood used by the household, to reduce the amount of smoke in the home, to reduce incidences of children falling into open fires, or a combination of all of these. These objectives seem so sensible that it is hard to believe the improved stoves would be rejected at the village level. Their rejection is often attributed to the fact that rural women are resistant to change. The available evidence, however, suggests that there are very sound reasons for rejecting many of these devices.

The solar reflective cooker, which uses no firewood at all, would seem to be of great advantage in areas where wood is becoming scarce. There are many reasons, however, why this has not been acceptable to rural women. One disadvantage is that it must be placed facing directly into the sun and has, therefore, to be constantly adjusted throughout the day as the sun moves. Another disadvantage is that only one small pot can be used for cooking and so a meal for a large family cannot be made using only this device. In addition many of the women in Africa are used to cooking inside the house, and are hostile to the idea of moving their stove into the open. Another objection is that the main meal of the day is usually made in the evening after the women return from their fields; by this time, the sun has either gone to rest or has lost most of its strength. It is somewhat unrealistic to

think that rural women could change the whole time pattern of their day just to accommodate a new technological device.

In Ethiopia, it was decided to introduce two methane stoves into the communal kitchen in a resettlement camp. At first, the women were hostile to the idea of cooking on something derived from animal dung but, once the methane was introduced, they became accustomed to it and the system is now working well. Since there are considerable economies of scale involved in the production and distribution of methane, it is proving to be a very low-cost way of cooking in the communal kitchen situation. In the normal village situation, however, an average household could not afford the cost of its own methane system and preliminary research findings suggest that women would be extremely reluctant to give up their own kitchen for a communal (village) kitchen fed by methane gas. Methane gas stoves are unlikely to gain much more acceptance at village level in the near future unless possibly they are aimed at schools or daycare centres where communal meals are being cooked.

In Sierra Leone, an attempt was made to introduce improved mud stoves that would reduce the amount of smoke inside the house and thus make the home environment more pleasant. These stoves met with little success and enquiries revealed the cause of this to be that the new stoves used much more firewood than the traditional stoves (Carr, 1976d). Their use would therefore have meant a diversion of either money or time (for gathering wood). There were obviously things that women preferred to a smoke-free kitchen.

Similarly, in Ethiopia, an attempt was made to introduce raised stoves, which would reduce the incidence of children falling into the fire. Again, these met with little success because raising the fire off the floor meant that the house was much colder and less comfortable during the night (Carr, 1976f).

*Crop production*   Another area in which little headway has been made is in the dissemination of equipment for weeding, applying fertilisers and harvesting, even though many devices have been developed that could help with these operations.

There have been some pilot projects, but these have led to very little. In Liberia, for example, an attempt was made to introduce simple low-cost (£10) hand-held weeders. These never got further than the demonstration plots because rice on the local farms was not planted in straight rows, and this is a necessary condition for using the weeders. Attempts to introduce this required planting method failed because the principle was being explained to the men, while it was the women who were doing the work. If more thought was given to the division of labour between men and women, a lot of time and effort could be saved.

Also in Liberia, some concern was expressed at the slow and inefficient way in which women harvest the rice, which involves cutting each stalk of the crop – one by one – with a small penknife. Women were reluctant to adopt the scythes that were demonstrated to them as being quicker and more efficient implements. Much later (after the technologists had written the women off as being uncooperative), a group of female extension workers discussed the problem with the women. They discovered that the women didn't want to use the scythes because they necessitated cutting further down the stalk, and this in its turn involved a much heavier load (mainly dead weight) to be carried from the farm to the home. The women also said that longer stalks resulted in nasty cuts when they threshed the crop with their bare feet. Having been told this, the technologists and agricultural development workers decided that they should try introducing scythes in combination with pedal threshers, which could be located near the fields, thus (at least technically) eliminating both the carrying and cuts problem (Carr, 1976e). Again no one asked the women if this was a feasible solution to the problem, and it would be interesting to know if such a scheme was any more successful than the original one. It seems that even when women are identified as being the end user of the devices being designed, their actual needs and wants are still ignored by the technologists.

*Crop processing*   There are many crop-processing devices that are cheaper than more sophisticated machinery but are still out of the price range of the average rural household.

This applies for instance to pedal threshers and hand-operated winnowers, which are currently in the £50–100 price range. Such devices are being designed or adapted in many workshops throughout Africa and then produced for sale. A few are bought by larger farmers – probably with the result that women lose a source of income from performing these operations on a casual basis. The remainder pile up in a storeroom because there is no other market in the neighbourhood and eventually production is stopped. The women farmers who could benefit from these devices are denied access to them because they have no assistance in forming themselves into co-operatives and acquiring loans to purchase them on a joint basis. If co-operative and credit facilities are available, it is often only the men who are eligible and they may see no point in spending cash on a pedal thresher when there is plenty of 'free' female labour to do the work.

Some devices that are cheap enough to be bought by the poorest households have still failed to gain popularity. One example of this is the hand-held maize sheller, which was originally designed by the Tropical Product Institute (TPI) in England and is produced in numerous workshops throughout Africa. However, it is not in common usage in the rural areas. The problem here is that the immediate reaction of rural women is that they can shell the maize more quickly with their bare hands, so the device is of no use even though it costs very little. One field test in Kenya persevered beyond this immediate reaction and asked several women to sit down together and shell maize. Half the women were given a sheller and half used their bare hands. Initially, it was obvious that the group using only their hands was getting along much more quickly. After a while, however, their pace slowed. In addition, at the end of the allocated time, the women using only their hands said that they felt unable to shell much more maize. The women using the shellers, on the other hand, felt they could continue for considerably longer. This was because the device had taken away some of the wear and tear on the hands. After this experiment, the women looked on the sheller in a somewhat different light.[3]

---

[3] Information provided by the East African Regional Office of UNICEF.

This suggests that a little time and effort spent on demonstrating the value of a piece of equipment are often necessary in gaining acceptance.

*Home improvements* Technologies that aim simply at improving the home environment are rarely greeted with much enthusiasm. The majority of technologies in this category relate to hygiene and cleanliness which are, of course, extremely important for the health and well-being of the family but are rarely identified by low-income families as a major need. For example, the report of a study in Swaziland (Vletter, 1978) pointed out that rubbish disposal was a problem although it was rarely mentioned by people: 60 per cent threw rubbish in the bush and the rest used some sort of pit. For personal sanitation, 28 per cent used pit latrines, 14 per cent an open pit and 57 per cent the bush. There are certainly very few villages in Africa where pit latrines, shower stalls, hot water for bathing and laundry, soak pits, water filters or raised shelves for food storage are common. This situation is unlikely to change while more pressing problems relating to the availability of food and water remain unsolved.

*Income-generating activities* There are many ways in which appropriate technology can help to provide extra income for women in the rural areas of Africa – both by improving the quality of the goods they are already producing and by opening up new ways of earning income. Unfortunately, many of these technologies are among those that have failed to reach the rural women. There are a variety of ways in which this can be explained. In most cases, a certain amount of capital investment and skill are required when upgrading a current enterprise or starting a new one. The evidence available suggests that it is often denial of access to credit and/or training that prevents women from becoming involved in activities that could benefit not only their families, but the economy as a whole. In other cases, women are simply not aware of the technologies that can help them to earn more money. In still other cases, the women do not involve themselves in income-generating activities simply

because they do not have the time to learn the necessary skills or to indulge in the production of marketable commodities. In such cases, the introduction of labour-saving technologies will be the necessary first step in helping the women to utilise yet other technologies that can enable them to acquire a better standard of living for their families. Many of these points are illustrated in the following case studies.

In West Africa, women farmers often have a surplus of rice for sale. People in the cities have come to prefer imported rice, but would buy local rice from the rural women if it was of a comparable quality. Equipment is available that would enable the women to upgrade the quality of their rice. Usually, however, the women are unable to gain access to such equipment because they do not have collateral in the form of land or a house to put up against a loan. As a consequence, the women are denied an important source of income and precious foreign exchange continues to be spent on imported rice. This situation could be changed to the benefit of the women and the whole nation if women were given access to credit and loans, help in quality control, business advice and marketing assistance (UNECA/ATRCW, 1975a).

In East Africa, on the advice of government extension agents, many women have started growing vegetables in the belief that this will help them to provide a healthy diet for their families and provide an additional source of income through the sale of surplus produce. Most have been disillusioned because their entire crop is harvested all at once and it is impossible to eat or sell all of the vegetables before they perish. Simple solar dryers, which can be made at very little cost by the women themselves from mud, wood and polythene, would easily solve this problem by enabling surplus vegetables to be preserved for home consumption or for sale throughout the year. However, there has been no system of informing the women that such devices are available or of training them to make them.

There are also many women in East Africa who are engaged in the production of pyrethrum. The women usually pluck the crop and sell it directly to processing factories in its 'wet' state. The factories will pay approximately twice as

much for the pyrethrum if it comes to them already dried. The women could increase their income significantly, at very little extra cost, if they started drying their crop in solar dryers or other simple, low-cost drying equipment before they sold it to the factory. Again, these women are unaware that this possibility is open to them and would not in any case know how to go about acquiring or making a dryer.

In areas where coconuts are plentiful, many cottage industries could be developed with the help of appropriate technologies. The flowers, leaves and nuts of the coconut palm between them provide, in varied form, food, drink, roofing material and coir yarn from which to make rope, string and matting. Coconut oil can be extracted from the dried flesh (copra) and this can then be used for a wide range of purposes from cooking to making candles. The fibre is used for brooms, floor mats and fish nets, and charcoal gas can be produced from the shells, while the waste products can be made into briquettes and burnt for fuel (O'Kelly, 1978). If information about small-scale equipment for making rope from coir or candles from oil were available to the women, and if they were given access to training and credit, then employment and income could be generated where they are needed.

It has been observed for several developing countries (including some in Africa) that government loan, price support and investment policies help the industrial- or large-scale processing establishments, which threaten the processing of several food items like rice, maize, fish, cane sugar and bread undertaken by rural women. Through a reversal of these policies, it may be possible to protect and stimulate these processing activites (Baron, 1980).

One country where a concerted effort has been made to help rural women increase income through improved technology is Ghana. Here, for example, the National Council on Women and Development has commissioned research to be carried out on improved soap making with the aim of disseminating the information to rural women currently making 'black' soap from palm oil and wood ash. To improve the smell of this soap, various local plants have been identified from which perfume can be extracted. To improve

colour and produce a really pale soap, caustic soda or potash are needed instead of wood ash. Caustic soda is difficult to obtain in Ghana, but women in some parts of the country have been taught by the Women's Council how to burn dry cocoa pods and palm waste, which previously had been discarded, in order to produce potash. It is expected that the women will prepare large quantities of the powder which will then be packed and sold to other women who can use it to make soap. Women are also being encouraged to grow sunflowers and caster seeds so as to augment the supply of oil available for making soap, and work is being done on finding a small machine that will be suitable for extracting oil from the seeds on a small-scale basis (Cole, 1977). This is a very good example of how much can be done when a government agency directs itself specifically to carrying out research and training aimed at increasing the earning capacity of rural women.

Kenya is another country that has a government Women's Bureau (established within the Ministry of Housing and Social Services in 1975). Here again, there are some striking examples of how improved technology, combined with government assistance in the form of loans and training, has helped rural women to earn extra income. One instance of this is the introduction of improved bee-keeping equipment. Traditionally, it is the men who harvest the honey from wild bees in Africa. This is largely because the hives are located high up in the trees and climbing up these to extract the contents of the hives is an occupation that women do not care to undertake. However, improved hives have been designed in Kenya (Republic of Kenya, 1974) that not only produce higher yields of honey but stand three feet off the ground and thus make extraction a relatively simple process. Two years ago, it was unheard of for women to keep bees. When the idea was first suggested to various women's groups, it was treated with a certain amount of amusement and dismissed. However, at the request of the Women's Bureau, community development workers concentrated on a few groups and eventually persuaded them to try bee keeping. The Bureau arranged for loans to be provided for equipment and for training to be given by officials of the Ministry of

Agriculture. Now several women's groups in the rural areas have taken advantage of government assistance in buying improved hives (these cost only about £5 and can be made in village workshops) and are successfully processing and selling honey at a significant profit. The wax from the cones is also sold for use in softening leather and making cosmetics. So far, this type of activity is limited to only a few groups of women, but the experiment could be repeated in other areas of Kenya and in other countries if the appropriate equipment, skills and financial assistance were made available.

On a slightly different theme, there are parts of the rural areas where formal employment opportunities are open in plantations or small factories, but where women are unable to take advantage of these opportunities because they have to spend too much time on collecting and carrying water and fuel and processing and preparing food. In the sugar-growing areas of Kenya, for example, it was found that women working on the plantations were earning only two-thirds as much money as the men, because they were working only two-thirds as many hours. The management's explanation for this was that women could not work as hard as men. The women, however, said it was because they were doing 8–10 hours work other than their plantation work and they simply did not have any more time, although they did need more money. These women were extremely interested in any device that could reduce the number of hours they spent on domestic and farm chores so that they could work more hours on the plantation. Until that date, however, they had no idea that such devices existed (Carr, 1976c).

This is one explanation for the universally low rates of female participation in wage employment in the rural areas of most countries. In Kenya, for example, there were only 15,000 females employed as regular wage workers on small farms and resettlement schemes in 1971/2, compared with 183,900 males; similarly, only 19 per cent of the total adult labour force engaged in permanent non-agricultural rural enterprises were women (Republic of Kenya, 1978a). The Central Bureau of Statistics commented about these figures in the following way (Republic of Kenya, 1978a, p. 12):

The low rate of female participation in rural wage employment is partly due to the workload of various chores which the rural woman has to contend with, and which leave very little time for other forms of more productive employment . . . a more appropriate technology for the tasks they perform would enable them to improve the quality of their employment through saving labour.

## Major problem areas

The statistics and case studies so far recorded indicate that planners and technologists understand very little about the process of acceptance, utilisation and dissemination of improved technologies in rural areas. As a result, conditions are such that:

- the technologies that have gained a moderate foothold in the rural areas have had a very limited effect in terms of improving the well-being of all members of the community;
- the spread of many potentially beneficial technologies has been severely limited;
- a great deal of money and effort has been wasted on developing technologies that are neither acceptable nor useful to the potential end user or that do not meet a high-priority need.

Until a greater understanding is reached about the process of dissemination and impact of technologies in the rural areas, instances of non-acceptance/non-use and limited/negative impact of technological innovations are likely to persist.

Because most of the available evidence relates to what has gone wrong in past attempts to introduce improved technologies, the only conclusions that can be drawn relate, for the most part, to what the problems have been. This is nevertheless useful in respect of suggesting what alternative strategies could be tried in the future. Empirical research will then be required to evaluate whether these strategies are more successful than previous ones.

*Limited impact*

One factor that seems to have limited the benefits of introducing new technologies is inadequate access of women to co-operative and credit facilities. As was seen, this usually prevents women from investing in their own equipment. Any crop production equipment owned by men is often made available for use on the women's fields only when it is too late in the season to be of any value. In the case of crop-processing equipment, commercial mills are operated at the times convenient to the owner/operator rather than at those times convenient to the women. In addition, many women cannot afford to use commercial mills on a regular basis unless their husbands give them the money to do so. In this event, the burden of handpounding is normally replaced by the equally laborious and underproductive task of doing more unpaid work on the men's fields. These points are well illustrated in the Senegal and the Upper Volta case studies.

A second factor limiting the impact of technological innovations is the high breakdown rate of water systems and crop-processing equipment and the high incidence of equipment being left unrepaired. As was seen, in many cases this is because women are given no training in the operation and maintenance of equipment. In addition, they usually have insufficient cash to pay for repairs and men are under no direct pressure to pay for these. This was illustrated in the case of water supplies in Lesotho and grinding mills in the Gambia and the Upper Volta.

The choice of an inappropriate technology also has limited impact and, in some cases, has even resulted in an absolute worsening of conditions for women. This happened with the introduction of large-scale palm oil mills in Nigeria, which took small-scale processing of the palm fruit out of the hands of the women and deprived them of the income they used to derive from this. Similarly, the choice of relatively large-scale diesel-generated grinding mills has involved a degree of centralisation that necessitates lengthy journeys for women wishing to make use of them. This was seen especially in the case study from East Africa. The rising price of diesel oil has also put the cost of using such mills out of the reach of many women. This was illustrated in the Upper Volta case study.

Other factors involved in and related to the above include: lack of planning for income-generating schemes along with the introduction of labour-saving devices to enable women to have their own money to pay for hire services or repairs; lack of training for women to allow any released time to be put to productive use; lack of orientation of men (through extension services) regarding exactly what is involved in women's responsibilities in terms of time and income so that they become more supportive of measures aimed at helping them.

*Limited dissemination*
As in the case of the impact of technologies, a major factor limiting the dissemination of many improved technologies is inadequate access of women to co-operative and credit facilities. Thus, women have little control over what equipment is purchased by the household or what facilities are provided in the village. Women may wish to have new technologies that would reduce the drudgery of their work or help them to earn income of their own, but they have no way of acquiring these. Men are able to acquire equipment related to women's work but they have no direct incentive to do so. This was found to be particularly important in the case of technologies relating to income-generating activities for women. The reasoning behind this would seem to be that these technologies do not relate to any significant time savings so the men perceive no direct return on an investment in these in terms of diversion of female labour into work on their fields.

Another basic problem is that the great majority of rural women are completely unaware of the existence of most of the improved technologies that can help them. When information does filter down to the village level, it is usually the men who receive it, either because the extension workers are men, or because it is only the men who have time to sit around at organised meetings where such information is given out. Unfortunately, these communication channels are rarely used simultaneously to inform the men about the importance of helping their wives through assisting them to acquire improved technologies.

A final problem is that women, who are frequently the

potential end users of the technologies, are rarely consulted by the technologists at the design stage. As a consequence, much effort is expended in designing technologies that relate to very low-priority needs and have little chance of being accepted, while more pressing problems remain unsolved. This is true of most technologies (such as water filters and pit latrines) relating to improved hygiene. Similarly, much research and development work is wasted on new technologies that are socially and culturally unacceptable to women (as in the case of solar reflective cookers), or that in their view would make their working conditions worse rather than better (as in the case of scythes in Liberia). Failure to take women into consideration has also resulted in the development of technologies that require the strength of a man to operate them, so that the women become dependent on the operator and cannot always use the equipment at the most convenient time. This was illustrated in the case of oil presses in Nigeria.

*Limited access*
Improvement in the access of the rural poor to goods and services has often been emphasised as a fundamental prerequisite for a more equitable sharing of the gains from rural development. Apart from the fact that women constitute a social group on the bottom of the ladder in many developing countries in respect of employment and poverty, they play a significant role, as noted above, in the rural economy as producers, processors and distributors. Therefore, from the technological perspective, it is equally important to ensure greater access of this group as producers to various inputs (physical, capital, skills and materials) needed to undertake production and to generate or adopt innovations within the 'traditional' sectors.

Not much systematic information is available regarding the relative access by rural women and men to non-formal education, rural institutions, extension services, etc. However, a rough estimate reveals that African women hardly have any opportunity to learn about agriculture, co-operatives or animal husbandry (see Table 5.2). Credit and loans are less easily available to women, either because they are made

Table 5.2   *Areas of access to non-formal education by sex: Africa*

| Area of activity | Units of participation[a] | |
| --- | --- | --- |
| | Men | Women |
| Agriculture | 85 | 15 |
| Animal husbandry | 80 | 20 |
| Co-operatives | 90 | 10 |
| Arts and crafts | 50 | 50 |
| Nutrition | 10 | 90 |
| Home economics | 0 | 100 |

*Note:*
[a] Units of participation are so defined that a 50:50 division between the sexes would imply equal access by both men and women.
*Source:* UNECA/FAO (1974).

against land titles, and the land is held in the men's name, or they are made through co-operative societies of which mainly men are members. In any case, it is quite clear that the relative access by women is in no way commensurate to their role in agriculture and livestock activities. Evidence from Malawi reveals that labour input by women of the rural households is higher than that of men in the cultivation of cash crops like tobacco and cotton (Clark, 1975, p. 91). It is significant that the sexual division of labour in these cash crops is such that the women are employed not only in the harvesting and grading work but also in tobacco nursery and planting and in the skilful work of spraying (insecticide) of cotton. That women assume major responsibility for agricultural work in Africa is supported by further cross-country data. In Ghana, women were found not only to own and operate food farms but also to own and manage cocoa farms, often acquired out of their own resources (Vellenga, 1977a). In such a situation women were the entrepreneurial decision-makers and have displayed a realistic appraisal of the use of factors of production, particularly labour inputs (Vellenga, 1977a, p. 206). The female share of the agricultural labour force in less developed countries appears highest where the rural economy is characterised by smallholder agriculture oriented towards production for subsistence or local markets and by low levels of urbanisation combined with male-

dominant outmigration to towns and cities (Dixon, 1983). Furthermore, the agricultural extension services are composed of male agents and tend to channel knowledge and training on improved farm technology to the male farmers.

In the United Republic of Tanzania, for example, under the National Maize Project (NMP), extension services (composed of male agents) on agriculture rarely reached the women fully involved in cultivation (Table 5.3). In Morogoro region, for example, extension agents visited 58 per cent of the men participating in NMP but only 20 per cent of the women (Fortmann, 1981a). Apart from access to knowledge, women producers remain untouched by programmes providing credit and inputs. Only 8 per cent of the participants under the NMP in a sample of twenty-seven villages were women (60 per cent of these being female-headed households). Evidence clearly showed that this occurred despite

Table 5.3 *Extension information contact scores[a] and participation in National Maize Project, United Republic of Tanzania, by region and sex (485 households)*

| Region/participation | Males | Females | t-value |
|---|---|---|---|
| Arusha: | | | |
| Participant | 4.08 | 3.54 | 0.68 |
| Non-participant | 2.16 | 1.24 | 2.27[b] |
| t-value | 4.33[d] | 5.73[d] | |
| | | | |
| Morogoro: | | | |
| Participant | 5.18 | 2.87 | 2.52[c] |
| Non-participant | 2.75 | 1.51 | 2.60[c] |
| t-value | 4.66[d] | 2.89[d] | |

*Notes:*
[a] The information contact score for respondents was constructed on the basis of the following factors: knows the extension agent's name, visited by extension agent in the past year, attended a farming demonstration in the past year, knows there is a demonstration plot in the village, listens to the agricultural radio programme, reads the agricultural magazine, has seen a film on maize. Using good maize practice scores as an indicator of efficiency. No significant difference was observed between males and females among 485 households covered by the NMP.
[b] Significant at .05 level.
[c] Significant at .01 level.
[d] Significant at .001 level.
*Source:* Fortmann (1981a).

the fact that women farmers were in no way less progressive than their male counterparts. As a result, men's labour productivity tends to increase, while that of women remains more or less static.

Such unequal channelling of agricultural extension services is true even for farming systems where women's labour input is greater than that of the men in virtually every operation. The consequences are more serious where women assume the responsibilities for entrepreneurial decision-making in the cultivation of cash crops and adoption of innovations, as in Kenya (Abbott, 1975, p. 181).

In Botswana, where female-headed households represent on an average one-third of rural households, women are responsible for crop production and decision-making (Bond, 1974), yet they were significantly less likely to receive extension advice (Table 5.4). Indeed, nearly three times the proportion of males had received extension advice in the previous three months. Access to extension services in Botswana is particularly important because it means not only access to information but access to government subsidies, grants and loans through the National Development Bank, the Arable Land Development Programme, etc. Moreover, compared to the male-headed households, female-headed households in Botswana own significantly less livestock. Timeliness of cultivation is therefore affected. Those female-headed households that can afford to hire draught animal or tractor power operate at lower profitability rates (e.g. P 7.91 as against P 11.57 per acre) compared to the male-headed households owing to the cash outlays for renting, despite the fact that productivity levels on both types of farms are the same (Fortmann, 1981b). It is notable that the proportion of rural households with female heads was found to range between one-quarter and one-third in several African countries like Sudan, Ghana and Malawi (Youssef and Hetler, 1984). In Ghana, rural women who own and operate cash crop farms possess scientific knowledge of cultivation including understanding of pests and diseases that attack the cocoa crop and their remedy even in the absence of any extension advice (Vellenga, 1977a, p. 206).

The sexual bias in the channelling of extension services is

Table 5.4  *Proportion of male- and female-headed households receiving extension advice*

| Frequency of extension contact | Household head | |
| --- | --- | --- |
| | *Male* (N=226) | *Female* (N=90) |
| Never received advice | 64.6 | 81.1 |
| Last received advice before 1979 | 10.6 | 4.4 |
| Last received advice Jan–June 1979 | 4.4 | 2.2 |
| Last received advice July–Dec 1979 | 5.8 | 0.7 |
| Last received advice Jan–March 1980 | 14.6 | 5.6 |

*Source*: Fortmann (1981b).

so pervading that technical assistance experts from abroad have trained men in activities that were entirely women's responsibilities, as occurred in Senegal in rice transplantation (Boserup, 1970, p. 55) and in Liberia in wet-rice cultivation (Tinker, 1977). A foreign development scheme for swamp rice essentially turned the crop over to men through male extension agents working directly with men in the villages (Tinker, 1981). Similarly, in one West African country, government extension personnel trained men in appropriate coffee planting techniques even though this task was the responsibility of the women! The coffee plant continued to be planted by traditional techniques under which the plants were placed into holes dug by women to insufficient depths. As a result, the tap roots were bent and the seedlings did not survive, leading to economic losses (Carr, 1978, p. 27).

An unequal channelling of extension services and key inputs is largely the result of the lack of appreciation and understanding of the complete role of women in the rural economy and society. Assuming only a narrow and partial view of rural women as farmers' wives, housekeepers, cooks and bearers of children, national development programmes and the international aid-giving agencies have directed funds towards maternal and child health clinics, family planning programmes and home economics projects (Simmons, 1976). When training is available to African women, it is usually in the supposedly 'female' areas of cooking and sewing (Carr, 1978).

**A new approach**

Out of the summary of major problem areas arise a number of suggestions of what policy changes are required to improve the situation regarding the dissemination and impact of new technologies in rural areas.

First, there seems to be a case for a change in content of existing extension services. At the general information/orientation level, a nutrition/health component included in the services aimed at men would help them to understand the importance of women's contributions in these respects and encourage them to be more supportive of projects aimed at improving the well-being of the family through reducing the workload of women or increasing their income. Similarly, an agriculture/technology component included in services aimed at women would increase their knowledge of what equipment and improved techniques are available to help them with their work.

At a more specific level, there is a very strong case for training women in the operation and maintenance of communal technologies such as water pumps and any equipment, such as grinding mills, that they own co-operatively. Experience from outside the Africa region has shown that women are very capable of learning how to maintain equipment and how to carry out simple repairs. For instance, women in Bangladesh have recently been successfully trained in pump maintenance (UNICEF, 1978a), and many women in Papua New Guinea have been successfully trained in blacksmithing and maintenance and repair of equipment at workshops organised by the South Pacific Appropriate Technology Foundation (SPATF).

Second, giving women equal access to co-operative and credit facilities would seem to be of utmost importance. This would enable women to purchase equipment that they see as being beneficial and would allow them to make use of improved technologies when it is convenient for them to do so rather than only when it suits their husband's purposes. Experience so far shows that most women's groups having access to credit facilities make use of them to purchase crop-processing equipment; it also shows that they have a much

better record of repayment than do men. For example, in
Sierra Leone in 1976, the repayment rate on loans given by
the Co-operative Department to women's co-operatives was
100 per cent: it was much lower for men's co-operatives
(Carr, 1976d). Similarly, loans given to women's groups in
the United Republic of Cameroon in the 1960s to purchase
corn mills were all fully repaid within a year (O'Kelly,
1978a).

Third, more attention needs to be given to introducing
money-earning projects for women alongside the introduction
of labour-saving devices. Having their own source of income
would reduce the women's dependence on men in cases
where crop-processing services are commercially available. In
cases where women have acquired their own machine, a
source of income would help in enabling them to pay back
any loan involved in its purchase and to pay for the
operation, maintenance and repair of the equipment. In
many cases, the money-earning project could be linked with
and based on the labour-saving device. For example,
improved soap making and improved methods of refining
cooking oil could be linked with the introduction of
improved palm oil presses.

Fourth, there is a need to give more consideration to the
scale and characteristics of the technology being introduced.
Small, hand-operated equipment would seem, in most cases,
to be preferable to larger diesel-operated equipment. There
are several reasons for this. Maintenance of smaller equip-
ment is usually simpler and less costly than for larger, more
sophisticated machinery, and breakdowns are less frequent.
When breakdowns do occur, repairs can usually be carried
out at a reasonable price by the village blacksmith. Hand-
operated equipment has much lower running costs – a point
that takes on increased significance with the high and rising
cost of diesel oil. Smaller technologies, because of their lower
cost and ease of operation, lend themselves more readily to
co-operative ownership and operation by women's groups,
thus giving women more control of the pattern and timing of
their work.

Finally, an attempt must be made to encourage technol-
ogists to consult rural women at the stage of designing new

technologies. This would help to ensure that research and development effort is directed towards meeting high-priority needs in the rural areas. It would also help to ensure that technologies are designed with the cultural, social and economic circumstances of the potential end users in mind. Part of the problem relates to the fact that male technologists have difficulty in communicating directly with rural women and getting a first-hand account of their needs and problems. Unless an efficient system can be worked out in which male technologists work with and through women sociologists/field workers, there would seem to be a good case for training more women technologists.

Ideally, a programme aimed at introducing improved technologies in rural areas would have the following phases. In the preparatory phase, field workers would be involved in general information and orientation work, which would consist of sensitising the men to the importance of women having access to improved technologies and of informing the women about the types of technologies available and how these can help them. The women should also be taught how to organise themselves into groups or co-operatives so that they can collectively purchase needed technologies when credit becomes available. During this phase, the technologists and field workers should also identify priority needs and collect cultural and socioeconomic data for consideration when designing and adapting technologies.[4] These data would be doubly useful if they were collected in such a way that they could also serve as a basis for comparison when evaluating the impact of the technology.

In the second phase, credit would be issued to women's groups and co-operatives to help them purchase a labour-saving device. They would be taught how to operate and maintain the equipment. They would also be given training in soap making, vegetable gardening, or some other money-earning activity, so that any released time can be used productively and savings generated to pay back loans and maintain equipment properly. When necessary, credit should

---

[4] The issue relating to small hand-operated equipment versus larger diesel-powered equipment should become clear in light of data relating to financial and technical constraints in the community.

be issued to enable the women to purchase any tools or equipment related to the money-earning activity. Progress should be monitored on a regular basis and advice given on how to overcome any technical, financial, marketing or social problems that arise.

Finally, the scheme would be evaluated in terms of impact of the technology on each member of the household and the community as a whole. This would clarify what, if any, further policy changes are needed.

# Programmes and Projects

# 6
# Modernisation, Production Organisation and Rural Women in Kenya

*VIVIANNE VENTURA-DIAS*

## Introduction

This chapter deals with the effects of technical change on the economic condition of rural women in Kenya in terms of both employment and income.

The basic premise is that the problem of rural women in Kenya is not one of employment *per se* but one of level of income and physical assets. African rural women produce not only the basic food crops but also other goods and services required for home consumption. Kenyan rural women are no exception to this tradition: water and fuel collection, child rearing, as well as helping the husband in his economic activities, complete the daily routine of Kenyan rural women. Rural women in Kenya are thus fully employed within the family-based mode of employment (Sen, 1975). Yet, in Kenya, rural households depend on the market to satisfy between one-half and two-thirds of their material needs (Kongstad and Mönsted, 1980).[1] In other words, market production is replacing domestic production, and consumption goods that were produced by women in the household became available in the market, albeit with very little female

---

[1] The relative dominance of market relations does not change the basic dynamics of simple reproduction that prevails in the household unit of production without profits and accumulation. However, there is a tendency for the family to get integrated into the market and to orient its production decisions towards the market rather than towards directly satisfying the family subsistence needs.

157

labour input. Cash income is necessary to purchase these consumption goods, as well as for production goods, and to pay for public services and school fees among other goods and services. However, job prospects are not bright in Kenya and labour markets are highly imperfect (Collier, 1982).

Rural women's access to modern technology is part of the problem associated with unbalanced growth and unequal income distribution that has characterised post-independence Kenya (International Labour Office, 1972; Republic of Kenya, 1979). In order to capture the dynamic effects of the introduction of new methods of work and new means of production in some areas of agricultural production in Kenya, it is necessary to bear in mind that the country moved from a classless barter economy into a complex, socially and economically stratified, monetised economy in less than two generations.

For historical and social reasons, women in Kenya have systematically been excluded from sources of capital formation. Cattle and land assets were initially the main sources of capital accumulation that provided access to technological innovations such as ploughs and water-powered grinding mills (Manners, 1962). In pre-colonial Kenya, women were excluded from cattle transactions and land ownership, although they had usufructuary rights on land (Pala, 1978). In colonial Kenya, women were excluded from non-farm employment (during the first decades of the colonial regime) because their presence in the fields was required both to feed their households and to feed non-farm populations. Women were also excluded from good primary and secondary schools, and they had access to primary education only after the saturation of the labour market for this level of education (Smock, 1977). In brief, women have not been associated with any of the elements that determine the level of farm output and income in modern Kenya: size of off-farm income and size of landholdings have been shown to correlate positively with adoption of technical innovations, as have off-farm income and level of education (Collier and Lal, 1979; Kitching, 1980; Knowles and Anker, 1981). As a result, women prevail in small-farm agriculture in Kenya, while, conversely, male absenteeism is high. Women are also

concentrated in areas such as pottery, basket- and mat-making, beer brewing and fish processing, as well as in petty trade. These are very competitive markets with a large number of participants and reduced margins of profit.

Kenya inherited its agrarian structure from the colonial period: a small number of large farms (concentrating on cattle raising and cash crops) and a large number of small farms (cultivating both food crops and cash crops). The average size of large farms is over 700 hectares and they correspond to the former 'scheduled' or European farms (less those that have been transferred for subdivision into land settlement schemes). Small farms are between 0.2 and 12 hectares.

The dynamics of the Kenyan agricultural sector in past decades were determined by the growth of smallholder agriculture. In the 1950s, high-value cash crops such as coffee, tea and pyrethrum (which were monopolised by European farms) were introduced into small-farm African agriculture. Changes in crop mix were associated with better agricultural practices and the use of biochemical innovations (Brown, 1968). Hence, although in terms of income and land distribution the sector is very heterogeneous (see below), smallholder agriculture accelerated its participation in total marketed agricultural output; smallholder agriculture accounted for less than one-third of commercial agriculture in 1963, but by 1972 more than half this output was being produced by small farmers (Republic of Kenya, 1980a).

Recently, development projects have spread the use of appropriate, alternative or improved small-scale technologies in order to increase the income and welfare of rural women. The underlying assumption of these projects is that technology can be used as a neutral instrument to modify patterns of income distribution without radical policies to change established priorities in rural development or the structure of landownership. The existing literature, however, points to the following situation: women prevail in areas where no new technology has been introduced, and they are the first to be displaced from tasks that can be commercialised and/or mechanised.

In this chapter, I shall argue that strategies based

exclusively on technologies conceived for or adapted to 'female' activities are likely to leave the scale of domestic production unaltered and condemn women to remain in the semi-subsistence sector or private production while commercial or social production of the same goods and services remain male domains. Essentially, the chapter suggests that, if income and employment of rural women in Kenya are to be improved on a permanent and continuing basis, short-run solutions based on small-scale technologies have to be associated with long-run policies to increase women's access to training skills, credit, education, agricultural services, off-farm employment and consequently to modern means of production. In brief, projects aimed at introducing technologies to relieve burden and drudgery in female tasks have to be integrated into rural development plans. This requires production techniques with economies of scale and collective use of resources, both to increase labour productivity and marketed output as well as to release (even partially) women from the responsibility for the nurturing and socialisation of their offspring. These collective forms of organisation are not foreign to traditions in Kenya and several women's groups have already been spontaneously created by women who felt the need to pool their scarce resources. These organisations could be used within integrated plans of rural development to channel new methods of production and for skill formation outside the sanctioned lines of the existing pattern of sexual division of labour. This is acknowledged by the Kenyan government: 'The roles of men and women must be redefined as agriculture becomes more specialised and education absorbs the time of children' (Republic of Kenya, 1979, p. 3).

The next section of this chapter introduces the conceptual framework of my analysis. Later an historical overview of the process of technical change in Kenya is provided. The subsequent section examines the macro aspects of the present situation of rural women in Kenya. The following section shifts from macro to micro aspects of women's productive tasks and the dynamic aspects of the household as a unit of production are discussed. Conceptual and empirical problems associated with the use of small-scale technologies to improve

the income level of rural women are examined. Women's activities are characterised by low labour productivity, and changes in these conditions will necessarily imply changes in the scale of production and in the labour process.

## Outline and analytical approach

Women, as the subject of analysis, are at the crossroads of two main systems: the class system and the gender system. Methodological problems arise because, on the one hand, women are affected by social, economic and technical changes as members of households and of social classes; on the other hand, women's roles are conditioned by their participation in human reproduction, which is not biologically but socially determined (Deere, Humphries and Leon, 1982; Fox-Genovese, 1982). This is particularly emphasised in the feminist analysis of the productive role of women (see Beneria, 1979; Deere, Humphries and Leon, 1982; McDonough and Harrison, 1978; Oppong, 1982). Female participation in social production, the nature of women's tasks, their share in household revenues and their pattern of budget expenditures are the result of their role in human reproduction, albeit influenced and limited by the requirements of the production system as a whole (Beneria, 1979). Accordingly, a sharp division of labour between the sexes assigns to women tasks related to the maintenance and growth of their households over and above whatever work they may do outside the home. It is the 'invisibility' of women's productive work and a stereotyped view of the roles attached to the sexual division of labour that have to be criticised because they prevent women from being taken seriously as productive agents with the same needs in terms of access to modern means of production, credit facilities and training as their male peers (Beneria, 1981). Instead, women are treated as a 'social welfare' problem (Feldman, 1981).

In Kenya, a class-stratified society based on the ownership of factors of production is a recent historical event, which changed the relations between sexes and between and within social classes. Furthermore, the impact of technical change on women differs according to the nature of their productive

tasks and the way they are integrated into a market economy – in other words, whether they stay in the realm of domestic production or move into market production; also, whether they participate in market production as independent producers or as part of the wage labour market. The topic is too complex to be treated adequately in one chapter and I underline this complexity to suggest that a comprehensive approach has to be adopted in order to use technological change to improve the situation of rural women in Kenya.

The simplest social formations present some specialisation by sex and age groups, which Marx considered to be a 'natural' division of labour 'based on a purely physiological foundation' (Marx, 1977). (Kongstad and Mönsted, 1980, among others, criticised biologically based explanations of this 'natural' division of labour that lack explanatory value for contradictory tasks such as heavy carrying done by women in many African countries.) The division of tasks between men and women is commonly associated with difference in prestige and power, although not always with differential access to social resources (Jones, 1977; Mullings, 1976). Across different non-market societies there seems to exist a rigid separation between the domestic sphere in which labour is for private use and the sphere in which labour is for social and ritual uses. Women mostly perform activities in the private domain, whereas men are involved with activities in the public domain as well as in the private domain. With the development of the capitalist system, these domains acquired different characteristics: the private domain became equivalent to the production of use-values or goods that were not sold in the market, and the social domain became the same as the production of commodities or goods with exchange-value. Different relations of production prevail in the two domains: private production is carried out with family labour, whereas wage labour is the dominant social relation of production in social production. Women nevertheless remain associated to the private sphere.

# Historical overview

*The division of labour between sexes*
The nature of female and male activities in pre-colonial
Kenya reveals the implicit cultural evaluation regardless of
the apparent complementarity of the tasks. In farming the
food items of the daily diet, the male's task was to clear the
land, which required concentrated strength. Women would
do all the routine tasks following initial clearing. Among the
Kikuyu, certain crops, mainly perennial crops such as
sugarcane, several kinds of banana, yams and tobacco, were
considered to be male crops. They were used on social and
ritual occasions to entertain mostly male guests (Kershaw,
1975/6). Women, unless old, were not allowed to drink beer
that was made from sugarcane. It is true that women had
their own granaries to store their crops where men were not
allowed to enter. Women also managed their gardens with
full autonomy to decide the level and composition of their
agricultural production. They had to be sure that the
production was enough to feed their families and eventual
guests and they could decide to produce a surplus over and
above these needs and to market it. In this case, whatever the
women bartered for their surplus would be entirely theirs.
Nevertheless, it is important to emphasise that in pre-colonial
Kenya the woman was responsible for the daily survival of
her family, which included the husband, while husbands
were also involved with community affairs. In other words,
women had to support the family with food from their
cultivation. When other items were introduced into the
household expenditures through market expansion, women
became responsible for all the main short-run daily consump-
tion expenditures, while men had to provide for long-run
investment expenditures. Hence, the basic elements that
became stressed with the development of the colonial
economy were already present in the previous tribal
economies.

Pre-colonial Kenyan tribes display a classic case of a
patriarchal society with unequal distribution of power and
authority.[2] Goats and cattle were used to acquire land.

[2] Patriarchy, according to some authors, is a universal mode of power

Women could own and handle goats and sheep but no cattle. They were forbidden to milk, or enter the cattle area or to slaughter cattle. They were allowed to eat only certain parts of the animal: high-protein foods were reserved for men (Hay, 1976). Only men could decide when, where and how much land should be acquired, whom and when his son or daughter could marry. In pre-colonial Kenya, wealth and social status were reached through the dual accumulation of livestock and wives. Bridewealth was in the form of livestock and it had to be accumulated if wives were to be obtained. Wives meant the expansion of the agricultural surplus, which, in addition, could be used to acquire more livestock (see Kitching, 1980). However, there was no way of investing this stock wealth in economic ventures. Economic decisions were not governed by profits. Wealthy families existed but their surplus could not be invested or used economically, although these families could afford higher levels of consumption (Kongstad and Mönsted, 1980). The growth of the economic system was based on simple reproduction, where land was cleared and cultivated according to the needs of the present community with a slack for possible hazardous events and population growth. The technology was simple: the soil was tilled with a digging stick, or a wooden hoe, which restricted the expansion of the cultivated area (Cone and Lipscomb, 1972). Each woman had an average acreage of $2\frac{1}{2}$–4 acres each season. The soil fertility was maintained by fallowing and crop rotation since manure was not used by most of the Kenyan tribes. Land was abundant and migration would follow land exhaustion within an open agricultural frontier. Production was not organised by markets, although trade or exchange of goods existed.

In less than 50 years, Kenya was transformed from a subsistence-oriented into a market-oriented economy. First, money replaced a system of wealth and accumulation based on stock and non-convertible units (cattle). Second, labour power and land became commodities, and markets, albeit

---

relationships and domination, although the precise character of patriarchal relations is shaped within the historical reality of a mode of production (see Millet, 1971, and Rowbotham, 1973).

imperfect, were created for their transactions. Third, new crops were introduced or certain existing crops were emphasised. Some of these crops (maize, cattle) had both use-value and exchange-value for the direct producer and replaced traditional food crops. Others (cotton, tea, coffee, pyrethrum) had no use-value for the direct producer and were for the first time planted with the sole purpose of being sold in international markets. Finally, goods and services that were previously produced in the realm of the household (or of the community) became commodities to be purchased in the market.

Because of the nature of male activities in pre-colonial Kenya – fighting, stockraising, hunting – male labour time was not devoted to material production for most of the year. With the development of a market economy, goods previously produced by skilled male artisans were replaced by manufactured goods, and ritual and judicial functions were replaced by British administration officers. The other activities were forbidden. Men could migrate out of their homesteads and male labour time could be distributed towards wage and farm employment. Under British colonialism, the major systems of securing labour in Kenya – wage migrant labour on European concerns, squatter labour on European estates and independent African peasant cash crop production – were subsidised by female rural labour (Wipper, 1975/6). The tasks of cultivation and food preparation for domestic consumption continued to be a female domain both in the reserve and on the settler farms (Sticher, 1975/6), although they became intensified with changes in the productive system. The intensification of women's work in the first three decades of colonial administration was self-evident. Data indicate that African production for the internal market grew without any substantial change in the agricultural methods or technology employed and with a high level of male absenteeism, which followed the creation of a labour market (Kitching, 1980).

*Social differentiation and technical change*
The reinforcement of female labour was influenced by the precise pattern of male labour migration, which was

dependent on the movements of international markets as reflected in the colonial economy. Up to the late 1920s, most male off-farm employment was based on short-term migration and it was timed to coincide with periods of low demand for labour on the farm. Moreover, the men who worked outside the sublocation were mainly young and unmarried and their departure from the farms did not put an extra burden on the women. From the 1930s on, the importance of off-farm jobs became the crucial variable to explain household and regional differences. Male workers who had migrated out of the farms for long-term and well-paid jobs were able to send money to their wives. This money was used to hire labour or the services of an ox-drawn plough.

African cultivators made modest improvements in their techniques of production in the period 1918–30. Initially, farm output was increased through the expansion of cultivated land and the adoption of the new iron-bladed hoe (*opanga*). In the 1920s the modern form of African hoe was introduced (Kitching, 1980). The Kipsigis used only the hoe for soil preparation and cultivation until 1921 when the first plough was introduced. The plough became a virtual necessity to increase the area under cultivation in order to get a sizeable cash income. By 1930, 400 ploughs were in use and 73 Kipsigis owned water mills for the grinding of maize into flour (Manners, 1962). In the Machakos district, there were around 200 ploughs and most of them were hired out to other households. The Kamba people bought the first ploughs in Machakos with the money earned either in small trade of poultry, eggs, bananas, sugarcane, maize and beans with Nairobi or in the cattle trade. In 1933, the comparative efficiency of the iron hoe and the plough was assessed by the Kenya Land Commission Report: with the iron hoe, a man and his wife could cultivate 1.75–2.5 acres depending on the characteristics of the soil, but with an ox plough each farmer could till about 4 acres (Kitching, 1980).

Nevertheless, the adoption of the plough did not represent labour saving for the women. The plough evidently had many advantages over the hoe because more land could be put under cultivation, but it would be drawn by men, and women would be in charge of the subsequent routine work

once the field was ploughed. Women generally had to accept the burden of extra sowing, weeding and harvesting implied by extensive plough cultivation.

Economic and educational opportunities, if and when they were created by the colonial agents to the African population, were without exception addressed to the male part of it. A few innovations were introduced by European settlers in the cultivation of their fields at the beginning of European agriculture in Kenya, and it was through employment on European farms that male Africans came into contact with exotic livestock farming and cereal crop agriculture. The missionary schools that were open to women only encouraged them to accept the Western stereotypes of women as wives and mothers.

Boserup (1970) blamed 'European settlers, colonial administrators and technical advisers' for neglecting the female agricultural labour force when commercial agriculture was introduced into African countries, so that only male labour productivity increased. Few women were employed on European farms since, even for light agricultural work such as hoeing, weeding, and harvesting, Europeans showed a clear preference for male children. Skilled work in agriculture – ploughing, driving, pruning, dairying and operating coffee, pulping or husking machinery – was done by men (Sticher, 1975/6). In her seminal book, Boserup set forth the now classic exposition of the impact of colonial penetration on female labour productivity and on the sexual division of labour: the monopoly by men of new equipment and modern agricultural methods to cultivate cash crops while women were left to cultivate food crops with traditional methods.

Nevertheless, Boserup also recognised that social stratification could decrease the workload for some women. Social differentiation means land reallocation and the creation of labour markets. During the process of impoverishment, some men and women become net sellers of labour power, while other men and women benefit from the availability of near-landless families working for wages. The women in both these groups could be released from manual work on their own plots: at one extreme women sold their labour to work

168     *Technology and Rural Women*

on other people's holdings and at the other extreme women took over managerial functions on their own farms.

The process of social and economic differentiation gained impetus in Kenya after the 1930s and particularly after the Second World War. The growth of marketed agricultural production entailed modifications in the customary allocation of land: 'separate' gardens for husbands and wives no longer existed 'and all the household's land resources were treated as one productive unit, the entire output of which would be disposed of as determined by the male household head' (Kitching, 1980, p. 112). Although tribal norms gave considerable autonomy and power to women to decide on the crop mix and on the content of their granaries, more and more infractions of these norms were registered.

The sexual balance of power within households in Kenya, although highly dependent on the historical context, was a function of the following variables, according to Kitching: (a) the presence or the absence of male household heads on the farm; (b) the level of male labour input; (c) the size of landholding; (d) the extent of hiring of labourers.

On the basis of research carried out by Hay in Kowe between 1930 and 1940 (see Kitching, 1980, pp. 90–2) and another study of households of Central and Nyanza Province in the early 1950s, Kitching (1980, pp. 140–6) outlined a typology of households with different capacities to accumulate capital and land according to their access to relatively well-paid off-farm employment:

(1)  Wife at home on the plot and absent husband in long-term off-farm employment. As a result of previous educational experience, he has a better-paid waged or salaried employment away from the reserve. Hence, he can send above average remittances, which lead to the adoption of ploughing and hiring of labour. Wife effectively acts as farm manager but some crucial decisions can still be made by the husband. Some investment in land purchase could occur.

(2)  Wife at home on plot and husband in better-paid waged or salaried employment within the reserve. Plough could be bought from husband's salary and also some hiring of

labour. Husband acts as the farm manager and some possibilities of land purchase exist.

(3) Husband and wife in full-time employment on the plot throughout the period. No changes in the labour process except for the adoption of maize, use of hand grinding mill and of better hoes. Smaller expansion of cropped area than (1) and (2). No land purchasing. Husband might increase his participation in farming and wife might be more involved in trading. Wife may have some control over her plot but she may also face pressures from the husband to merge her plot with his.

(4) Husband and wife leave the reserve on long-term labour migration. Land is sold to groups (1) and (2).

(5) Husband departs on long-term labour migration but as unskilled labourer and with frequent changes of job. Wife stays on plot but cannot benefit from money remittances to adopt technical innovations. She will restrict production to minimum subsistence. She may sell her labour power to (1) and (2). They may decide to sell some land to meet short-term cash needs or because of labour shortage to work it effectively. Wife may have control over income and day-to-day managerial decisions. A survival strategy may be defined in which cash crops are cultivated almost exclusively and part of this marketed production is traded for subsistence items.

(6) Husband in short-term labour migration; he returns at time of peak labour demand. No ploughing, limited adoption of maize but use of hand grinding mill, better hoe, etc. Very small expansion of cultivated area. Wife may have lost her previous autonomy since the husband prefers to centralise control over farmland, the labour process and derived income.

This exercise by Kitching is an important contribution to opening up aggregate statements related to women, colonial rules and technical change, which are so common in the literature of women and development (Seidman, 1981). There are writers who claim that women exist as a universal category of analysis regardless of the historical or cultural form domestic labour takes, but the basis of their assertions

is not free from criticism (Molyneux, 1979). It is an accepted fact in the literature on 'women and development' that technology, credit and know-how have become concentrated in the hands of men, while women have been relegated to food production for subsistence consumption; yet, as one writer candidly asked, did it mean that the process of development actually included all males? (Tadesse, 1979). Moreover, it is evident from Kitching's typology that women in cases (1)–(3) are better off than either men or women in the other cases. It is not true that the process of introduction and dissemination of new techniques into non-market economies improved only the welfare of men, leaving the women's situation unaltered or worsened. In relative terms, holding economic class constant, women have benefited less than men, yet it can be shown that, across groups of women ranked by the quantity and quality of their assets, some women could benefit from access to modern means of production and consumption as well as to hired labour to decrease their burden. For example, Oboler (1977b) carried out a study of time allocation of all members of rural households among the prosperous Nandi peasant mixed farmers and she found no significant difference between male and female workloads. The low average agricultural work week was explained by the general affluence of the Nandi, who make extensive use of tractors and hired labour on their lands.

In other words, women are sub-categories of racial and economic groups. In the analysis of the social impact of technical change and progress, the differential role of gender has to be appreciated within the broader picture of class analysis. (The literature on technical change and women is already voluminous and several writers have analysed gender within class analysis – see Bukh, 1979; Conti, 1981; Deere and Leon, 1980; Palmer and Buchwald, 1980; Staudt, 1978; Whitehead, Chapter 3 in this volume, among others.) Gender is an additional factor to explain access to economic resources and opportunities within groups separated by race and by levels of income. Race was a binding constraint for social and economic mobility during the first decades of the colonial period, but it was replaced by the level and the quality of

economic assets with the development of the market economy in Kenya; some male Africans were able to make their way up on the basis of some training and the agricultural surplus they could derive either from female labour or from cattle trading.

The commercialisation of agricultural production in Kenya contributed to higher intensity of female labour use on the aggregate without parallel improvement in their skills. The pre-colonial division of tasks between the sexes that allocated female labour to food production for household consumption permitted the transfer of 'unproductive' male labour from tribal lands to European ranches and plantations as well as to non-agricultural jobs. Female production of food both for subsistence and for the internal market subsidised European production, but the colonial response was to ignore female participation in production and through religious and state institutions to try to confine women to the Victorian roles of wives and mothers, even though these roles had not been the only ones with which Western women could historically identify themselves, let alone Kenyan women. (The recent literature on the history of women's work outside the home in industrialised countries has revealed the productive tasks women performed in the domestic economies; see Scott and Tilly, 1980, and for an extensive review of the bibliography, Fox-Genovese, 1982.) Women were prevented from acquiring new skills either through informal on-the-job training or through access to high-quality formal education.

The analysis of the access of rural women to modern means of production thus has to take into consideration: (1) the unequal agrarian structure within which women operate, (2) the access of women to sources of capital formation and credit, and (3) the alternative opportunities of employment for women.

I shall now review the condition of rural women in Kenya and the problems they face in improving their methods of production.

**Rural women in modern Kenya**

*Rural women and the agrarian structure*
Women play an important role in the smallholder agriculture
in Kenya, mainly as owner–operators of their farms. The
*Integrated rural survey 1974–75* (IRS 1) registered 97.51 per
cent of women aged 17 years and over in the smallholding
population with no other source of employment except the
farmholding itself, against 78.81 per cent of males of the
same age group (Republic of Kenya, 1977). Women
represented 50.85 per cent of the total farm population.

As information on the holding is the only source of
information on rural women's employment, it has to be
treated with reservation because most of the activities carried
out by women are related to agricultural work and are
considered to be complementary to activities carried out on a
part-time basis – fish processing, crafts and the petty com-
modity trade in general. Therefore, the above information
should be accepted as the proportion of rural women that
have their own holding as the main source of employment.
The published information from IRS 2 (Republic of Kenya,
1980a) lowered these figures: the share of women having no
other source of employment except the holding was reduced
to 85.3 per cent, but the male share was reduced even more,
to 54 per cent. However, from the scanty published
information, it is not possible to ascertain whether the two
populations are exactly comparable.

Although women have numerical importance in farming in
Kenya, they do not have the same access as men to the basic
factors of production – land, labour, material inputs and
agricultural services including credit. Gutto (1976, p. 2),
remarked that the independence Constitution of Kenya
excluded sex attributes from the elements that cannot be
used to bar Kenyans from access to social resources and
revenues; only 'race, tribe, place of origin or residence or
other local connection, political opinions, colour or creed'
were considered. Traditionally, women did not inherit land,
but their rights to use land belonging to a male relative were
assured. Currently, unless the land is registered in their own
names, women's rights to the use of land are threatened by

land commercialisation. According to Okoth-Ogendo (1976), less than 5 per cent of total registered holders are women, except for parts of Central Province and the matrilineal descent groups in the Coast Province. Property rights after the dissolution of marriage or death of husband are different among the various tribal groups, and tribal customary laws are enforced by the legal system in Kenya. For instance, among the Kikuyu, women are entitled to property acquired before marriage and to some share of property acquired with joint effort. Among the Luo, Kisii and Masai, on dissolution of marriage, the wife may be forced to return to her family with nothing because the wife has no property of her own (World Bank, 1980).

Women take part in rural production with different levels of autonomy. The main factor explaining these differences, as was discussed earlier, is the presence or absence of the male head. At one extreme, there are the female-headed households (FHH), meaning households that do not have the husband on the farm through either divorce, decease or separation. At the other extreme, there are the women who participate as unpaid labour and are part of the aggregate family labour but have very little say in the decisions concerning the composition and the level of the production mix as well as the share and the final use of the revenues. There is also an important group of women who replace their husbands in the day-to-day managerial activities when they are away in long-term, off-farm employment.

According to IRS 1 (Republic of Kenya, 1977), 24 per cent of small-farm households were counted as FHHs. The proportion of FHHs in the total number of households varied across regions, from 19 per cent in the Western Provinces to 27 per cent in the Coast and Eastern Provinces. In addition, 20.73 per cent of the households were listed as having the wife as holding operator (see Tables 6.1 and 6.2).

Although FHHs are defined as households where women have complete control over the allocation of their resources, these resources tend to be such that FHHs are more likely to be among the poorest households. They are mainly at the lower end of the socioeconomic scale and the existence of females as 'heads of the household is often a better indication

Table 6.1  *Percentage distribution of heads of household by sex of head and province*

| Head of household | Central | Coast | Eastern | Nyanza | Rift Valley | Western | Total |
|---|---|---|---|---|---|---|---|
| Male | 77 | 73 | 73 | 75 | 78 | 81 | 76 |
| Female | 23 | 27 | 27 | 25 | 22 | 19 | 24 |

*Source:* Republic of Kenya (1977), Table 6.2.

of poverty and dependence than of authority and autonomy' (United Nations, 1981, p. 11).

Mbithi and Mbula (1981) produced evidence that male-headed households (MHHs) in Kenya own more land and more equipment (bicycles, ploughs, wheelbarrows, radios, water-tanks, jerry cans, etc.) than FHHs. Similar results were put forward by the *Baseline study* of the Ministry of Transport and Communications (Republic of Kenya, 1980b), which surveyed 1,660 households, of which 23 per cent were FHHs (ranging from 9 to 47 per cent). The following variables were analysed: demographic characteristics, educational level of family head, land tenure and area cultivated, ownership of equipment and implements, types of household structure, possession of improved or unimproved livestock, sewage disposal facilities, radio listening habits and access to health-care facilities. In terms of farming equipment, as could be predicted, the greatest difference was in the number of ploughs owned: on average, MHHs had 87 per cent more ploughs per family than FHHs. MHHs had higher agricultural output, marketed more of the agricultural produce and had higher income than FHHs. The data also showed that in terms of consumption expenditure MHHs enjoyed higher standards of living than FHHs. This could be explained by the fact that MHHs also had a higher non-farm income level than FHHs.

Very little is known about the structure and performance of FHHs. It is not possible to compare the economic decisions taken in male- and female-headed households to identify the role that gender or sex plays in the allocation of resources for the same level and composition of resources.

Table 6.2 *Percentage distribution of holding operators[a] by residence of holder[b], relationship of operator to holder, and province[c]*

| | Central | Coast | Eastern | Nyanza | Rift Valley | Western | Total |
|---|---|---|---|---|---|---|---|
| *Holder living on the holding:* | | | | | | | |
| The holder | 72.79 | 90.38 | 78.09 | 86.26 | 89.22 | 85.62 | 81.91 |
| His wife | 16.62 | 5.52 | 17.89 | 5.18 | 6.18 | 7.86 | 11.05 |
| His son | 5.54 | 3.35 | 1.38 | 0.35 | 3.75 | 4.19 | 2.56 |
| Another relative | 5.04 | 0.38 | 2.64 | 8.20 | 0.85 | 2.32 | 4.47 |
| A non-relative | 0.00 | 0.37 | 0.00 | 0.00 | 0.00 | 0.00 | 0.02 |
| *Holder living off the holding:* | | | | | | | |
| The holder | 10.99 | 5.51 | 10.06 | 23.13 | 14.99 | 32.02 | 15.04 |
| His wife | 41.34 | 62.86 | 44.68 | 65.45 | 50.12 | 36.10 | 46.42 |
| His son | 3.94 | 4.50 | 13.05 | 0.00 | 3.22 | 13.82 | 7.61 |
| Another relative | 26.49 | 23.97 | 16.09 | 5.71 | 23.11 | 18.06 | 19.56 |
| A non-relative | 17.24 | 3.15 | 16.13 | 5.71 | 8.55 | 0.00 | 11.36 |
| *Holder living outside the district:* | | | | | | | |
| The holder | 0.00 | 0.00 | 0.00 | 0.00 | 0.00 | 0.00 | 0.00 |
| His wife | 65.29 | 77.22 | 75.95 | 48.12 | 57.48 | 65.34 | 64.48 |
| His son | 2.46 | 0.00 | 12.19 | 8.08 | 14.01 | 1.09 | 4.63 |
| Another relative | 21.51 | 22.78 | 11.86 | 41.12 | 24.71 | 31.20 | 25.94 |
| A non-relative | 10.75 | 0.00 | 0.00 | 2.69 | 3.80 | 2.37 | 4.94 |
| *Total:* | | | | | | | |
| The holder | 50.92 | 64.75 | 65.76 | 77.62 | 77.89 | 64.62 | 66.05 |
| His wife | 29.28 | 24.33 | 24.78 | 10.49 | 12.76 | 21.39 | 20.73 |
| His son | 4.73 | 3.05 | 3.30 | 0.92 | 4.59 | 4.28 | 3.23 |
| Another relative | 10.88 | 7.12 | 4.61 | 10.57 | 4.01 | 9.23 | 8.43 |
| A non-relative | 4.19 | 0.74 | 1.54 | 0.40 | 0.76 | 0.47 | 1.56 |

*Notes:*
[a] The operator is defined as the person in charge of the day-to-day running operation of the holding.
[b] The holder is defined as the person with overall control over the management and operation of the holding – usually the head of household when resident on the household compound.
[c] Excludes pastoral and large-farm areas.
*Source:* Republic of Kenya (1977), Table 6.8.

Paterson (1980) surveyed 166 households in a single community in the district of Kakamega where a small number of households were engaged in cash crop cultivation. The writer observed that 'all but one of the households which had in the past grown cash crops or who were planning to do so in the future were also headed by resident adult males'. Kakamega has had a high proportion of FHHs owing to high rates of male outmigration in search of wage employment. The 1969 Kenya census (Republic of Kenya, 1980a) showed that there were 36 per cent of FHHs in Kakamega district. Some of these households were helped by men who worked outside the area and sent money back home, which the women used to hire labourers and purchase seeds, fertilisers and tools. Paterson raised the question whether there would be a relationship between the presence of the male household head and the adoption of cash cropping. Since the correlation between FHHs and the level of income is not known, it is not clear whether the main constraint is the preference for food production because of the risks imposed by the reliance on the market for subsistence, given a low level of physical resources, or whether women give preference to securing food for their families, regardless of the level of their resources, because of their sex role.

Staudt (1975/6) showed that women are handicapped by male biases in the offer of agricultural services even when they have large tracts of land. Her research covered three types of agricultural service: visits from agricultural instructors, training, and loan acquisitions (visits being the most common service). She collected information on 212 small-farm households divided into two types: female-managed – when women were fully responsible for the management of the farm (this being a more precise definition of FHH); and jointly managed – when a man was present to share or to take the decisions. In this sample, 40 per cent of the households were FHHs. The number of FHHs benefiting from the services decreased with the nature of the agricultural service.

Roughly half of the farms solely managed by women had never been visited by agricultural officers, whereas only a quarter of the jointly managed farms had failed to be visited.

Abbott (1975) has pointed out that social constraints prevent normal conversation between women and instructors who are predominantly male. In addition, women are supposed to be traditional, conservative and to resist or have difficulties in adopting crop and husbandry innovations that are disseminated by the government. Contrary to these views, Hay (1976) described the intensity with which Luo women in Kowe enjoyed developing new seeds and new methods of cultivating their crops. Rather than promoting conservative behaviour, the social group rewarded innovative behaviour and successful innovators benefited from higher social status. Pala *et al.* (1975) criticised the institutionalisation of the discrimination against women farmers, stating that the roots of the discrimination are to be found in the traditional Ministry of Agriculture's practice of distinguishing between home economics and farm management services. Women have been regarded as homemakers for whom only home economics extension services should be provided, and not as farmers in need of farm management and real agricultural extension services.

In Staudt's field work, discrimination was also observed in the case of attendance at farm training centres and in access to loans. Only 5 per cent of FHHs had at least one member of the household who had been trained in these centres, compared with 20 per cent of the jointly managed households. No FHH had received any loan from the agricultural loan system, compared with 2 per cent of other farms. In addition, only 1 per cent of FHHs knew of the application procedures to apply for loans or had actually applied for loans, against 12 per cent of jointly managed farms (Staudt, 1975/6).

When the households were disaggregated by level of income, access to agricultural services improved for richer FHHs vis-à-vis poorer FHHs, but they still lagged behind jointly managed farms of the same economic level. The number of FHHs of the highest economic group receiving services was practically the same as the jointly managed farms with fewer economic resources. When the size of the farm was taken into account, the results were not changed. The share of FHHs with farms over 5 acres that had been

visited at least once by agricultural instructors increased as compared to the aggregate average for all FHHs (from 51 per cent to 62 per cent) but the proportion of jointly managed farms in the same category increased even more (from 72 to 93 per cent).

Staudt considered that women have been able to diffuse agricultural innovations among themselves through informal channels and women's networks. These means of communication and diffusion cannot replace the agricultural services, however, and the exclusion of female farmers from formal networks decreases their possibilities of improving their labour productivity. Staudt also made clear that in jointly managed farms women were the actual farmers but it was through the 'male' presence that these women farmers had access to agricultural services.

*Access to sources of capital formation and credit*
The problems that affect smallholding agriculture in terms of land, labour, credit and employment directly affect rural women as part of both female or jointly managed smallholding households. The level and the quality of women's assets set up real boundaries that they have to overcome in order to gain access to modern means of production.

Land size and the size of off-farm income are important factors in household differentiation: in addition to providing accumulated savings to finance the purchase of productive inputs such as improved seeds, fertilisers, improved tools, etc., the level of non-farm income determines both the 'ability as well as the willingness of smallholders to borrow' (Collier and Lal, 1979). David and Wyeth (1978) showed that commercial banks favour applicants with collateral (the land presently owned by the applicant) or those with secure wage employment in the formal sector. Since there is a strong correlation between land size and access to well-paid jobs, the two credentials ultimately benefit owners of large holdings. By the mid-1970s, formal credit was available to fewer than 200,000 smallholders, whereas more than 80 per cent of the short- and medium-term credit was channelled towards large holders.

Modern technology, in terms of mechanisation of farming

activities, is concentrated on large arable farms. According to FAO estimates, there were 6,005 four-wheel tractors in Kenya in 1977, 5,728 of them employed on large farms (FAO, 1979; Republic of Kenya, 1980a). Technological innovations in small-farm agriculture have been limited to changes in the crop pattern and the use of fertiliser to increase the productivity of the land. The relative cost of labour compared with machinery and the relatively abundant supply of labour make machinery very expensive for smallholders. Unsuitability of terrain is another factor that explains the low level of smallholding mechanisation. When used on large farms, tractors have many purposes – on large coffee farms, tractors are used for weeding, spraying and also for transporting berries to factories – whereas on small farms they are used almost solely for preparing land for planting. Among smallholders, practically all cultivation is done by hand, which restricts the maximum workable area to the existing labour resources. Although the level of technology varies greatly from crop to crop, the equipment employed by small farms comprises simple implements such as the right-angled fork (*huma*), the right-angled hoe (*jembe*), a machete (*panga*), sickle for grass-cutting and ploughs driven by oxen. Because of the annual feed requirements of oxen, ploughs are mainly used when a landholding exceeds 2.5 acres (International Labour Office, 1976a). Farm equipment represented less than 3 per cent of the mean value of assets per smallholding and the cost of machinery contracts averaged 5.3 per cent of the mean value of farm inputs, while seed, fertiliser and sprays were equivalent to 19.2 per cent of the same total. On the other hand, wages to regular and casual labour represented 27.8 per cent of average farm inputs among smallholders in the same period (Republic of Kenya, 1977). When labour inputs are converted into days worked, the share of hired labour in total days worked on smallholdings is reduced to roughly 10 per cent and it is mostly seasonal (Collier, 1982). In other words, family labour (particularly female adult labour) still remains the main source of labour in smallholding agriculture.

The credit policy, besides favouring privileged farming groups within Kenya, favours privileged technologies: credit

is more readily available for the purchase of four-wheel tractors than for oxen or for ox equipment (Heyer and Waweru, 1976). Subsistence crops received almost no credit (World Bank, 1973).

*Employment alternatives for rural women*
Women constitute a small fraction of regular wage employees in rural areas. In 1971/2, 15,000 females were employed as regular wage workers on small farms and settlement schemes compared to 183,900 males (Republic of Kenya, 1978a). The number of women engaged in casual wage employment is much larger: on coffee estates, women constitute 37 per cent of the regular workers but 80–90 per cent of the seasonal force taken on for the harvesting of the coffee crop. For example, the ILO report on Kenya found that the wives of the regular resident male workers were employed for coffee-berry picking (International Labour Office, 1970). A study of the supply conditions of the female labour force in Kenya showed that women with farms and whose husbands were absent were more likely to be in the labour force than female farmers whose husbands were residents (Anker and Knowles, 1978).

There is some use of hired labour among smallholders; the level of use varies with the size of holding. It is economically rational for a man to sell his labour power for digging, weeding, pruning coffee or tea and to buy female labour to work on his holding, since he may pay only 2–3 kshs per day to a woman, whereas he will be paid around 5 kshs per day. Also, some services such as tractor ploughing have to be paid in cash and this may have to be generated by women as casual workers. The husband may hire labour for his cash crops and still the wife has to sell her labour power to provide money for food or household expenses.

The main activity in the informal non-agricultural sector is petty trade because it requires little money capital to start. Trade and agriculture are none the less tightly connected because most of the traders lack working capital to promote trade as an enterprise and so they sell their own produce. Most of the traders lack cash and storage facilities to purchase crops at harvest time and sell later in periods of scarcity, so trade is often seasonal, becoming more intensive

just after harvesting of maize. It is a very competitive industry, with low barriers to entry but where the returns depend on initial capital and investment. This can be inferred from data from IRS 1 showing that income from trading or homecrafts is fairly stable around the mean value of 450 kshs for all sizes of land below 5 hectares. This value doubles for land sizes between 5 and 7.99 hectares and it increases four-fold for holdings over 8 hectares (Republic of Kenya, 1977).

In the survey of non-farm activities carried out by the Central Bureau of Statistics at the end of 1976, beer brewing was reported in 13 per cent of the sample at the national level, but it amounted to as much as 26 per cent in Nyanza, 18 per cent in Western and 15 per cent in Rift Valley (in terms of frequencies of activities) (Kongstad and Mönsted, 1980). In the study by Paterson (1980), off-farm self-employment was observed to be twice as frequent as wage and salaried positions. Within the area of the sample, females participated in about 30 per cent of the income-generating activities, most of these being in market trading (produce, staples and charcoal sales). Few women reported being employed outside the area of research. Kongstad and Mönsted also estimated that 30 per cent of adult women participated in petty trade in the Rift Valley to earn necessary cash, although the proportion changes over time.

Around the lakes and in the coastal areas, women are both fish traders and fish processors (sun-dried, fried or smoked fish). Women do all the processing operations, which in the case of dried and salted fish involve gutting, refining of guts, splitting, salting, sun drying and transport of the dried fish. The intestines of some fish are used for local fish-oil production (NORAD, 1980). The technology is rudimentary and processing is part of the trade operation because of the lack of proper storage facilities. There is no information on women fish traders, although there are plans to develop the fish industry in the country (World Bank, 1973).

Fish, cooked food, beer brewing and charcoal are the main items that are processed by women traders. Other items are either purchased from shops or food crops cultivated by the women themselves.

Trade on a part-time basis can only supplement the minimum income that is required for household subsistence. Market penetration in Kenya has intensified economic exchanges in labour, land and commodity markets and it has also meant that the reproduction of the labour force is increasingly dependent on the market. Female labour is mainly allocated to food production, but when the holdings are very small and when cash cropping has replaced food crops the household is forced to purchase food. Data from IRS 1 indicated that roughly half of the agricultural production in the different sizes of smallholdings was being marketed through various commercial channels (Republic of Kenya, 1977). In addition, smallholders purchased at least half of their total food consumption on the average. This share increases, the smaller the size of the holding. The main items of food expenditure are grain, flour and root crops, which comprise almost 20 per cent of total food consumption. This expenditure represents both the purchase of items to complement household production and the purchase of a service previously performed by women within the household (maize grinding).

So far, I have attempted to show that women have been traditionally associated with food production and with the daily survival of the household. Even in conditions of land shortage, women are responsible for the supply of additional cash to purchase food (Chapter 4). In male-headed households, husbands participate in household expenses through farm investments and the purchase of farm inputs such as seeds, fertiliser, ploughing and casual labourers. The only service that most husbands pay for is education (school fees), and even this quite often falls on women's shoulders (Kongstad and Mönsted, 1980). Yet, while the money earned by women has very little labour input from the husbands, the reverse is not true. Women and children work on male fields and take care of the husbands' cows. They are also in charge of milking the cows and selling the milk for their husbands.

The general situation of rural women in Kenya is not likely to change in the near future since their education levels are only slowly improving: the IRS 1 showed that 62.09 per cent of the female small-farm population over 5 years had never

attended school, against 42.18 per cent of the male population of the same age. Moreover, although recent data showed that primary school attendance was becoming more equal for males and females, women were still lagging behind in secondary school attendance – the percentage of females aged 13–16 years attending secondary school being half the percentage of males of the same age cohort. In the 1979 census, 55 per cent of the entire female population over 14 years of age in Kenya had no formal education, against only 32.3 per cent of the male population of the same age group. The differences in education between the sexes, although still large, have been decreasing over the census periods, but only at lower educational levels; at the secondary level, the gap between the sexes became wider.

Girls' opportunities for education are also differently affected by their social background or their family's economic status. Children of both sexes, and particularly female children, contribute to the chores of the household, assisting their mothers in the fields and in child care. In one study covering Embu, Nyanza and Tana River districts, three-quarters of the respondents said that they would find it difficult to complete their housework and the *shamba* work without their children's help (Kayongo-Male and Walji, 1977). Child labour activities include planting, weeding and harvesting, running errands, herding and child care.

Smock (1977) stressed the quality of education as an important variable to explain access to job opportunities and social mobility, and was pessimistic about the possibilities for women to increase their odds on the job market through education: basically, women's improved access to primary schooling came after the market for primary school leavers was saturated and they are now disadvantaged in terms of their chances for good secondary and higher education. The educational system also helps to institutionalise fixed female roles since girls are not exposed to the same curriculum, standards and options as boys. These roles fit Western traditions and they do not reflect the past Kenyan experience; they imply that only men should provide for the economic support of the household and that 'women's place is and should be in the home'.

These are the structural problems that rural women of the lower strata in Kenya face in improving their labour productivity and consequently their production and income levels. They are cut off from formal networks of dissemination and diffusion of new inputs and new methods of production both because they lack formal education and because they are supposed to be 'conservative' farmers. Whether as head of their households or as part of jointly managed farms, poor rural women lack the resources to adopt agricultural innovations or adopt them only partially because the whole package of seeds, fertilisers and irrigation cannot be purchased (USAID, 1979a). No study has been carried out to identify the role played by gender in resource allocation and production decisions; in other words, whether female farmers are more responsive to their household needs than to market signals as compared to male farmers. Rural women, as small farmers producing commodities to be sold in the market, face the same constraints as other small farmers to increase their income levels. Yet, rural women are mainly perceived as caretakers of their households, producing goods and not commodities to fulfil the household needs. Empirical research does indicate that female farmers tend to be more reluctant to adopt non-edible cash crops than male farmers with similar resource levels (Paterson, 1980); on the other hand, there is also evidence of innovative behaviour among rural women in Kenya (Hay, 1976).

To discuss the impact of technologies for female tasks on the economic conditions of rural women in Kenya, we have to move from sectoral problems to micro variables at the level of the household. General factors associated with the gender system have to be brought in to explain why women tend to be displaced from productive tasks by technical innovations without any institutional assistance to reincorporate them in social production.

## Alternative technologies for rural women

### The nature of female tasks

The notion of technologies for female tasks is obviously associated with the existence of sex-specific activities where

improvements can be introduced. It therefore seems relevant to continue to investigate the nature of female tasks in Kenya to see whether technologies specific for these tasks could improve the economic conditions of rural women in the country.

The sexual division of labour in terms of specific productive tasks reserved for each sex, as was described for the pre-colonial period, does not seem to prevail any more in Kenya. Sticher (1975/6) mentioned that Nandi men refused to cut roads for the colonial administration since removing top soil was to them equivalent to agricultural work, which was considered to be 'women's work'; Nandi women had to be hired for this type of work. Similarly, Nandi men would not carry loads for the government because this was also considered to be a female task. Men and women nowadays perform virtually the same tasks in agricultural production. In addition, Pala found that, when men moved out of the farms, wives spent more time tending animals (United Nations, 1977b). Cattle herding no longer involves the defence of the herds from enemies or beasts of prey; it has become a routine activity involving mostly watching the animals, driving them to drink water, etc. Children are more active in taking care of animals, but women also herd cattle when children are at school (Oboler, 1977a). In her study, Mbula (1981) raised the hypothesis that the sexual division of labour was no longer an important variable in the analysis of labour allocation and family socioeconomic structures in rural Kenya.

The survey of the division of labour on smallholdings conducted by the Central Bureau of Statistics together with the fourth Integrated Rural Survey (1978)[3] confirmed these changes in the sexual division of labour. Table 6.3 shows that a higher proportion of women alone (20 per cent of respondents) take the major share of the responsibility for preparing the land for farming than adult males (8 per cent of respondents). Hired labour and tractor services are used by only 13 per cent of the interviewees. The task is mostly performed with the use either of both adult male and female

[3] Unpublished data obtained from the Central Bureau of Statistics, Kenya.

labour or of the entire family. The high proportion of female labour for land preparation is explained by the proportion of households without adult males: 23.3 per cent of the households were classified as female-headed.

Table 6.3 *Percentage distribution of participation of household members in preparing the land for farming*

|  | Percentage of the respondents |
|---|---|
| No answer | 3.7 |
| Adult females | 20.0 |
| males | 8.0 |
| females and males | 33.6 |
| females and children | 3.4 |
| males and children | 0.1 |
| Entire family | 18.1 |
| Family and hired labour | 9.4 |
| Hired labour | 2.0 |
| Tractor service | 1.6 |

*Source:* IRS 4 (unpublished data).

Table 6.4 shows the frequency distribution of the respondents by sex and level of participation in four activities (planting, weeding, harvesting and marketing) for six different food crops or groups of food crops (maize, millet and sorghum, tomatoes, cow peas, English potatoes, sukuma wiki, spinach and cabbage) and four cash crops (pyrethrum, cotton, coffee and tea). Although the proportion of women performing a task regularly was roughly 1.5–2.0 times greater than male participation (across all crops), there was still a significant proportion of adult males in weeding, an activity that was traditionally considered to be 'female' and that African males refused to perform for European farmers (Kongstad and Mönsted, 1980). There were differences in labour use for planting cereals, other vegetables and cash crops (including tomatoes). The female share was 1.6 times higher than the male share for maize and 2.0 times higher for millet, and this proportion increased to 2.3 for cow peas and 2.4 for other vegetables (sukuma wiki, spinach and cabbage). Male participation increased for cash crops. Female partici-

Table 6.4 Percentage distribution of participation of household members in agricultural tasks, by sex and crops[a] (% respondents aged 15 and over)

| Task | Maize F | Maize M | Millet and sorghum F | Millet and sorghum M | Tomatoes F | Tomatoes M | Cow peas F | Cow peas M | English potatoes F | English potatoes M | Sukuma wiki, spinach and cabbage F | Sukuma wiki, spinach and cabbage M | Pyrethrum F | Pyrethrum M | Cotton F | Cotton M | Coffee F | Coffee M | Tea F | Tea M |
|---|---|---|---|---|---|---|---|---|---|---|---|---|---|---|---|---|---|---|---|---|
| *Planting:* | | | | | | | | | | | | | | | | | | | | |
| N.A. | 8.9 | 24.5 | 8.9 | 24.5 | 8.9 | 24.5 | 8.9 | 24.5 | 8.9 | 24.5 | 8.9 | 24.5 | 8.9 | 24.5 | 8.9 | 24.5 | 8.9 | 24.5 | 8.9 | 24.5 |
| No work | 2.5 | 9.7 | 56.2 | 54.4 | 86.6 | 71.9 | 63.2 | 59.6 | 77.3 | 66.0 | 68.8 | 62.6 | 84.3 | 69.7 | 82.6 | 68.3 | 77.2 | 61.1 | 85.3 | 69.8 |
| Regularly | 87.0 | 54.4 | 34.2 | 16.5 | 4.1 | 3.0 | 27.4 | 11.9 | 13.4 | 8.0 | 21.4 | 9.0 | 6.7 | 5.1 | 7.7 | 6.0 | 12.8 | 12.5 | 4.8 | 5.1 |
| Sometimes | 1.5 | 11.4 | 0.6 | 4.6 | 0.4 | 0.6 | 0.5 | 4.0 | 0.4 | 1.6 | 0.8 | 3.9 | 0.1 | 0.7 | 0.7 | 1.3 | 1.0 | 1.9 | 1.0 | 0.6 |
| *Weeding:* | | | | | | | | | | | | | | | | | | | | |
| N.A. | 8.9 | 24.5 | 8.9 | 24.5 | 8.9 | 24.5 | 8.9 | 24.5 | 8.9 | 24.5 | 8.9 | 24.5 | 8.9 | 24.5 | 8.9 | 24.5 | 8.9 | 24.5 | 8.9 | 24.5 |
| No work | 2.7 | 7.2 | 56.2 | 54.0 | 86.5 | 72.2 | 63.4 | 57.8 | 77.2 | 66.3 | 68.8 | 63.2 | 84.2 | 70.0 | 82.7 | 68.2 | 73.5 | 60.9 | 84.4 | 69.6 |
| Regularly | 86.9 | 54.7 | 34.1 | 16.3 | 4.4 | 2.7 | 27.3 | 13.2 | 13.4 | 7.6 | 21.5 | 8.5 | 6.8 | 4.8 | 7.7 | 5.9 | 16.1 | 11.9 | 6.2 | 4.7 |
| Sometimes | 1.5 | 13.6 | 0.8 | 5.2 | 0.2 | 0.6 | 0.4 | 4.5 | 0.4 | 1.6 | 0.8 | 3.8 | 0.1 | 0.7 | 0.7 | 1.4 | 1.5 | 2.7 | 0.5 | 1.2 |
| *Harvesting:* | | | | | | | | | | | | | | | | | | | | |
| N.A. | 8.9 | 24.5 | 8.9 | 24.5 | 8.9 | 24.5 | 8.9 | 24.5 | 8.9 | 24.5 | 8.9 | 24.5 | 8.9 | 24.5 | 8.9 | 24.5 | 8.9 | 24.5 | 8.9 | 24.5 |
| No work | 2.5 | 7.9 | 56.2 | 56.6 | 86.5 | 72.2 | 63.5 | 60.3 | 77.2 | 66.3 | 68.7 | 64.8 | 84.4 | 70.1 | 82.6 | 68.2 | 74.6 | 61.7 | 84.6 | 70.0 |
| Regularly | 87.3 | 53.7 | 34.2 | 13.5 | 4.3 | 2.6 | 27.2 | 11.2 | 13.6 | 7.6 | 21.7 | 7.4 | 6.4 | 4.6 | 8.0 | 6.0 | 15.5 | 11.4 | 6.2 | 4.5 |
| Sometimes | 1.3 | 13.8 | 0.6 | 5.4 | 0.3 | 0.7 | 0.4 | 4.0 | 0.3 | 1.6 | 0.7 | 3.4 | 0.2 | 0.8 | 0.4 | 1.3 | 1.0 | 2.4 | 0.2 | 1.1 |
| *Marketing:* | | | | | | | | | | | | | | | | | | | | |
| N.A. | 8.9 | 24.5 | 8.9 | 24.5 | 8.9 | 24.5 | 8.9 | 24.5 | 8.9 | 24.5 | 8.9 | 24.5 | 8.9 | 24.5 | 8.9 | 24.5 | 8.9 | 24.5 | 8.9 | 24.5 |
| No work | 31.2 | 40.5 | 65.8 | 65.3 | 87.8 | 73.3 | 73.0 | 67.3 | 83.0 | 70.3 | 76.4 | 70.1 | 85.9 | 70.6 | 84.0 | 69.0 | 76.0 | 63.0 | 84.7 | 70.6 |
| Regularly | 52.1 | 24.1 | 21.9 | 6.0 | 2.8 | 1.6 | 15.8 | 5.4 | 7.3 | 3.9 | 12.9 | 3.5 | 4.6 | 4.0 | 5.5 | 5.2 | 13.3 | 10.2 | 5.9 | 3.6 |
| Sometimes | 7.8 | 10.9 | 3.4 | 4.2 | 0.5 | 0.5 | 2.3 | 2.8 | 0.7 | 1.2 | 1.8 | 1.9 | 0.6 | 0.9 | 1.5 | 1.4 | 1.7 | 2.3 | 0.5 | 1.3 |

*Note:*
[a] The proportion of both male and female participation decreases with the nature of the crop because the population is not separated by crop cultivation and therefore the number of farmers who do not grow the crop increases across the group of crops.
N.A. = No answer.
*Source:* IRS 4 (unpublished data).

pation was higher than male participation for pyrethrum and cotton but they were fairly similar for coffee and only for tea was the proportion of males performing the activity regularly higher than the proportion of females. This trend was repeated for weeding and harvesting for all food crops but not for the cash crops. For all high-value cash crops, female participation was stable at around 1.3 higher than the male participation. In marketing, there was a similar separation: women prevailed in the commercialisation of vegetables and grains, but they participated in almost equal proportions to men in trading high-value crops.

No change in terms of the sexual division of labour is observed when we move from crop cultivation to animal rearing. Female participation is 3.0 times higher for poultry and milking cows, and it is slightly higher for stall-fed cattle and grazing sheep and goats (see Table 6.5). Male participation is a little higher for cattle grazing, a traditionally 'male' domain, but women participate in almost equal proportion.

The real cleavage in terms of male and female activities occurs in non-monetised domestic food preparation and cooking, house cleaning, child care, buying food, fetching water and firewood. Monetised and non-monetised tasks sometimes overlap with productive and unproductive operation: I define as unproductive the activities that do not produce exchange-values and cannot generate cash income on a permanent basis. Housework activities become 'productive' when hired labour is used in these services. With the only exception of buying food, where 22.9 per cent of the households reported that adult males also participated, all the other activities relied (and still rely) almost solely upon adult female labour.

Female tasks become defined as those primarily producing use-values for household consumption. Weeding is not a 'female' task, but women will tend to do more weeding without male help in crops cultivated for household subsistence than in crops cultivated for commercial purposes (Fordham, 1973). Cleaning the house is a 'female' task; nevertheless, males have been hired as house cleaners in European houses and in the urban areas since the beginning of the colonial period. The same can be said of laundry and

Table 6.5 *Percentage distribution of participation of household members in animal rearing and household tasks, by sex* (% respondents aged 15 and over)

| | Poultry | | Stall-fed | | Cattle grazing | | Milking | | Sheep or goat grazing | | Food preparation and cooking | | House cleaning | | Child care | | Buying food | | Fetching water | | Fetching firewood | |
|---|---|---|---|---|---|---|---|---|---|---|---|---|---|---|---|---|---|---|---|---|---|---|
| | F | M | F | M | F | M | F | M | F | M | F | M | F | M | F | M | F | M | F | M | F | M |
| N.A. | 6.9 | 20.5 | 6.9 | 20.5 | 6.9 | 20.5 | 6.9 | 20.5 | 6.9 | 20.5 | 6.9 | 20.5 | 6.9 | 20.5 | 6.9 | 20.5 | 6.9 | 20.5 | 6.9 | 20.5 | 6.9 | 20.5 |
| No work | 81.4 | 73.0 | 78.1 | 67.7 | 55.0 | 41.2 | 50.8 | 59.3 | 54.2 | 46.1 | 1.9 | 71.5 | 1.4 | 72.1 | 27.5 | 73.5 | 10.5 | 33.8 | 2.1 | 71.4 | 2.2 | 70.6 |
| Regularly | 9.2 | 3.0 | 12.3 | 8.1 | 24.1 | 25.2 | 37.4 | 11.8 | 26.7 | 20.9 | 90.0 | 4.7 | 89.7 | 4.6 | 63.2 | 1.3 | 71.4 | 22.9 | 89.1 | 5.1 | 88.6 | 5.2 |
| Sometimes | 2.5 | 3.5 | 2.7 | 3.7 | 14.0 | 13.1 | 4.9 | 8.3 | 12.2 | 12.5 | 1.3 | 3.4 | 2.0 | 2.8 | 2.4 | 4.7 | 11.3 | 22.8 | 1.9 | 3.0 | 2.3 | 3.7 |

N.A. = No answer.
*Source:* IRS 4.

ironing clothes, let alone food preparation and cooking. In the urban areas of Kenya, male workers are hired to produce the same goods and services that women produce at home, whereas women represent a small share of this wage employment (Republic of Kenya, 1980a). Examples of 'female' activities that become 'male' activities when they are commercialised can be found in other social and historical contexts: when a tourism project was implemented in Ixtapa-Zihuatanejo (Mexico) and modern laundries for the tourism industry were installed they employed men, whereas up to then the laundry for tourists had been done by women (World Bank, 1979).

In this sense, rural women in Kenya do not differ from other women in industrialised economies, although the nature of female work, the economic function of the household and the concrete needs to be satisfied are diverse. The literature on women and technical change has emphasised that the concentration of women on unpaid household tasks or on low-paid tasks that are compatible with the prevailing sexual division of labour is a persistent trend that followed the industrial revolution. Women's history in the first industrialised countries showed that during the industrial revolution urban and industrial development 'generated employment opportunities in a few traditional sectors in which women worked at jobs similar to household tasks' (Scott and Tilly, 1980, p. 93). When employed in the textiles and garment industry, women were young and unmarried. With the development of a market economy, the subsistence character of domestic production changes and the household reduces its productive capacity to the maintenance and reproduction of the social system. This transformation was gradual in the case of the first industrialised countries: as late as 1924, 70 per cent of American rural families were still producing their own food (Vanek, 1980).

It is important to identify the various factors that affect the integration of women into social production. The limits for female employment in the more advanced sectors of the economy are not set by their activities in the subsistence production of goods and services *per se*. The level and the nature of female engagement in subsistence production

depend on the level of development of the productive forces
of the economy as a whole (or, in other words, on the process
of transformation of private production into social pro-
duction), and also on the participation of the household to
which the woman belongs in the control and distribution of
social resources. Changes in social production obviously alter
the nature of household work: women are no longer in charge
of the direct production of goods and services for household
consumption although they are still responsible for the
provision of these goods in the house (managerial tasks), for
the final transformation of products and for the socialisation
of their offspring.

Some women in Kenya were positively affected by the
introduction of new technologies embodied in consumption
goods that decreased part of their burden: for instance,
corrugated iron roofing replaced thatching (a female task
among Kikuyu), processed sugar replaced honey, aluminium
pots replaced pottery, and so on (Stamp, 1975/6). However,
the access of women to mass-produced goods and services
will be a function of the socioeconomic class to which they
belong.

If market economy penetrated all social domains, ultimately
no use-value would be produced within the household and
capitalist enterprises would provide all the goods required to
maintain and reproduce both the labour force as well as
capitalists. All household members – including women –
would sell their labour in labour markets and purchase
commodities in product markets (Conti, 1981). This had not,
however, been achieved even in the most advanced industri-
alised economies, and domestic labour is crucial for the self-
reproduction of the capitalist system (Himmelweit and
Mohun, 1977). None the less, private and social production
in those countries share the same level of technological
complexity: machines used in domestic and market pro-
duction differ only in the scale of production. However, the
scale of domestic production prevents the machine from
being used for market production of the same goods.
Domestic production cannot compete with production organ-
ised by capitalist enterprises.

In newly industrialised countries, domestic or subsistence-

oriented production is achieved with traditional labour-intensive tools with very few purchased inputs (including labour). Different forms of production exist in commodity or market production. There is no clear demarcation between goods and commodities since, depending on the survival strategy adopted by the household, any good or service primarily produced for the household consumption can be sold in the market if demand materialises. Household production does not face the competition of organised capitalist enterprises and the economic logics of household units of production explains their resilience.

In order to increase the effectiveness of policies to improve the economic conditions of rural women, the static and dynamic features of the household units of production where women operate have to be fully appreciated. The internal allocation of resources within the household has to be understood so that technological change can be introduced in the unit so as to increase the output level in economic activities. I shall briefly review some features of the household unit of production.

*The household unit of production*
The household is the fundamental unit of production in peasant economies (see Chayanov, 1925; Mellor, 1969; Sen, 1975; Shanin, 1971). It is within this organisational framework that resources are allocated to produce goods and services to satisfy household needs. The household unit of production (HUP) is characterised by a low specialisation of labour, based, when it exists, on sex and age. At the same time, several labour processes occur in the HUP, each one representing the set of operations required to produce specific goods or services. In this sense, the HUP is a multi-purpose social organisation. The instruments of labour themselves represent embodied household labour and very few inputs are purchased. Surplus agricultural labour will depend on available physical and labour resources. The organisation of productivity is low and the amount of work is dictated by wealth and environmental conditions since the technology employed is rudimentary.

In contrast to factory-based production, there will be no

division of labour within the crafts in an HUP, although there may be division of labour in terms of particular crafts. Any worker occupied in a specific task at a given moment is equally capable of performing other phases of the work. The HUP can thus be conceptualised as a group of enterprises co-existing in the same physical unit or as a multi-product enterprise. Each labour process can be broken down into its constituent elements but the skills required for each work operation are still concentrated in the same worker:

> . . . except under the most unusual circumstances, we do not find the kind of organisation where one woman characteristically specialises in gathering the clay, another in fashioning it, and a third in firing the pots; or where one man devotes himself to getting wood, a second to roughly blocking out the proportions of a stool or figure and a third to finishing it. (Braveman, 1974, p. 71)

In contrast to private enterprises, HUPs are not profit maximisers. Indeed, the notion of profit is alien to HUPs. Decisions are taken on the basis of internal consumption needs rather than market demand. In Kenya, as was mentioned above, HUPs act with imperfect information about imperfect markets for factors and products. Each HUP commands a given level of physical and labour resources and, given the development and the organisation of these markets, domestic resources can be allocated among a finite number of alternatives. In a peasant economy, the first concern of the productive unit is to grow food crops to feed producers and families. Consumption needs can be partially satisfied with goods and services domestically produced, depending on the survival strategy adopted by the household, and any surplus over and above household needs can be sold. The survival strategy is determined by the level and quality of the resources avilable and the organisation of market production. Goods and services may also be purchased in the market, in which case marketable skills and/or commodities have to be exchanged for them.

Several writers have pointed to the multi-dimensional character of female activities in HUPs, which include both

paid and unpaid tasks (see Chapters 2, 3 and 4). Unpaid tasks may refer to non-monetised services that are directly linked to the maintenance and reproduction of the household, such as meal preparation, child care, collection of water and fuel, but they may also refer to unpaid labour services in male cash crop production. Non-monetised activities such as fetching water and fuel are often the input for monetised or 'productive' activities such as poultry keeping, cash crop farming, fish processing, etc. In addition, raw material produced or collected by males in the house may be processed for sale by women.

Hence, HUPs are characterised by complexity and flexibility – complexity because a large number of activities is carried out in the unit and every household member co-operates to produce the goods and services necessary for the household's survival; flexibility, because the low level of its resources forces the HUP to adapt quickly to changes in the natural and socioeconomic environment. Although evidence exists that rural women work longer hours than men, labour processes in HUPs are based on the collective participation of males, females and children.

*The nature of technological change*
Technology encompasses accumulated scientific knowledge, technical skills, factories, machines, products or infrastructures (roads, water distribution systems, storage facilities, etc.). Every human activity involves a procedure by which a task is accomplished and generally it also involves the use of tools. Yet, it was only under the competitive struggle for capitalist accumulation that methods of production became science-based and the level of production increased tremendously.

Resources have been invested in the research and development of low-cost, small-scale technologies to relieve rural women of their burden and to increase their output, while accepting the restrictions imposed by their low purchasing power. These small-scale technologies relate to home tasks (water collection, meal preparation, farming, food processing and storage) and they have been associated with the ideas of the intermediate technology movement of the 1970s led by

Schumacher (1973). They originated out of concern with the disruption caused by the transfer of technologies and equipment from industrialised to less industrialised countries. The factor endowments of the two sets of countries and the factor combination embodied in the technologies were mismatched, with negative consequences for the employment of resources in the recipient countries.

I separate the concepts of 'improved' village technology and 'appropriate' technology, although the objective in both cases is to increase the level of labour productivity and production without decreasing the level of employment. The concept of improved technology is fundamentally conservative since it does not really intend to introduce social, cultural or environmental changes. Improved village technology 'should provide a solution to a felt need, should depend predominantly on locally available skills and materials, should be affordable and culturally and socially acceptable to the community' (UNICEF, 1980, p. 7). Also, 'an improved technology could be a new technology which improves performance of a traditional task or a modification of an existing technology to give better results' (Stevens, 1981, p. 34). Village technology may not, however, be 'appropriate' because the increase in productivity it allows may not be enough to increase the producer's competitive capacity in the market. Kalecki (1976) recognised that, to increase agricultural output in developing economies, mainly technologies that increase productivity per acre rather than productivity per person should be encouraged. The introduction of such technologies was to be associated with the organisation of producers for credit distribution, sale of produce and the utilisation or establishment of irrigation facilities.

In the particular case of female rural producers, very few projects on improved village technology have attempted to provide women with the whole package of credit and technical assistance. Several authors have called attention to this point (Pala *et al.*, 1975; see also Chapters 5, 7 and 9). A piecemeal and project-oriented approach prevails, in the sense that technologies are introduced to relieve women from some visible problem without integrating these efforts into rural development programmes (Date-Bah and Stevens, 1981).

Economic as well as non-economic considerations are involved in the dissemination of low-cost improved village technology among rural women. It can be argued that changes in methods of production can improve the health and working conditions of rural women without affecting the level of marketed output. In this sense, technological change will be induced to increase the subsistence capacity of the household unit of production without taking into account market factors. However, this can be done only if the HUP is interested in isolating itself from monetised patterns of consumption. In other words, if the specific characteristics of the HUP and its insertion in the market economy are not properly analysed, economic factors may defeat policies addressed to non-economic objectives.

When the income level is part of the objective function to be maximised, the introduction of technology has to be preceded by an accurate analysis of resource allocation within the HUP, the alternative employment opportunities that exist, the conditions under which labour process is developed, the real obstacles to increased production and marketing. I shall propose later that an increase in marketed production for any particular good will imply the reorganisation of the labour process and the transformation of domestic production.

Backward and forward linkages in the process of production have to receive adequate attention for induced technological change to be effective. We may take the process of domestic production of groundnut oil and examine one segment of it – the shelling of groundnuts for which there is the traditional method of bare-hand shelling and an improved hand sheller. A new piece of equipment would increase labour productivity but would require more raw material in order to run at full capacity. The existing volume of raw material to be processed may ultimately be compatible with the productivity of bare-hand shelling rather than with the improved hand sheller. In addition, if the demand conditions – as part of the environment – are assumed to be unaltered, even if the shelling was the main constraint to increasing the level of production of domestic groundnut oil, the new surplus would not be marketed. Again, bare-hand shelling

would be 'appropriate' for the level of output the household consumes. I shall develop this point further below.

*Reallocation of labour time*

Let us imagine that time is a transferable resource that can be freely reallocated from one activity to another according to the opportunity cost of each person's time at each stage. In addition, let us assume that different technologies exist to improve the productivity of female non-monetised tasks that are near costless when compared with technologies to improve productivity in agricultural tasks.

Projects to introduce small-scale technologies for non-monetised activities have been implemented by international organisations (UNICEF, 1981). Bhaduri (Chapter 2) was very careful to point out that the slackening of the female time budget without parallel creation of cash-generating opportunities is unlikely to improve the female cash situation. Conceptually, as was mentioned above, the time budget of women can be roughly divided into paid or monetised tasks, unpaid or non-monetised tasks and con-sumption/leisure. If cash income opportunities exist and the time spent on non-monetised tasks was the major barrier to the use of these opportunities, the introduction of low-cost technologies would reduce the time spent and could positively affect the income situation of rural women (United Nations, 1977a; UNECA, 1967). This is one of the main concerns of organisations involved in the dissemination of this type of technology:

> There are two complementary roles that appropriate technology can play in development of the welfare of women. The first role is that of labour saving, i.e. developing devices and techniques that will cut down on the time and drudgery spent in performing tasks such as gathering firewood, collecting water and grinding grain. The time saved by the use of this type of technology can be channelled towards benefit-producing activities. (UNICEF, 1980, p. 16)

There is no doubt that adult females in Africa spend a high

proportion of their working time fetching water for the household. According to official statistics, in 1975 only 1 million rural inhabitants in Kenya, representing roughly 9 per cent of the rural population, had access to an improved safe water supply (Carruthers and Weir, 1976). Data from IRS 1 showed that the source of drinking water was farther than one mile from the holding for 14 per cent of smallholding households in the wet season, and this share was increased to 28 per cent in the dry season (Republic of Kenya, 1980a). Fetching water and firewood is still the responsibility of adult females, although children also help in these tasks (Table 6.5). IRS 2 (Republic of Kenya, 1980a) reported that 51 per cent of small-farm households fetched water at least three times a day. In 46 per cent of the households, adult females were totally responsible for this task and in another 40 per cent of the households adult females and children would fetch water together. The remaining 15 per cent was distributed among adult males (7 per cent), children only (3 per cent), adult males and children (2 per cent) and adult males and females (2 per cent) (UNICEF, 1981). A reliable water supply for rural households is necessary regardless of the effect on women's time budget, but my main concern here is the increase in cash income for rural women in a market economy with the characteristics of Kenya. In other words, reorganisation of the female time budget is not relevant if it fails to improve productive employment and cash generation.

Empirically, there are several problems associated with the reallocation of time from non-monetised to monetised activities. One study carried out in Zaire (quoted in Carruthers and Weir, 1976) concluded that, on average, each household could save as much as 100 minutes per day if water was available on the farm. When a water supply was introduced in the area, it was expected that this would have a positive impact on productive activities. In reality once both water and time were available, more time was put into other non-monetised activities such as cooking, cleaning and washing. No change in the volume of agricultural production or in cropping was observed and very little additional time was spent on agricultural activities. This stemmed from the

fact that not just one but three–four persons were involved in water collection and the time saved on this activity was reallocated individually. On the other hand, no change was introduced in the physical assets (land, productive inputs and means of production) and no research had been undertaken to verify whether labour time was the basic constraint to increasing agricultural production.

In concrete terms, the amount and the quality of the information required for an effective reallocation of time from non-monetised to monetised activities is a severe obstacle to its applicability. Resources have to be channelled towards the gathering of detailed information on time-budget composition of household members, which presents several problems. First, there is the problem of aggregation of labour time calculated on a daily basis. In the previous example of water collection, almost 2 hours in one day could be reduced to half-an-hour per person per day if divided among four persons or half-an-hour four times a day if carried out by the same person in different periods of time. Second, the household unit of production is very complex because of its flexibility and its adaptability to seasons, to problems of the individual members of the household, to demand fluctuations, etc. Also, the labour process (or the way the different tasks are organised within the household) is co-operative, with the participation of various members of the family and/or hired labour. The importance of identifying the links between the tasks of every member of the family in order to make any intervention effective has been recognised by some development organisations (World Bank, 1979).

It has to be stressed that, with a given level of information on tasks, tools and objectives, the female head of the household acts as the manager of her labour time and of that of other members of the family from whom she can get help with her duties. General studies of female time expenditures are too aggregate to indicate precisely whether one or more than one female performed all the activities. If the number of hours that adult females were found to spend in individual tasks such as fetching water, fuel collection, agricultural production, animal rearing, meal preparation, and so on, in different studies are added up they may go beyond the

physical limit of 15 or 17 hours of work per person. (Wallis, 1975, quoted one study where women spent up to 10 hours per day looking for water and queueing for it.) This indicates either that some of these activities are done simultaneously or that more than one person takes care of the operation. The association of activities may preclude time reallocation: the same agent may collect water while taking maize to the mill; if the water supply is made more accessible, the same person will still walk long distances for the second operation and no time will be saved to be employed in productive activities.

Moreover, it is unclear whether women would spend more time in productive activities just as the result of time availability. If no income-generating opportunities are created, the expansion in the level of output in labour processes in which women are already involved is more likely to be limited by the level and the quality of the resources and the technology to which they have access (in these areas) rather than by their labour time *per se*. In other words, it is improbable that the time women assign to agricultural production would increase just because more time is available. In order for the level of output to increase, the size and the characteristics of the land, the tools, the crops and the associated market conditions have to be improved.

These statements should be phrased as hypotheses since we do not have clear evidence on the limiting factors to increased agricultural productivity on low-income female farms. From my review of small-farm agriculture in Kenya, it was concluded that improvements in productivity in the small-farm sector were a direct consequence of access to modern biochemical inputs through savings out of off-farm income. Family labour resources then become a binding constraint if capital resources are not enough to hire in labour. It was also mentioned that at low levels of income the importance of the holding as a source of income decreases. This seems to be less a result of lack of human resources than of physical resources. From this it follows that further research should identify whether women's labour time is the real constraint to increased agricultural and agriculture-related production.

There are other aspects of technologies that I still want to

discuss with respect to rural women: they refer to scale of production and changes in the labour process.

*Indivisibilities of scale* Empirically, technology embodied in tools and machines presents problems of indivisibilities of scale that have to be considered in the existence and development of technologies 'for women'. Let us assume the following example: one family consuming an average of 5 kg of grain a day and a woman grinding about 2 kg of grain a day if she relies only on her hands, mortar and pestle. If no change in the technology is introduced, she will spend 7–8 hours a week grinding maize. A maize sheller and a hand-operated maize grinder can be developed that will increase the efficiency of this operation, cutting the labour time to half. A power-operated maize grinder which would drastically decrease the time spent on the operation, would not be economic to purchase because, at this level of performance, the output of the power-operated equipment is beyond the consumption capacity of the family. Thus, unless the surplus production can be commercialised, the woman has to decide whether she wants to incur the purchasing and training costs of the simpler machine, which will halve the time she spends in grinding maize, or, alternatively, purchase shelled maize and take it for grinding, which saves her time and, if the price of the low-cost maize grinding machine is higher than the total fees she pays for renting the services of the *posho* mill, may save her money. In addition, buying shelled maize and taking it to the mill is an activity that can be done by other members of the household, particularly children. Needless to say, in order to pay for the shelled maize and the milling the woman would have to produce more goods to sell in the market or sell her own labour services. Poor women will still plant their own maize and do the shelling and grinding by hand, or they may do just the shelling by hand and pay for it to be processed.

Between hand-operated machines and power-operated machines there are discontinuities in the scale of production that ultimately involve changes in the labour process. A given labour process implies the combination of labour time and tools to produce a given level of goods and services. The

labour productivity is associated with the ultimate destiny of these goods and services: if they are produced for internal consumption, the level of consumption defines the requirements for labour productivity. In other words, innovations may not be required because at this level of consumption the technology employed, regardless of how rudimentary it is, meets the needs of the household. We arrive, therefore, at a paradox. Drudgery is commonly associated with low levels of productivity resulting from the use of manual tools. 'Evolutionary' technologies that improve upon manual tools without drastically affecting the scale of production cannot eliminate the drudgery involved in the operations, because the source of energy is still the same – calories burnt by human beings. The introduction of power-driven machines can decrease the drudgery but the labour productivity is not compatible with the previous levels of consumption. The costs of purchasing and operating the machine define a minimum level of production below which the operation of the machine is not economical. Even if the machine is to be non-profit operated, the labour process has to be removed from individual households and the consumption needs of several households have to be combined or socialised. In addition, any small change in the way of performing an activity will always imply additional costs in terms of learning new postures, which may not be offset by the marginal gains in productivity. A sensible article on village technology and women's work in Eastern Africa called attention to the fallacy of improving technology without taking into account human factors and indirect problems connected to the use of new technologies:

> So far, there has been little progress towards improving means of transport . . . Muscles adapted since early childhood to the head-carrying of loads would be ill-suited to the task of struggling to push a cart or wheelbarrow over such tracks. This type of approach would be likely to add to the workload rather than reduce it. (McDowell and Hazzard, 1976, p. 57)

Technological advancements that may alleviate the drudg-

ery involved in female tasks do not necessarily advance female economic and social participation (Landes, 1977/8) if women remain confined to subsistence production. Such solutions maintain and reinforce a division of labour based on sex that is the very element precluding women from fully participating in the process of economic and social development. Induced technical change must promote the social participation of women by bringing men and women into the sharing of responsibilities in and outside the family (United Nations, 1977a, p. 7). Otherwise, perverse results may occur. For instance, it was found that in Kenya, after water was made more accessible to women, they received less assistance from other family members in fetching it: 'Without supporting programmes, such as improving the efficiency of the water-carrying system, improved access to water may hold no benefits for women' (World Bank, 1979, p. 21).

On the other hand, if technological change is induced with the objective of decreasing the drudgery in potentially cash-earning activities for women, this will necessarily lead to increased production beyond the subsistence requirements of the household unless the woman chooses to rent the services of the machine or to purchase processed food in the market, in which case she will almost inevitably purchase the good or service from a man. This is why Bryson suggested that:

> The designs of programmes to enhance the women's productivity would have to be carefully handled. It is important to avoid presenting them as commercial programmes as that would defeat their purpose, i.e. 'cash' crops are male crops and men would be more likely to take over such programmes. (Bryson, 1981, p. 44)

Projects that do not challenge existing power relations and retain conventional concepts of the sexual division of labour do not help women to see themselves as economically active and capable persons. Similar objections have also to be raised to the way 'female' projects are developed. These are very rarely considered to be 'serious and productive' ventures: women are often taught to make articles for which the

market is non-existent, limited or short-lived (World Bank, 1979). Feldman is even more incisive when criticising women's projects in Kenya:

> Projects should be investigated by experts from the appropriate departments to assess their economic and technical viability and to give advice. In this way women's projects can come to be taken seriously at ministerial levels and, instead of being trivialised as women's projects, they can take their proper place as serious social and economic projects carried out by women. (Feldman, 1981, p. 66)

Savane (1979) criticised projects that do not consider the different phases of production, storage, transportation and marketing. She quoted one case where women invested their meagre resources in tools, seeds and fertilisers without realising that they had no means of transporting their perishable agricultural products to market.

It is not part of the scope of this chapter to analyse women's projects in general, and I wanted to substantiate my initial argument that the mere idea of technologies for women without other rural development policies consolidates the position of women in sectors of low productivity and low returns (see Chapter 5 for the description of a successful project for women in the United Republic of Cameroon). Women face similar problems to men of the same social class but they have been handicapped by lack of training and by lack of access to formal education and economic opportunities. Their condition can be upgraded only with the recognition of their double role as producers of physical goods and services as well as of human beings. Women have to have access to social services to remove from their shoulders the responsibility for the maintenance and reproduction of the labour force. (Employment of women can be uneconomic if the private sector has to bear the costs of social services for child care and education which are freely done by housewives – Molyneux, 1979; see also Humphries, 1977.)

Nash (1977) and Beneria (1979) have both strongly emphasised the constraints imposed by women's biological role in reproduction on their mobility and on choosing how

to allocate their resources: '. . . a basic assumption about the division of labour . . . has linked women's biological role in reproduction to the social responsibility of nurturing and socialising the future generation' (Nash, 1977, p. 161). Tinker held that the non-consideration of the fact that women must perform two roles in society whereas men perform only one is the major explanation for the adverse effects of development on women. She claimed that 'men "subtract" a woman's home and child care responsibilities from her ability to hold down important positions' (Tinker, 1976, p. 23). It seems, therefore, that the productive activities women perform are connected only to their role in the household and no attention is given to the attitude of women towards their work as productive beings. As Bryson remarked:

> Unfortunately, most of those who have written about the women's agricultural activities have either emphasised the back-breaking nature of their toil and the observer's desire to get the women out of the hot sun and into their houses or decried the fact the women have been left behind in the traditional sector while men have moved on to modern occupations. (Bryson, 1981, p. 37)

The role women play in biological reproduction and the activities that are consequently assigned to them have to be taken into account in the interpretation of the impact of technical change on rural women in Kenya and in policy recommendations that would follow.

## Summary and conclusions

Subsistence production based on manual tools and rudimentary technology involves physical strain, back-breaking work and tedious, routine tasks, regardless of the sex of the agent involved in the production. The toil of rural women in Kenya has not been reduced as much as it should have been by the process of economic and technical change: a large proportion of women have stayed in subsistence production while men have mostly moved out to commercial production

and off-farm wage employment. This of course does not overlook the trade-off that could exist between family income and women's toil (see Chapter 2). Improvements in the technical conditions under which women work have to consider the concrete barriers to the transformation of subsistence into market production, otherwise technical change will fail to improve the condition of rural women on a permanent basis.

I have reviewed the present situation of rural women in Kenya with reference to small farmers. I have referred to self-employed women in the small-farm sector because this is the main source of female employment in Kenya. Historically, these women subsidised the migration of adult males out of the farms in their transition to modern wage jobs. Some of these women benefited through remittances used to replace male labour by hired labour or tractor services, and women in the high-income groups could purchase goods and services in the market instead of producing them within the home. The majority of rural women, however, reproduce the vicious cycle of poverty: they do not generate enough cash income to accumulate savings and without savings they cannot change the technical conditions of production and increase their productivity.

It is well established in the literature of economic development that rural poverty results not from the lack of technical solutions to increase productivity, production and income but from the impossibility of access to modern means of production and productive inputs: 'Poverty can be traced to a lack of access to employment opportunities, land, water, markets, credit, modern technological innovations (hybrid seed, appropriate mechanisation and transport, and fertiliser, for example), power, quality education and medical care' (Republic of Kenya, 1979, p. 21). This impossibility is dictated, on the one hand, by the level of physical and human resources controlled by the rural poor and, on the other hand, by the development of the productive capacity of the economy.

Low-income female-headed rural households in Kenya usually do not have adult males in the house to perform heavier tasks and do not have the means to replace this family labour with hired labour or tractor services. The soil that they can till is dependent on their labour helped by

rudimentary manual tools. The women's capacity to save and to acquire new means of production is generally limited because of the volume and quality of their assets. This does not make them different from other male small farmers except that women have a 'double burden': whenever they are engaged in productive activities, their normal chores related to housework and child rearing are still their responsibility. In addition, as was mentioned above, low-income female small farmers in Kenya have hardly any access to agricultural extension services and are excluded from the formal networks of information and dissemination of agricultural technology. This is the basic picture to be kept in mind when technological solutions for women are to be discussed.

Both monetised and non-monetised tasks performed by rural women can be affected by improvements in agricultural production with different outcomes. Technical change can mean the loss of previous sources of income for women or an increase in their unpaid workload.

> Mechanisation usually places women at a disadvantage by carrying out heavy tasks, notably breaking and preparing land, which are often the traditional responsibility of men, but leaving to hand labour those tasks such as weeding normally carried out by women, the burden being aggravated by the additional acreages being cultivated by mechanisation. (Chambers, 1969, pp. 174–5)

In Kenya, for instance, women in Mwea had their unpaid weeding workload increased by the additional acreages cultivated through mechanisation (Hanger and Moris, 1973). On the other hand, in Uganda and Kenya, the use of herbicides and knapsack spraying reduced the number of days needed for weeding per acre by 80–85 per cent on certain coffee and tea plantations. This task was mainly done by women (United Nations, 1980).

This is not to ignore the fact that male workers also lose sources of employment. Nash (1977) mentioned that the introduction of pumpsets for irrigation, wheat threshers and reapers in Punjab reduced the male labour force to about

one-fifth of that involved in traditional farming. The data provided by Agarwal (Chapter 4) indicated relatively more employment losses for men than for women as a result of the Green Revolution in India. Nevertheless, the private losses are higher for women than for men because over time new occupations and training opportunities are created for men but not for women:

> Machines that replace women's labour, manufactured or imported goods that successfully compete with women's crafts and the advantage of large-scale trade that competes with small-scale women's trade decreases access to income-earning opportunities . . . These factors affect both men and women, but occupational and training opportunities offset this tendency for men. (Staudt, 1978, p. 10)

Tadesse (1979, p. 12) said that women's participation in the agricultural sector is inversely related to development: 'In areas where no new technology has been introduced one finds a high percentage of women. Conversely, women are the first to be displaced from tasks that can be mechanised.' Moreover, she observed that technological changes have led to the concentration of women in domestic roles (food production, household maintenance and child care), non-market productive work (both agricultural and non-agricultural) and labour-intensive activities in general. Palmer and Buchwald (1980) also concluded that, unfortunately, the usual forms of peasant agricultural intensification maintain or even create more labour-intensive, low-productivity work for women in sex-typed tasks such as planting and weeding, whereas the more labour-saving, high-productivity work goes to men in sex-typed tasks such as ploughing and harvesting. The latter tasks can be more easily upgraded through mechanisation. It seems that it is not because women prevail in some sectors that little or no technical change has taken place there but, conversely, that women predominate in these sectors because no technological innovation was introduced. Technological change is associated with the development of new skills and with the know-how to operate new machines and new inputs. Women are handicapped by factors acting at

both the supply and demand sides: from the supply side, they are restricted in their mobility by their responsibilities for the physical and social reproduction of human beings; from the demand side, they are constrained by the decisions of male 'gatekeepers' who do not upgrade female skills either through formal or informal training and who select male workers to perform new activities. When activities that were previously performed by women (for example, maize grinding) are mechanised, women are not selected to be trained to operate the power-driven machines. Men, who never ground maize by hand before and who always associated this task with female activities, are proud to learn how to grind with power-driven machines the maize brought by the women.

I have criticised the piecemeal approach of intermediate technology 'for women' on ideological and empirical grounds. The concentration of effort on small-scale technologies for women necessarily implies relegating women to low-productivity, subsistence-oriented activities. Studies have shown, however, that it is not the nature of tasks that makes them male or female but their end use: a given task will be identified as 'male' if it is part of social or market production; conversely, 'female' tasks are associated with private consumption or subsistence production. Hence, if women's conditions are to be transformed on a permanent basis, the conventional roles and power relations have to be challenged. Women have to be integrated into social production and forms of organisation have to be found to allow women to benefit from power-driven machines that can relieve them from their work burden and provide sources of cash income. Women have to be trained to operate modern machines, to do book-keeping and to understand market operations.

Technologies to improve the condition of rural women will necessarily affect the organisation of the labour process and they will imply the creation of collective forms of production and/or consumption in order simultaneously to make women benefit from technical progress and from the existence of new sources of energy and to increase their income level. Kenya has a prominent tradition of self-reliance groups, and women have been encouraged to organise themselves as women's groups. This organisational form has not been adequately

used because officials involved with women in the field are either community development assistants or home economics extension workers, 'both concerned with women's welfare and domestic functions' (Feldman, 1981). Yet the organisational structure exists and it could be an effective instrument to improve the economic condition of rural women. For that to happen, women's projects have to acquire credibility within governmental institutions, and established notions of the sexual division of labour have to be brought up to date:

> If women's groups are to have an economic impact at all, then they need to be the focus of breaking down existing conceptions of the sexual division of labour . . . This could mean women themselves engaging in the construction of feeder roads, of domestic water tanks, of buildings for crèches and nurseries, women learning to drive and do cost accounting. . . . (Feldman, 1981, pp. 66–7)

The trend of commercialisation of production and the need for cash income felt by rural women in Kenya is not likely to change in the near future. However, they will have to compete with other groups for scarce social resources and employment opportunities. The promotion of women's situation is part of the objectives of planned development in Kenya with the underlying assumption that economic development and the integration of rural women in the general process of development are interdependent issues.

# 7

# Technologies for Rural Women of Ghana: Role of Socio-Cultural Factors

*EUGENIA DATE-BAH*

## Introduction

Technology is widely recognised as an important factor in the development process. In recent times, scepticism has been expressed about the extent to which complex industrial technology imported from the developed societies can transform, among other things, the economic condition of the bulk of the people in the developing countries. Increasingly, people are coming to realise the key role that simple but improved technologies, preferably developed with endogenous materials, can play in ameliorating the lot of large rural populations in these countries. It is in this general context that lately such technologies are discussed as an effective means of bringing relief to Third World rural women from their numerous back-breaking tasks, an increase in their income and employment and a general improvement in their conditions of life as well as that of their families and communities that greatly depend upon them. The focus on rural women and improved technologies in the developing countries in recent years is also related to the observation that the improved technologies already developed have tended to assist rural men more than women. The bulk of rural women remain saddled with traditional techniques and tools that are not always efficient and that also tend to make the tasks laborious, time-consuming and strenuous.

In the case of Ghana, there is a third reason for the

upsurge of interest in rural women and their use of improved technologies. This is related to the current deteriorated economic condition of the country with its associated acute shortages of food and other essential items for running the home. Since rural women have traditionally cultivated food crops and made some of these needed items, such as soap, it is now vital for them to have improved tools to be able to produce more to meet the household and also the country's needs.

In this chapter, 'improved' technology refers to simple tools, techniques and skills that are more efficient than the traditional ones, in terms of the increase in the quantity and quality of their output and the lessening of human strain and stress, and that, unlike the advanced technologies, are not capital intensive. An improved technology could emerge as an upgrading of a traditional technology or a development of a new one.

This chapter has three main objectives: (a) to examine the women's traditional activities, the methods, tools and skills they employ in the performance of these activities as well as the institutional constraints on these activities prevailing in Ghanaian society in order to show some of the areas that could benefit from improved technologies; (b) to attempt an evaluation of the improved technologies already introduced on a pilot scale to the women in some villages to ascertain the precise factors (social, economic and technical) contributing to their acceptance or rejection, a finding that could guide the planning of future improved technologies for these women; and (c) to examine dissemination strategies adopted in the past and new ones that could also be employed. Its scope is, however, considerably limited by the paucity of detailed documentation on Ghanaian women's activities, their time use and methods, and the absence of a survey of rural technologies in the country. A full evaluation of the women's tools and methods is thus greatly impeded. Within these limits, the chapter nevertheless shows, to some degree, that the issue of introducing improved technologies to rural women even in one society is a complex one that has to take into consideration not only the economic cost, complexity, technical efficiency and economic profitability of the improved

tools – factors often stressed in the literature – but also socio-cultural factors, such as diverse traditional beliefs, cultural practices, tastes, land tenure systems, linkages between people, including male and female activities, ethnic and regional variations. This points to the need for adopting a holistic approach to the issue of improved technologies for rural women. The chapter concludes with a summary of the main findings and a list of areas for further research to form the basis for the formulation of a comprehensive project on improved technologies for Ghanaian rural women.

## Potential for technological improvements in rural women's traditional activities

Of the 2.5 million women aged 15 years and over in Ghana, 71 per cent live in the rural areas (1970 population census of Ghana). These women are a very industrious lot and perform a wide range of labour-intensive domestic chores, including fuelwood and water fetching, and multifarious economic activities such as farming, processing and distribution of goods in addition to their role as mothers of large numbers of children. The statement is often made that the idea of a full-time housewife is unknown in traditional Ghanaian society. The national activity rate for all females (both rural and urban) aged 15 years and over is 61 per cent (Republic of Ghana, 1970; this figure is viewed by many as an under-estimation). The 1960 and 1970 population censuses show the important role that these women play in the national economy. In 1960, 579,000 Ghanaian women were engaged in agriculture and by 1970 the figure had increased to 771,726. In commerce, women completely outnumber men: in 1970, women accounted for 84.6 per cent of the country's total labour force in this activity. Modern industry, construction, transportation and mining, on the other hand, have very few women. Women are also found in food processing, the manufacture of bakery products and wearing apparel. Because of this high rate of economic participation, many of the women are able to support themselves and their children.

A breakdown of the female labour force by status indicates that they are mainly in self-employment (74 per cent) and

also in the informal sector. Some of the women (19 per cent) are unpaid family workers and only 7 per cent are salary and wage earners. There are also rural–urban differences in the economic activities of the women (Table 7.1). With the urban women, trading is the most important occupation but with the rural women it is farming, followed by trading. Farming, some food and other processing activities as well as domestic chores of the rural women are discussed in some detail below to show the methods and tools they currently employ and in what ways improved technologies, in the form of upgrading and adaptation of the traditional techniques or development of new ones, can help them. This help is seen in terms of increasing the women's output in both marketable and non-marketable activities and lessening their burden by reducing the time and effort involved in the performance of these activities. Another benefit of the improved technologies for the women is perceived to be an improvement in the hygiene condition of their food-processing activities and thus an improvement in the health of the women as well as that of those who depend upon them. In what follows, it is also observed that, in some of the women's activities, an improvement in the tools used may not bring about much change in the women's lives unless there is also an improvement in the institutional and other related features of their social environment.

*Farming*

Ghanaian women play such a major role in the country's agriculture that Boserup (1970) describes the agricultural system of southern Ghana as a female farming system. Although the sexual division of labour in traditional farming is such that men do the initial difficult task of clearing the land and felling trees, the women shoulder most of the remaining laborious and time-consuming farmwork such as planting, subsequent weeding, harvesting and carrying of the produce home from the farms. There are, however, some regional differences here, especially between the extreme north and the rest of the country. The pattern described above is what obtains in southern Ghana. In the northern half, clearing of land, weeding and harvesting are all done by

Table 7.1  *Employment of females by occupation on a rural–urban basis, 1970*

| Occupation | Rural No. | % | Urban No. | % | Total No. | % |
|---|---|---|---|---|---|---|
| Agriculture, animal husbandry and forestry workers, fishermen and hunters | 704,794 | 68.6 | 66,932 | 17.3 | 771,726 | 54.5 |
| Professional, technical and related workers | 10,056 | 1.0 | 18,037 | 4.7 | 28,093 | 2.0 |
| Administrative and managerial workers | 186 | 0.0 | 400 | 0.1 | 586 | 0.0 |
| Clerical workers | 1,201 | 0.1 | 12,157 | 3.1 | 13,358 | 0.9 |
| Sales workers | 171,327 | 16.7 | 191,814 | 49.5 | 363,141 | 25.7 |
| Service workers | 4,709 | 0.4 | 16,266 | 4.2 | 20,975 | 1.5 |
| Production and related workers, transport, equipment operators and labourers | 135,693 | 13.2 | 81,547 | 21.1 | 217,240 | 15.4 |
| All occupations | 1,027,966 | 100.0 | 387,153 | 100.0 | 1,415,119 | 100.0 |

*Source:* Unpublished data from the 1970 population census.

the men, and women do the planting (Bogaards, 1969). Indeed, women's farming work in the north is reported to be mainly backyard gardening to provide the family's vegetables. Staple food, such as millet, is grown by the men. (In recent years, a few of the women here are also found in small-scale rice farming and face some of the problems to be considered later with women farming in the country.) This limited participation in farming of the rural women in the northern half of the country has been observed by Klingshirn (1971) to be related to the long time the women have to spend in search of water and firewood because of the arid nature of this part of Ghana.

Before the introduction of cash cropping in Ghana, members of the extended family or village – males and

females – used to assist each other in food crop cultivation and harvesting. With the introduction of cash crops, especially cocoa, more of the male farmers moved into pure cash crop farming and the burden of growing food crops to feed the family fell heavily on the women (Hardiman, 1974; Bukh, 1979). Bukh observed in the village of Tsito that, without male assistance, the women could not continue in yam farming, which required more physical strength, and had to turn to the cultivation of cassava, which required less labour and effort but also provided less nutrition.

At the current time, the bulk of rural women in Ghana are food farmers producing plantains, maize, cocoyam, cassava and also vegetables such as tomatoes, peppers, garden eggs, shallots, beans and okra. Most of the women who are also owners of farms are in food farming (see Tables 7.2 and 7.3). Some of the women are also found in cocoa farming in other parts of the country, such as Ashanti, Brong Ahafo and Akim (P. Hill, 1963; Okali and Mabey, 1975). There are, however, more male than female cocoa farm owners. Apart from farm owners, a large proportion of the group loosely referred to as 'family workers' and also labourers on these farms are women and they offer a lot of assistance to the men on their farms, such as the transporting of farm produce by head loading from the farms to the house.

Whether in food farming or cocoa farming, the productivity of the Ghanaian women farmers compared to that of the males has been found to be low (North *et al.*, 1975; Okali and Mabey, 1975). The major contributory factors to this low output are:

- The small sizes of their farms owing to their lack of resources to hire extra hands to cultivate larger plots, especially with the children now attending school and the women thereby deprived of their help.
- The rudimentary nature of the tools they work with, including hoes and cutlasses, whereas some of the men have access to tractors. Moreover, cutlasses are often scarce on the market and when available are expensive.
- The land tenure system, which sometimes discriminates against women in the allocation of land for farming.

Table 7.2  *Detailed occupations of employed persons in agriculture, by sex, 1970*

| Occupation | Male | % of male labour force | Female | % of female labour force | Total | % of total labour force |
|---|---|---|---|---|---|---|
| Staple foodstuffs and vegetable farmers | 514,320 | 50.1 | 542,231 | 70.3 | 1,056,551 | 58.7 |
| Cocoa farmers and farm managers | 367,343 | 35.8 | 205,121 | 26.6 | 572,464 | 31.8 |
| Tobacco farmers and workers | 1,678 | 0.2 | 628 | 0.1 | 2,306 | 0.1 |
| Rice farmers | 8,120 | 0.8 | 3,816 | 0.5 | 11,936 | 0.7 |
| Cotton farmers | 75 | t | 123 | t | 198 | t |
| Rubber planters and plantation workers | 1,246 | 0.1 | 608 | 0.1 | 1,854 | 0.1 |
| Sugarcane | 3,168 | 0.3 | 1,802 | 0.2 | 4,970 | 0.3 |
| Coconut | 5,924 | 0.6 | 1,677 | 0.2 | 7,601 | 0.4 |
| Coffee farm managers | 11,633 | 1.1 | 7,813 | 1.0 | 19,446 | 1.1 |
| Oil palm farmers | 2,881 | 0.3 | 1,046 | 0.1 | 3,927 | 0.2 |
| Livestock and dairy farmers | 5,262 | 0.5 | 720 | 0.1 | 5,982 | 0.3 |
| Poultry farmers and farm managers | 3,470 | 0.3 | 782 | 0.1 | 4,252 | 0.2 |
| Other farmers | 29,972 | 2.9 | 1,338 | 0.2 | 31,310 | 1.9 |
| Horticultural farmers | 4,604 | 0.4 | 227 | t | 4,831 | 0.3 |
| Forestry workers | 6,940 | 0.7 | 1,655 | 0.2 | 8,595 | 0.5 |
| Fishermen | 58,648 | 5.7 | 800 | 0.1 | 59,448 | 3.3 |
| Hunters | 1,246 | 0.1 | 1,339 | 0.2 | 2,585 | 0.1 |
| Total | 1,026,530 | 99.9 | 771,726 | 100.0 | 1,798,256 | 100.0 |

*Note:*
t = trace, i.e. only a few people engaged in that sector.
*Source:* Unpublished data from the 1970 population census of Ghana.

- The fact of their not being reached by the male extension workers and the lack of chemical inputs such as fertilisers.

Table 7.3 *Detailed occupations of employed persons in agriculture, by sex, 1960*

| Occupation | Male | % of male labour force | Female | % of female labour force | Total | % of total labour force |
|---|---|---|---|---|---|---|
| Farmers and farm managers (food-stuffs) | 462,730 | 46.9 | 385,499 | 66.8 | 548,229 | 54.3 |
| Farmers and farm managers (cocoa) | 313,922 | 31.8 | 143,234 | 24.8 | 457,156 | 29.2 |
| Farmers and farm managers (other crops) | 26,142 | 2.7 | 37,497 | 6.5 | 63,639 | 4.1 |
| Farmers and farm managers (live-stock and poultry) | 5,484 | 0.6 | 642 | 0.1 | 6,126 | 0.4 |
| Farm equipment operators | 1,292 | 0.1 | 6 | t | 1,298 | 0.1 |
| Curators of grounds (grounds keepers) | 145 | t | 5 | t | 150 | t |
| Agricultural workers | 103,555 | 10.5 | 6,687 | 1.2 | 110,242 | 7.1 |
| Hunters and related workers | 1,427 | 0.1 | 27 | t | 1,454 | 0.1 |
| Fishermen and related workers | 53,790 | 5.5 | 2,785 | 0.5 | 56,575 | 3.6 |
| Loggers | 7,876 | 0.8 | 55 | t | 7,931 | 0.5 |
| Palmwine tappers | 6,707 | 0.7 | 181 | t | 6,888 | 0.4 |
| Firewood cutters | 285 | t | 244 | t | 529 | t |
| Chewing stick cutters and gatherers of other forestry products | 10 | t | 60 | t | 70 | t |
| Rubber tappers | 181 | t | 4 | t | 185 | t |
| Charcoal burners | 1,527 | 0.2 | 405 | 0.1 | 1,932 | 0.1 |
| Other forestry | 1,070 | 0.1 | 8 | t | 1,078 | 0.1 |
| Farmers, fishermen, hunters, loggers and related workers | 986,143 | 100.0 | 577,339 | 100.0 | 1,563,482 | 100.0 |

- The considerable distance of the farms from the village, which necessitates a lot of time and energy expenditure simply walking to and from the village, often carrying their babies on their backs. Hardiman (1974) reports that the women in a Brong Ahafo village walked 3–6 miles to reach their farms and Bukh (1979) observed that when the women settle for farmlands near the village they end up with infertile land.
- The numerous other chores the women have to perform, in addition to food crop farming, which deplete the energy and time the women have for farming.
- The fact that the initial clearing of the land and felling of trees for female farmers who are without male assistance, such as widows, divorcees and those with migrant husbands, is more expensive because it has to be hired out and with the increasing cost of farm wage rates, this affects the size of the farms they cultivate.
- Lack of access to credits. It has been observed that the Agricultural Development Bank, the main bank in Ghana that lends to small-scale farmers, has not extended much of its lending activities to women farmers because women tend to lack the security or collateral often required by the Bank, such as a house (Ewusi, 1978). The women therefore have to rely upon their own personal savings, which are often inadequate, to cultivate their farms and therefore they are unable to till large farms. They do not approach the village moneylenders because exorbitant interest rates are charged.

These factors stress not only tools utilised in the women's farming activity but also institutional constraints, such as the land tenure system and the lack of agricultural extension inputs as crucial determinants of the women's low farm output. This indicates that a change in the traditional farm tools alone will not totally solve the problem but that it must be accompanied by some changes in the country's agricultural

*Note:*
t = trace, i.e. only a few people engaged in that sector.
*Source:* Republic of Ghana (1960), Vol. 4.

extension programme and land tenure systems. These latter factors are, therefore, discussed in more detail below.

*Agricultural extension services*

The agricultural extension service, which concerns itself with giving instruction and practical demonstrations in improved farm practices, is the main avenue for the dissemination to rural farmers in Ghana of improved tools, the use of fertilisers and high-yielding seeds. The service has been in operation in the country since 1890 (Opare, 1979-80, p. 5). However, its personnel are mainly males. (Only 10 per cent of the extension officers trained at Kwadaso, Kumasi, are females.) Naturally, male farmers have been the main focus of their work and very few women farmers have benefited from them. For example, only 15 per cent of women farmers in Aburi mentioned in 1978 that they had been visited by the extension officers (Ewusi, 1978). We also learn from the literature that, in some ways, the European colonial administration contributed in no small way to this state of affairs by choosing to concentrate agricultural extension training only on the men (Hardiman, 1974).

Food farming, which is mainly done by the women, therefore still continues to be carried on in the traditional way, so that an acre of maize yields 500 lbs instead of the potential 1,500 lbs. Post-harvest losses remain high – 12 per cent for grains, 20–25 per cent for cassava and 30 per cent for plantain (Opare, 1979/80, p. 4). The farms also suffer from lack of insect and pest control.

Although the women farmers continue to lack access to extension services, a new unit has been set up within the Ministry of Agriculture for women farmers. This is the Home Extension Unit, which came into being in 1967–8 to convey agricultural information to women farmers. Its staff are mainly female field workers with training in agriculture and home economics. Their main focus has been nutrition in relation to food production and diet improvement, processing and storage of farm produce and also management of resources in the farm and home. The operation of this unit needs to be evaluated since its impact appears to be limited although it has been in existence for more than a decade.

*Land tenure system*

There are always institutionalised rules that govern the use and non-use of land in a particular society or ethnic group and these rules influence tremendously the agricultural practice of the people concerned. The rules can, for example, put constraints on people's access to land or to a particular type of land and, therefore, on their output. Although there are differences between the ethnic groups in Ghana in connection with the land tenure system, in many of the ethnic groups of southern Ghana land belongs to the lineage or the *stool*. (The *stool* is the symbol of the community; it is the chief's symbol of office.) In other words, absolute or allodial title is vested either in the lineage or in the *stool*. However, any member of the lineage group or any stool subject – male or female – is entitled to occupy any unappropriated portion of the communal land and thereby acquire an interest in that land. It is this interest that Ghanaian customary lawyers call a usufructuary title or the usufruct. This term is not synonymous with the usufruct in European law. In the customary law, it refers to a bundle of rights that the occupier has in the land, which amount to ownership for most practical purposes.

In practice, members of the lineage or stool subjects, when they want land for farming, tend to ask the lineage head (the *abusuapanyin*) or the chief to assign them a piece of land. It is sometimes observed that the *abusuapanyin* discriminates against women in the allocation of land. Ewusi (1978) reported that this was the main reason given by the women of Kwamoso village in the eastern region to explain why only a few of them (23 per cent) were farming on their own piece of land and over 70 per cent were farming jointly with their husbands on their husbands' plots. Bukh (1979) also observed with respect to the village of Tsito that in practice men more than women have access to the lineage land and also to land that is more fertile, which they put under cash crop cultivation. With the infertile land, the women can cultivate only cassava, which is a hardy carbohydrate crop that can grow on virtually any type of soil.

It would also appear that the women are often allocated small-sized plots and, therefore, cannot practice shifting

cultivation – the main mode of traditional farming – and are forced to farm on the same piece of land every year. Also because of this weaker access of the women to lineage land, Okali and Mabey (1975) found in some Ashanti and Brong Ahafo villages that the women farm on small acreages that they have received mainly as gifts from their parents or husbands.

Among a few ethnic groups such as the patrilineal Krobos, women as a rule do not have access to the lineage land (Sarpong, 1974, p. 118). The exception is an unmarried woman residing in her father's home who could be given a piece of land as a gift by the father if the father has acquired his own land.

Over the years, some individualisation of title to land has been occurring. With the introduction and spread of commercial agriculture, such as cocoa farming, land sales have occurred. This has greatly eroded the principle of inalienable lineage landholdings, which was very much in evidence in the traditional period. Tenancies have also emerged as the other principal form of alienation of rural land. In the case of both land sales and the granting of tenancies, the landowners have complete discretion whether to sell or to lease and to whom. Consequently, in contrast with the situation where the head of a lineage allocates a portion of the lineage land to a member, owners have more scope to discriminate against various categories of people including women. This, however, needs to be studied, since there is no documentation of actual discrimination of this nature in the limited literature available.

The discussion so far on farming has shown that it is a predominant activity of rural Ghanaian women, especially in the southern half of the country, and therefore an improvement in this activity through, *inter alia*, the introduction of more efficient energy- and time-saving devices probably has a greater capacity for transforming the lives of rural women than an improvement in any other area, with the possible exception of domestic chores and food processing. Apart from the rudimentary traditional tools used, institutional factors such as the land tenure system, extension services and credit have also been mentioned as constituting a major

constraint on the effective participation of women in this activity. There are, however, other problem areas here. For example, no tools exist in many parts of the country for shelling maize and groundnuts, or for winnowing. These activities therefore have to be done manually by the women in addition to their other farming activities. Another major problem with farming is storage and lack of effective linkages between the farmers and the urban markets. (These are problems faced not only by the women but also the men.) Thus, a substantial proportion of the already inadequate agricultural output gets destroyed.

*Food processing*
Food processing is virtually a women's domain, not only for family consumption but also for sale. This would thus seem to be another important area where improved technology has the potential for greater impact on the lot of rural women and on society. The general characteristic of the traditional techniques and tools used by the women in this activity would seem, from the discussion that follows, to be their tedious and time-consuming nature. Consequently, the introduction of more efficient and labour-saving implements should stand these women in good stead.

*Fish preservation*  Fish smoking is a major activity of rural women along Ghana's coast. A good proportion of the fish caught by the fishermen is smoked by the women before being sold on the markets (Lawson and Kwei, 1974). In a survey of the fish-smoking industry in some parts of the country by the Fisheries Department, it was found that as many as 12,784 women engaged in this activity, operating 38,260 ovens and smoking 79,700 tons of fish annually (Kagan, 1970). The 1960 census gave an even bigger figure: out of a total of 90,000 people in the canoe fishing industry, 47,000 were women who processed and sold the fish.

The fish smoking is done in big cylindrical ovens built out of mud, using firewood as the fuel. The fish-smoking operation involves a number of activities. Firewood has to be collected or bought; the fish have to be scaled manually; the ovens have to be packed with the fish; after being smoked,

the fish are removed and packed in baskets, to facilitate easy transportation to the various parts of the country for sale. An evaluation of this traditional method of smoking fish seems to indicate that it considerably reduces the net protein utilisation (NPU) of the fish. Fish smoked in this way has an NPU of 65 per cent compared to 91 per cent for fish preserved by improved technology (Oracca-Tetteh, reported by Campbell-Platt, 1978).

Another way of preserving the fish, especially the very small ones, is by drying on flat sunbaked surfaces such as the sides of roads. Vercruijsse (1983) found in some Fante villages that the women occasionally resorted to sun-drying of fish when they did not have enough firewood and could not raise the money for it or if the fish was going rotten, but, generally, they prefer smoking as a way of preserving the fish.

Some species of large fish are preserved not by smoking but by being heavily salted and then dried. The bones in the fish are first removed and the fish cleaned with fresh water. They are then packed in drums with a lot of salt. After some days, they are removed from the drums and left on a flat surface in the sun to dry. Because of the brine saturation, when dry the fish still contain some moisture and therefore are a little soft, unlike the fish dried without prior brine saturation. The fish in this state can last 6–10 months.

The operation of the fishing industry involves co-operation between the fishermen and their wives or, where they have no wives, wife surrogates. The fisherman catches the fish and the 'wife' processes and sells them. This 'wife' may be the real wife or, if he is single, widowed or divorced, the woman who cooks his pot, namely his mother or sister (Vercruijsse, 1983). This woman is often assisted by younger female relatives or daughters in the household. After selling the fish, the 'wife' makes accounts to the man, deducting the expenses she has incurred on transportation and marketing of the fish. The man pays her a commission and also gives her part of the money for the upkeep of the family. The relationship between the fisherman and his 'wife' is thus like that between a supplier and an agent. Some fishermen are reported to say 'we do not have any bank, we do not have any source of

income. Our wives are our bank and our sources of income' (Hagan, 1976). The money the fisherman gives out of the fish sales for the upkeep of the family is often not enough to last the family through the lean non-fishing season. Therefore, the 'wife' often trades with it to generate more income to provide food for the family. Thus, Hagan (1976) described the fishing community of Winneba as possessing a family economy that 'rests on a system of division of labour based on sex and on husband and wife co-operation'. A pertinent implication (applicable to other areas as well) of this form of economic co-operation is that improved technologies should not be addressed exclusively to one sex, since the changes in behaviour needed for the successful operation of such technologies may have to come from both sexes.

*Gari making*   Gari (processed cassava) was originally a staple food prepared and eaten by the Ewes in the Volta region. In recent years, however, it has become increasingly popular with many Ghanaians as a result of the shortage of many other food items and also because it is easy to make dishes out of it. To prepare *gari*, the women peel fresh cassava and grate it manually. This process often takes a long time. The ensuing mash product is put in sacks and left to ferment for several days. During the process of fermentation, the sacks are left on the ground with big stones on them to help squeeze out the water and the excess starch. After the fermentation, the mash is sieved to remove the odd lumps in it and then roasted in a small clay pan over a wood fire. The *gari* prepared in this way can keep for a long time without going bad. However, this mode of preparation is time-consuming and tiresome. Moreover, during the fermentation stage, when the cassava mash in sacks is left on the ground, some contamination occurs.

*Dried cassava flour (kokonte)*   Kokonte is another way in which rural women process cassava. The women peel fresh cassava, cut it into pieces and dry it in the sun, which takes about seven days or more, depending upon the weather. The cassava is then taken by the women to the mill or pounded into flour in a mortar using a pestle. This process of drying

the cassava has been observed to expose the cassava to dew and other atmospheric changes, as well as to contaminants. As a result, the cassava often changes from white to black in colour and becomes 'unpleasant and unappetising' (Campbell-Platt, 1978, p. 8).

*Cooking oil* Rural women also process cooking oil from coconut, groundnut, palm nut and palm kernels, mainly by using the technique of pounding and boiling. The oil extraction rate using this traditional method is low – only 41 per cent for copra processing and 10 per cent in the case of palm oil (Oracca-Tetteh, reported by Campbell-Platt, 1978). Particularly laborious is the process by which palm kernel oil is made. Rural women have to spend days doing the tedious job of cracking the palm nuts one by one with a stone. In some districts, a nutcracker machine has now been introduced, but there are at present no improved tools for many of the other processes, except for the grinding of the nuts. The roasting of the kernels is done by the women in a pot on a wood fire. The roasted kernels are milled and the ensuing mash is boiled in water. The oil that rises to the top of the water is then collected. The whole process is thus quite labour-intensive and time-consuming.

The various kinds of food-processing activities described above are not meant to be a comprehensive catalogue, for the women also process numerous other foodstuffs, such as maize into *kenkey*. These other food-processing activities share the time- and labour-consuming features of the activities already described. Thus, their performance could also be augmented through the use of improved tools. Most of the food-processing activities also involve the use of water and firewood. The fetching of water and firewood constitutes part of the most burdensome chores of these women as will be perceived from the following discussion of the women's domestic chores.

*Domestic chores*
In the traditional social structure of Ghana, the sexual division of labour is such that women are responsible for all

the domestic chores. In connection with this, Hardiman reported that in all the 'village communities, the routine daily tasks of cooking, sweeping, washing clothes and household effects, fetching water and firewood and caring for children fall mainly on the women, and it is rare to see adult men taking any part' (1974, p. 109). These domestic tasks tend to consume a consierable amount of women's time and strength. Thus, Hardiman noted that in some Akwapim and Brong Ahafo villages the women work continuously for 15–16 hours a day. Wagenbuur (1972) also observed from a study of some lime farmers and their families in southern Ghana that the females, unlike the males, have very little time for leisure and spend more hours in domestic chores in addition to on- and off-farm productive activities (Table 7.4).

Table 7.4   *Rural family members (excluding children) and their time use: five lime-farming families*

| Activity | Hours per month | |
| --- | --- | --- |
| | Male | Female |
| Household | 64.2 | 171.5 |
| On- and off-farm production | 123.6 | 141.8 |
| Leisure | 103.2 | 40.8 |

*Source:* Wagenbuur (1972).

*Fetching water*   Fetching of water features prominently among the domestic chores of rural women. Only 2.8 per cent of the 47,643 rural communities have pipe-line water in Ghana (Republic of Ghana, 1977). Women and children therefore often have to walk long distances every day to the water supply, which may be a stream or a pond. In the village of Kpompo in the south-eastern part of the country, Parker (1978) reported that women carry up to 60 lbs of water on their heads on each journey to collect water from the riverside. From a study of twenty-one households in the village, Parker observed that in only three of them was a man involved in this activity and this was found to be related to

the sickness or absence of the wife. In the northern and upper regions of Ghana because of the drought conditions, women and children have an especially onerous responsibility looking for water and often have to walk for miles before finding any.

An infrastructural technology in the form of a pipe or the provision of adequate and safe water supply in the villages and near the homes is seen here as important from the point of view not only of saving the women the excessive time and energy expended on water fetching, which they could put into other activities, but also of the improvements of the general health of the village people. In a study of water utilisation in some rural villages near Accra, Nukunya and Boateng (1979, p. 22) observed that the transmission of many diseases in the area was related to the nature of water used. Thus the provision of safe water might also lead to an increase in the physical energy the people put into economic activities. In another study of rural water use, Twumasi *et al.* (1977) noted that improved water supply in the Ghanaian villages would lead to a reduction in infant mortality and in parasitic, preventable and other water-borne diseases such as bilharzia, dysentry and typhoid infections, which tend to be rampant in areas that rely on rivers, ponds and other traditional water supply systems. One could, thus, infer that rural women would also save on the time and energy they spend looking after sick children as well as adults, and since idleness tends to be frowned upon for women in these rural communities, they are likely to put the released time to more productive use.

In Ghana, there has been some governmental effort in the past to provide villagers with improved water supplies. For example, in 1975 there was a crash programme launched with the assistance of the Canadian government to construct wells in the upper region of the country (Nukunya and Boateng, 1979). In spite of this effort, many rural settlements both in the upper and in the other eight regions remain without a safe source of water near the homes.

In rural houses roofed with corrugated iron sheets, women and children are able to collect water when it rains by simply putting buckets and pans under the eaves. The water is then

stored in large earthenware pots or, to a lesser extent, in oil drums. (Not many people have access to the oil drums because of their high cost.) Water collected in this way relieves the women and children for only brief periods from the burden of walking long distances to look for water because the storage capacity is often very limited. In addition even where rural houses have corrugated roofs, not much water can be collected if there is no guttering to catch the rain water.

*Fuel and cooking methods employed by the women* It is also relevant here to examine the tools used in the domestic realm. Firewood is the main form of fuel used for cooking and food processing generally, and the women have to walk long distances to comb the forest for it. When they find it, the only tools they have for chopping it up are the cutlass and the axe, and they therefore expend a lot of their strength and time on these activities. (When the task of hewing the wood is particularly difficult, the womenfolk sometimes ask for the assistance of the men.) In the upper region, because of its savanna vegetation, looking for firewood is an especially lengthy process, particularly when the millet and sorghum stalks are used up. The women have to walk for miles to obtain enough firewood for cooking. This points to the great need for fuel-efficient technologies and/or substitutes for firewood in the rural areas of Ghana. In the upper region, for example, there are cattle, and therefore biogas from cow dung could be explored. Other materials now completely wasted, which could be used, are corn cobs and groundnut shells. Other techniques for improving the fuel supply situation could be the sowing of quick-growing trees near the villages and also the utilisation of improved cutting technologies, such as portable mechanical saws instead of the cutlass and the axe.

The stove currently used by the rural Ghanaian women for cooking is the three-point open mud stove, which stands low on the ground, tends to consume a lot of fuelwood and gives out a considerably amount of smoke, which often irritates the eyes, causes headaches and coughs and also makes the women's clothes smell (Asare, 1976; Hevi-Yiboe, 1979).

Moreover, the cooking process is very cumbersome and, therefore, very time-consuming. Although the long hours of pounding grains have been considerably curtailed by the increasing use of power-operated mills, the daily pounding, in a wooden mortar using a pestle, of cassava, plantain, and cocoyam or yam to make *fufu* (a favourite dish in many Ghanaian homes) still continues. In addition, the daily grinding of vegetables such as pepper, tomatoes and leaves in a shallow earthernware bowl (*asanka*), using a wooden spoon, or sometimes on the smooth surface of a flat stone, is still prevalent. The women have to go through this elaborate cooking process every day because they lack refrigerators and other technologies for preserving cooked food.

When these hours spent in domestic chores are added to the women's working day on the farm, 'the picture that emerges is one of a normal day fully spent in work of one kind or another' (Hardiman, 1974, p. 108). The women spend their non-farming days catching up with domestic chores, such as washing. The women thus have very little time for rest or for participation in political and other social activities or in training programmes mounted in the village. The effect on the women of the performance of these numerous back-breaking chores is natural tiredness and constant complaint of 'chronic ailments, such as backache, headache, aching limbs, chest pains and the like, and as the well-being of themselves and their families depends so much on their maintaining their strength, life indeed seems hard when they are feeling under the weather' (Hardiman, 1974, p. 108).

*Other activities*

*Salt mining*    The women around the Keta Lagoon in the south-eastern corner of Ghana mine salt, as there is very little land for farming in this area. The Keta Lagoon is brackish and during the dry season the outer fringes evaporate leaving large incrustations of salt, which is mined by the women for selling. Salt mining in this traditional way tends to be time-consuming and labour-intensive and, therefore, necessitates the women spending a greater part of the day in the salt mines during the mining season.

*Soap making*  Rural families in Ghana have always tended to be relatively self-reliant compared to urban dwellers. They produce and process not only their food but also their soap and pots. Traditionally, the women prepare soap (*kokodoma*) from boiling together palm oil and lye – a mixture of water and the ashes of burnt cocoa pods, plantain, banana peel or palm bunches. The traditional mode of combustion of these waste products tends to take a lot of time. Moreover, the type of soap produced has a dirty colour; it is also very soft and therefore quickly dissolves in water (Holtermann, 1979, p. 31).

In recent years a major handicap rural women in Ghana have faced in soap preparation is the inadequacy of the supply of palm oil. Until recently there was no large-scale cultivation of the oil palm in the country – oil palm grew in the wild and a few people cultivated it alongside their food crops – and the limited output of palm oil is put to many uses, such as cooking, in addition to industrial use in the modern sector. Faced with the acute shortage of palm oil, women in the villages are increasingly collecting and processing other oleaginous plants, such as shea butter, into cooking oil and for use in soap preparation. They also make use of other locally available but secondary oleaginous plants that they had stopped using for many years (Posnansky, 1980).

*Pottery*  Some of the rural women produce various types of round clay pots that are used for cooking, serving of meals and storage of things such as water. In some rural villages, such as the Fodjorku area near Akuse and Pankronu near Kumasi, almost all the women make these pots in addition to farming and they sell the surplus pots on the markets of the nearby towns. This pottery activity is traditionally considered an exclusively female sphere and is regarded as a taboo for men, in the same way as weaving is considered an exclusively male activity and a taboo for women.

The women collect the clay from a swampy place and carry it home in containers on their heads. The clay is sometimes stored in the containers in the open air for a week to allow the ageing process to occur. The women next pound and

knead the clay to get rid of any pebbles and twigs it may contain. The clay is then divided up, the size of each portion depending upon the size of the pot to be made. A hole is dug in the middle of each portion by scooping out some of the clay. The shape of the pot is obtained by pressing the lump of clay from the inside with a corn cob. The desired height is reached by adding layer upon layer of clay. The excess clay is then scraped off. The pot is also smoothened during this stage by applying a flat piece of wood. After this process, the pot is left to dry and then put to woodfire in the open air. When burnt, the colour of the pot becomes black or red depending on the type of clay used. The burning process alone takes about six hours. The whole traditional pot-manufacturing method absorbs much time and energy.

Before the onset of Ghana's present economic crisis, the production of earthenware pots was on the decline because of the availability of cheap cast-iron cooking pots. Now, because of shortages, cast-iron pots are very expensive, costing from ¢30–100 (Posnansky, 1980) and therefore villagers are tending to use earthenware pots instead, which cost only ¢2–5.[1] They are also resorting to earthenware bowls rather than enamel bowls and plates, as a result of the latter's scarcity and high costs at the present time. Thus, women potters now have a good market for their wares. Posnansky (1980, p. 2419) reported of the potters of Bonakyere in the Brong Ahafo region that they 'are selling their pottery as fast as they can make them'. However, with the manufacturing process unchanged, it would appear that the making of pottery must now consume a lot of the women's time and energy. (Female activities are not the only ones to have experienced this growth as a result of the country's economic crisis. According to Posnansky's study (1980), some male craftsmen who were almost on the verge of extinction, such as tinkers and blacksmiths, are now back in full business to repair old broken-down metal items, which cannot be replaced because of the acute shortages.)

In the ILO Tarkwa Women's Project (International Labour Office, 1980a) a beginning in the improvement of the

---

[1] Currently US$1 equals Cedes 50 approximately.

process of pottery production has been made. Tests on local clays have been carried out not only to decide on their suitability but also to find ways of making their processing more efficient. New designs and products have also been thought of, such as casseroles, covered jars, pitchers, drinking cups and teapots in addition to the usual pots and bowls the women make. Improved firing of the products is also under consideration.

*Charcoal making*   In some of the villages in the Volta region with little forest land, the women have taken to charcoal burning as a source of income to supplement the unpredictable yields from their farms. In a sample survey of some households in one such village in 1970, it was found that incomes from charcoal selling accounted for 33 per cent of the total income for women and 10 per cent for men (Parker, 1973, p. 87). Thus, it is quite an important source of income for some of the village women.

The process of making charcoal consumes both time and labour. First, hardwood is obtained by felling dead trees. The wood is chopped up manually with an axe or cutlass and the pieces are arranged tightly in heaps. The heaps are then covered with a lot of grass and a layer of earth, leaving a small hole on one side of the heap through which the fire is applied to get the wood alight. Usually the fire spreads slowly and it takes about seven days to burn the wood partially and turn it into charcoal. The ensuing charcoal is lighter than the wood. Often during the burning stage holes appear in the mound and have to be immediately sealed to prevent oxygen from entering the mound. The women are able to tell whether the charcoal is ready or not from the colour of the smoke. While the wood is burning, the smoke is often blue and when the burning of the wood is completed the smoke changes in colour to whie. The mound is then broken and the charcoal carried on the head to the village. Improved methods and tools for charcoal production need to be developed to save the women from the enormous time and energy spent in this activity.

This review of some of the rural women's domestic and

economic activities has brought to the fore the general plight of the Ghanaian rural women: they are responsible for numerous time-consuming and laborious chores, which are, however, vital for the survival of the rural family and the society. The alleviation of the burdens of rural women would seem to require a multidimensional approach, although a consideration of the technological dimension is of considerable value since it has been observed above that the plight of these women is to some extent related to the type of tools, techniques and methods they employ in the performance of their activities. Their current traditional methods are able to yield some results, but there are areas in which they could be improved upon both to give higher output in terms of quantity and quality and also to lessen the strain and stress through saving time and energy. It is, however, clear from the discussion of land tenure systems and inadequate extension inputs that improvements in technologies alone would not in all cases ensure the desired progress for the women unless these are accompanied by institutional changes.

## Constraints to technological improvements in rural women's activities

In some of the rural women's activities outlined above, improved technologies have already been developed and introduced, albeit in only a few villages. The discussion that follows will examine some of these technologies and attempt to identify the major constraints on their adoption. Carr (1980) and others who have reported on the introduction of improved technologies to rural women in Africa have tended to stress, among other factors, the high cost and degree of complexity of the improved tools as the main factors restricting the women's acceptance of them. In this section, the main hypothesis that is tested, using the limited available data on these technologies in Ghana, is that, apart from these factors and profitability, rural women are more likely to accept improved technologies that fit into the customary practices, production processes, tastes, taboos and beliefs they are familiar with than those that conflict with them.

*Food processing*
Many of the improved technologies already developed for rural women in Ghana are in the area of food processing.

*Fish smoking*  A number of improved ovens for the smoking of fish have been introduced in Ghana, although with very limited results (Campbell-Platt, 1978). Examples are the altona and Adjetey ovens. The altona oven, which was imported from Germany, was introduced by the German Volunteer Service to women fish smokers at the coastal village of Biriwa in the central region. The metal oven has a closed smoking chamber with a chimney that is built on a lower combustion chamber made of brick. Within 4–5 hours, it can smoke a total of 180 kg of fish threaded onto thin metal rods. The altona oven's adoption rate was low primarily because of its high cost.

The Adjetey oven, built of heavy metal, has a combustion chamber that is located to the side of the smoking chamber, with a line connecting the two chambers. This oven was also rejected by the women because of its cost and complexity and the change it introduced in the smoked fish. The women observed that the fish smoked with this oven did not come out as dry as that smoked with their traditional oven since little heat was retained in the smoking chamber. Thus, the new technology led to the modification of the product to the dislike of the women and this was a major contributory factor to its rejection.

A third type of oven that has also been introduced in recent years was devised by the Fisheries Department of the Ministry of Agriculture. Unlike the first two, this oven has been very successful from the point of view of its acceptance by the women. Kagan (1970) reported that it is found in many coastal villages. Its acceptance is related not only to its low cost and high productivity, but also to its nearness to the traditional process of fish smoking familiar to the women. The only changes it introduced in the traditional oven were the addition of more drying trays and its use of less firewood.

The Ghana National Council on Women and Development assisted some of the women at the village of Kokrobite to acquire the improved oven by granting them loans for its

purchase; these loans were quickly repaid because of the profitability of the improved technology. It was observed that with the improved ovens the women could smoke more fish than before and there was therefore a greater demand by them for fish to smoke. This demand could not be met because of the lack of a related change in the tools of the fishermen.

*Sun drying of fish and kokonte (cassava)*   It was observed earlier that Ghanaian women traditionally dry cassava by leaving it in the sun for days. Fish is also dried in the same way. This process 'may take more than six weeks to dry the fish or "kokonte". Even then, the moisture content may be as high as 17 per cent' (Campbell-Platt, 1978, p. 14). It is also inefficient in terms of exposing the food item to the vagaries of the weather, humidity and contamination. The quality of the product thus depreciates.

In recent years, improved low-cost equipment – namely sun-drying racks – for the drying of fish and *kokonte* has been introduced by the Ghana/IDRC Rural Fishery Research and Development Project. The rack stands off the ground on poles and is a considerable improvement on the traditional method since it takes only a few days for the fish to dry. This improved technology has so far been introduced on a pilot scale only in one area, Elmina, and it needs to be disseminated over a wider area. In fact, there is evidence that this technology is not altogether new to Ghana because it is the customary mode of drying fish in some parts of the country, such as the Axim area in the western region. This fact probably explains why it was so readily accepted by the women in Elmina. The speed with which it dries the fish or *kokonte* was another contributory factor to its acceptance.

*Gari making*   An improved method for preparing *gari* consists of a mechanical cassava grater, which can grate more cassava in less time than manual grating, thus removing the strain in the latter traditional method. A pressing machine has also been introduced that is able to squeeze out the water from the grated cassava within a few minutes instead of the usual several days. The cassava mash is then roasted in a big

enamel pan that can take almost ten times the quantity as the traditional pan. This innovation has been implemented so far only in one village in the Volta region of Ghana (namely the village of Mafi-Kumasi), but there are plans to have it replicated in the other regions.

Before the use of this innovatory technique, the women of Mafi-Kumasi produced 500 *gari* bags, weighing 50 kg each, a week, but with the improved tools they are now able to produce 5,000–6,000 bags a week (Ghana National Council on Women and Development, 1980, p. 4) when they have enough cassava. This increased output of *gari* can be maintained only with a higher yield of cassava in the area. Therefore, a male cassava growers' association has been formed to step up cassava production and a tractor has been acquired through the USAID by the women co-operatives to be able to put more land under cassava cultivation.

This success story amply supports the hypothesis: the women were already engaged in the making of *gari*. Under the new scheme, the main traditional techniques – the grating of the cassava, the squeezing out of the water and the roasting of the cassava – were maintained but improved upon. However, this factor was not the only explanation for the success of the scheme. The women also had a lot of say in the design and development of the improved technologies by a local company. Also of importance was the economic factor of increased output and income flowing from the improved mode of production.

## Other improved technologies

*Improved seeds for maize cultivation*   Within the past decade, high-yielding maize and rice varieties have been introduced in the country by the government through the Grains Development Board and the Ministry of Agriculture, but the extent of their adoption by women farmers has not been fully documented. However, Bukh (1979, p. 69) reported that women farmers in Tsito were reluctant to adopt the new hybrid maize because it tasted different from the local variety. In addition, according to the women, the new maize 'is harder to prepare' into *kenkey* and the other maize dishes

that they often cook for their families. The women therefore
considered the hybrid maize only as a cash crop and not as a
food crop that they could grow to feed their families.
Another complaint was that the new maize, unlike the local
variety, was 'less resistant to drought and insects'; it also
required different storage methods. Moreover, the yield was
highly dependent on the use of chemical fertilisers, which
they found expensive. The women also believed that the use
of fertilisers changed the taste of the crops. Thus, only one of
the female farmers Bukh (1979) interviewed in her Tsito
study was growing the new maize.

The reasons proffered by the women for not accepting the
new hybrid maize seem to fit into the hypothesis postulated
above. The new maize produced a taste different from what
they were used to and was not as suitable for the preparation
of their customary dishes as the traditional maize. They also
show that often rural women may have reasons that are
rational, but are not thought of by government departments
and development agencies, for rejecting improved technol-
ogies intended to assist them.

*The kiln*   A special kiln has been constructed by the
Engineering Faculty of the University of Science and
Technology to simplify and speed up the burning of plantain,
banana peels and palm bunches into powder that is used by
the rural women as caustic potash in the manufacture of
soap. Instead of going through a lengthy process every time
soap is to be prepared, the women now have ready for their
use powdered caustic potash produced in a kiln by the Ghana
National Council on Women and Development (NCWD).
The women soap makers have accepted the powdered caustic
potash because it is a product with which they are very
familiar. Moreover, it considerably shortens the time the
women previously spent in the preparation of soap (it now
takes the women just one hour to prepare the soap instead of
one whole day); it also saves them the firewood they often
have to fetch or buy to do the day-long burning of the palm
bunches and plantain peels. The NCWD has established a
small plant with the kiln at Kwamoso, a village in the eastern
region where there is a government oil mill, in order to utilise

the palm bunch waste of the mill to produce the caustic potash. The main problem with traditional soap making in Ghana now, as already indicated, is the scarcity of palm oil. The Technology Consultancy Centre is therefore experimenting with substitutes such as cocoa butter, castor oil, physic nut, neem and monkey cola and shea butter. (It has already been observed that the rural women themselves have started using other oleaginous plants available in the villages.) The Technology Consultancy Centre has found neem to give the best soap but there is the problem of the high cost of its collection (Holtermann, 1979).

*The broadloom* Traditionally, rural Ghanaian women do not participate in the weaving of *kente* and the other types of cloth their men produce. This is related to the belief that weaving on the narrow loom with the legs apart creates infertility in women. It is believed that when a woman touches the loom during her menstrual period her reproductive organ is immediately rendered unproductive (Konadu, 1980). The Technology Consultancy Centre has developed the broadloom, which is 40 inches wide compared to the 4–6 inch width of the traditional narrow loom, and has tried to interest women in weaving by it. Although a few men have already been to the TCC to learn how to operate the new loom, only two women have so far participated in the exercise, probably because the broadloom is an improved technology introduced in an area unfamiliar and traditionally forbidden to Ghanaian rural women. Thus superstition and other non-scientific factors would appear to be just as important as the technical efficiency of the new technology considered for introduction to rural women.

*Bullock ploughs* Other small-scale improved technologies have also been introduced to some rural farmers by various foreign volunteer groups. For example, in the Binaba Agricultural Project in the upper region an attempt was made to introduce the farmers to bullock ploughs and dry season gardening. The women farmers, however, could not participate in the bullock plough programme because local customs and taboos forbade women from touching cattle (North *et al.*, 1975).

The discussion in this section has shown that, although the cost and complexity of the improved technology sometimes act as constraints on its adoption by the Ghanaian rural women, the social factor of whether or not the technological innovations bring about drastic changes and conflicts in the women's accustomed behaviour practices, tastes, taboos and beliefs appears to be also a crucial variable (see summary Table 7.5). This table demonstrates that sometimes, in spite of high technical efficiency as in the case of hybrid maize and bullock ploughs, an improved technology is still rejected on the grounds of social factors. This points to the need to include social assessment in the measurement of improved technologies. The table further shows that there are cases where the social factors combine with technical factors to determine the women's acceptance or non-acceptance of the improved technology (such as the smoking oven of the Fisheries Department, *gari* processing and Adjetey oven).

It is worth pointing out that the improved technologies that have been accepted so far by the rural women have almost all been ones that have been developed by local R&D institutions. They have also generally been those that involve the upgrading of traditional techniques. This observation could again be explained in terms of the hypothesis explored in this section: that since improved technologies for the rural women would not be easily accepted by them unless they are also socially appropriate (in the sense of not disrupting accustomed behavioural practices, tastes, taboos and beliefs) local R&D institutions stand a better chance of knowing what these social practices and beliefs are and, therefore, could develop a technology that agrees with them.

A major exception is the broadloom which was developed by the Technology Consultancy Centre (TCC) – a local R&D institution – but which has not as yet become popular with women. However, one could say that the broadloom was developed by the TCC not specifically for the women but as an improvement on the traditional narrow loom used by the men. Moreover, there has not been much dissemination of the broadloom.

An important economic factor observed to be preventing rural women's adoption of improved technologies – in the

Table 7.5   *Summary of improved technologies introduced to the women and the reasons for their acceptance or non-acceptance*

| Type of technology | Reasons for acceptance | | | | |
|---|---|---|---|---|---|
| | *Increased output per unit time* | *Low cost of the tool* | *Not complex* | *Lack of conflict with traditional beliefs and taboos* | *No drastic change in accustomed production processes and/or tastes* |
| Fish smoking oven of Fisheries Department | x | x | x | x | x |
| *Gari* processing | x | | x | x | x |
| Caustic potash produced by the kiln | x | | x | x | x |
| Solar drying racks for *kokonte* and fish | x | x | x | x | x |

| Type of technology | Reasons for non-acceptance | | | | |
|---|---|---|---|---|---|
| | *Low output per unit time* | *High cost of the tool* | *Complexity* | *Conflict with traditional beliefs and taboos* | *Drastic change in accustomed products and their tastes and in production processes* |
| The altona oven for fish smoking | | x | x | | |
| Adjetey oven | | x | x | | x |
| High-yielding hybrid maize seeds | | | | | x |
| Broadloom | | | | x | |
| Bullock ploughs | | | | x | |

Ghanaian situation as well as elsewhere (see, for example, Carr, 1980) – is the high cost of the technologies. This indicates the need to develop credit schemes with less stringent demands and also with lower interest rates than

those of the national banks and individual moneylenders.

Apart from the improved technologies discussed above, a few others have also been developed in Ghana but could not be discussed here because of lack of data and also because some are still being tested or awaiting dissemination by the country's R&D institutions. Examples are smokeless stoves, instant *fufu*, iceless coolers, groundnut shellers, and 'soak-away' pits. Others have also been identified by researchers. A case in point is the range of water catchment systems recommended by Parker (1978) in his study of the village of Kpompo in south-eastern Ghana. Examples are deep guttering made of bamboo, which is locally available in abundance, to catch rainwater from the corrugated roofs of houses and also concrete tanks to store water. Through various calculations, Parker noted that such small improvements in the mode of water supply would be of immense benefit, given a benefit/cost ratio of up to 3.0 when 100 per cent of the time saved in the collection of water is utilised in productive work or up to 1.7 when 57 per cent of the time saved is so used. The hypothesis tested above needs to be retested with the dissemination of these and other improved technologies yet to be developed.

## Strategies for technology diffusion

The view is often expressed by visitors to Ghana that considerable improvement in rural life could occur through the dissemination of the improved technologies and skills already developed by the country's research and development institutions. These technologies are found in only a few villages and are largely unknown even by people in nearby villages in the same region. Widespread dissemination of these technologies is thus a major task that needs to be tackled in Ghana. So far, the strategy has been for researchers to visit the villages to demonstrate the use of the technology. This has been the approach adopted by the Ghana National Council on Women and Development (NCWD). Members of the Council's projects committee organise workshops in some of the districts to teach the women how to operate the new improved technologies and

skills as well as to revive old skills and identify viable economic projects the women could enter into using the improved technologies and skills. The main problem with this approach is that because of the Council's limited resources, especially as regards vehicles, it has not been able to reach enough villages to make its impact in this area really significant.

Examining the efforts of the National Council on Women and Development at propagating the improved technologies, one observes that the women's use of a technology is greatly facilitated when it is introduced as part of a package. Thus, in cases where the NCWD provided the women with credit with which to acquire the tools, such as fish-smoking ovens in the village of Kokrobite in the Greater Accra region, the women were quick to use the improved tools. In other cases, the NCWD has encouraged the women to form a multi-purpose co-operative in order to make it easier for the banks to lend to them to acquire the improved tools. In addition, the NCWD tries to find the women a guaranteed market.

A finding by the Council that is relevant to the process of dissemination is that early involvement of the rural women in the identification and development of the improved technology contributes to more ready acceptance of it. This is hardly surprising since such early involvement is likely to lead to the fashioning of the improved technology in a way that agrees with the women's accustomed modes of doing things and their values and in an area they perceive to be of prior concern to them.

A second strategy that has been tried in the dissemination of improved technologies to the rural people has been for the institution that has developed it to invite some of the villagers to its premises to observe the technology and how it operates. This has been one of the approaches adopted by the Technology Consultancy Centre (TCC), which is located in Kumasi (the heart of Ghana's rural hinterland); it has also used its links to obtain loans for these people from the commercial banks for the purchase of the technology. The main disadvantage of this approach, as has been observed by the TCC itself, is that the research centre's location on a university campus tends to discourage the rural people and

small-scale operators from coming near it. The TCC is therefore establishing rural technology centres (RTCs), or what it calls 'Intermediate Technology Transfer Units', off the campus to make its work reach the rural folk and the craftsmen in the slums of the city. These units or centres are where the improved tools are exhibited and people trained in their use. Being near the users of the improved tools, the centres will also collect the feedback on the operation of the technology and rectify any shortcomings that the people find in their use of the technology. These technology transfer units have been observed (see International Labour Office, 1980b) to be a useful channel to link R&D institutions and the rural people.

Other strategies that could be employed in the dissemination process are the utilisation of already existing traditional groups and the mass media, which are familiar to the women. With reference to the former, the technologies could be introduced to the leaders of these traditional groups, such as dancing groups and even some modern village associations like church associations[2] and village development committees, which already have a role in effecting development such as the construction of schools and latrines in the villages through the use of communal labour. If the leaders of these associations are trained in the rural technology centres in the use of the improved technologies, then they in turn could go back to their groups to disseminate their acquired knowledge to the members. Even the traditional queen mothers of the villages could be invited to participate in such a programme.

This group approach has been used, to some extent, in Kenya (see Pala *et al.*, 1975). The main advantage with the group approach, as was observed in Kenya, is that it is capable of reaching more people than the visits of extension officers to individual homes. In addition, one could also emphasise that, since the rural women are very familiar with these associations and groups, they are more likely to feel at home learning about new improved ideas and technologies in them than in unfamiliar surroundings.

[2] Klingshirn (1971) found in one village (Larteh) in the eastern region that as many as 20 per cent of the women in her study belonged to a church association that met regularly for literary and Bible classes.

Another institution that could be utilised for the dissemination of technology is the 'concert' system. In traditional Ghanaian society there are drama groups that move from village to village performing humorous drama in the local vernaculars often interspersed with songs. These groups are still very popular in the country and their concerts are often well patronised by men as well as by women and children. These local drama groups try not only to entertain the people but also to draw their attention to social evils in the society. They could be used to dramatise the use of the improved technology and its benefits. Since they are able to reach large numbers of people of both sexes, they could be an effective agent of dissemination.

Other local groups that could be used are the local blacksmiths and carpenters, who are found in almost every village. Brokensha (1966), for example, in his study of the village of Larteh in the Akwapin region, found seven blacksmiths who made cutlasses and hoes, and repaired guns. They could be trained in the RTCs in the maintenance and repair of the women's improved tools. Since they are near the women, they can assist them in the repair and maintenance of the improved technologies and can also explain to them how the new tools work.

The use of the mass media – not necessarily the print media since the illiterate rural folk would not be able to read newspapers – could also be employed for the dissemination of new techniques. For example, short demonstration films on the improved tools could be shown in the villages by mobile cinema vans. This mode of dissemination was widely used during the period of the cocoa boom to teach farmers about methods of planting and insecticides to use for the swollen shoot disease which attacked the cocoa trees. High-life songs were also composed about these improved techniques. This approach to dissemination, which proved to be a great success at that time, could be tried now with respect to the improved technology for the rural women. High-life songs are popular, very rhythmic Ghanaian songs, not only for dancing but more essentially for communicating messages and ideas, so that their use to disseminate knowledge about improved technologies would not be out of

place but would be an approach the women would feel at home with. The women themselves are very fond of singing high-life songs while working.

Radios are found in many villages in Ghana, although with the present widespread shortages in the country the batteries to operate them may not always be available. Radio programmes in the local vernaculars could be used to create interest in and awareness of these improved technologies. However, it is often found that it is the men rather than the women who own the radios in the villages. This could be one reason why it is essential to involve the men in the planning of the improved technologies for the women, so that, even if the women do not hear of the programmes, the men can pass on the message to their kinswomen or wives. The men could even call the latter when these programmes are on the radio to come and listen to them.

A new institution has also been tried in the ILO Tarkwa project. Village project committees made up of both men and women have been set up in some of the villages covered in the project (see International Labour Office, 1980a). These committees explain the project's activities to the villagers, encouraging women to participate in them, and also provide or organise communal help if needed for the project. Furthermore, they provide feedback from the village to the project experts and also make recommendations on strategies that could be adopted to make the project successful.

Although the strategies have been discussed separately, it would seem that, to be effective, a combination of these strategies may be necessary. One of the observations from the little dissemination already undertaken in Ghana is that not much detailed evaluation and monitoring of the improved technologies has been done, except in relation to those introduced by the Technology Consultancy Centre. This is an important task, which has to be executed before effective wide-scale dissemination of the technologies can take place. The researcher needs to know the successes and failures of each of the improved technologies and what is likely to be their impact on the life of the village folk, so that any problems are quickly resolved to facilitate acceptance of the technologies by the women. It is in this context that the

project committee in the Tarkwa project is useful, because its role also involves monitoring of the operation of the project's activities in the village.

It is also worth stressing here that improved technologies for the rural women are more likely to be adopted if the women are already sufficiently conscious of their plight and what could be done about it. In other words, it is important for some consciousness-raising and mobilisation to be done to make the rural women mentally prepared for the improved technologies that the R&D institutions and development agencies are anxious to plan for them. This awareness raising could be done by the women's organisations, such as the Ghana National Council on Women and Development and the Ghana National Assembly of Women, through mass mobilisation activities and informal meetings at the local level. Project and research planners could also do it through visits to the villages to meet the traditional and opinion leaders as well as representatives of the women to discuss the women's roles and their problems. The mass media, the village churches, associations and drama groups already described could also help in this exercise.

## Conclusions

This chapter has described the traditional tools, skills and techniques deployed by Ghanaian rural women in their customary activities and what improvements have been introduced in some of them. In analysing the rural women's acceptance or non-acceptance of such improved technology, I have postulated the hypothesis that technological innovations blending with the women's accustomed modes of behaviour stand a higher chance of quick acceptance. Those that entail drastic changes in behaviour practices or that conflict with their value system and tastes are likely to have a limited chance of success. (With time, a change may gradually occur in these values, but at the initial stage these values need to be respected by the researcher to prevent the target people being quickly put off by the innovation.) On the whole, the data supported this hypothesis. It is clear, therefore, that in making a judgement about what kind of simple improved

technologies should be introduced to these rural women, social factors have to be taken into account; in other words, such technologies should be not only appropriate to the economic situation of the rural women and be economically profitable, as well as technically efficient, but also socially appropriate in the sense that they must not generate undue conflict with the social values and tastes of the target group.

Other factors have also been shown to be important to the facilitation of the introduction of improved technologies to Ghanaian rural women. For instance, there is the economic factor of the cost of the new equipment and the importance of introducing the improved technology as part of a package. There is also the factor of the general economic condition of the country and its impact in making the products of simple technologies competitive against imported manufactured goods.

Among the range of relevant factors additionally considered are the land tenure system, extension services and rural women's access to credit. Such institutional factors may affect the productive capacity of the rural women even after their acceptance of improved technologies. Consequently, those seeking to improve the lot of these rural women cannot focus exclusively on technology. As stressed earlier in the chapter, a multidimensional approach is required, which should include tackling institutional constraints. This is an area where governmental support could be of great assistance through legislation and campaigns on institutional reforms such as on land tenure systems.

It also appears that there are regional variations in the activities of the Ghanaian rural women: for example, salt mining is carried out in the south-eastern coastal corner and fish smoking along the coast, and there is cocoa farming by some of the women in the interior. This would imply that the activities chosen for the introduction of improved technologies may not necessarily be the same for all Ghanaian rural women.

Again, it has been observed that some of the activities tend to involve more of the rural women than others. Examples of the former are farming and trading, which are done by women in almost all the regions. This would indicate that,

when resources are limited, a choice has to be made between activities that involve many of the women, where the use of improved technologies would have more impact on the society, and those that involve only a few women, who may need technological help but where the overall impact of such help on the society may not be very great.

Bearing in mind the acute shortages of some essential items such as soap and cooking oil in the country, one could also arrange the areas in the women's activities that need technological improvements in an order of priority. Areas such as soap making and food production would be in the first group, to meet the unbearable scarcities in the country. These are also areas that are likely to have a lot of governmental backing. The second group would consist of areas such as fetching of firewood and food preservation, which are necessary to relieve the women from drudgery but for which no improved technologies have as yet been introduced. The last group would be areas for which improved technologies have already been introduced and what is required is mainly dissemination. An example is *gari* making.

The review of the improved technologies so far introduced to Ghanaian rural women has further shown that the rural women's activities are interrelated with the activities of others. Therefore, an improvement in women's activity without an improvement in the intertwined activities of others, including men, would not achieve much. For example, 'fish wives', using improved ovens for smoking, have come to require more fish to smoke, but the catch of fish by the male fishermen has not been on the increase. Such a situation is likely to cause frustration in the women and dampen their enthusiasm for any new technologies introduced to them. Thus, the linkages between rural women's activities and those of other groups in the community need to be studied to enable this more holistic approach to technological innovation to be pursued.

Various dissemination strategies making use of already existing traditional groups and familiar media such as high-life songs, queen mothers, mobile cinema vans and local drama groups have been suggested. The use of the new

institution of rural technology centres has also been stressed for this purpose.

A problem that needs to be solved in the villages to enable the women to have the time to learn and operate any improved technologies introduced to them is child care. In the urban areas there are nurseries, although an inadequate number, where some of the working women could leave their children when working. In the villages, however, the women do full child care as well as their other activities and this tends to reduce their output as well as concentration on their work. Also it does not allow them any free time for participation in any skill or technology training programmes mounted for them in the villages. The earlier view (see, for example, Oppong *et al.*, 1975) that in the traditional villages women are able to combine their child care and other household chores with farm work outside the home because there are many 'mother substitutes' such as older daughters, sisters and aunts to offer ready assistance with child care has undergone considerable change. The modern urban-based sector has served to attract some of these people from the rural areas and it is now common in the villages to see mothers with their babies on their backs walking long distances to and from the farm, carrying heavy loads of firewood or farm produce.

A nursery programme could be started in the villages, organised by the women in a way that would not involve any great cost. They could select a few of their daughters who have completed the elementary school, and who would otherwise migrate to the urban areas, as the nursery attendants. The girls could be given a crash course by the Social Welfare Department in child care, first aid and the hygienic preparation of well-balanced diets for children. They could also be taught various socialisation techniques, such as games and the singing of songs. This would prepare them for adequate handling of the children. On a farming or other occupied day, the women would leave their children at the nursery with foodstuffs such as plantain, yam, gari, vegetables and fish, which would be used by the attendants to prepare balanced meals for the children. These attendants

could be paid through small monetary contributions by the parents (cf. Date-Bah, 1980a).

Reflecting, finally, over this whole area of finding improved technologies for Ghanaian rural women, one cannot help but observe that Ghana could benefit from a system of technical co-operation and exchange of information, prototypes and personnel between her institutions of research and development and those of her neighbours, such as Nigeria, the Niger, Togo, the Ivory Coast and Sierra Leone. Although there are differences, Ghana is similar to these countries with respect to ecology, cultural practices, activities of the women, stages of development and economic environment. Such collaboration would be mutually beneficial for these countries.

# 8

# Innovation and Rural Women in Nigeria: Cassava Processing and Food Production

*TOMILAYO O. ADEKANYE*

## Introduction

The survey of literature on African women suggest that women make considerable contributions to agriculture. Their contribution is relatively more important in food production, food processing and trade than in cash crop production. In general, however, women's association appears to be marginal to such agro-development projects as extension programmes, co-operative development and cash crop improvement programmes. The drudgery of women's work in agro-related activities (food processing, fetching water, etc.) provides a justification for the introduction of labour-saving devices and technological innovation for productivity improvement in agriculture. Women's reliance on traditional technology results in food waste and poor quality of produce. It is possible to increase efficiency (i.e. increase output and/or reduce costs from a given unit of input) by modifying existing methods of production or by adopting and utilising some new methods. The important issue, therefore, is the relevance of a particular technology to the area or country under consideration. Technological innovation is one factor, albeit a crucial one, necessary for agricultural development. Other factors include investment in skill development (education), such purchased inputs as fertilisers, other agro-

chemicals, credit supply and efficient delivery of these inputs.

## Objectives

The major objective of the study is to analyse the effect of innovation on rural women, with particular reference to *gari* processing in the Ibadan area of south-western Nigeria. (Cassava is mainly a small cultivator root crop, grown virtually all over Nigeria, and processed into *gari*, serves as the most important source of staple food. The following specific objectives are involved: (i) to analyse the economics of traditional *gari* processing; (ii) to analyse the economics of mechanised *gari* processing; (iii) to make a comparative study of the traditional and mechanised processing methods in order to assess the role of technology in development, particularly the effects of innovation on women *gari* processors; (iv) to provide necessary policy recommendations.

## Survey design

The study was carried out in two separate areas of Oyo state, in south-western Nigeria. The first is the Elere group of villages, consisting of Ilaju and Eleyeile, situated about 35 kilometres south-west of the city of Ibadan, the Oyo state capital. Preliminary investigation revealed that ecological factors favour the cultivation of arable crops in this area. Furthermore, large-scale mechanised *gari* processing through innovative co-operative effort takes place at Ilaju, where there is a *gari* factory. Cocoa is the most important tree crop in the area and it used to be the main source of income to farmers. There has now been a shift to cassava production and this crop is being grown for both subsistence and commercial uses. Other cash crops grown in the area are coffee, kola, orange, rubber and oil palm.

The second area of study is Fasola, located about 100 kilometres north-east of Ibadan in the derived savannah zone. The Ogun River, which passes through the area, serves as the major source of water supply for the area. The soil in Fasola area is sandy, leading to a lot of erosion and

consequent decrease in the yield of crops, including cassava.

Data were obtained for this study from both primary and secondary sources. The primary source of data involved the use of pre-coded, structured questionnaires, which had been pre-tested. Secondary data were collected from both published and unpublished sources such as the International Institute of Tropical Agriculture (IITA), the Oyo State Ministry of Agriculture, the Ido Co-operative Society Office and the Nigerian Institute of Social and Economic Research (NISER), all at Ibadan.

A sampling frame was constructed for the first phase of the study. This involved going round villages in the two study areas, several times, to undertake preliminary investigations on, and to compile a list of, *gari* processors. (Although we had undertaken some previous surveys in the area – see Favi, 1977 – it was still necessary to undertake these preliminary investigations to ensure reliability.) These investigations revealed that there were about 525 women *gari* processors in the two areas of study. On the basis of available research resources – time, money, etc. – it was decided that a fifth of the women *gari* processors would be studied. Random sample selection was effected by choosing every fifth *gari* processor on the list. A total of 105 were studied (see Table 8.1). This was the first phase of the data collection process during which traditional *gari* processors were interviewed in both Fasola and Elere group of villages. The second phase was the in-depth study of sub-samples of the original sample to obtain quantitative estimates of costs and returns and the time spent on particular operations. The third phase focused primarily on the second (Elere) area of the study. It involved the study of the innovative co-operative processors as a group as well as the collection of secondary data on mechanised production at the *gari* factory at Ilaju.

The bulk of the field work and primary data collection lasted for one year, from September 1979 to September 1980. Data collection, particularly from secondary sources, and in-depth studies of selected variables and analysis took place in 1981–2.

Table 8.1   *Women processors of gari in Ibadan district, south-western Nigeria*

| Villages | No. of women processors of gari Total | Sample selected |
|---|---|---|
| *Fasola area:* | 415 | 83 |
| Igbonla | 90 | 18 |
| Kokogi | 70 | 14 |
| Iporin | 40 | 8 |
| Obakayeja | 10 | 2 |
| Olorioso | 25 | 5 |
| Okikiola | 15 | 3 |
| Fasola | 60 | 12 |
| Ikolaba | 35 | 7 |
| Olorunda | 50 | 10 |
| Awon | 20 | 4 |
| *Elere area:* | 110 | 22 |
| Ilaju | 50 | 10 |
| Eleyeile | 60 | 12 |
| Total | 525 | 105 |

*Source:* Survey data.

## Technology of *gari* processing

### Traditional processing
The different stages involved in the traditional processing of *gari* are described briefly below:

- *Peeling*: The outer layers of the roots are peeled with the aid of a small sharp knife, usually within two days of harvest. The peeled roots are washed, depending on handling and availability of water.
- *Grating*: This is done manually or by means of a mechanical grater. The latter is widely used in the two areas of study. However, the machines frequently broke down.
- *Pressing*: First, the grated cassava pulp is bagged. The bags (locally called *saka*) are then compressed with heavy

stones. This reduces the water content of the pulp, making it sufficiently dry for roasting. Also, fermentation occurs during pressing. The fermentation period is about four days. The longer the fermentation period, the more sour the *gari* becomes in taste.

- *Sieving*: This is done prior to roasting. A sifter made from bamboo is used. An appreciable amount of the fermented pulp gets wasted during this process.
- *Roasting (or toasting)*: This is the major determinant of the quality of *gari* processed and it is usually done by the owner and not by a relative or friend. However, when large quantities of *gari* are processed, hired labour is used. Roasting is the most difficult aspect of *gari* processing in the area of study. The women complained of the heat and smoke that they have to withstand as they sit very near the fire in order to stir the *gari* continuously.

Table 8.2   *Sources of cassava roots processed*

| Source | Fasola area | | Elere area | | Both areas | |
|---|---|---|---|---|---|---|
| | No. | % | No. | % | No. | % |
| Only from own farm | 25 | 30.12 | 2 | 9.09 | 27 | 25.71 |
| Mainly from own farm and by purchase | 36 | 43.38 | 16 | 72.73 | 52 | 49.52 |
| Mainly by purchase and some from own farm | 20 | 24.10 | 4 | 18.18 | 24 | 22.86 |
| By purchase only | 2 | 2.40 | — | — | 2 | 1.90 |
| Total | 83 | 100.00 | 22 | 100.00 | 105 | 99.99 |

*Source:* Survey data.

The problems encountered in the traditional processing of *gari* include manual peeling of cassava, grating, the need to obtain and carry the big stones used for expressing water from grated cassavas, as well as the tedious method of roasting *gari*. Furthermore, the problem of scarcity of roots virtually sets an upper limit to the amount of *gari* that could be produced regardless of the type of technological innovation introduced for processing. The other problems encountered

were lack of funds and the incidence of cassava pests and diseases (see Table 8.3).

Table 8.3  *Problems in traditional gari processing*

| Problem | Fasola area No. | % | Elere area No. | % | Both areas No. | % |
|---|---|---|---|---|---|---|
| Scarcity of cassava roots | 40 | 48.20 | 6 | 27.27 | 46 | 43.80 |
| High labour cost | 5 | 6.02 | — | — | 5 | 4.76 |
| Difficult traditional processing method and scarcity of roots | 31 | 37.35 | 16 | 72.73 | 47 | 44.76 |
| Disease and pests of cassava | 3 | 3.61 | — | — | 3 | 2.86 |
| Lack of funds | 4 | 4.82 | — | — | 4 | 3.81 |
| Total | 83 | 100.00 | 22 | 100.00 | 105 | 99.99 |

*Source:* Survey data.

Table 8.4  *Suggestions for improving the traditional gari industry*

| | Fasola area No. | % | Elere area No. | % | Both areas No. | % |
|---|---|---|---|---|---|---|
| More loans | 1 | 1.20 | — | — | 1 | 0.95 |
| Provision of processing machines and increased cassava supply | 50 | 60.24 | 18 | 81.82 | 68 | 64.76 |
| Loans and machinery | 7 | 8.43 | — | — | 7 | 6.67 |
| Increased cassava supplies | 19 | 22.90 | 4 | 18.18 | 23 | 21.90 |
| No response | 6 | 7.23 | — | — | 6 | 5.72 |
| Total | 83 | 100.00 | 22 | 100.00 | 105 | 100.00 |

*Source:* Survey data.

The women were asked to give suggestions for improving the traditional method of *gari* processing. About 65 per cent of the respondents suggested the increased supply of processing machines and cassava roots (see Table 8.4).

*Mechanised processing*
The mechanised method of *gari* processing is described below. Unlike the traditional method, machines are used for most stages of the operation.

- *Peeling*: Cassava roots are loaded into a peeling machine where the first round of peeling is done. After this, the cassava roots go on to the conveyor belt, down to the grater. Peeling is then done manually for the roots that have not been properly peeled by the machine. It takes about 20 minutes to load and completely peel 1 tonne of roots.
- *Grating*: The peeled tubers are grated and then packed from the mill into black plastic fermentation bags where they are left to ferment.
- *Fermentation*: This lasts for about five days, to ensure that the *gari* has a slightly sour taste.
- *Pressing*: Hydraulic presses are used for this and it takes about 40 minutes to press 250 kg of grated *gari* mash. The pressed mash is transferred to an elevator fitted with a grater-type inlet where large lumps may be broken down by hand and any fibrous material is removed.
- *Frying and drying*: The pressed cassava mash is then conveyed into a cylindrical frier. About 20 kg of cassava mash are continuously fed into the *gari* frier at an interval of 2 minutes. The *gari* is passed from the frier into a rotating drier, where it is heated at a temperature of 120°C. The drier removes all moisture that might still be left. It takes about 9 minutes for about 200 kg of *gari* to move from one end of the huge drier to the other end. The *gari* is then separated into coarse and fine grain components.

**Time spent in processing**

In estimating the time spent in processing, the bag was used as the unit of measurement as was popularly done in the study area for traditional processing. The bag contained approximately 125 kg of *gari* and about 200 cassava tubers were required for this. It was on this basis that time spent per kilo of *gari* was derived.

*Traditional processing*

- *Peeling of cassava roots*: Peeling was usually done by the owner and some friends or relatives. It usually took a whole day, from very early in the morning to late in the evening, because cassava deteriorates in quality quickly. Table 8.5 gives the estimated time spent in cassava peeling in selected villages of the study area.
- *Washing*: There was a shortage of water in the area of study. Consequently, not all the women washed the peeled tubers before grating. Furthermore, there was no pipe-borne water or wells. The women therefore had to carry buckets and other containers to fetch water from brooks and streams, walking long distances. An average of 1 hour and 34 minutes was spent on washing approximately 200 tubers required for one bag or approximately 0.75 minutes per kilo of *gari* (see Table 8.6).

Table 8.5   *Time spent peeling cassava in traditional processing*

| Village | Time spent for 200 tubers |
|---|---|
| Igbonla | 3 women × 10 hrs = 30 hrs |
| Olorunda | 6 women × 5 hrs = 30 hrs |
| Iporin | 6 women × 6 hrs = 36 hrs |
| Ilaju | 5 women × 5 hrs = 25 hrs |
| Eleyeile | 5 women × 6 hrs = 30 hrs |
| | |
| Total | 151 hrs |
| Average | 30 hrs 12 mins |
| Range | 25 – 36 hrs |
| Average time for 1 kg *gari* | $\frac{1,812}{125} = 14.50$ mins |

*Source:* Survey data.

- *Grating of the peeled roots*: In general, the grating machines used in traditional processing were old and needed to be replaced. At Ilaju and Eleyeile villages, there were powered graters, in contrast to the hand-operated mechanical graters in Igbonla, Olorunda and Iporin. Breakdown of the machines was a frequent occurrence in all the villages. An average of 30 minutes was spent on grating 200 cassava tubers in the two

Table 8.6   *Time spent washing cassava in traditional processing*

| Village | Time spent for 200 tubers |
|---|---|
| Igbonla | 1 hr 30 mins |
| Olorunda | 1 hr 45 mins |
| Iporin | 1 hr 30 mins |
| Ilaju | 1 hr 35 mins |
| Eleyeile | 1 hr 30 mins |
| Total | 7 hrs 50 mins |
| Average | 1 hr 34 mins |
| Range | 1 hr 30 mins – 1 hr 45 mins |
| Average time for 1 kg *gari* | $\frac{94}{125}$ = 0.75 mins |

Source: Survey data.

Table 8.7   *Time spent grating cassava in traditional processing*

| Village | Time spent for 200 tubers |
|---|---|
| Igbonla | 1 hr 30 mins |
| Olorunda | 1 hr |
| Iporin | 1 hr 15 mins |
| Ilaju | 30 mins |
| Eleyeile | 30 mins |
| Total | 4 hrs 45 mins |
| Average | 57 mins |
| Range | 30 mins – 1 hr 30 mins |
| Average time for 1 kg *gari* | $\frac{57}{125}$ = 0.46 mins |

Source: Survey data.

villages that had powered graters, whereas in Igbonla, Olorunda and Iporin it took an average of 75 minutes, giving an average of 57 minutes for 200 tubers or 0.46 minutes per kilo of *gari* (see Table 8.7).

• *Bagging and sieving*: For 200 tubers, an average of 1 hour and 28 minutes was spent on bagging the grated pulp prior to fermentation. The time spent for bagging was highest in Iporin at 2 hours and lowest in Igbonla at 1

hour. Sieving was done after fermentation had been completed. A lot of mash got wasted in this process and it took an average of 2 hours 33 minutes to complete it.

- *Roasting of cassava pulp*: Whereas sieving could be done by a friend or relative, roasting was always left to the owner as the quality of *gari* depends on the skill of the person who roasts it. However, hired labour was sometimes used for roasting. In Igbonla, the women spent a total of 12 hours to roast cassava pulp from 200 cassava tubers. The process lasted two days. In Olorunda, the women spent 15 hours over two days on roasting – 7 hours the first day and 8 hours the second day. In Iporin, the women spent a total of 14 hours on roasting. This gives an average of 6.53 minutes for roasting 1 kg of *gari* (see Table 8.8).

*Mechanised processing*

For comparative purposes, the time spent on processing 125 kg is calculated for the mechanised system. Factory processing is usually done in tonnes of cassava. One tonne of cassava roots loaded into the peeling machine gives about 200 kg of *gari* on the vibrating screen. The time spent on 125 kg at each stage is obtained as 0.625 of that for 200 kg (see Table 8.9). In making the comparison, only three stages of the *gari* processing are taken into consideration. Washing, bagging, pressing and sieving are not considered, for two reasons. First, peeling and roasting account for 87.05 per cent of the total time required for traditional processing (see Table 8.8). Secondly, it was difficult to measure the time spent on washing and sieving by the mechanised method. Furthermore, fermentation and pressing occur simultaneously in traditional processing whereas they are done separately in the mechanised system. The roasting of *gari* by the traditional method is the equivalent of *gari* frying and drying in the mechanised system.

Table 8.10 shows that approximately 21.5 minutes were needed for peeling, grating and roasting 1 kg of *gari* in traditional processing as against 2.0 per kilo in mechanised processing, representing only 0.09 per cent of the time spent in the traditional system. However, there was underutilisation

Table 8.8    *Time spent in traditional gari processing*

| Village | Time (hours/minutes) Peeling (hrs) | Washing (hrs) | Grating (hrs) | Bagging (hrs) | Sieving (hrs) | Roasting (hrs) | Total (hrs) |
|---|---|---|---|---|---|---|---|
| *Fasola area:* | | | | | | | |
| Igbonla | 30.00 | 1.50 | 1.50 | 1.00 | 3.00 | 12.00 | 49.00 |
| Olorunda | 30.00 | 1.75 | 1.00 | 1.00 | 2.00 | 15.00 | 50.75 |
| Iporin | 36.00 | 1.50 | 1.25 | 2.00 | 2.50 | 14.00 | 57.25 |
| *Elere area:* | | | | | | | |
| Ilaju | 25.00 | 1.58 | 0.50 | 1.75 | 2.75 | 13.00 | 44.58 |
| Eleyeile | 30.00 | 1.50 | 0.50 | 1.58 | 2.50 | 14.00 | 50.08 |
| Average for 200 tubers | 30.20 | 1.57 | 0.95 | 1.47 | 2.55 | 13.60 | 50.34 |
| Average for 1 kg *gari* (mins) | 14.50 | 0.75 | 0.46 | 0.70 | 1.22 | 6.53 | 24.16 |
| Percentage of total | 60.02 | 3.10 | 1.90 | 2.90 | 5.05 | 27.03 | |

*Source:* Survey data.

Table 8.9   *Time spent in mechanised gari processing*

| Operation | Time (mins) | No. of persons required |
|---|---|---|
| Loading and peeling | 20 mins × 0.625 = 12.5 mins | 14 people |
| Milling | 8 mins × 0.625 = 5 mins | 2 people |
| Pressing | 40 mins × 0.625 = 25 mins | 8 people |
| Frying | 20 mins × 0.625 = 12.5 mins | 3 people |
| Drying | 9 mins | |
| Total for 125 kg | 64 mins | 27 people |
| Time for 1 kg *gari* | $\frac{64}{125}$ = 0.51 mins | |

*Source:* Survey data.

Table 8.10   *Comparison of time spent in traditional and mechanised gari processing*

| Operation | Traditional processing (mins) | Mechanised processing (mins) |
|---|---|---|
| Peeling | 14.50 | 14 × 12.5 = 175 |
| Grating | 0.46 | 2 × 5.0 = 10 |
| Roasting and drying | 6.53 | 3 × 21.5 = 64.5 |
| Total for 1 kg *gari* | 21.49 | $\frac{249}{125}$ = 2.0 mins |

*Source:* Tables 8.8 and 8.9.

of capacity in the mechanised system, for two reasons. First, storage space was inadequate and, since cassava roots spoil easily, there would be wastage if large quantities of cassava were harvested. Secondly, there was a shortage of cassava tubers so that, even if the factory had had enough labour for processing the full capacity of 10 tonnes of *gari* per day, the cassava farm could not supply the required 50 tonnes of cassava. An estimated 0.14 minutes would have been spent

(instead of the 2.0 minutes that was actually spent) on processing 1 kg of *gari* in the mechanised system if the machine had been working at full capacity.

## Costs and returns

Costs and returns were also estimated per bag of *gari*, i.e. 125 kg of *gari*, or per 200 cassava tubers. Costs and returns were then derived per kilo from the estimates. In general, the 1979/80 cost and price structures were used for the analysis of costs and returns. Costs and prices have generally increased since 1980 but the structure (the relationship of costs to prices and returns) has remained relatively constant. It was therefore decided to leave the 1979/80 relationship unchanged as adjusting it by a constant proportion for price and cost changes would leave the estimates unchanged. This is similar to the homogeneity hypothesis in demand analysis, implying that, if one changes all prices and quantities in the same direction and by the same proportion, one leaves the quantities demanded unchanged.

### Traditional processing

The fixed assets were: knives, baskets, jute bags (or *saka*) for pressing, jute bags for the marketing of *gari*, calabashes, roasting pots, shed, sifter. The roasting pot is the most expensive item of fixed cost used in the area of study, costing about ₦10 with an annual depreciation of ₦2.00[1] (see Tables 8.11 and 8.12). The items of variable costs were: cassava roots, labour, grating, transportation, harvesting (see Table 8.13).

The women in Okikiola spent the highest amount (₦30.09) to process one bag of *gari*. This was largely due to the high cost of cassava roots in the area. On the other hand, the processors in Ilaju, where cassava roots were relatively cheap, spent the least amount to process one bag of *gari*. Cassava roots were a major determinant of processing cost of *gari* in all the villages: in general, the cost of cassava roots averaged 58.77 per cent of the total cost (see Table 8.14).

[1] US$1 equals ₦1.24 approximately.

Table 8.11   *Fixed cost in traditional gari processing by item used*

| Item | No. required | Life Span (yrs) | Cost (₦) | Depreciated[a] (₦) |
|------|------|------|------|------|
| Knife | 1 | 1 | 1.00 | 1.00 |
| Basket | 1 | 1 | 0.75 | 0.75 |
| Flour Bag | 2 | 1 | 0.25 | 0.25 |
| Jute Sacks | 2 | 1 | 0.60 | 0.60 |
| Calabash | 2 | 1 | 0.25 | 0.25 |
| Roasting Pot | 1 | 5 | 10.00 | 2.00 |
| Sifter | 1 | 2 | 2.0 | 1.00 |
| Shed | 1 | 5 | 5.00 | 1.00 |
| Total | | | 19.85 | 6.85 |

*Note*:

[a] Depreciation calculated using the straight line method

$$= \frac{\text{Cost} - \text{Salvage value}}{\text{Life span}}, \text{ with the salvage value being zero.}$$

*Source:* Survey data.

Table 8.12   *Fixed cost per 125 kg in traditional gari processing by village*

| Village | Average no. of bags produced | Fixed cost (depreciated) (₦) | Fixed cost per bag (₦) |
|------|------|------|------|
| Igbonla | 12 | 6.85 | 0.57 |
| Kokogi | 8 | 6.85 | 0.86 |
| Iporin | 9 | 6.85 | 0.76 |
| Obakayeja | 4 | 6.85 | 1.71 |
| Olorioso | 5 | 6.85 | 1.37 |
| Okikiola | 6 | 6.85 | 1.14 |
| Fasola | 10 | 6.85 | 0.69 |
| Ikolaba | 12 | 6.85 | 0.57 |
| Awon | 7 | 6.85 | 0.98 |
| Olorunda | 10 | 6.85 | 0.69 |
| Ilaju | 12 | 6.85 | 0.57 |
| Eleyeile | 11 | 6.85 | 0.62 |
| Average | 8.8 | 6.85 | 0.88 |

*Source:* Survey data.

Table 8.13  Variable cost per 125 kg in traditional gari processing

| Village | Harvesting roots (₦) | Transport- ation from farms (₦) | Grating (₦) | Labour (₦) | 200 cassava roots (₦) | Total variable cost (₦) | Cost of cassava as percentage of variable cost |
|---|---|---|---|---|---|---|---|
| Igbonla | 2.00 | 2.00 | 3.00 | 3.80 | 16.40 | 27.20 | 60.29 |
| Kokogi | 2.00 | 1.00 | 3.00 | 3.50 | 16.60 | 26.10 | 63.60 |
| Iporin | 2.00 | 1.00 | 3.00 | 3.30 | 15.00 | 24.30 | 61.73 |
| Ilaju | 1.50 | 1.75 | 3.50 | 3.20 | 14.00 | 23.95 | 58.46 |
| Eleyeile | 1.50 | 1.50 | 3.50 | 3.60 | 14.50 | 24.60 | 58.94 |
| Obakayeja | 2.00 | 1.00 | 3.00 | 4.25 | 17.50 | 27.75 | 63.06 |
| Olorioso | 2.00 | 1.00 | 3.00 | 4.00 | 17.45 | 27.45 | 63.57 |
| Okikiola | 2.00 | 1.50 | 3.00 | 4.95 | 17.50 | 28.95 | 60.45 |
| Fasola | 2.00 | 2.00 | 3.00 | 4.45 | 17.00 | 28.45 | 59.75 |
| Ikolaba | 2.00 | 2.00 | 3.00 | 4.25 | 16.60 | 27.85 | 59.61 |
| Awon | 2.00 | 1.00 | 3.00 | 4.55 | 15.00 | 25.55 | 58.71 |
| Olorunda | 2.00 | 1.00 | 3.00 | 4.30 | 15.55 | 25.85 | 60.15 |
| Average | 1.92 | 1.40 | 3.08 | 4.01 | 16.09 | 26.50 | 60.69 |
| Range | 1.50–2.00 | 1.00–2.00 | 3.00–3.50 | 3.20–4.95 | 14.00–17.50 | 24.30–28.95 | 58.46–63.60 |

Source: Survey data.

Table 8.14  *Average cost per 125 kg of traditional processing*

| Village | Fixed cost (₦) | Variable costs Cassava cost (₦) | Other costs (₦) | Total cost (₦) | Cost of cassava as percentage of total cost |
|---|---|---|---|---|---|
| Igbonla | 0.57 | 16.40 | 10.80 | 27.77 | 59.06 |
| Kokogi | 0.86 | 16.60 | 9.50 | 26.96 | 61.57 |
| Iporin | 0.76 | 15.00 | 9.30 | 25.06 | 59.86 |
| Ilaju | 0.57 | 14.00 | 9.95 | 24.52 | 57.10 |
| Eleyeile | 0.62 | 14.50 | 10.10 | 25.22 | 57.49 |
| Obakayeja | 1.71 | 17.50 | 10.25 | 29.46 | 59.40 |
| Olorioso | 1.37 | 17.45 | 10.00 | 28.82 | 60.55 |
| Okikiola | 1.14 | 17.50 | 11.45 | 30.09 | 58.16 |
| Fasola | 0.69 | 17.00 | 11.45 | 29.14 | 58.34 |
| Ikolaba | 0.57 | 16.60 | 11.25 | 28.42 | 58.41 |
| Awon | 0.98 | 15.00 | 10.55 | 26.53 | 56.54 |
| Olorunda | 0.69 | 15.55 | 10.30 | 26.54 | 58.59 |
| Average | 0.88 | 16.09 | 10.41 | 27.38 | 58.77 |
| Range | 0.57–1.71 | 14.00–17.50 | 9.30–11.45 | 24.52–30.09 | 56.54–61.57 |

*Source:* Survey data.

Table 8.15  *Net annual revenue in traditional processing*

| Net revenue per annum | No. of respondents | % of respondents |
|---|---|---|
| Below ₦99 | 14 | 13.33 |
| 100–149 | 5 | 4.76 |
| 150–199 | 6 | 5.71 |
| 200–299 | 12 | 11.43 |
| 300–399 | 42 | 40.00 |
| 400–499 | 14 | 13.33 |
| Above ₦500 | 9 | 8.57 |
| No response | 3 | 2.90 |
| Total | 105 | 100.00 |

*Source:* Survey data.

Table 8.16   *Net revenue per 125 kg in traditional gari processing by village*

| Village | Gross revenue (₦) | Total cost (₦) | Net revenue (₦) |
|---|---|---|---|
| Igbonla | 34.50 | 27.77 | 6.73 |
| Kokogi | 37.56 | 26.96 | 10.60 |
| Iporin | 34.23 | 25.06 | 9.17 |
| Ilaju | 31.60 | 24.52 | 7.08 |
| Eleyeile | 31.00 | 25.22 | 5.78 |
| Obakayeja | 36.35 | 29.46 | 6.89 |
| Olorioso | 36.28 | 28.82 | 7.46 |
| Okikiola | 34.32 | 30.09 | 4.23 |
| Fasola | 32.38 | 29.14 | 3.24 |
| Ikolaba | 33.12 | 28.42 | 4.70 |
| Awon | 32.44 | 26.53 | 5.91 |
| Olorunda | 33.00 | 26.54 | 6.46 |
| Average for 125 kg | 33.90 | 27.38 | 6.52 |
| Average for 1 kg gari | $\frac{₦6.52}{₦125} = ₦0.05$ | | |
| Range | 31.00–37.56 | 24.52–30.09 | 3.24–10.60 |

*Source:* Survey data.

The respondents were asked to estimate their total annual sales, taking into account seasonal fluctuations. Table 8.15 shows that the net revenue for over 50 per cent of the respondents ranged between ₦300 and ₦499 per annum. Kokogi had the highest average net revenue, while Fasola had the lowest net revenue. This relatively low net revenue is due to the high total cost of processing (see Table 8.16). The average net revenue for all the villages was ₦6.52 per 125 kg bag, or ₦0.05 per kilo of *gari*. If one takes into account the transportation cost, which was about ₦1.40 on average, but ignores storage costs, the net revenue would be ₦3.02 per 125 kg bag of *gari*. Monthly incomes were estimated at about ₦83 per woman, i.e. ₦996 per annum. Monthly incomes from cassava processing alone averaged ₦600 per annum, indicating that approximately 60 per cent of the women's total income came from cassava, and the rest from other

sources, including the production of yam, maize and other food crops and trading.

*Mechanised processing*

Items of fixed costs in mechanised processing include machines, factory buildings and such other capital equipment as tractors, caterpillars, cost of building the dam, furniture and office equipment, electricity generators, farm implements (hoes and cutlasses), landed property, etc. Depreciation was estimated at ₦40,426.72 per annum for these items or ₦3,368.89 per month. However, the factory sometimes had breakdowns, spare parts problems and scarcity of cassava roots for processing, so that the factory produced an average of only 40 tonnes of *gari* per month. The fixed cost per tonne of *gari* was therefore 3,368.89/40 = ₦84.22; ₦10.53 per 125 kg bag, or ₦0.08 per kilo of *gari*.

Items of variable cost included costs of land preparation, labour costs in cassava production, and administrative, factory and sales expenses in cassava processing. To produce 1 tonne of *gari*, 5 tonnes of cassava roots were needed. Since 40 tonnes of *gari* were produced per month, 200 tonnes of cassava roots were needed per month for processing in the factory. Labourers were engaged to work on the farm and paid ₦78.50 per month. Eighty labourers were actively engaged in the production of cassava for factory use. Therefore, the labour cost of producing 5 tonnes of cassava was (₦78.50 x 80)/40 = ₦157.00, or ₦19.63 to produce 125 kg of *gari*.

In the factory, a total of twenty-seven people, each paid ₦70.00 per month, were responsible for the processing of 40 tonnes of *gari* per month. With one person processing 7.41 tonnes of cassava roots per month, the labour cost of processing 5 tonnes of cassava to produce 1 tonne of *gari* was (₦70.00/7.41) × 5 = ₦47.25, equivalent to ₦5.91 per 125 kg bag of *gari* (i.e. ₦0.05 per kilo of *gari*).

On the basis of these estimates, the total cost of producing 125 kg of *gari* at the factory was ₦36.07 (see Table 8.17). The price of 125 kg of *gari* in the factory was ₦37.50, indicating a net revenue of ₦1.43 per 125 kg (i.e. ₦0.01 per kilo of *gari*).

Table 8.17   *Total cost per 125 kg in mechanised gari processing*

|  | ₦ |
|---|---|
| Fixed cost | 10.53 |
| Labour cost on the farm | 19.63 |
| Labour cost of processing in factory | 5.91 |
| Total cost | 36.07 |

*Source:* Survey data.

The financial records of the factory for cassava production and *gari* processing reveal that, in general, the factory made losses, due mainly to high overhead costs and the fact that the factory has been operating much below capacity, producing only about 2 tonnes of *gari* per day, or 40 tonnes per month if breakdowns are considered, compared with a full capacity quantity of 10 tonnes per day.

## Innovation, women and development

*Alternative technologies*
Mechanical graters were introduced into Nigeria around 1940 (Jones and Akinrele, 1976). The implicit reasons for mechanisation included: the need for modernisation; the need to increase productivity; the necessity for improved hygiene and quality of commodity; removing the drudgery of traditional techniques.

The institutions that have made important contributions towards the mechanisation of *gari* processing in Nigeria include: the Federal Institute of Industrial Research (FIIR), Oshodi, Lagos, south-western Nigeria; the Product Development Agency (PRODA), Enugu, in eastern Nigeria; the Fabrication and Production Company (FABRICO), Asaba, in the south-west.

FIIR has successfully tested the fermentation of cassava in plastic containers and is currently using fibreglass silos in its pilot-scale *gari* production. The FIIR has also conducted research on the possibility of improving the nutritional value of *gari* through vitamin supplement, and on the biochemistry

Table 8.18 *Costs and returns in mechanised gari processing* (₦)

|  | 1976 | 1977 | 1978 | 1979 |
|---|---|---|---|---|
| *Costs:* | | | | |
| Depreciation sundries | 2,323.15 | 29,154.92 | 33,847.52 | 40,426.72 |
| Factory expenses | 10,157.95 | 58,215.57 | 44,396.10 | 97,183.21 |
| Administrative expenses | 16,717.05 | 23,598.55 | 39,275.48 | 75,976.16 |
| Weeding expenses | — | 10,510.00 | 33,151.77 | 38,778.16 |
| Miscellaneous expenses | 129,594.09 | 38,410.00 | — | — |
| Total | 158,792.24 | 159,889.04 | 150,670.87 | 252,364.25 |
| *Revenue:* | | | | |
| Sales | — | 71,087.55 | 32,236.92 | 67,866.62 |
| Miscellaneous income | 8,245.00 | 21,968.93 | 1,691.03 | 2,562.14 |
| Harvesting account | — | 38,400.00 | 13,227.39 | 38,394.93 |
| Total | 8,245.00 | 131,456.48 | 47,155.34 | 108,823.69 |
| Total revenue minus total cost | −150,547.24 | −28,432.56 | −103,515.53 | −143,540.56 |

*Source:* Survey data.

of *gari* frying and drying; as a result, it has developed a rotary sequential cooker that first subjects the grated cassava to high temperatures for gelatinisation, and then passes it on to a separate container to bring the temperature down to acceptable levels.

Other technological innovations of the FIIR, and subsequent improvements by the two indigenous enterprises (PRODA and FABRICO), formed the basis for the 3-tonne-a-day *gari*-processing plant, which is essentially intermediate in technology. Lever presses that could be made by village craftsmen were developed by FIIR in the 1950s. These presses have, however, not been adopted. The improved designs for traditional village frying of *gari* produced by FIIR, PRODA and FABRICO have also not generally been adopted. Furthermore, PRODA has developed a continuous cooker in which the mash is moved along a heated trough by a screw feed, but it has not offered it for sale pending further research and development. FABRICO manufactures and sells a similar cooker with a reported capacity of 3 tonnes per day. The other types of village cooker that can toast large volumes at a time, thus effecting savings in labour and time, are the Brazilian and Togo type cookers. The Brazilian village cooker is a large pan, 60 or more inches in diameter, that is supported by a waist-high ring of brick or concrete with a fire door. Village *gari* centres in Togo have cooking sheds in which a row of 30-inch cooking pans is supported on a concrete structure with an opening under each pan for its cooking fire. The cookers can handle large batches and they are most efficient if a number of batches can be roasted in succession.

*Impact of innovations*
An attempt was made, first, to discover the macro effects of innovation on the women. Preliminary investigations in the study area revealed that the main types of innovative technologies relating to cassava were the use of mechanical graters in traditional processing, co-operative organisation, the establishment of the cassava farm and *gari* factory complex, and infrastructural improvements. Before the introduction of mechanical cassava graters to the study area

in the early 1970s, women *gari* processors grated their cassava manually. The use of mechanical graters is now common in both the Fasola and the Elere areas of study and forms a part of the traditional processing system. Co-operative development and the establishment of the 10 tonne-a-day factory, however, have taken place only in the Elere area of the study and are not a part of the traditional system.

*Mechanical cassava graters*   The effect of innovation on the women was assessed first through a consideration of the ownership of mechanical cassava graters. In all the villages in the study area, men rather than women owned the graters, and the women took their peeled cassava tubers to be grated at a fee. When asked why they did not own the graters, the women said that only the men could afford to buy them. Two effects of the *gari* graters on the women could thus be deduced. First, the mechanical graters had the direct effect of opening up investment opportunities for men and not for women, who could not afford to buy them. Secondly, the graters had the indirect effect of reducing the drudgery involved for women in the manual grating of cassava.

*Co-operative organisation and factory processing*   The Ido Co-operative Farming and Produce Marketing Society was formed in 1918. The objectives of the society included: (i) to promote the economic interests of its members and improve the methods of agricultural production in its area of operation; (ii) to engage in the cultivation of cassava roots and other farm crops as well as the manufacturing of *gari* and other agro-allied products; (iii) to acquire and manage large areas of land for farming and to encourage its members to use new techniques of farming.

However, it was only in 1972 that the society was able to obtain land in Elere, in the study area. The governing body of the society was the Committee of Management, which was made up of non-profit-making members, officials of the state Ministry of Agriculture and Natural Resources and of the Industrial and Credit Corporation, officials of the state, some representatives of the members of the society and senior officials of the society, including the plantation manager, the

production manager and the accountant. The society received a loan from the Western Nigerian Agricultural Investment and Industrial Development Corporation for starting the cassava project in 1975. Tractors and ploughs were hired from the State Ministry of Agriculture for land clearing and harrowing. In general, a definite attempt was made to encourage co-operative cassava production and mechanised *gari* processing through the supervisory role of the Oyo State Ministries of Agriculture and Natural Resources and Trade, Industry and Co-operatives, as well as by generating loans and supplying modern factory inputs to the co-operative venture. However, a study of the effects of co-operative organisation and of the factory processing of *gari* indicated that: (i) investment opportunities were opened up for men in cassava production and processing; (ii) no attempt was made to encourage or involve women; and (iii) cassava processing, which was traditionally a woman's occupation, was taken up by men through co-operative activities so that the overall effect of the co-operative *gari* venture and mechanisation was that women were replaced by men in *gari* processing.

*Infrastructures*   The infrastructural facilities in the study area were also examined in order to deduce the effects on the women of innovation relating to *gari* processing. The facilities examined (following Wharton, 1968) were access to credit sources, extension services, transportation facilities and storage equipment. In general, there was little change in the infrastructural environment as far as the women were concerned.

The women received little or no loans from public institutionalised credit sources (see Table 8.19). They indicated that their personal savings and loans from their husbands, other relatives, friends, as well as moneylenders were their main sources of funds. The women encouraged their husbands to innovate, such as in the purchase of cassava graters, in joining the co-operative or in seeking the advice of extension officers for improved farm practices.

Tables 8.20–8.24 illustrate the nature of the transportation and storage facilities used by the women studied. In Elere, the *gari* factory seemed to have helped to open up the area to

Table 8.19   *Most important sources of 'help' for the respondents*

| Sources of help | % of respondents |
|---|---|
| Husband | 30.1 |
| Children | 20.0 |
| Other relatives | 20.2 |
| Women's groups | 18.3 |
| Banks | 0.2 |
| Co-operatives | 0.3 |
| Ministry of Agriculture | 0.9 |
| Hired labour | 10.0 |

*Source:* Survey data.

Table 8.20   *Methods of transporting gari*

| Method | Fasola No. | % | Elere No. | % | Both areas No. | % |
|---|---|---|---|---|---|---|
| Headload | 5 | 6.02 | — | — | 5 | 4.77 |
| Lorry | 74 | 89.16 | 22 | 100.0 | 96 | 91.42 |
| Doesn't transport | 4 | 4.82 | — | — | 4 | 3.81 |
| Total | 83 | | 22 | | 105 | |

*Source:* Survey data.

Table 8.21   *Distance travelled to markets*

| Distance | Fasola No. | % | Elere No. | % | Both areas No. | % |
|---|---|---|---|---|---|---|
| About 1 km | 10 | 12.05 | — | — | 10 | 9.52 |
| 2 – 10 km | 17 | 20.48 | — | — | 17 | 16.19 |
| Over 10 km | 55 | 66.27 | 22 | 100 | 77 | 73.33 |
| No response | 1 | 1.20 | — | — | 1 | 0.95 |
| Total | 83 | | 22 | | 105 | |

*Source:* Survey data.

Table 8.22   *Storage of gari*

|       | Fasola No. | % | Elere No. | % | Both areas No. | % |
|-------|-----------|-------|----------|------|---------------|-------|
| Yes   | 71        | 85.54 | 22       | 100  | 93            | 88.57 |
| No    | 12        | 14.46 | —        | —    | 12            | 11.43 |
| Total | 83        |       | 22       |      | 105           |       |

*Source:* Survey data.

Table 8.23   *Place of storage for gari*

| Storage place | Fasola No. | % | Elere No. | % | Both areas No. | % |
|---------------|-----------|-------|----------|-------|---------------|-------|
| Market        | 29        | 34.94 | 9        | 40.91 | 38            | 36.19 |
| House         | 42        | 50.60 | 9        | 40.91 | 51            | 48.57 |
| No response/do not store | 12 | 14.46 | 4 | 18.18 | 16 | 15.24 |
| Total         | 83        |       | 22       |       | 105           |       |

*Source:* Survey data.

Table 8.24   *Storage period for gari*

| Duration | % of respondents Fasola | Elere | Both areas |
|----------|------------------------|--------|------------|
| 1 day         | 2.41   | —      | 1.90   |
| 2 – 3 days    | 19.28  | —      | 15.24  |
| About 1 week  | 13.25  | 86.36  | 28.57  |
| About 2 weeks | 27.71  | 13.64  | 24.76  |
| 2 – 4 weeks   | 19.28  | —      | 15.24  |
| No response   | 18.07  | —      | 14.29  |
| Total         | 100.00 | 100.00 | 100.00 |

*Source:* Survey data.

lorry transport, and all the women studied indicated that they transported their *gari* to the market by lorry – compared with 89 per cent in the Fasola area, where roads were particularly bad. Similarly, all the respondents in Elere indicated that they stored their *gari*, whereas 14 per cent of the respondents in Fasola indicated that they disposed of their supplies immediately after processing. The women in the Fasola area often processed large quantities of *gari* at particular time periods for private traders who came to the villages for purchase immediately after processing. Many respondents stored their *gari* supplies at home in such receptacles as basins, calabashes, bags, etc. The *gari* containers were simply seated on earthern or, very rarely, cemented floors.

*Direction of change* Apart from the macro effects of innovation discussed above, an attempt was made to indicate, on a micro basis, the effects of innovation in *gari* processing on the women. First, the women were asked to indicate the direction of change in selected variables. The women were asked to check by '+', '−' and 'n' for increase, decrease or no effects, respectively. A summary of the responses is presented in Table 8.25. In general, the respondents felt that processing costs per unit had fallen, particularly as a result of the use of the mechanical graters, and their productivity had increased, leading to higher incomes. There were also improved family and social relationships and awareness. However, women's access to modern factor inputs and to public sources of credit as well as such culturally and socially determined factors as male–female status remained unchanged.

*Index of the effect of innovation* The respondents were asked to rank the effects of innovation on selected variables by assigning values of 0, 1, 3 and 5 to high, medium, low and no effects, respectively. Sixteen variables were involved, so that the possible scores ranged from 0 to 80. A summary of the respondents' ranking of the effects is presented in Table 8.25. On the basis of this, an index of the effect of innovation was constructed. In general, the value and costs of *gari*

Table 8.25   *Direction of change in socioeconomic variables*

| Variable (in rank order) | Change | % of respondents |
|---|---|---|
| 1 Income | + | 90.4 |
| 2 Productivity | + | 80.6 |
| 3 Processing costs for *gari* | – | 81.3 |
| 4 Returns in *gari* processing | + | 76.4 |
| 5 Family relationships | + | 63.5 |
| 6 Social relationships | + | 68.9 |
| 7 Value of *gari* processed | + | 73.4 |
| 8 Employment | + | 61.2 |
| 9 Role of women | + | 91.8 |
| 10 Status of women | n | 89.0 |
| 11 No. of children | n | 87.4 |
| 12 Loans from public sources | n | 81.2 |
| 13 Modern farm inputs | n | 71.6 |
| 14 Market outlet | n | 77.0 |
| 15 Capital | n | 59.3 |
| 16 Investment opportunities | n | 76.1 |

*Source:* Survey data.

processed, income and productivity received high scores, while accessibility to factor inputs received low scores. According to this index 21, 29, 20 and 30 per cent, respectively, of the respondents felt that the innovations had no, low, medium and high effects.

*Index of high innovative effect*   The respondents' scoring of the effect of innovation was analysed further to capture the high effect of the innovations. First, high effect as a proportion of total effect was obtained. Then, with the highest proportion regarded as base (13.5 = 100), an index was constructed for the different variables, ranging from 0 to 100. For seven out of the sixteen variables the index of high innovative effect took a value of 0–25 compared with the other variables whose index took a value of 50–100. The policy implications of this is that, to achieve success, subsequent or similar programmes should be targeted at variables showing such high innovative effects. (Alternatively, the chi-square or regression analysis could have been

undertaken to show the effect of innovation on these variables. However, the construction of indices was preferred because of the desire to indicate those variables that had showed high effects of innovation, for the purposes of policy formulation.)

## Conclusions and policy implications

### Conclusions

One of the main conclusions that emerges from this chapter is that the problem of food production in Nigeria and other African countries is the low productivity of the small traditional farmer (male and female) – on the farm, in processing and in other post-harvest operations. Women occupy an important position in Nigerian agriculture in terms of physical farm activities of production, but even more so in the off-farm activities of processing and in trade, particularly for food. Improved technology, in embodying the benefits of science, modern knowledge and know-how, techniques and implements, is a useful instrument for effecting productivity increases in agriculture in Nigeria and other African countries. However, improved technology is useful only if it is relevant to the needs of a particular system. It is clear from an analysis of the evidence that in African countries improved technologies must be relevant to the needs of women. In addition, the traditional agricultural system is beset with such problems as ageing farmer population and low educational level, which affect the capacity of the farmers to adopt innovations.

The main problems in relation to food processing were observed to be the use of old technologies in traditional processing, cassava shortages at peak periods and overcapitalisation and underutilisation of modern or mechanised processing. The most significant finding of this study is that the traditional *gari*-processing system is more efficient than the mechanised system, in terms of both costs and returns and its relevance to the needs of the village economy. Moreover, the study shows that, although innovations can have positive and beneficial economic effects in increasing agricultural productivity and rural incomes and in reducing costs, innovation may not, at least in the short run, lead to

demographic changes because family size, the number of children per woman, as well as the role perception and status, are often socio-culturally determined.

*Policy implications*
The policy implications of the findings of this chapter are discussed below in terms of technology, the role of women in development, transforming traditional agriculture and *gari* processing.

*Technology*  The pivotal role of technology in agricultural development needs to be recognised. Attempts should therefore be made to identify and promote the creation (or adaptation) and transmission of new knowledge, new implements and new technologies. Particular attention needs to be paid to the relevance of technology for promoting agricultural development. Agricultural development and rural transformation in Africa need to walk on two legs by conserving the advantages of the traditional system while introducing a preferred technology to overcome the disadvantages of the traditional system. Therefore, the introduction of relevant and appropriate technology should proceed, first, by identifying the advantages and disadvantages of existing or traditional technology, and secondly by screening preferred technologies. Then the most relevant or appropriate should be selected on the basis of its capacity for overcoming the disadvantages of traditional technology.

Small-scale technologies are particularly significant for favourable costs and returns. It has also been observed that the strategy of selective rather than complete mechanisation is often the answer, especially in the early stages of agricultural development. Only difficult aspects of agricultural processes need to be mechanised to break bottlenecks in manual operations, thereby increasing productivity while still maintaining the essentially labour-intensive nature of the processes. Biochemical and mechanical innovations are based on continuing research and the application of science and technology in agriculture. To this extent, continuing research, both basic and applied, is necessary. The critical role of change agents in the diffusion of innovation needs to be

recognised, particularly through the development of a virile agricultural extension service. Possible effects of innovations should be identified prior to their introduction so that particular measures can be targeted at particular groups or issues (for example, income increases, employment generation, etc.) for maximum effect.

*Women in development* The notion of wives of leisure is really foreign to much of Africa; women have always worked, even within the confines of the family compound for those women in purdah. By-passing women in development leads to underutilisation of productive resources. It is therefore essential to ensure that women are catered for in development projects. Integrating women into development means not only providing for male and female involvement but sometimes positively discriminating in favour of women by encouraging female participation in co-operatives, in the adoption of improved practices, and so on. An effective method for integrating women into development is to train more female development agents (for example, extension agents) and to target improvement programmes specifically at women. The socioeconomic role and importance of the women frequently exceeds their low status relative to men's, which is often due to socio-cultural and religious factors. Further education of women is therefore essential to rectify the imbalance. An education–employment–incomes strategy needs to be devised for women to promote their technical education, to increase their productivity and incomes and to generate more employment for them in agro-related activities. In particular, the introduction of improved village technology is essential, for the supply of water, for grating and grinding food commodities and for simple implements for use on the farm and in the home.

*Transforming traditional agriculture* The small farmer (male and female) is the basic unit of African agriculture. Attempts at productivity increases in African agriculture should therefore centre on increasing the productivity of the small farmer through biochemical and mechanical innovations. They would also have to be encouraged to work together and

reap possible economies in input supply, in farm operations and in marketing through the formation of co-operative societies. Developing agriculture is often brought about by the use of more modern but purchased inputs such as fertilisers and herbicides. This means that it is often necessary to supply supervised credit, particularly in kind, to the farmers. Agricultural development projects often concentrate only on the technical problems of productivity increases, neglecting the problems of marketing. However, since farm inputs and outputs enter the market on the way to or from the farm, then market development needs to be incorporated into agricultural development projects. A minimum of government intervention is necessary for effecting agricultural modernisation and development, to counter market imperfections and improvements. Government effort would have to be concentrated mainly on the establishment of a suitable infrastructural environment (the provision of good roads, better storage facilities, more research, a more vigorous extension service, easier access to agricultural credit, etc.) rather than on direct involvement in agricultural production, processing and distribution, so as not to stifle but to promote private enterprise, initiative and investment. The delivery of improvement packages is often as important as the packages themselves. For instance, if fertilisers arrive late, then they become irrelevant and useless to the farm needs. It is therefore essential that improvement packages are relevant and timely and that they actually reach the farmers who need them.

Gari *processing* Cassava supply needs to be increased through research into the production of hybrid, high-yielding and disease-resistant varieties of cassava. Village and intermediate technology for *gari* processing needs to be promoted to increase incomes and productivity in the traditional system. Better methods of effecting the different stages in traditional processing could be devised for adoption at the village level. In particular, overcapitalisation and underutilisation of capacity should be avoided in order to minimise costs. Better methods for the diffusion of innovation should be adopted. This could be aligned to such existing pro-

grammes as the agro-service system, the Green Revolution Programme and the seed multiplication system in Nigeria. Quality improvements in traditional *gari* processing should be encouraged to enhance storability and promote consumer satisfaction. Marketing improvements could be introduced through the formation of co-operatives, for the adoption of a more appropriate channel of distribution and a reduction in marketing costs and margins.

# 9

# Improved Technologies for Rural Women: Problems and Prospects in Sierra Leone

*YVETTE STEVENS*

## Introduction

Three-quarters of the Sierra Leone population is rural, of which over one-half are women. Agriculture, fisheries and livestock contribute significantly to the rural economy. Provision of water, a matter of direct concern to rural women, is a serious problem. In 1974, 58.1 per cent of the population of the western area had access to pipe-borne treated water supply. The figures for the northern, eastern and southern provinces were 3.4 per cent, 5.6 per cent and 15.6 per cent, respectively. Yet another 129,000 persons were served by pipe-borne untreated water (Nath and Thomas, 1976). The remainder of the population depended on local rivers, streams, wells and swamps for water supply. In 1978, 60 per cent of rural households got their water from rivers and streams (Government of Sierra Leone, 1978).

In Sierra Leone there are eighteen or so ethnic groups with a considerable degree of cultural uniformity throughout the country (Harrel Bond and Rijnsdorp, 1976). Evidence of this is the prevalence of female (Bondo, Bundu or Sande) and male (Wande, Gbangbani and Sokko) secret societies among almost all the ethnic groups and the similarity of customary laws relating to marriage and divorce.

Only 54 per cent of the rural women could be described as

primarily housekeepers. The rest, even though responsible for all the household chores, still have to devote considerable time to other activities, notably farming. It should be noted that the provision of rice for the family is the responsibility of the men. Household income is derived from the sale of surplus rice or other food crops and from other income-generating activities. The 48 per cent of women from rural Sierra Leone engaged in the labour force contribute an average of only 1.7 per cent to the total family income because most of them are engaged in unpaid family work (Government of Sierra Leone, 1970b) (this might be an underestimation owing to the fact that men's incomes are derived from activities in which women actively participate, for example food crop and rice farming). Even in non-farming villages (fishing and cattle-rearing areas), most of the food for home consumption is grown by women. There has not been any detailed study on the time budget of these women, but available evidence seems to suggest that they spend about 8–9 hours a day during the peak rice-farming season on the farms. The rest of the day they spend fetching water and firewood, cooking, doing household chores, as well as engaging in income-earning activities to supplement the family income. Sometimes they have to travel long distances on foot to fetch firewood and water and to trade.

Communal (chiefdom) ownership of land is prevalent, and even though women have access to communal land the initial work of clearing and ploughing prove to be too difficult for the women who generally cannot afford the cost of tractors or hired labour. Thus women work on their husbands' or other male relatives' farms or as hired labourers on other farms for which they receive payment in cash or in kind (Spencer, 1976, 1979). There is considerable co-operation between the sexes in farming (Ottenburg, 1983; Harrel Bond and Rijnsdorp, 1976). In both swampland and upland farming, planting, weeding and harvesting operations are mainly women's responsibility, while the more physically demanding tasks of clearing and tilling are carried out by men.

Sometimes, as well as working on the farms, women possess backyard gardens or make gardens on deserted rice farms, to grow crops such as groudnuts and cassava, mainly

as dietary supplements for the household. They are not expected to sell these crops unless there is a substantial surplus or there is financial difficulty. In some areas of the country women grow cotton, which is spun in their spare time. The yarn is either sold or woven by the men for themselves or for the women. The rural woman takes pride in growing first-class crops and would often boast of her yields. The tools available to her are, however, simple and inefficient and this limits her farming activities and yields. She prepares manures from wood ash and plant and animal wastes. Agricultural mechanisation has mainly been used for ploughing but not for planting, weeding or harvesting, tasks traditionally the responsibility of women.

Food processing and preservation are predominantly female tasks. The processing of rice after the harvest (threshing, parboiling, dehusking and winnowing) is undertaken by women. A familiar scene in the rural areas of Sierra Leone is the 'incessant' pounding of rice by women. Women also have the responsibility for milling grains, spices and vegetables; sun drying of vegetables, spices and fish; fish and meat smoking; preparation of vegetable oil from coconut and palm fruits; milking of cattle; and preparation of *fufu*, cassava and starch.

In addition, women look after the children, the sick and the aged. In the Nutrition Survey of 1978 (Government of Sierra Leone, 1978), over 99 per cent of the participating children in the rural areas were recorded as being cared for by mothers and grandmothers.

Women engage in petty trading, selling of vegetables, fruits and cooked foods along the roadside as well as extensive business activities in selling rice and cement. Some even own transport vehicles. In some areas women are involved in trade of *gara* (tie-dyed) materials and even employ men (Harrel Bond and Rijnsdorp, 1976; MacCormack, 1976). Women are also engaged in other income-generating activities such as tie-dying, soap making and shallow water fishing. Because of the increasing financial burden of the rural men they even encourage these activities and actually provide their wives with capital.

Recently self-help projects have sprung up and women

have been involved in the building of roads, hospitals and community centres. In addition, migration to the towns and mining areas have meant that some women are left to manage their husbands' farms. The increasing range of tasks performed by the women in the rural areas has led to the situation where they are seriously overemployed. The prolonged hours of work and heavy burden involved in women's tasks could in fact result in a lowering of the life expectancy of these women. Moreover, women aged 15–44 (that is, of child-bearing age) form about 50 per cent of the total female population. The strain imposed by these tasks on pregnant women could therefore affect their health as well as that of their offspring. The fact that women at all stages of pregnancy can be seen performing most of these laborious tasks could be a contributory factor to the high maternal mortality rate (4.5 in 1,000 births): complications in pregnancy, labour and puerperuum account for no less than 25 per cent of deaths of women aged 15–49 years.

The vast majority (94 per cent) of the rural women in Sierra Leone have had no formal education. Adult education programmes could thus benefit these women if they are given time to participate in them. The women would, however, have to be convinced of the need to be involved in these programmes.

In rural Sierra Leone it is considered respectable for a woman to be married or at least have some male direction or supervision (Harrel Bond and Rijnsdorp, 1976). In some chiefdom regulations it has been written that no woman is allowed to reside on her own without the care and protection of a man. This 'protector' could be a 'husband, father, relative, lover, chief or a big man she has attached herself to as a widow' (Ottenburg, 1983, p. 77). It is also said that she needs a male to direct her funeral in the event she dies. It is this 'protector' who advises her on vital matters and to whom she turns in times of trouble. Female headship of rural households is not common in most of the country, (although MacCormack reports a large percentage of female-headed households in the Kagboru chiefdom – 59 per cent in the capital Shenge). The 1980 household surveys of the Central Statistics Office revealed that on average only 8 per cent of

the rural households are headed by women (Government of Sierra Leone, 1980). Polygamy is widely practised throughout the country, although more predominantly in the north and east.

Particular mention has to be made of rural women's groups in the country. The Bondo (Sande) secret societies are exclusively women's groups that are completely autonomous. The functions of these societies go far beyond merely educating and preparing young girls for marriage and womanhood as is generally believed (Beoku-Betts, 1976). Madam Yoko, a Kpa Mende woman chief (1895–1906), was able to further her political career through her leadership and membership of the Sande society. In the Bafodea chiefdom, Ottenburg observed that 'outside the domestic sphere and the network of kin ties in various villages it is largely through the female secret society that women move out of the home' (Ottenburg, 1983, p. 77).

Within the past decade women have grouped themselves together and formed their own co-operatives. These are arts and crafts and thrift and credit societies. It is perhaps noteworthy that the all-female co-operatives are reputed to be well organised and good at paying back loans within the specified periods. (In 1976 the Co-operative Department reported a 100 per cent repayment of all loans to women's co-operatives.) Although there is some scepticism on the part of the rural population about co-operatives where sharing of profits is involved, it is felt that with proper administration and supervision 'co-operatives possess great potentials for disseminating and implementing appropriate technologies' (Government of Sierra Leone, 1979).

In addition to secret societies and co-operatives there exist in the rural areas a number of other women's organisations. Such organisations encourage the active participation of women in economic, social, religious and political activities as well as acting as pressure groups to preserve the rights and dignity of women. Exclusively female groups in Sierra Leone therefore have the great advantage that they can be utilised to promote women's interests and make their voices heard.

In the Sierra Leone context, it is felt that efforts in the design and introduction of improved rural technologies have

been haphazard and unco-ordinated. In order to conserve scarce resources, a methodical and co-ordinated approach should be taken. At this stage, this should of necessity start with some 'stock-taking'.

In the light of the above, an attempt is made in this chapter to put together evidence on the condition of rural women in Sierra Leone and on the role of technology. This state-of-the-art survey begins by looking at the status of rural women in Sierra Leone and the range of technologies relevant to their work. Activities for which rural women in the country are primarily responsible are highlighted and the methods and technologies (both traditional and improved) that are in use are described. A critical appraisal of the methods and technology is made, particular emphasis being given to the problems encountered in their use. It then identifies the conditions of availability, practicability and profitability necessary to ensure acceptability and widespread use of improved technologies by rural women and develops a flow chart for the introduction of improved technology devices. Improved technologies developed to date are analysed using the conditions for ensuring acceptability outlined earlier. Problems of improved technology generation, production and adoption are highlighted. Possible ways in which improved technologies can be used to relieve boredom and drudgery and increase the rural women's income-earning capability are suggested.

## Technology spectrum for rural women's tasks – review and appraisal

As was seen from the introductory section, there exist in the rural areas of Sierra Leone a well-defined sexual division of labour. That is, a number of tasks are primarily the responsibility of the women. Many of these activities are non-income generating, as well as being both time- and labour-consuming. In this section the existing methods utilised for women's tasks are reviewed in order to permit a critical appraisal and to identify areas in which improved technology can be useful, and to see which existing methods can be upgraded to give better performance (Table 9.1).

Table 9.1 *Improved technologies for traditional methods*

| Activity | Methods | Major operations | Possible 'improved' technologies | Comments |
|---|---|---|---|---|
| Cooking | '3-stone' method, charcoal stoves. | | Improved fuel savings, wood and charcoal stoves. Stoves utilising non-conventional fuels. | Stoves being developed at Faculty of Engineering, FBC, and National Workshop. |
| Water collection and storage | From wells, streams, catchments. | Carrying, pulling, lifting. | Hand pumps and power-driven pumps, for driving water from wells and streams. Sancrete and charcoal filters for water. | Hydro power generation to provide power for driving pumps can be used. |
| Farming | Hoes, *sondees* and other handtools. | Digging, weeding, harvesting. | Planters, seeders, improved handtools. | |
| Rice processing | Rice is threshed, winnowed, parboiled and dehusked. | Pounding, boiling, winnowing, threshing. | Mills for dehusking, rice threshers, winnowers and parboiling units (solar-operated) | Rice threshers and winnowers are manufactured by the TAEC. |

| | | | | |
|---|---|---|---|---|
| Food preservation | Salting, sun drying, fish smoking. | Drying. | Solar driers, solar/fuel-fired driers, unconventional and conventional fuel 'smokers'. | Driers and smokers being developed at Faculty of Engineering, FBC. |
| Food processing: Palm oil production | Boiling or fermenting palm fruit. Pounding or stamping to remove nuts. Squeezing to get oil. | Pounding, sun drying, boiling, pressing. | Palm oil screw press, hydraulic presses. | Palm oil screw press designed by Faculty of Engineering, FBC, undergoing field tests. |
| Palm kernel oil production | Palm kernels cracked open, copra roasted and mixed with water and boiled, oil scooped from the water. | Cracking of nuts, roasting, pounding, boiling. | Palm kernel crackers. | Designed by Faculty of Engineering, FBC. |
| Milling | | Grinding, pounding, sieving. | Hand-operated grinders, hand- and power-driven mills. | Hydro power sources can be tapped. |

*continued*

Table 9.1 (continued)

| Activity | Methods | Major operations | Possible 'improved' technologies | Comments |
|---|---|---|---|---|
| Cassava processing: | | | | |
| Gari production | Grating cassava, draining excess water, drying and roasting in pots. | Peeling, grating, sieving, drying, roasting, pressing. | Cassava graters, hydraulic press, solar/fuel-fired driers, mechanical sieves, peelers can be designed. | Cassava graters being designed by TAEC. |
| Fufu production | Cassava soaked and allowed to ferment, then grated and drained. | Peeling, grating, baking. | Hand- and power-driven cassava graters and peelers, hydraulic presses. | |
| Cassava bread production | Cassava grated, pounded and baked in iron rings. | Peeling, grating, baking. | Hand- and power-driven cassava graters and peelers, ovens for baking. | |
| Starch production | Cassava peeled and grated then sieved, and filtrate evaporated. Residue is starch. | Peeling, grating, sieving. | | |

| | | | |
|---|---|---|---|
| *Ogiri* production | Benniseed is pounded to remove skin, boiled and fermented. | Pounding, boiling, fermenting. | Mill for dehusking benniseed, solar cookers or 'hot box' cookers for boiling. | |
| Coconut oil production | Coconut cracked open, copra grated, mixed with water and left to stand. Oil is scooped off and heated in pot. | Decorticating, grating. | Coconut decorticator, graters. | |
| Maize and groundnut shelling | Shelled by hand. | Shelling. | Maize and groundnut shellers hand/power-operated. | Groundnut shellers manufactured by TAEC. |
| *Gara* dyeing | Dye dissolved in water, left for some time then stirred. Patterns achieved by tying, stamping, sewing or waxing. | Stirring, dipping. | Improved dyes from local leaves, fixants for dyes. | |
| *Lubi* and soap making | Plant material is dried and burnt. The ashes are mixed with water and filtered. Filtrate is collected and evaporated. The filtrate is *lubi*. If mixed with water and boiled with palm oil black soap is obtained. | Drying, filtering, evaporating. | Solar driers could be used for drying plant wastes. | |

*continued*

Table 9.1 (continued)

| Activity | Methods | Major operations | Possible 'improved' technologies | Comments |
|---|---|---|---|---|
| Laundry soap making | Solution of caustic soda is mixed with preheated palm oil and boiled, then mixture allowed to set. | Boiling, stirring. | | |
| Handicrafts | Cloth weaving, crochet, knitting, embroidery. | Weaving, knitting, embroidery. | Knitting and weaving looms and embroidery machines. | |

*Notes:*
FBC = Fourah Bay College
TAEC = Tikonko Agricultural Extension Service.

*Cooking*

*'Three-stone' method*   Traditionally, the 'three-stone' method is used throughout the country. Heat regulation is obtained by fanning or adding more wood (to increase heat) or by pulling out some wood and extinguishing with water (to reduce heat). The by-product, wood ash, is used as manure for backyard gardens, to clean teeth and remove hair, and also to facilitate handling of cotton fibre in weaving operations. The species of wood used are usually 'black tumbler' (*dialium guineense*) and plum (*prunus domestica*) but any dry wood with reasonable combustion properties is utilised in sizes of approximately 5×5×80 cm. When wood is cut or bought in larger sizes it is chopped into this size with an àxe by the women. The pots used are earthenware, cast iron and recently even aluminium.

The obvious disadvantage of this method of cooking is its low efficiency, which is approximated at less than 10 per cent. (Efficiency here is defined as useful heat/heat produced.) A large percentage of the heat is lost to the atmosphere, mainly by convection. Since these are open fires, accidents frequently occur esepcially when there are little children around. When cooking is done indoors a lot of smoke is produced, particularly at the initial stages of cooking and when fresh wood is introduced. This smoke, although useful for drying grain, which is sometimes stored in the ceiling, has a harmful effect on the lungs and eyes. The method, however, is ideal for traditional cooking, which often requires continuous stirring for over half an hour (e.g. *fufu*) and is done either sitting or stooping. Cooking times of dishes usually are long according to Western standards. The stones are obtained free of charge and the fuel firewood is either collected from the nearby forest or purchased from woodcutters.

*'Coal pots'*   Some of the richer rural people utilise the 'coal pot'. These are charcoal stoves made of cast iron or scrap metal sheets and manufactured by the village blacksmith or in the local workshops. The wood charcoal is produced by incomplete combustion of wood in closed pits (the gases

produced are not utilised). Again, *dialium guineense* and *prunus domestica* are frequently used wood species. Charcoal sizes are usually 2.5 inches or less. Heat regulation is achieved by removing some live charcoal and sprinkling water on burning charcoal (to decrease heat) or by putting on more charcoal and fanning until the charcoal is red hot (to increase heat). As the pot is supported on a stand a few centimetres from the charcoal, it is sometimes possible to obtain heat regulation by lowering or raising the pot stand. This method is also convenient for traditional cooking procedures. The by-product, charcoal ash, is utilised in the same way as the ash from the 'three-stone' method.

The efficiency of this method is estimated at 10–15 per cent, which is an improvement on the 'three-stone' method. The 'coal pot' produces smoke only if the charcoal is wet or badly prepared. The cost of the coal pot ranges between Le 10 and Le 20 for the cast iron variety and between Le 5 and Le 10 for the sheet metal variety (1979 prices). Wood charcoal produces little smoke but is much more expensive than firewood. A bunch of ten sticks of wood 5×5×50cm, costs Le 0.20, whereas a bag of charcoal containing 1m³ costs about Le 4.50 (Le 0.80 = US$1.0). There are no figures available to me as to the calorific values of these fuels to make accurate comparison of their cost in terms of useful heat, but generally charcoal cooks less food per unit cost, even though the charcoal stoves have a higher efficiency than the three-stone method utilising wood.

*Kerosene*  A few imported kerosene stoves have found their way into some rural homes. These are extremely expensive for the average rural family and the price of kerosene has gone up recently to Le 3.00 per gallon, which is outside the reach of most rural dwellers.

*Water collection and storage*

*Underground water*  Where underground water is accessible, hand-dug open wells are available. The water is pulled up via ropes tied to buckets. This method is very laborious, dangerous and time-consuming. Frequently the wells are

contaminated by pit latrines in the vicinity, causing diseases such as gastroenteritis, diarrhoea, dysentry, cholera and typhoid. The damp soil around the wells serves as host for guinea worms.

*Experience with pumps*   The use of well pumps has helped to relieve time and burden in water collection in some areas. Self-help village water supply schemes and hand-pump projects have been set up with villagers providing voluntary labour, the Ministry of Works and the Peace Corps providing engineers and technicians, and the Co-operation for American Relief Everywhere (CARE) providing additional resources such as food supply. Over 250 Dempster deep well hand pumps have been installed in villages in the rural areas, each pump serving 200 persons. USAID hand pumps that have been installed in some parts have not been a success as the cylinders were intended for limited use, and in villages where a single pump has to serve up to 20 families there were problems of frequent replacement of cylinders (Government of Sierra Leone, 1974).

*Rivers and streams*   When underground water is not easily accessible or streams and rivers are nearby, water is fetched from rivers and streams and carried on the head in buckets to the village, which is sometimes a few miles away. Since these streams may be used for excreta disposal further upstream, the water is usually contaminated. Often dams are erected in the streams to store water for dry periods. This damming, however, provides a breeding ground for hosts and vectors of diseases such as malaria, filaria and yellow fever (from mosquitoes), schistosomiasis,[1] bilharzia, onchocerciasis,[2] hookworm and guinea worm (Williams, 1978). In one or two rural communities water is pumped by diesel engines from streams via water pipes to serve the local people.

*Rainwater*   In the rainy season, water can be collected from

[1] Schistosomiasis poses particular problems in the mining and farming areas in the eastern province.
[2] A recent sample survey in some areas in Sierra Leone showed that as much as 80 per cent of the population suffered from onchocerciasis.

roof catchments and stored in containers. These containers could be anything that holds water – usually 44-gallon drums, buckets, tins, etc. More recently, cemented jars have appeared in some areas. The water collected is reasonably clean except after long dry periods. The volume of the container limits the amount of water that can be collected.

*Need for water purification*    Water from all these sources is impure and untreated and, as yet, the need to boil or filter water is nor apparent to most rural dwellers.

It is interesting to note that a large percentage of people in the rural areas of Sierra Leone suffer to some extent from water-associated infective diseases, even when these are not diagnosed, which could account for the decreased labour productivity of these people. The number of man-hours claimed by the water-borne diseases could be alarmingly high.

## Farming

In farming, women use the simplest handtools such as hoes, shovels, *sondees* and knives. The locally manufactured hand hoe is a universal tool used in planting, weeding and harvesting.

## Rice processing

Rice processing is done mainly by women.

*Rice threshing*    After harvesting, the first stage in rice processing is threshing. Traditionally the rice is threshed by hitting the stalks on cemented or tarred surfaces or by laying the stalks on a mat or tarpaulin and trampling by foot. The rice grains are then collected, winnowed (see below) and stored.

Recently, pedal-operated rice threshers have been introduced in the Bo district. One such thresher consists of a revolving cylinder with raised galvanised wire loops on its outer surface. This cylinder is supported on a stand made of galvanised iron pipes. At the base of the stand is a pedal which, by means of a chain mechanism, rotates the cylinder. Rice stalks placed on the rotating cylinder are threshed and

the grains that fall on the ground are collected and stacked.

The Sierra Leone Produce Marketing Board (SLPMB) operates tractor-driven threshing machines for threshing rice from their plantations. These machines have been used by farming co-operatives.

*Parboiling and drying* For parboiling, rice is put in a container, usually 44-gallon drums, and covered with water. It is then heated to about 60°C when the heat is removed and the rice left to soak overnight. Next morning the water is strained out, fresh water is added and the rice is heated again, this time to boiling point. The hot rice is then removed for drying. Drying is done by spreading on mats, tarred surfaces or tarpaulin in the sun.

*Dehusking and winnowing* The next stage in rice processing is dehusking and winnowing. Dehusking is done traditionally by pounding the rice in a mortar with a pestle and winnowing by using a *fanna*. A *fanna* is a shallow tray woven from rattan and bamboo cane, round or oblong in shape. For separating the rice from the husks, pounded rice is put on the *fanna* and tossed. The tossing separates the heavier rice from the lighter husk. The husk is subsequently tossed out of the *fanna*. The processes of pounding and winnowing are continued until the rice is husk-free.

A pedal-operated winnower, which has been introduced in a few villages, consists of an empty 44-gallon oil drum with a plywood hopper suspended on top of it. To one end of the drum is a fan which is operated by a pedal mechanism. The pounded rice is introduced in the hopper and the fan blows out the husks, thus separating them from the grains.

Diesel- and power-operated rice hullers have been used widely throughout Sierra Leone, mainly in the towns. One type is the Engleberg steel roller mill. This consists of a hollow cylinder in which a grooved roller rotates at very high speeds. The rice is fed into the cylinder and husks and bran are removed in a single operation. Where these mills are operated, women who can afford it come to have whole sacks of rice milled for a fee.

The Sierra Leone Produce Marketing Board buys rice

from farmers in the parboiled stage for dehusking at its mills. In rural areas, however, rice for household consumption is still being processed by the traditional methods.

*'Rough' rice*   'Rough' rice is rice that is not parboiled. It is used to prepare rice flour for making snacks such as *kanya* and rice bread, which women usually prepare to sell to workers and schoolchildren.

Since rice is the staple food in Sierra Leone it is needless to say here that the traditional methods of processing are laborious and occupy most of the women's time during the periods immediately following harvest.

## Food preservation

*Sun drying*   In Sierra Leone, where most food crops are harvested only once a year, the need for food preservation is of paramount importance.

Sun drying is used for preservation of grains, vegetables, plant wastes (for potash production), salted fish and herbs. These are spread out in the sun, usually on mats or cemented or tarred surfaces or on raised stands (*bandas*), and stirred or turned over periodically. This method is unhygienic, especially for products that are not subsequently cooked before consumption, as insects rest and lay eggs on them and dust and airborne germs collect in them.

To remain stable in storage, agricultural crops should be dried to a moisture content of 12–15 per cent by weight. The relative humidity for equilibrium with crops of this moisture content is 48–60 per cent, depending on the crop (US National Academy of Sciences, 1976). The high relative humidity in Sierra Leone (70–90 per cent) means that crops dried in the open air cannot achieve the desired moisture content for successful preservation. Because the process is slow, the quality of the finished products (in terms of taste, flavour and nutritional value) is poor. Also, the period of harvest of some crops is during the rainy season when sun drying becomes very difficult and crops rot because of lack of sunshine.

*Fish smoking*  Fish (and rarely meat) is preserved mainly by smoking. In the traditional method the products are placed on *banda* and a slow-burning smoky fire is lit under them. Usually the fuel is raw wood or coconut fibre. Corrugated iron guards are placed along the sides to concentrate the smoke on the products. Dried fish produced by this method is used widely as an essential component of the traditional palm oil sauces and stews.

This process of drying takes a very long time and flies and other insects rest and lay eggs on the products while they are drying. There is also the need to turn the fish over from time to time, which has to be done carefully as damaged fish do not sell at high prices.

## *Food processing*

*Palm oil processing*  Processing of palm oil is a specialised female agricultural task. The oil palm trees start to bear fruit when they are about 4 years old. Men harvest the ripe fruit, which are then piled in the compounds and covered with palm, banana or plantain leaves and left in the sun for four or five days to make them easier to remove from the cob. A locally produced implement called *sondee* in Mende, which is a long stick with a sharp blade at one end, is used to separate the fruit from the cob. Basically, two methods are used to separate the pulp from the kernel.

*Method I – boiling*  A small quantity of water is sprinkled on the fruit and they are left to dry in the sun for a period of three days. Boiling is done in 44-gallon drums or earthenware pots for 8–10 hours. The fruits are then crushed by foot in trenches or pounded in mortars by the women. This breaks the outer skin and disengages the oil from the fibre. When treading is used, hot water is added afterwards. After allowing to cool, female adults rub the nuts and fibres between their hands and squeeze out the chaff by hand. The water/oil mixture is put in a pot to boil. Boiling continues until the oil begins to float. The oil is scooped off with a small bowl or scooping spoon and put in receptacles.

*Method II – fermentation*  In this method, the palm fruit is sprinkled with water to soften it and buried in holes for a

week. They are then either pounded in a mortar and squeezed or trodden on by foot. The processing continues as for method I.

*Comparison of traditional methods of production*   Oil produced by fermentation is clear and is locally referred to as 'Masanki palm oil', which is mainly sold to traders for export. Such oil has a free fatty acid (FFA) content of 20 per cent and upward, depending on fermentation (its quality is inversely proportional to its FFA). Oil produced by boiling fresh fruit is bright red in colour and is of higher quality, but it requires more labour and more fuel (boiling before and after crushing). For the local markets the price of the palm oil is determined by its colour, taste, consistency and flavour. If it is red and has a pleasant taste and smell and good consistency, it will fetch a high price. These traditional methods of palm oil production have a low technical efficiency of 40–50 per cent (Kaniki, 1980) and are labour-, fuel- and time-consuming.

The improved oil palm varieties now being planted give a high yield of palm oil. The taste and texture, however, have been criticised by the local people as being 'inferior' to the traditionally produced oil. There is, therefore, still a widespread preference for the traditionally produced palm oil from wild fruits and local varieties of palm fruits.

*Hand-operated oil presses*   Hand-operated palm oil screw presses were introduced in Nigeria in the late 1920s. Some of these presses found their way into Sierra Leone and are to be seen in a few villages (e.g. Tikonko near Bo). They are not widespread, possibly because of their cost and availability at the time. The oil produced by these presses has about 18 per cent FFA (slightly superior to the traditional method).

In 1979, hand-operated screw presses designed at the Faculty of Engineering, Fourah Bay College, were introduced in some villages by the Ministry of Social Welfare and Rural Development in collaboration with the UNECA. This prototype is light and small and easily transportable. It is a screw press, which has a small boiler to increase the output of palm oil during pressing. Unfortunately, during the last palm oil producing season the presses were not utilised by

the villagers for reasons that have to be investigated. It is hoped that once the apparent teething problems have been solved they would be of use to the rural women. There is one hydraulic press, which has been utilised at the Niala Oil Palm Centre. Hydraulic presses are, however, very expensive and therefore have not found widespread use.

*Palm kernel oil production* Palm kernel oil, or nut oil as it is commonly called, is made from the kernels of the palm fruit. Whereas the income from palm oil goes to the family purse, income from nut oil prepared from the by-product of palm oil processing is the women's reward for making palm oil. Palm kernel oil is used as a supplement for palm oil or groundnut oil, particularly for frying fish. It is also used as a traditional treatment for ear infection.

To prepare palm kernel oil, the kernels are cracked open to remove the copra. The copra is roasted in a pot and then pounded in a mortar. The ground copra is mixed with water and boiled. The mixture is strained and the oil is scooped from the water/oil mixture after being allowed to stand. The by-product – chaff – is used as an animal feed. A palm kernel oil mill opened by the SLPMB in the late 1960s produces palm kernel oil and 'cake' only for export. The kernels are purchased from farmers or obtained from the palm oil mills run by the board.

The cracking of palm kernel is probably the most tedious part of the process of palm kernel oil production. The nuts can be damaged and wastage through damage is estimated at about 50–60 per cent. So the yield from the traditional method is poor.

*Milling* Grains, vegetables and spices are sometimes cooked in paste or powder form and this makes it necessary for milling to be done. Three methods of milling are used traditionally.
*Mortar and pestle* The products are placed in a mortar and pounded with a long stick (the pestle). The pounding is accompanied by sieving for dry products. This method is used for milling spices, vegetables, *fufu*, etc. It is also used

for dehusking grains, particularly rice, as well as sesame, millets, etc.

*Grinding stones*   This method is usually used to mill products that are difficult to mill using the mortar and pestle. Two stones are used. The *peppe stone* is a smooth flat piece of rock, usually of a hard variety such as gabbro, which has a surface area of approximately 200 cm$^2$. The *peppe stone pikin* is a small round or oval rock of the same material large enough to be hand held. The products to be ground are placed on the flat stone and ground with the smaller stone. This method is used for grinding pepper, corn, beans, *egusi* (melon seeds), groundnuts, etc.

*Wooden grinding board and bottle*   This is used mainly for grinding groundnuts. The board is usually of hardwood with a well-planed surface. A bottle is used to grind the nuts on the board.

In addition to these traditional methods, hand-operated mills have been acquired by the richer. Others have been able to pay to have their grain or vegetables milled at markets where hand- or power-operated mills are used to mill large quantities of grain, spices and vegetables.

*Cassava processing*   Cassava is a tuber crop that grows under adverse (drought) conditions without much care. It is attacked only rarely by a leafy mosaic. However, it stores for only 48 hours after harvest so that preservation is desirable. It is stored in the form of sun-dried cassava chips, *gari*, *fufu* and cassava bread.

*Gari*   *Gari* is a cassava product that is widespread in West Africa. In Sierra Leone only *gari* made from cassava is prepared. Red or white skinned cassava is peeled, washed and grated on a rectangular metal sheet made out of kerosene tin (grates made by punching with nails). The grated cassava is put into a sack tied and strapped with four sticks (a weight is sometimes placed on the sack). The strapped sack is kept for three–four days to allow the liquid to drain out. After draining, the grated cassava is dried in the sun for about 30 minutes. Sometimes this grated cassava is pounded. After drying it is placed in a large pot, which has been greased to

prevent sticking, and roasted. The material is stirred with a wooden spoon until it is dry, crisp and cream in colour.

*Fufu* For production of *fufu*, cassava is peeled, washed and soaked in a container (usually a 44-gallon drum) for one or two days. The soaked cassava is then grated and put in a basket lined with banana or bread-fruit leaves. It is covered with these leaves and a large stone is placed on top of it. It is left three days to ferment, after which *fufu* is ready.

*Cassava bread* In cassava bread production, cassava is peeled, washed and grated. The grated cassava is pounded in a mortar to soften it, after which it is baked on a flat thick iron pan in iron rings.

*Starch* For laundry starch production, cassava is peeled, washed and grated. It is mixed with water and passed through a basket sieve. The filtrate is allowed to settle and then the water is strained off. The residue is starch.

In cassava processing it is seen that grating is widely used. This is very laborious and time-consuming.

*Ogiri preparation* *Ogiri* is benniseed (sesame) stock used as flavouring for traditional dishes. To prepare *origi*, benniseed is pounded in a mortar to remove the skin. Cleaned benniseed is boiled for 8 hours until all the water evaporates and the seeds are in the form of a paste. This paste is left for about three–four days to ferment, after which it is pounded again and wrapped in leaves.

*Coconut oil production* Coconut oil is used as a substitute for groundnut oil or palm oil and gives a distinctive flavour. To prepare coconut oil, the fibre is removed from the coconut and the nut is shelled. The copra is removed and, after washing, is grated and mixed with water. The mixture is strained and the filtrate is left to stand for about 4 hours when two distinct layers of liquid can be observed – an upper viscous layer and a lower aqueous layer. The viscous layer is scooped off with a spoon and put in a pot. The mixture is heated whilst stirring until it is brown and all the water has evaporated. The by-product – the chaff – is used as animal feed, while the coconut fibre is used as fuel for fish smoking.

*Beans, groundnut and maize processing* Groundnuts and maize are grown by women during the slack rice farming periods (between harvesting and planting of rice) or are sometimes planted in the rice fields with the rice during the rice-growing seasons. The crops are usually harvested, dried in the sun (groundnuts and beans in pods; corn in cobs) and then shelled by hand and dried further before sale or storage.

Dried maize is milled and used to make *ogi* porridge and *agidi*, which is a substitute for *fufu*. Dried groundnuts are roasted and either sold in this form or milled. Milled groundnuts are used to prepare groundnut stew or snacks such as *congoo*, *kanya*, and groundnut cakes. Groundnut oil is also prepared, although not on a large scale. Dried beans are milled and used to prepare snacks such as *akara*, *olele* and bean pudding. These products are used in the home or sold to supplement the income. Some women specialise in the preparation of one or two or these snacks and sometimes even make preparation and selling of these a full-time occupation.

*Other crops* Other crops such as millet and sesame are grown on a small scale in some areas of the country. Processing of these grains is much the same as rice processing. These grains are used mainly as substitutes for rice and for preparing snacks that are sold by the women in villages, towns or worksites.

Gara *(tie) dying*
By far the most successful (in terms of income generation) women's activity in Sierra Leone is tie dying. The processes of tying, gathering, folding, stitching, stamping and subsequently dyeing are highly specialised tasks performed mainly by women. A variety of textiles and designs are obtainable and are available both in the local market and for export.

Traditionally the dye-stuff used in the dyeing is prepared from the leaves of plants such as *terminilia ivorensia*, *indifofera arrecta* and *lonchocarpus cyanescens*. The raw leaves of these plants are collected and pounded. They are moulded into balls and dried. Thus *gara* balls are produced. For dyeing,

these balls are broken up and immersed in water overnight. The leaves are transferred to a basket sieve and more water is added. The wet leaves are put in a 44-gallon drum to which caustic soda and water have been added. The drum is covered and left to stand for about three days, after which it is exposed to sunlight for a few hours then covered again and left to stand for seven days. The mixture is stirred with a special stirrer. The resulting coloured dye is used for dyeing tied, waxed, sewn or folded fabrics.

Natural indigo dyes were exclusively used in Sierra Leone for tie dyeing until about the mid-1950s when synthetic dye-stuffs were introduced. The use of natural indigo has some drawbacks: there is not much colour variety, as only white, blue and dark blue coloured patterns could be obtained (kola dyes can produce different shades of brown); the odour of the dye on the cloth is almost impossible to get rid of; it is not easy to ensure colour fastness; the processes of preparing the dye solution and dyeing are lengthy; and the dye produces uneven results owing to the difficulty of controlling the concentration.

Synthetic dyes are now utilised extensively in *gara* dyeing, mainly because of their obvious advantages. They appear in diverse colours that make variety of design and colour combinations possible. They also ensure colour fastness, are easy to use and leave no distinctive odour. The price of these dyes, however, has increased tremendously over the years (about threefold in the past five years). This has forced some traditional tie dyers to fold up their businesses (Chuta, 1980), and has led to a considerable increase in the price of dyed products. It is thought that the quality of local dyes could be improved if systematic research could be undertaken. Research could also reveal new herbs that could produce commercially usable dyes of various colours, and methods of obtaining local dye-stuffs in powdered form to ease prep-aration of the dye solution.

## Lubi *and 'black' soap production*

*Lubi* preparation is very widespread in rural Sierra Leone. *Lubi* is basically oxides and carbonates of sodium and potassium, which can be used in soap making, snuff making,

*gara* dyeing, black soap making, and as a tenderiser for meats and vegetables. To prepare *lubi*, plant material (such as banana stalk, fignut trees, pawpaw plant, groundnut leaves and palm fruit heads) is chopped into bits, dried in the sun, then burnt to obtain ash. This ash is mixed with water and left overnight. Ash and water are thoroughly mixed and passed through a filter in the form of a basket lined with rice bags. The filtrate is collected in a container and later evaporated. The residue from filtration is *lubi*.

To prepare 'black' soap, the *lubi* solution is not evaporated but mixed with palm oil and boiled. When thick, the mixture is put in the mortar and pounded. The black soap thus obtained is rolled into balls for use.

*'Soda' soap preparation*
A solution of caustic soda is boiled in a drum or pot for 2 hours. Preheated and cooled palm oil is added to the boiling caustic soda and the mixture is allowed to boil until gelatinous. The mixture is then removed from the fire and allowed to set overnight.

The soap produced by the traditional processes is plain and soft and, because of the arbitrary measurement of ingredients, tends to be inconsistent from person to person and from one preparation to the next. Also the boiling of caustic soda in open pans presents danger and it is not uncommon for serious burns to occur.

*Handicrafts*
Women in the rural areas find time in the evenings or between performing their various back-breaking tasks to engage in handicrafts. This could be an effective way of earning extra income as they usually possess uncommon skills in embroidery work, basket making, crochet work, knitting, pottery and weaving.

Marketing of the products and purchase of raw materials present problems, but with the setting-up of co-operatives, which run shops for rural handicrafts in the urban centres, some of these women have been able to expand their activities in this area.

*Shallow water fishing*

This is done by women in rivers and from beaches. They use basket nets known as *baimbay*. Their catches include fresh water fish, shrimps, crabs and minnows. These are either sold or used for household consumption.

## Conditions for the widespread adoption of improved technologies

In a number of cases, technologies that have been designed and developed for use by rural African women have failed to be adopted by these women (Chapter 5 and Ahmed, 1978). Moreover, some of these technologies have not even reached the target groups because the R&D institutions that design and develop them lack dissemination centres to take their equipment to the people and also because manufacturing enterprises are not willing to take the risks involved in producing new equipment. There is thus a visible gap between the sources and the users of the equipment.

The technologies that have reached the women have been mainly in pilot schemes. Three main factors have led to resistance and in some cases rejection: first, the technologies have been known to conflict with the existing social norms and beliefs, thus disrupting life in the communities; secondly, the resources (financial and human) for the acquisition, use, repair and maintenance of the technological innovations have not been available locally; and, thirdly, the performance of the devices has not been good enough to justify the costs, risks and effort involved in adopting new methods to replace the 'well proven' traditional methods. In order to ensure easy and widespread acceptance of techno-logical change, these factors must be taken into account by planners or designers when planning projects aimed at introducing technologies for use by rural women in their activities.

It is required to introduce a technology in a given activity that is the responsibility of women in a given community. The target group has to be determined for each activity and can be defined as that represented by at least 60 per cent of the women engaged in that given activity. The conditions for

widespread adoption of improved technologies can be grouped under three main headings: availability, practicability and profitability. I shall examine each of these in turn.

*Availability*   For each technology, the income level of the target group should be considered here. The following questions should be taken into account:

- Is the technology available in the market? (This assumes that the target group knows of its existence.)
- Can she afford to buy it either directly or through some available credit scheme?
- Can it be purchased by collective effort?
- Can she afford to pay for its use and maintenance?

*Practicability*   Practicability should be considered in the local context. One technology can be practicable in one area but not in another. The following questions could be considered:

- Does the technology disrupt prevailing social, cultural and religious life or blend with it?
- Can it be operated by the woman herself?
- Is it convenient for the woman to use?
- Can it be easily maintained and repaired?

*Profitability*   Profitability in the present context needs to be understood in a broad sense. Gains and savings in time, money and labour could for the purpose of our study be considered as profits. The questions to be raised here are:

- Is time, labour or money saved by the new technology?
- Does it provide more income?
- Are there no marketing problems?

With these concepts a framework for analysing and predicting the impact of technology on rural women can be drawn.

It is interesting to note that the condition of availability is crucial to the acceptability of a technology. For the other two factors, if one is perfectly fulfilled, there is a possibility that

the other might be ignored. This would be the case when an available and practicable technology that does not necessarily increase profit is adopted for prestige reasons or when a highly profitable technology is adopted in spite of its impracticability.

To ensure availability of improved technologies in women's tasks, certain steps have to be taken:

- In the design and manufacture of improved technologies, means of cutting down on costs of the final products (e.g. use of local materials, mass production where the demand warrants it) should be exploited.
- Where the basic components (namely steel and aluminium sheets and rods, nails, rivets, etc.) required in the manufacture of the simplest equipment have to be imported because the country lacks the industries to produce these components and the prices are high, governments should ensure that these components are made available to the manufacturers at subsidised or reduced prices.
- Extension work to inform women of the innovations and to give demonstrations and advice should be intensified by government ministries and other responsible bodies. Wherever possible, the mass media should be used, as well as audio visual displays.

To ensure practicability, the following have to be taken into account:

- Before embarking upon design of improved technologies, socioeconomic studies should be performed. These would reveal the priority areas for improvement, the type of labour employed for specific tasks, the customs, traditions and religious beliefs of the people. These findings would be taken into account at the design stage. The local people should also be consulted at all stages of the design and testing.
- The designer should be able to assess the capabilities of local expertise and the possibility of maintenance and repair.

To ensure profitability, the following should be kept in mind:

- The designer must consider tapping locally available sources of energy to power the equipment and provide savings in labour.
- The designer must do tests on local methods and ensure that his design would give better technical performance.
- In income-generating activities, the economist should ensure that innovation would be warranted, considering factors such as marketing etc.
- For time-saving devices, activities to fill in saved time should be introduced by the extension workers as an incentive to save time. This could include literacy classes, income-generating activities, and interest groups.
- Infrastructural facilities for marketing extra produce obtained from use of improved technologies should be provided.

*Flow chart for the introduction of improved technologies*
The flow chart in Figure 9.1, designed to facilitate the introduction of improved technologies in women's activities, takes into consideration the conditions for acceptability described above.

The socioeconomic studies (element 1 in flow chart) should seek information on the social norms and beliefs in the specific area, the locally available human and financial resources, as well as environmental factors prevailing in the specific area.

In the choice of activity in which improved technological devices could be introduced the women should be consulted to ensure that the activity is one in which they themselves feel a need to change the traditional methods (elements 2, 3 and 5 of flow chart).

The next step after the choice of activity should be to study the traditional methods of performing these activities in order to obtain performance figures, the scale of production and participation by sex and age in the particular activity (element 4 of flow chart). These studies should

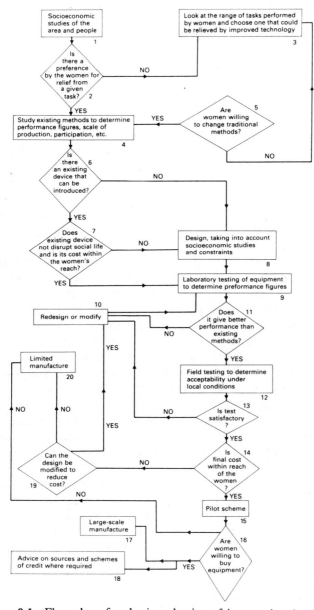

**Figure 9.1** Flow chart for the introduction of improved technology in women's activities.

investigate how specific qualities such as colour, texture and taste are achieved by the traditional methods.

In order to avoid duplication of efforts, a search should then be made of existing devices available for the activity in question (element 6 of the flow chart). These devices should be examined to ensure that they do not conflict with existing social norms and beliefs in the community, and that they can be afforded by the target group (element 7). If no devices exist or if the existing ones cannot be accepted or afforded by the group, then a new device could be designed taking into account the constraints revealed by the socioeconomic studies (element 8).

Whether a new device is designed or an existing one is chosen, laboratory testing (element 9) should be done to compare the performance of the device with that of the traditional methods and to ensure that the device is an 'improved' one. It should be stressed here that, in order to create an impact, a technology has to produce visible results. It is not enough to raise the technical efficiency from 30 to 40 per cent, as this would not be visible enough to persuade the women to change from their 'well proven' traditional ways.

After redesign or modification (element 10) of the equipment to give the desired performance (element 11), field testing can be done under the conditions in which the equipment is expected to operate in the locality (element 12). Modifications and redesign can also be effected at this stage to ensure that the desired results are obtained under local conditions.

If the tests are satisfactory (element 13), then a final consideration must be given to the cost. If the cost is such that the equipment can be afforded by the women in the target group either directly or through credit (element 14), then a pilot programme could be launched (element 15). It would be hoped that this would introduce the new device to the women who would be able to watch demonstrations without taking any financial risks. Depending on the success of the pilot scheme and on the willingness of the women to adopt the device (element 16), large-scale manufacture can then be undertaken (element 17) while ensuring that, where the women cannot afford to pay for the device directly, credit

schemes are devised or the women are informed of credit facilities where these already exist (element 18).

If the women are not willing to buy the equipment or the final cost is not within the reach of most of the women of the target group, limited manufacture of the equipment is recommended (element 20).

*Examination of 'improved' technologies developed in the light of the conditions for widespread adoption*

A limited number of 'improved' technologies have already been developed for rural women's tasks. Using the conditions for widespread adoption described in the previous section, Table 9.2 examines these 'improved' technologies. It can be seen from this table that those technologies that fulfil the conditions of our criteria have succeeded and those that do not have had no success. It can also be seen that most of these technologies are not 'available' to the women and therefore have not achieved widespread adoption.

*Problems of generation, production and diffusion of improved technologies in Sierra Leone*

Many of the devices that have been designed by R&D institutions (mainly the University) cannot be constructed, tested and developed owing to lack of funds. If the funds were made available to these institutions, they could develop this equipment as well as other devices that could be useful to the women.

Even in the cases where the equipment has been developed and tested, it has never gone beyond the testing stage. This is owing to a lack of an intermediate institution to take the technology of the women and to get information on its acceptability in order to attract manufacturing enterprises to embark upon production of this equipment.

The National Workshop, the Tikonko Agricultural Extension Centre (TAEC), and the Advisory Services of Technology, Research and Development (ASTRAD) at Fourah Bay College possess workshops with facilities for manufacture of equipment. Their capacities are however felt to be inadequate to meet the demands that might arise for improved technological devices from the rural areas of the

Table 9.2  *Analysis of the impact of 'improved' technologies on rural women*

| Activity | 'Improved' technology | Is it available to women? | Is it practicable for women? | Is it profitable for women? | Has it received widespread use? | Comments |
|---|---|---|---|---|---|---|
| Cooking | Solar cookers | No | No (in its present form) | Yes | No | Being developed |
| | Improved charcoal and wood stoves | No | Yes | Yes | No | Prices phenomenal |
| | Stoves using non-conventional fuel sources | No | Yes | Yes | No | Being developed |
| Water collection | Hand pumps (USAID type) | Yes | No (cylinders intended for limited use | Yes | Yes | Subsidised project |
| | Hand pumps (Dempster deep well) | Yes | Yes | Yes | Yes | Government-sponsored project |
| Food preservation | Solar driers solar/fuel driers | No | Yes | Yes | No | Being developed |
| Food processing | Palm oil screw presses | Yes | No (in its present form) | Yes | No (to date) | UNECA/Ministry of Social Welfare and Rural Development |
| | Palm oil hydraulic presses | No | No | No | No | |

| | | | | | |
|---|---|---|---|---|---|
| Rice processing | Threshers, winnowers, hullers (hand- and power-driven) | Yes | Yes | Yes | Being developed |
| Maize and groundnut shelling | Hand-operated | No | Yes | Yes | No | |
| Palm kernel oil processing | Power-driven nutcracker | No | Yes | Yes | No | |
| Milling | Milling using hand grinders | Yes | Yes | Yes | Yes | |
| | Milling using powered grinders | No | Yes | Yes | No | |
| | 'Improved' cassava graters | No | Yes | Yes | No | Being developed |
| Gara (tie-dye) production | Use of synthetic dyes | Yes | Yes | Yes | Yes | |
| Farming | Improved handtools, planters, etc. | Yes | Yes | Yes | Yes | |
| Handicrafts | New nylon cords and threads used in bag making | Yes | Yes | Yes | Yes | |

countries. Another problem faced by these institutions in the manufacture of equipment is that materials and components are mainly imported unless scrap metal is used, and the prices of these materials are so high that costs of final products become prohibitive. Sometimes the manufacturing enterprises (the National Workshop, the Tikonko Agricultural Extension Centre, the University on a small scale and other small workshops) cannot embark on large-scale manufacture because essential materials might not be available for periods of time or the high cost of manufacture does not warrant the risks involved in manufacture of devices whose success cannot be guaranteed. Reduced prices brought about by government subsidies or controlled prices could thus help in alleviating the problems of supply of improved technology devices.

Imported devices have been found acceptable wherever they have proved appropriate in terms of cost, size, resources required and quality of the outputs. However, the foreign exchange situation in the country has recently led to a reduction in imports and a sharp rise in the price of imported commodities.

The rural households in Sierra Leone are mainly subsistent and any investment in equipment or new methods would involve consideration of credit facilities available. Moneylenders exist in many areas and are easy to contact. The usual interest rate is 25 per cent, but the borrower does not have to produce security or collateral and loans can be provided immediately. Commercial banks, on the other hand, insist on 100 per cent security that money and interest will be repaid. It is usually impossible for rural dwellers to provide these collaterals. Recently a rural banking scheme was set up by the Bank of Sierra Leone to assist farmers with small loans for the purchase of farm implements, seeds, etc. Other sources of credit include the National Co-operative Development Bank, which acts as a sort of marketing agent, buying produce from farmers and selling it to the Produce Marketing Board. The National Development Bank, which provides funds for development projects, recently opened a scheme for small borrowers to give loans of Le 1,000–5,000.

**Improved technologies to increase production, relieve boredom and save women's labour time**

Table 9.1 showed the types of technologies that could be used in rural women's activities. In this section, some of these technologies will be described in some detail.

*Cooking stoves*

The heat efficiency of local methods of cooking is very low. In order to conserve fuel it is necessary to use stoves with higher efficiency. This would mean a reduction of the fuel requirements of the household and thus savings in time and labour of the women whose responsibility it is to fetch fuel, or, alternatively, this could leave the women with a surplus of firewood that could be sold to subsidise the family income. Wood and charcoal stoves have been designed and manufactured from scrap metal by the National Workshop and local blacksmiths, but their prices are high by local standards. Raised cooking platforms built with sun-dried bricks, like the type displayed at the UNICEF/Kenya Government Village Technology Unit in Kenya, could be introduced (UNICEF, 1979). The 'hot box' cooker could conserve fuel. This 'cooker' basically prevents heat escaping from an already boiling pot and thus can be used for cooking food items that do not require frequent attention. This would be useful for preparing rice and other grains and vegetables.

A lot of industrial and agricultural waste is thrown away. Stoves utilising fuels such as sawdust, groundnut shells, rice husks, coconut fibre and palm kernel shells could be designed for use by rural women. Some of this agricultural waste is obtained from within the villages as a result of farming and processing of agricultural products. If these could be used as fuels this could reduce the time and effort used in collecting firewood from distant forests. It would be preferable to design multi-fuel cookers so that any of these wastes could be used as and when available. Work on non-conventional fuel cookers is being undertaken by the Appropriate Technology Unit of the Faculty of Engineering, Fourah Bay College, and a prototype cooker using sawdust as fuel is now undergoing tests.

Existing solar steam or reflective cookers have the drawback that they have to be used in the burning sun. A cooker that uses solar energy but can be used indoors is being designed by the AT Unit of the Faculty of Engineering at Fourah Bay College.

Utilisation of biogas obtained from plant and animal wastes is another alternative for cooking. In areas where cattle rearing is predominant (that is, in the northern parts of the country) cattle dung can be used to produce biogas. In the rural western area pig and poultry waste could be utilised. Initial problems involved in deciding whether the gas should be used in communal kitchens, piped to houses or put in cylinders would depend on careful study of the socioeconomic factors involved.

*Problems of water supply*

As regards water supply in the rural areas in Sierra Leone, two factors are at play. The first is that in many rural areas there is a problem of adequate water supply, especially in the rainy season. Distances travelled by women to fetch water are usually very long, in some cases a few miles. If these trips could be reduced or cut by 'bringing' the water to the villages, the time and effort used for fetching water could be used for other meaningful activities. The second factor is that of health. Existing water sources, as outlined previously, pose problems of poor sanitation, which leads to disease and illnesses. Since women also care for the sick in the rural areas, if the incidence of disease is reduced they would benefit from the release of time used to nurse the sick.

*Water pumps* As well as the water pumps now in use, locally manufactured pumps can be designed and developed. Pumps of the flat valve type, rope and washer type, shallow well type and hydraulic ram type, and bicycle pumps, can be designed by engineers and manufactured at the National Workshop or the Tikonko Agricultural Extension Centre. Pumps used to pump water from streams could be powered by electrical power generated from the same stream. Solar pumps can also be implemented.

*Wheelbarrows and carts*  Hand-driven or pedal-operated carts and wheelbarrows would considerably relieve women of the burdensome task of fetching fuel and water and could be used for transporting cooked food, snacks, fruit and vegetables, which are carried on the head for miles to get to the market.

*Water storage and purification*  Large water jars made of cement to collect rainwater from roof catchments or to store water collected from streams and wells could be useful to the women. Taps could be attached to these containers so that the water can be withdrawn with ease.

Filters made from commonly available sand and charcoal could be beneficial, and solar stills could be used to purify drinking water.

*Farming and rice processing*
The existing tools used by the women on their farms and in their tasks of planting, weeding and harvesting on the household's cash crop farms are still the traditional ones. Their productivity is usually low and they require considerable effort to operate. Since the women usually sell the surplus obtained from their food crop farms, better tools that would improve their productivity on these farms could earn them more income. The introduction of technologies to ease their tasks in the cash crop farms could also be both time- and labour-saving. Rice processing is primarily the responsibility of women and, during the period immediately following the harvest of rice, women are burdened with this responsibility. Mechanisation of some of the processes involved would thus ease their burden during this period.

A number of locally designed farm tools could be introduced. Planters, seeders, pedal- and diesel-operated rice threshers and winnowers and handtools manufactured by the Tikonko Agricultural Extension Centre (TAEC) have had widespread use. The cost, especially of the motor-driven types, is quite high owing to the high cost of materials and components. Small handtools are manufactured by the National Workshop, which has facilities for the design and manufacture of specialised tools and equipment.

*Food preservation*

*Crop driers*   The drying of crops in rural areas is inevitable given the prevailing facilities for marketing fresh products. Fruits, vegetables, grains and plant wastes for *lubi* preparation all need to be dried. Open sun drying is used extensively but this gives rise to losses, especially in the rainy season. These losses both cause reduction in the income from these products and mean that the family has to spend money on purchase of these products during their period of scarcity.

Solar crop driers using natural convection as well as solar/fuel crop driers which can be used in both the rainy and dry seasons, are being tested at the Faculty of Engineering, Fourah Bay College. These would speed up drying operations (solar crop driers can shorten drying times by 50–75 per cent) and prevent wastage caused by products going rotten as a result of lack of sunshine during the rainy season. It would also make the crops 'transportable' without having to collect them and spread them out repeatedly.

Forced convection crop driers can produce better results and, where power can be obtained from natural sources, these could be considered as an alternative. Fuel driers utilising agricultural and industrial wastes such as sawdust, rice husks, coconut fibres, etc., would be useful and could be used indoors in periods of rain.

*Smoking ovens*   In the fishing villages, smoking is practically the only means utilised by the women to preserve fish. Because the traditional smoking method takes a long time to smoke the fish to the desirable moisture content for preservation, and because of the prevailing climatic conditions in the country, there are frequent cases of fish going rotten when there is a big catch or when the fishermen return late in the evenings. It is therefore desirable to have improved, faster methods of fish smoking. Improved methods could also cut down on fuel use, which again would be beneficial to the women.

For preservation of fish (and some meats), special smoking ovens can be introduced. These can be designed to use sawdust or wood wastes, or agricultural wastes as fuel. A

prototype has been designed at the Faculty of Engineering at Fourah Bay College. Other possibilities are permanent type ovens and ovens improvised from wooden barrels with remote fire pits underground, or from oil drums cut into three sections with the lowest section used for a firebox and the middle and top sections with fettered bars on which products are hung. Simple Altona type ovens are another alternative (O'Kelly, 1978b).

*Food processing technology*
Food processing is one of the main income-generating activities that the rural women in Sierra Leone engage in. The emphasis in introducing improved technologies in this area would therefore be on increasing productivity in these tasks. This could lead either to increased output (when the inputs are available to increase the level of production) or to savings in time (when the inputs cannot be increased), to enable the women to engage in other activities of benefit to them.

An examination of Table 9.1 would reveal that, in food processing, certain operations are involved in more than one activity. This makes it possible for multi-purpose equipment to be designed. For instance, a solar drier could be used to dry the grated cassava used in making *gari* as well as vegetables and spices and also plant wastes for *lubi* preparation. A press used to extract palm oil, say, could be used for pressing grated cassava in the *gari*-making process. Multi-purpose mills could grind grains, vegetables, nuts, etc.

Adaptable devices that perform the basic operations such as grinding, pressing, grating and sieving would cut down on costs. In addition, whole processes could be mechanised. In palm oil production, for instance, a centrifugal device for separating the fibre from the nuts, a screw or hydraulic press for pressing out the oil, a palm kernel cracker and a crusher for the nuts could form a 'package' to be used for palm oil and palm kernel oil production.

For cassava processing, hand- or power-driven graters would considerably reduce time and effort. Hydraulic presses could be used to press grated cassava, and mechanical sieves could be utilised in *gari* processing.

Other improved technology devices that can be introduced
are: shellers for groundnuts and maize, coconut decorticators,
mills, graters, etc.

*Improved technologies in income-generating activities*
In income-generating activities like soap making, tie dying
and handicrafts, improved methods of production could
produce better-quality products as well as increasing pro-
ductivity.

In soap making, additives that would produce harder or
perfumed soap would probably be welcome. So would
improved methods of production to speed up the processes.

In tie dying, results from research into the local dyes
produced from local plants would make them competitive
with imported synthetic dyes and hence promote their use,
thus cutting down on costs of dye-stuffs. Methods of
obtaining local dyes in powdered form to facilitate preparation
of the dye solution could also usefully be researched.
Mechanisation of the dye preparation and dipping processes
could save time and labour.

In handicrafts, the introduction of weaving and knitting
looms and machines for embroidery could save time and
labour. Where resources permit, these could be powered by
generating plants utilising water or wind or by photovoltaic
panels.

Improvement of health and sanitation should be an important
consideration in the introduction of technologies for rural
women, and indeed in all rural development efforts. In both
the design and introduction of improved technologies,
therefore, ways in which hygiene could be improved should
be of utmost concern.

## Conclusions

In reviewing the available literature, some gaps have become
apparent: there is a general lack of technical data on both
traditional and improved technologies utilised by the women,
so that effective comparison of methods and technologies
could not be made; no literature on the time budget of rural

women could be obtained; anthropological studies on rural areas of Sierra Leone are few and far between; and economic data relating to rural women and technology are absent.

Even though technologies have been designed and developed both within and outside Sierra Leone that could relieve rural women of their most burdensome tasks, traditional methods continue to be used. The main reason for this is that the improved devices have either not reached these women or the women have not been able to buy them owing to the high costs. The income that they earn from cash cropping and other activities goes to subsidise the family income and, because women cannot provide the securities required by financing agencies (they rarely own land), they are denied credit. Even though the men might be able to provide the women with funds, they might not always be prepared to spend money on equipment for women's activities, particularly if the prospects of additional income are not apparent.

It is assumed in this review that the women themselves are willing to save their time and effort by utilising improved technologies. There is no evidence to prove this, except that, given the subsistence nature of rural households and the boredom and burden associated with women's tasks, any opportunity to reduce their drudgery and to raise extra income is likely to be readily accepted. Education and training could help to motivate them to adopt these improved technology devices.

Since the rural women in Sierra Leone spend most of their time farming and fetching water, the introduction of devices that reduce the time spent on these tasks would create additional opportunities for income-earning activities and leisure. Improved farm tools or equipment for their farm operations such as planting, weeding or harvesting would serve this purpose (in addition to increasing productivity and reducing arduousness). So, too, would water supply schemes, while improved seed varieties and fertilisers, which increase yields on the women's food crop farms, fetch more money for extra crops. Women could also increase their farming activities if they had access to mechanisation to enable them to cultivate bigger and better farms.

It should be stressed that it is not enough to provide a

change in one little area of women's activities and expect it to create an impact. Technological change should come as a 'package'. Thus, in addition to introducing improved technologies for rural women's activities, programmes need to be planned to occupy any time that might be saved by the new technology. Infrastructural facilities for marketing increased outputs from women's activities also need to be provided, since at present women sell their products to nearby markets and within the villages.

In order to avoid the mistakes of projects to introduce improved technologies for rural women that have been made in the past elsewhere (Ahmed, 1978; Chapter 5), the steps described in the flow chart (Figure 9.1) could serve as a useful guide for planning technological innovations in the rural areas of Sierra Leone.

# 10
# Conclusions

*IFTIKHAR AHMED*

## Introduction

In this concluding chapter an attempt is made to highlight
and synthesise the major themes in the individual chapters.
The approach is to review the analytical arguments and
conceptualisations so as to bring out clearly the contribution
made by this volume to theoretical work, policy-making and
design of operational activities.

## Traditional macroeconomic theories

The volume shows that the traditional macroeconomic
theories of technological change, which have been primarily
concerned with analysing the impact of technological change
on class distribution of income, are inadequate in providing a
framework for analysing the question of technological change
and rural women. It is clear that gender hierarchy does not
have the same analytical base as class hierarchy. It none the
less has a production and distribution component, with its
own institutional bases, and it is for this reason that
technological change in rural areas is not 'indifferent' to
gender any more than it is indifferent to class. The inability
to move from empirical evidence to conceptualisation creates
difficulties in policy-making and prediction of the impact of
technological change on rural women.

## Prediction of impact

Prediction of the impact of technological change is made
difficult by the intricacies of the labour process (within the

household and at times outside) and the institutional basis of female labour use.

*Labour and production processes*

The intricacies in the labour process operate in three principal spheres (labour process being defined as the manner in which different tasks are organised within the household). First, complexity arises from the sex-sequential nature of some of the production processes. The simplest illustration of this is provided by palm oil processing. Palm fruit, which serves as a raw material to processing undertaken by women, is grown and provided by the men. An innovation such as a small hand-operated oil press raises the productivity of women's work and, because of the bigger scale of production, the quantity of palm fruit required becomes greater. If there is no corresponding increase in palm fruit production, capacity underutilisation of the oil press will be the direct result. Indeed, a mechanical cassava grater introduced in Ghana that increased women's *gari* output (as well as reducing the arduousness of the work and providing higher incomes) was accompanied by increases in acreage (through tractorisation) and output of cassava supplied by the men (Chapter 7). Conversely, additional supplies of palm fruit by the men through technological change in palm fruit production (e.g. increased acreage through tractorisation) could contribute to a greater work burden for the women in its processing by arduous, low productivity manual oil extraction methods. Therefore, technological change in sex-sequential labour processes, where women's labour is put into specific tasks in a crop cycle that includes the labour of her husband and/or is initiated by him, may make it more difficult for her to increase her share of the rewards for the additional effort (work burden) since the basis on which she is rewarded for this work may be unclear (Chapter 4).

The second complexity in predicting the impact of technological change arises from the interrelationship between the tasks undertaken by the different members of the household. For example, with the provision of water, rural women's time disposition may not improve if household members withdraw help normally extended in water collec-

tion. In reality, in one such instance in Zaire, more time was spent in non-monetised activities such as cooking, cleaning and washing, once both water and time were available (Chapter 6). Therefore, it is important that such interlinkages between the tasks of household members are identified in order to make any intervention beneficial.

The third type of complexity in the labour process arises from the linkages between tasks performed by an individual woman. This occurs essentially when women undertake multiple tasks simultaneously. For example, in rural Bangladesh a woman in her homestead undertakes paddy processing, cooking, child rearing, animal care, household maintenance, etc. that do not require public appearance (seclusion is a cultural characteristic). When the introduction of new technology disrupts a woman's concurrent management and performance of numerous activities within the household and requires her to leave the seclusion of her compound, there is a danger of the task being shunned by the women and taken over by the menfolk. The impact on the same women would be different if the technology were designed and introduced without such disruptions.

From the three types of intricacy in the household labour and production processes, it is clear that technological change that could affect rural women need not necessarily result from innovations directly aimed at her, but rather from the indirect consequences of planned and unplanned innovation in the rural production system as a whole, which, as the volume shows, could be fed through the sexual division of labour and family relations. It can therefore be concluded that technological change does not always affect all segments of the technical division of labour equally and that existing literature has not paid adequate attention to this dimension.

*The institutional basis of female labour input*
Another feature of the agrarian structures of many developing countries that makes the straightforward assessment of technological change and rural women difficult is the existence of institutionalised female labour input, particularly in agriculture. The impact of technological change on women will vary significantly depending on the social and economic

organisation of work with different reward systems – those of wage employment and of family-based production (Chapters 3 and 4). For example, with the advent of the Green Revolution and the associated increase in the demand for hired labour, employment possibilities are increased for women from landless households who receive payments in cash wages. A peasant family, on the other hand, makes more intensive use of unpaid female family labour, which (unlike her counterpart from the landless household) receives no payment at all. In effect, this technological change has simply reinforced the patriarchal or entrepreneurial role of men in the household to the detriment of women. It may be pointed out that this phenomenon is not unique to the Green Revolution belts of Asia. For instance, in Zimbabwe it has been observed that the increased demand for labour (for example in weeding and harvesting) following the commercialisation of agriculture leads to increasing appropriation of surplus from women as wives. Such exploitation is observed to far exceed the exploitation characteristic of peasant production systems (Cheater, 1981). The Green Revolution technology has also opened the doors to negotiating production credit from institutional sources and marketing of increased output, placing the male member of the household in a more dominant position. Large landowners, on the other hand, think in terms of mechanising farm operations by displacing hired female labour often from profitability considerations. Women in these households play more of a supervisory function. Owing to status considerations, women in peasant families withdraw from field work whenever the household's economic condition improves.

*Are women a homogeneous group?*
It is clear from the above discussions that, at least conceptually, women cannot be treated as a single homogeneous group. The broad groups identified by this volume include women from: landless households; small cultivator households; large cultivator households; tenant households; female-headed households. Women in all five categories perform the common roles of reproduction, child rearing and household maintenance, but the impact of technological

change (on both unpaid and income-earning activities) varies between these groups, requiring different policy solutions. Among these subsets of rural women, the female-headed households are seen to constitute the most disadvantaged and poorest of the rural poor, requiring the most urgent attention.

*The household as a unit of analysis*
Treating the household as the basic unit for data collection and policy-making has institutionalised sexual discrimination in two principal respects: (a) the intra-household effect of technological change is not analysed by sex, and (b) subsidised modern agricultural inputs and government extension services are channelled to the male head of the household (further discussed under factor market imperfections). Clearly, reliance on the household as the unit of socioeconomic analysis has made the assessment of technological change on rural women difficult.

## Mechanisms and causes of female labour displacement

The volume reveals that women are displaced in certain activities in three principal ways: mechanisation of sectors previously using female *wage* labour; male takeover (at lower levels of labour intensity) of activities traditionally performed by women as soon as they are mechanised; and male takeover of female tasks following their commercialisation. The trends are summarised below and a diagnosis points to two basic casual factors.

*Factor price distortions*
Capital/labour substitutions as a result of relative factor price distortions in environments of surplus labour are by now well known. Such price distortions have led to a reduction in the price of capital below its equilibrium level (i.e. its marginal value product) while forcing the price of labour above its equilibrium. As a direct consequence of such factor price distortions, entrepreneurs naturally tend to take advantage of the relatively cheap factor (i.e. capital) and economise on the relatively more expensive one (i.e. labour). This simple

economic principle is rigorously applied to any economic activity irrespective of the sexual composition of the labour force. This still constitutes one of the neoclassical explanations for the displacement of female wage labour in, for example, rice processing in both Indonesia and Bangladesh. In Indonesia, rice hullers were well subsidised through provision of credit at 1 per cent per month interest, whereas regular village credit cost 5–10 per cent per month (Cain, 1981). As a result, the cost of commercial milling was low owing to the overcapacity of the many new mills in Java (Tinker, 1981). Similarly in Bangladesh, the introduction of rice mills has displaced female hired labour and depressed wages. The result is that, whereas the return to labour through custom mills was of the order of 139–163 per cent higher than the wage rate, it was 22–34 per cent higher than the wage rate through traditional (manual *dheki*) technology (J. U. Ahmed, 1982). However, in both instances it has been noted that the labour-displacing innovations tend to occur in women's work activities performed as wage labour. Therefore, it is little wonder that in Indonesia handpounding technology continues to be used for most domestic consumption, which accounts for about 40 per cent of the crop (Tinker, 1981). The extra burden of work on female 'family' labour does not carry with it sufficient economic (or social) returns to make the purchase of alternative inputs worthwhile, whereas the purchase of and use of mechanical substitutes for hired female labour is profitable in cutting costs.

*Scale of production and commercialisation*
This volume produces additional evidence in support of the fact that the production of certain goods and services became male domain as soon as the scale of production increased (through mechanisation) or when subsistence production became commercialised. For example, all along coastal India women could be seen marketing headloads of fresh fish. Preservation techniques like salting and drying, which increased the shelf-life of fish, were also mainly in the hands of rural women. However, the Integrated Fisheries Development Programme in Kerala, India, uses trawlers to catch prawns, which are frozen and exported. Factories have been

built to process and freeze the prawns and fish, and men have taken over the marketing and transportation of fish by means of trucks and bicycles. Rural women's jobs and livelihood from fish trading and processing have been lost and there are no alternative sources of income and employment.

Traditionally, dairy production and marketing were carried out mainly by women, particularly of the poorer castes in Gujarat, India. Subsequently, with the introduction of a modern dairy complex, not a single woman has been trained in the use of the new technology that has taken over her traditional tasks of making butter and cheese.

This clearly shows that, with changes in the scale of production and consequent commercialisation, the acquisition of corresponding skills and training by men facilitates the process of male usurpation of the sources of women's livelihood.

## Rural factor market imperfections, technology choice and institutionalisation of sexual discrimination

The existence of a high degree of factor market imperfection in the rural areas of most developing countries is by now fairly well known (Ahmed and Freedman, 1982). The main feature and manifestation of this imperfection is that access to factors of production is much easier for some groups than others. In the absence of technological change, the existence of such a phenomenon would affect the allocation of resources, the methods of production and the distribution of rural incomes. With technological change, when there is a greater need for credit, modern means of production, knowledge of new technology, extension services, participation in rural organisations, etc., the question of access to these factors by such disadvantaged groups would be of crucial significance.

Analysis of rural factor market imperfections has almost always been applied to an understanding of class-based inequalities. This volume has established (a common theme in virtually every chapter) that rural women are systematically denied access to land rights (collateral to loans), resources, skills, training, farm inputs, knowledge, extension

services and the modern means of production. This is the direct result of inequalities in the agrarian structure (e.g. tenancy and women's rights to land – it was observed in Chapter 3 that the size of women's landholdings is less than that of men's, their land occupancy tends to be insecure, and the socially dominant position of women is critical in determining her access where there is competition for land) and biases among male extension agents who consider women as relevant for extension advice only in the area of home economics. Such discrimination has arisen not only from ignorance of women's roles but also from treating the household as the unit of production with all services channelled through the male head. It has also been observed that the social structure pushes women to a status of 'contractual inferiority' in the rural market.

Gender-based discrimination is most glaring in cases where female-headed households managing large tracts of land are ignored by the extension agencies. Women farmers are as efficient and progressive as their male counterparts in Botswana, the United Republic of Tanzania and Kenya (Chapters 5 and 6) despite such a lack of access. Perhaps this has been accomplished through more intensive use of female family labour and through the application of better farm management. In Botswana, although productivity on women's farms is as high as that of the men, their net income is lower because they cannot afford to hire draught power (Fortmann, 1981b). Just as high labour intensity on small farms is a manifestation of the existence of rural factor market imperfections, rural women's predominance in labour-intensive sectors is another manifestation of this phenomenon.

### Diffusion of innovations

The volume essentially followed three approaches in dealing with the question of the diffusion of innovations to rural women. The first approach was conceptually and empirically to identify the constraints that prevented the widespread use of potential technologies. The second approach was to understand from a review of improved technologies in use the factors that have favoured their adoption. The third

approach was to propose future strategies based on the first two.

A combination of economic, technical and socio-cultural factors has either favoured the diffusion of innovations or prevented their wider use. This calls for a multidisciplinary assessment of the suitability of technologies. In Ghana, for example (Chapter 7), despite high levels of economic and technical efficiency of certain technologies, these were rejected by women (for instance, superstitions about fertility prevent the use of the broadloom in weaving). It is, of course, quite clear that a major obstacle to wider use is the lack of awareness of the intricacies of the household/ rural labour and production processes that need to be taken into account at both the technology design and implementation phases. Due account needs to be taken of the social organisation of work – for example locational factors (concurrent supervision and performance of child care, cooking and processing) and accustomed time pattern of work (an important part of palm oil processing is undertaken in the afternoon). (For further elaboration of this point, see Date-Bah *et al.*, 1983.) Successful adoption has been observed in cases where improved technologies were locally developed with the active involvement of its users.

Measures taken at the household level for technology dissemination will have to be supported by macro policies, including choice of appropriate products.

It is often assumed that time disposition is a binding constraint to women's adoption of income-earning opportunities: the element of gender observed in the rural factor market imperfections does not permit women access to such possibilities. This volume shows that labour time is not necessarily a constraint (to be eased by innovations in non-monetised work) in reallocating labour time to income-earning activities (for example in agriculture and processing); reallocation is more likely to be limited by the level and quality of resources and technology that they have access to rather than by their labour time *per se*. However, where time disposition is genuinely a constraint to income-earning opportunities, the benefit/cost ratio for investments in labour-saving devices (e.g. in water collection in Ghana) has

been of the order of 3:1 when the entire women's labour time saved is reallocated to the new activity.

Some authors in this volume have pointed to the importance of indigenous channels for the dissemination of innovations in view of their high credibility. There are others who believe that such informal networking is no substitute for the organised extension services.

## Technology and welfare

Conceptually, indices have been formulated and a set of conditions identified for quantitatively capturing the impact of technological change on the welfare of rural women. This impact has been defined in terms of income comparisons and time disposition comparisons, before and after technological change (Chapter 2). However, even if women's income were to increase from technological change, the division of cash and consumption within the household tends not to be in women's favour. In analysing the impact of technological change, use of the household as a unit of analysis (Chapters 3, 4 and 6; Banerjee, 1983) is misleading as it wrongly assumes that the needs and well-being of each member regardless of sex, age or economic status get equal consideration and that each member gets an equal share of the household's supply of goods and services. Evidence from a region of India that had benefited from several development schemes reveals that though there was no significant difference in male–female weights at birth, female members were significantly more malnourished from the age of 3 months onwards (Banerjee, 1983). In some instances, the actual physical burden of women's work could increase as a result of technological change (e.g. increases in carrying loads of the harvested Green Revolution crops in Asia or a new harvesting tool in Africa).

## Areas for future research

This review of available evidence on analytical and empirical work on technology and rural women confirms a lack of systematic effort to organise existing information into a

comprehensive body of knowledge. Furthermore, it points to the need for a suitable analytical framework in the light of which specific hypotheses could be empirically tested. The present volume sheds some light on the types of issues and hypotheses that need to be tested, as well as the gaps that future research could fill. These are briefly described below (some of these are directly based on suggestions made by authors of individual chapters).

There is not much detailed documentation of the women's activities, time use and the methods and tools they currently use to accomplish their ends. This is an important research area with which any project on improved technology for rural women should begin. Such research would be useful for project planning by helping to identify the women's activities that are time- and energy-consuming. Some of the specific data to be collected should include the time duration of each activity performed, the co-operation between family members and/or others in the activity's performance, the technique of performing the activity (in terms of implements used and skills required), any seasonal variations in the activity's performance, the rewards and benefits that accrue from the activity's performance and what proportion of them is actually received by the participant. Also worth investigating are the ethnic variations in these activities.

Also requiring study is the mode of organisation of the performance of the activities or roles – whether they are undertaken by the women alone or with the assistance of others such as children, husbands, other members or women of the extended family or non-kinswomen; in other words, is the mode of work organisation employed based on kinship, marriage, age, sex or a combination of these variables? It is also necessary to inquire whether the activity is performed in the family compound or far away from it and the reasons for this. Such data would aid the researcher to develop technologies that would not unduly disrupt the mode of organisation familiar to the women, and the researcher would also be able to assess or note any impact that his technological innovation is likely to have on the social organisation of the people concerned.

It is necessary empirically to verify how technological

change in the present context can have either a 'time-displacing' or 'income-displacing' character, the nature of this 'income' and 'time displacement' and its interrelation with socioeconomic class.

It is necessary to examine the relationship between the existing or changing sexual division of labour and the type of rural economy, such as the subsistence/cash crop mix for direct producers, subsistence/migrant labour composition and the different available roles in more complex production institutions (e.g. temporary or permanent wage labourers, plantation workers, agricultural entrepreneurs, etc.).

Clearly, the impact of technology on women may differ a great deal according to whether the general direction of change in an area is towards the creation of a female agricultural wage labour force or its withdrawal into primarily production and work for household consumption.

It is important to examine in depth the uneven impact of technical change on the various socioeconomic classes of women in rural areas and the interrelationship between technical change and life-style of rural women in the various socioeconomic classes. For this purpose, it is necessary to look closely at rural households, to identify and finely categorise them into specific socioeconomic groups. In the African context, the following classification might be relevant:

- women with large land holdings;
- women with smallholdings in need of additional work/income;
- women farming land as tenants (with and without need for extra income); and
- women who do not have land but who earn money from casual agricultural employment or from non-agricultural sources.

There appear to be two important points to consider: (i) the differential impact on women with large landholdings and those who are landless or have such small holdings that they are reliant on casual agricultural or other employment to maintain their family; and (ii) the differential impact on women who farm their own (household) land and those who are tenants.

Other social, cultural and economic factors will no doubt crop up when more detailed work is undertaken. This would include differences such as households headed by women and by men; households with only one and with several wives; households that own cattle or have a major non-agricultural source of income and those that have none; households where women have had access to education and/or training and those where they have not; etc.

The next important area to cover relates to the question of social acceptability and diffusion of technology. Hypotheses will need to be generated regarding the process of technological adaptation and diffusion in rural societies. It is important to recognise that the whole process of dissemination of technology must be related to the economics of the area. A set of hypotheses such as those that follow would be generated from this premise alone:

- users of commercial mills for grinding maize or rice belong to well-off households and those who continue pounding by hand cannot do so owing to the cost constraint;
- there is a linkage between adoption of labour-saving devices and income-earning potential in the immediate neighbourhood or region – in other words, do women need the incentive of alternative remunerative employment before the idea of labour-saving devices appeals to them?
- is money a bottleneck in acquiring labour-saving devices that would release women's time to earn more income? If such a bottleneck exists, will greater access to credit facilities be a realistic way of breaking it?

It is also important in understanding the locus of the sexual division of labour and the effects of technological change that the nature of relations between men and women in the household be examined. For example, a relevant question is how the men will react to women earning more money. If the husband used to subscribe to the family upkeep in terms of food, clothing, school fees, etc., he may feel that he no longer has to do this if his wife is earning

money, and this could result in the woman and children being worse off than they were before. If this is likely to happen, women may be discouraged from adopting labour-saving devices as a means of releasing time for income-generating activities.

In future research on women, studies of the impact of technological change on them should no longer use the household as the unit of analysis in view of the empirically established existence of gender-based intra-household discrimination in the sharing of responsibilities and the supply of goods and services.

Other areas that need to be looked at in respect of dissemination are priority needs and the socio-cultural patterns in various regions. For example, wider dissemination of improved technologies has occurred in the most arduous and time-consuming components of rural women's tasks of palm and maize processing in Africa. In other cases, a new technology may not spread successfully because it does not meet a priority need. Moreover, in rural instances technically efficient tools have been rejected by the rural women on the basis of their beliefs. This points to the need to design R&D work such that it takes cognizance of the traditions, social values and beliefs of the community. Thus, both in the designing and introduction of technical innovations in a specific activity of the rural women, the taboos, beliefs and traditions about that activity would need to be ascertained, for these tend to be important factors influencing behaviour in the traditional society.

There is also a need to study the existing local traditional groups and associations that could be used to channel the improved technology. The researcher needs to identify the number and types of such associations in given areas and what their current roles are in order to assess how they can be used to play this additional role.

Much greater empirical work needs to be undertaken regarding the contribution of improved technologies to the creation of income-generating activities and energy needs. Utilisation of by-products such as rice husks, palm kernel shells and palm fruit peel in food-processing activities undertaken by African women could be facilitated by the

application of appropriate technologies. Similarly, fuel wastage in both food processing and cooking is observed to be exorbitant in Africa, and technologies (e.g. improved stoves) could contribute significantly to fuel conservation (Date-Bah *et al.*, 1983).

The organisational basis for the use of improved technologies also deserves attention. The successful improved technologies in use are those used on a customs (cash rental) basis. Given the financial constraints of the rural women's enterprises and their scale of operation this seems to be one way of reaching rural women with technological innovations. Communal ownership of equipment could also be a feasible proposition (Date-Bah *et al.*, 1983).

# Bibliography

Abbott, S. (1975), 'Women's importance for Kenyan rural development', *Community Development Journal* (London), Vol. 10, No. 3, October, pp. 179–182.

Abdullah, T. A. and Zeidenstein, Z. A. (1975), *Socio-economic implications of introducing HYV rice production on rural women in Bangladesh*. Paper No. 34, to the International Seminar on Socio-economic Implications of Introducing HYVs in Bangladesh, Bangladesh Academy of Rural Development (Dacca, Ford Foundation, April).

Addo, N. O. (1971), *Migration and economic change in Ghana, Vol. 1: Social and demographic characteristics of the cocoa farming population of the Brong Ahafo region* (Legon, Demographic Unit, University of Ghana).

Addo, N. O. (1972), 'Employment and labour supply on Ghana's cocoa farms, the pre- and post-Aliens Compliance Order', *Economic Bulletin of Ghana* (Accra), Vol. 2, No. 2.

Adekanye (Adeyokunnu), T. O. (1982), *Agricultural cooperatives as an aid to rural development in Nigeria: Problems, prospects and policies*. Report of a study commissioned by the Federal Department of Agricultural Cooperatives (Lagos).

Adelheim, R. and Schmidt, H. (1975), 'Economic aspects of ox-cultivation', in S. Westley and Bruce F. Johnston, *Proceedings of a workshop on farm equipment innovations for agricultural development and rural industrialisation* (Nairobi, University of Nairobi, Institute of Development Studies), Occasional Paper No. 16, pp. 104–168.

Adepoju, A. (1975), 'Population policies in Africa: Problems and prospects', *African Affairs* (London), Vol. 74, No. 297, October, pp. 461–479.

Adeyeye, V. A. (1980), 'Women in traditional agriculture: Oyo State of Nigeria experience', unpublished MSc thesis (University of Ibadan, Department of Agricultural Economics).

Adeyokunnu (Adekanye), T. O. (1977), 'Food waste in Nigeria', in *Food and Agriculture Organisation of the United Nations Sub-Regional Consultation on Increasing Food Availability through Waste Reduction and Improving Marketing System in West Africa* (Addis Ababa, FAO).

Adeyokunnu (Adekanye), T. O. (1978), *The food availability problem of West Africa*. Paper presented at the Third General Conference of the Association for the Advancement of Agricultural Sciences in Africa, University of Ibadan, April (Ibadan, mimeo).

Adeyokunnu (Adekanye), T. O. (1979), 'Designing rural development projects: some lessons of the Nigerian experience', *Agricultural Administration* (Essex, England, Applied Science Publishers), Vol. 6, No. 1, pp. 11–18.

342

Adeyokunnu (Adekanye), T. O. (1980), *Women and agriculture in Nigeria.* Study commissioned by the Training and Research Centre for Women of the UN Economic Commission for Africa (Addis Ababa).

Adeyokunnu (Adekanye), T. O. (1981), 'Agricultural and small farmers in Nigeria', in S. O. Olayide *et al.*, *Nigerian small farmers: Problems and prospects* (London, Caxton Press), pp. 142–190.

Adinku, V. (1980), *Salt mining by women in the Keta area* (Legon, Department of Sociology, University of Ghana).

Adomako-Sarfo, J. (1974), 'Migrant Asante cocoa farmers and their families' in C. Oppong (ed.), *Legon family research papers*, No. 1 (University of Ghana, Institute of African Studies).

Afful, E. M. (1968), 'Investing in the food industries', in *Proceedings of the first seminar on food science and technology in Ghana* (Legon, University of Ghana).

Agarwal, B. (1979), *Work participation of rural women in the Third World: some data and conceptual biases* (University of Sussex, Institute of Development Studies, mimeo); forthcoming in *Serving two masters* by Kate Young, ed. (London, Routledge & Kegan Paul).

Agarwal, B. (1980), *Technical change and rural women in Third World agriculture: some analytical issues and an empirical analysis* (University of Sussex, Institute of Development Studies, mimeo).

Agarwal, B. (1981a), *Agricultural modernisation and Third World women: pointers from the literature and an empirical analysis* (Geneva, ILO; mimeographed World Employment Progrmme research working paper No. WEP 10/WP.21; restricted).

Agarwal, B. (1981b), 'Agricultural mechanisation and labour use: a disaggregated approach', *International Labour Review* (Geneva, ILO), Vol. 120, No. 1, January–February.

Agarwal, B. (1983), *Mechanisation in Indian agriculture: an analytical study based on the Punjab* (New Delhi, Allied Publishers).

Agarwal, B. (1984), 'Rural women and the high yielding variety rice technology', *Economic and Political Weekly*, *Review of Agriculture* (Bombay), 31 March, Vol. 19, No. 13.

Ahmad, Z. (1980), 'The plight of rural women: alternatives for action', *International Labour Review* (Geneva, ILO), Vol. 119, No. 4.

Ahmed, I. (1978), *Technological change and the condition of rural women: A preliminary assessment* (Geneva, ILO; mimeographed World Employment Programme research working paper; restricted).

Ahmed, I. and Freedman, D. (1982), 'Access to rural factor markets, technological change and basic needs', *International Labour Review* (Geneva, ILO), Vol. 121, No. 4, July–August.

Ahmed, J. U. (1982), 'The impact of new paddy post-harvest technology on the rural poor in Bangladesh', in M. Greeley and M. Howes (eds), *Rural technology, rural institutions and the rural poorest* (Kotbari, Comilla, Bangladesh, CIRDAP; Brighton, Sussex, Institute of Development Studies).

Akoso-Amaa, K. (1976), *Ghana/IDRC Rural Fishery Research and Development Project Research Report*, No. 5 (Accra, Food Research Institute).

# 344 Technology and Rural Women

Alamgir, S. Fuller (1977), *Profile of Bangladesh women's roles and status* (Dacca, USAID).

Alexander, C. and Saleh, C. (1974), *The distribution and production factor inputs by representative farm groups in Jati, West Africa* (Bogor, Agro-economic Survey Research Notes).

Alli, S. M. (1979), 'Women in the labour force data of Egypt', in *The Measurement of Women's Economic Participation: Report of a Study Group* (Egypt, Giza, The Population Council, October).

Ampratwum, D. B. (1979), *Promotion of technology for improvement of rural life in Ghana*. Paper presented at the Workshop for Trainers and Planners on Village Technology for the Rural Family (Freetown, Fourah Bay College).

Amsden, A. H. (ed.) (1980), *The economics of women and work* (Harmondsworth, Middx, Penguin Books).

Anker, R. and Knowles, J. C. (1978), *A micro analysis of female labour force participation in Kenya* (Geneva, ILO; mimeographed World Employment Programme research working paper; restricted).

Anker, R., Buvinic, M. and Youssef, N. H. (1982), *Women's roles and population trends in the Third World* (London, Croom Helm).

Arens, J. and Van Beurden, J. (1977), *Jhagrapur: Poor peasants and women in a village in Bangladesh* (Amsterdam, Priv. Print).

Arnold, J. E. M. (1978), *Wood energy and rural communities*. Position paper presented at the Eighth World Forestry Congress, Djakarta, 16–28 October 1978 (Rome, FAO).

Arnold, J. E. M. and Jongma, J. (1977), 'Fuelwood and charcoal in developing countries: an economic survey', *Unasylva* (Rome, FAO), Vol. 29, No. 118.

Aryee, A. F. (1980), *The migration factor in rural development strategy: The case of Ghana*. Paper presented at seminar on The Role of Population Factor in the Rural Development Strategy (Monrovia, mimeo).

Asare, J. (1976), 'Making life easier for Africa's rural women', in *Village Technology* (Nairobi, UNICEF News).

Asian Development Bank (1978), *Rural Asia: Challenge and opportunity* (New York, Praeger).

Atol (1982), *Aangepaste en de vrouw in de derde wereld* (Leuven, Belgium, Aangepaste technologie ontwilskelingslanden).

Banerjee, N. (1983), 'Women and poverty: report on a workshop', *Economic and Political Weekly* (Bombay), Vol. 18, No. 40, October.

Bangladesh Ministry of Agriculture (1978), *Report of the task force on rice processing and by-product utilisation in Bangladesh* (Dhaka, draft).

Bardhan, P. (1981), *Poverty and 'trickle-down' in rural India: a quantitative analysis*. Mimeographed working paper (Berkeley, University of California).

Bardhan, P. and Rudra, A. (1978), 'Interlinkages of land, labour and credit relations: an analysis of village survey data in East India', *Economic and Political Weekly* (Bombay), Vol. 13, Nos 6 and 7, February.

Barker, R. and Cardova, V. G. (1978), 'Labour utilisation in rice production', in *Economic Consequences of the New Rice Technology* (Los

Banos, Philippines, International Rice Research Institute).

Baron, C. G. (ed.) (1980), *Technology, employment and basic needs in food processing in developing countries* (Oxford, Pergamon Press).

Bartsch, W. H. (1977), *Employment and technology in Asian agriculture* (New York, Praeger).

Bassey, M. W. (1979a), *Report on Palm Oil Press Workshop* (Freetown, UNECA/Sierra Leone Government Palm Oil Project).

Bassey, M. W. (1979b), *Technical aspects in the implementation of appropriate technology: role of the Faculty of Engineering, Fourah Bay College.* Paper presented at the Workshop for Trainers and Planners on Village Technology for the Rural Family (Freetown, mimeo).

Batliwala, S. (1983), *Women in poverty: the energy, health and nutrition syndrome.* Paper presented at a workshop on Women and Poverty, Calcutta, 17–18 March (Calcutta, Centre for Studies in Social Science).

Baumann, H. (1928), 'The division of work according to sex in African hoe culture', *Africa* (Dakar, Senegal), Vol. 1.

Beecham, A. (1979), *The programme and operations of the Home Extension Unit Department of Agriculture, Ghana, in the field of appropriate technology.* Paper presented at the Workshop for Trainers and Planners on Village Technology for the Rural Family (Freetown, mimeo).

Begum, S. and Greeley, M. (1979), *Rural women and the rural labour market in Bangladesh: an empirical analysis* (Dacca, Bangladesh Institute of Development Studies).

Beier, N. U. (1955), 'The position of Yoruba women', *Présence africaine* (Paris, Nouvelle Société Présence Africaine), Vol. 1/2, pp. 39–46.

Beneria, L. (1979), 'Reproduction, production and the sexual division of labour', *Cambridge Journal of Economics* (London, Academic Press), Vol. 3, pp. 203–225.

Beneria, L. (1981), 'Conceptualising the labour force: the underestimation of women's economic activities', *Journal of Development Studies* (London, Frank Cass), Vol. 17, No. 3, pp. 10–28.

Beoku-Betts, J. (1976), 'Western perceptions of African women in the 19th and early 20th centuries', *Africana Research Bulletin* (Institute of African Studies, University of Sierra Leone, Fourah Bay College), Vol. 6, No. 4.

Bequele, A. (1980), *Poverty, inequality and stagnation: The Ghanaian experience* (Geneva, ILO; mimeographed World Employment Programme research working paper; restricted).

Bertocci, P. (1975), *The position of women in rural Bangladesh.* Paper No. 33 to BARD–Ford Foundation Seminar on Socio-economic Implications of introducing HYVs in Bangladesh (Comilla, Bangladesh Academy for Rural Development).

Bhalla, S. (1976), 'New relations of production in Haryana agriculture', *Economic and Political Weekly* (Bombay), Vol. 11, No. 13, 27 March.

Billings, M. and Singh, A. (1970), 'Mechanisation and the wheat revolution: effects of female labour in Punjab', *Economic and Political Weekly* (Bombay), Vol. 5, No. 52.

Binswanger, H. P. (1978), *The economics of tractors in the Indian subcontinent: an analytical review* (Hyderabad, International Crops Research Institute for the Semi-Arid Tropics).

Birmingham, W., Neustadt, I. and Omaboe, E. N. (eds) (1966), *A study of contemporary Ghana*, Vols 1 and 2 (London, Allen & Unwin).

Bogaards, J. N. (1969), *Report on an inquiry into the farms of some Kumasi farmers* (Deventer, Netherlands, mimeo, December).

Bohannan, P. and Dalton, G. (eds) (1962), *Markets in Africa* (Evanston, Ill: Northwestern University Press).

Bond, G. A. (1974), *Women's involvement in agriculture in Botswana* (London, ODM Extension Advisory Team, Ministry of Overseas Development).

Boserup, E. (1970), *Woman's role in economic development* (London, Allen & Unwin).

Brain, J. L. (1976), 'Less than second class: women in rural settlement schemes in Tanzania', in N. J. Hafkin and E. G. Bay (eds), *Women in Africa: studies in social and economic change* (Stanford, Calif., Stanford University Press).

Brausch, G. (1964), 'Change and continuity in the Gezira region of Sudan', *International Social Science Journal* (Paris, UNESCO), Vol. 16, No. 3.

Braveman, H. (1974), *Labor and monopoly capital (The degradation of work in the twentieth century)* (New York, Monthly Review Press).

Breman, J. C. (1981), *Of migrants, peasants and paupers* (Rotterdam, Erasmus University, mimeo).

Brokensha, D. (1966), *Social change at Larteh* (London, Oxford University Press).

Brown, C. K. (1974), 'Strategies of rural development in Ghana', *Universitas* (Legon, University of Ghana).

Brown, L. H. (1968), 'Agricultural change in Kenya 1945–60', in *Food Research Institute Studies in Agricultural Economics, Trade and Development* (Stanford, Calif., Stanford University), Vol. 8, No. 1, pp. 33–90.

Bryson, J. C. (1981), 'Women and agriculture in sub-Saharan Africa: implications for development (an exploratory study)', *The Journal of Development Studies* (London, Frank Cass), Vol. 17, No. 3, pp. 29–46.

Bukh, J. (1979), *The village woman in Ghana* (Uppsala, Centre for Development Researh, Scandinavian Institute of African Studies).

Burch, D. (1979), 'Overseas aid and the transfer of technology: a case study of agricultural mechanisation in Sri Lanka' (University of Sussex, D.Phil. dissertation, unpublished).

Buvinic, M. and Youssef, N. H. (1978), *Women-headed households: The ignored factor in development planning.* Report submitted to USAID, Office of Women in Development (Washington, DC, International Centre for Research on Women, March).

Cain, M. L. (1981), 'Java, Indonesia: The introduction of rice processing technology', in R. Dauber and M. L. Cain (eds), *Women and technological change in developing countries* (Boulder, Colo., Westview Press).

Cain, M. T. (1977), *The economic activities of children* (Dacca, Bangladesh Institute of Development Studies, Village Fertility Study Report No. 3, June).

Cain, M. T., Khanam, S. R. and Nahar, S. (1979), *Class, patriarchy and the structure of women's work in rural Bangladesh* (New York, The

Population Council, Center for Population Studies, Working paper No. 43, May).

Campbell-Platt, G. (1978), *The development of appropriate food technologies in Ghana: An overview* (Legon, University of Ghana, Department of Nutrition and Food Science).

Carr, M. (1976a), *Report on a visit to the Gambia, April 1976* (Addis Ababa, UNECA).

Carr, M. (1976b), *Report on a visit to Upper Volta, November 1976* (Addis Ababa, UNECA).

Carr, M. (1976c), *Report on a mission to Kenya, January 1976* (Addis Ababa, UNECA).

Carr, M. (1976d), *Report on a visit to Sierra Leone, April 1976* (Addis Ababa, UNECA).

Carr, M. (1976e), *Report on a visit to Liberia, May 1976* (Addis Ababa, UNECA).

Carr, M. (1976f), *Report of activities, November 1975–June 1976* (Addis Ababa, UNECA).

Carr, M. (1976g), *Economically appropriate technologies for developing countries: An annotated bibliography* (London, Intermediate Technology Publications).

Carr, M. (1978), *Appropriate technology and African women* (Addis Ababa, UNECA/SDP/ATRCW/VIGEN/78).

Carr, M. (1979), 'Preface' to S. Holtermann, *Intermediate technology in Ghana: The experience of Kumasi University's Technology Consultancy Centre* (London, Intermediate Technology Publications).

Carr, M. (1980), *Technology and rural women in Africa* (Geneva, ILO, mimeographed World Employment Programme research working paper; restricted).

Carruthers, I. D. (1970), 'The contribution of rural water investment to development', *Eastern Africa Journal of Rural Development* (Makerere University, Uganda) Vol. 3, No. 2.

Carruthers, I. and Weir, A. (1976), 'Rural water supplies and irrigation development', in J. Heyer, J. K. Maitha and W. M. Senga (eds), *Agricultural development in Kenya (an economic assessment)* (Nairobi, Oxford University Press), pp. 288–312.

Caulfield, M. D. (1974), 'Imperialism, the family and cultures of resistance', in *Socialist Revolution* (Oakland, Calif., New Fronts Publishing Co.), No. 20.

Central Bank of Nigeria (1977), *Nigeria's principal economic and financial indicators 1970–76* (Lagos).

Central Bank of Nigeria (1979), *Annual Report and Statement of Accounts for the year ended 31st December 1978* (Lagos).

Chakravarty, K. and Tiwari, G. C. (1977), *Regional variation in women's employment: a case study of five villages in three Indian states* (New Delhi, Indian Council for Social Science Research, Programme of Women's Studies, mimeo).

Chakravorty, S. (1975), 'Farm women labour: waste and exploitation', *Social Change* (New Delhi, Council for Social Development), Vol. 5, Nos 1 and 2, March/June.

Chambers, R. (1969), *Settlement schemes in tropical Africa (a study of organisations and development)* (London, Routledge & Kegan Paul).

Chayanov, A. V. (1925), *Peasant farm organisation* (Moscow, The Cooperative Publishing House).

Cheater, A. (1981), 'Women and their participation in commercial agricultural production: the case of medium-scale freehold in Zimbabwe', *Development and Change* (The Hague), Vol. 12, No. 3, July.

Chen, M. and Ghuznavi, R. (1978), *Women in Food-for-Work: The Bangladesh experience* (Oxford, Oxfam).

Chlora-Jones, C. (1979), *Women's legal access to agrarian resources.* Paper prepared for USAID for the UN/FAO Conference on Agrarian Reform and Rural Development (Rome, FAO).

Chuta, E. (1978), 'The economics of gara (tie-dye) production in Sierra Leone', in *African Rural Economy Programme*, WP25 (Michigan State University).

Chuta, E. (1980), *Growth and change in small-scale industry: Sierra Leone, 1974–80* (Geneva, ILO, mimeo).

Chuta, E. (1984), *Employment and growth in small-scale industry* (Geneva, ILO).

Clark, B. A. (1975), 'The work done by rural women in Malawi', *Journal of Rural Development* (Sri Lanka Academy of Administrative Studies), Vol. 8, Nos 1–2.

Cleave, J. H. (1970), 'Labor in the development of African agriculture: the evidence from farm surveys', PhD dissertation (Stanford University).

Cleave, J. H. (1974), *African farmers: labor use in the development of smallholder agriculture* (New York, Praeger Special Studies in International Economics and Development).

Cole, J. (1977), 'Providing access to new skills and modern techniques', *Assignment Children* (Geneva, UNICEF), No. 38, April/June.

Cole, J. (1980), *National Council on Women and Development: policies and action* (Accra, NCWD).

Cole, M. J. and Hamilton, D. (1976), *Indigenous technology in Sierra Leone* (Sierra Leone Government/UNECA/UNICEF).

Collier, P. (1982), *Contractual constraints upon the processes of labour exchange and surrogate labour exchange in rural Kenya.* Study prepared for ILO (Geneva, ILO, mimeo).

Collier, P. and Lal, D. (1979), *Poverty and growth in Kenya* (Washington, DC, World Bank, mimeo).

Collier, W. L., Colter, J., Sinarhadi, Shaw, R. d'A. (1974), *Choice of technique in rice milling in Java: a comment* (New York, Agricultural Development Council, Research and Training Network reprint, September).

Cone, L. Winston and Lipscomb, J. P. (1972), *The history of Kenya agriculture* (Nairobi, University Press of Africa).

Consortium for International Development (1978), *Proceedings and papers of the International Conference on Women and Food*, Vol. 3 (Tucson, Arizona, University of Arizona, 8–11 January).

Conti, A. (1981), *The impact of transfer of technology on women.* Study prepared for UNCTAD (Geneva, UNCTAD, mimeo).

Dadson, J. A. (1973), 'Farm-size and the modernisation of agriculture in Ghana', in I. Ofori (ed.), *Factors of agricultural growth in West Africa* (Legon, Institute of Statistical, Social and Economic Research).

Dalton, G. E. and Parker, R. N. (1978), *Agriculture in south-east Ghana,* Vol. II (University of Reading, Department of Agricultural Economics and Management).

Dasgupta, B. (1977a), *Village society and labour use* (New Delhi, Oxford University Press).

Dasgupta, B. (1977b), *Agrarian change and the new technology in India* (Geneva, United Nations Research Institute for Social Development, Report No. 77.2).

Date-Bah, E. (1980a), *Rural development and the status of women.* Paper presented at seminar on The Role of Population Factor in the Rural Development Strategy (Monrovia, mimeo).

Date-Bah, E. (1980b), *The changing work roles of Ghanaian women* (Accra, National Council on Women and Development).

Date-Bah, E. and Stevens, Y. (1981), 'Rural women in Africa and technological change: some issues', *Labour and Society* (Geneva, International Institute of Labour Studies), Vol. 6, No. 2, April–June, pp. 149–162.

Date-Bah, E., Brown, C. and Gyekye, L. (1978), *Ghanaian women and co-operatives* (Accra, National Council on Women and Development).

Date-Bah, E., Stevens, Y. and Ventura-Dias, V. (1983), *Technological change and the condition of rural women* (Geneva, ILO, draft).

Dauber, R. and Cain, M. L. (eds) (1981), *Women and technological change in developing countries* (Boulder, Colo., Westview Press).

David, M. and Wyeth, P. (1978), *Kenya commercial bank loans in rural areas: a survey,* WP. 342 (University of Nairobi, Institute of Development Studies, August).

Deere, C. D. (1977), 'Changing social relations of production and Peruvian peasant women's work', *Latin American Perspectives* (Riverside, Calif., Latin American Perspectives), Vol. 4, Nos 1–2.

Deere, C. Diana and Leon de Leal, M. (1980), *Women in agriculture: peasant production, proletarianisation in the Andean regions* (Geneva, ILO; mimeographed World Employment Programme research working paper; restricted).

Deere, C. Diana, Humphries, J. and Leon de Leal, M. (1982), 'Class and historical analysis for the study of women and economic change', in R. Anker, M. Buvinic and N. Youssef (eds), *Women's roles and population trends in the Third World* (London, Croom Helm), pp. 87–114.

Development Alternatives Inc. (1974), *A seven-country survey on the roles of women in rural development* (Washington, DC).

de Wilde, T. (1977), 'Some social criteria for appropriate technology', in R. J. Congdon, *Introduction to appropriate technologies* (Aylesbury, Bucks, Rodale Press).

Dey, J. (1975), 'Role of women in Third World countries', MA thesis for Agricultural Extension and Rural Development Centre (University of Reading).

Dey, J. (1979), 'Women farmers in the Gambia: The effects of irrigated rice development programmes on their role in rice production'. Unpublished paper (Oxford, mimeo).

Dixon, R. (1983), 'Land, labour and the sex composition of the agricultural labour force: an international comparison', *Development and Change* (The Hague), Vol. 14, No. 3, July.

Dixon, R. B. (1978), *Rural women and work: strategies for development in South Asia* (Baltimore, Md, and London, Johns Hopkins University Press).

D'Ononfrio-Flores, P. M. and Pfafflin, S. M. (1982), *Scientific–technological change and the role of women in development* (Boulder, Colo., Westview Press).

Duff, B. (1972), *Design, development and extension of small-scale agricultural equipment*. Paper to the Seminar on Farm Mechanisation in South-East Asia (Penang, Malaysia, Agricultural Development Council).

Dutta-Roy, D. K. and Mabey, S. J. (1968), *Household budget survey in Ghana* (Legon, Institute of Statistical, Social and Economic Research).

Ellickson, J. (1975), *Observations from the field on the conditions of rural women in Bangladesh* (Comilla, Bangladesh Academy for Rural Development).

Elson, D. and Pearson, R. (1978), *Internationalisation of capital and its implications for women in the Third World*. Paper presented to the Conference on the Continuing Subordination of Women and the Development Process (University of Sussex, Institute of Development Studies).

Epstein, T. S. (1962), *Economic development and social change in South India* (Manchester, The University Press).

Epstein, T. S. (1973), *South India: yesterday, today and tomorrow* (London, Macmillan).

Epstein, T. S. (1976), *Introductory comments: Workshop on Women and Development in South Asia* (University of Sussex, Institute of Development Studies).

Eva, M. (1978), *Determinants of the intra-household allocation of time*. Paper presented at the Workshop on Women's Role and Demographic Change Research Programme (Geneva, ILO).

Evenson, R. E. (1976), *On the new household economics* (New York, Agricultural Development Council Staff reprints 76–1).

Ewusi, K. (1978), *Women in occupations in Ghana*. Paper presented at a seminar on Ghanaian women and development (Accra, National Council on Women and Development).

FAO (1977), *Production Year Book* (Rome, Food and Agriculture Organisation), Vol. 31.

FAO (1979), *FAO Product Yearbook* (Rome, Food and Agriculture Organisation).

FAO (1980), *FAO Product Yearbook* (Rome, Food and Agriculture Organisation).

FAO (1981), *FAO Production Year Book* (Rome, Food and Agriculture Organisation).

Favi, F. (1977), 'Women's role in economic development: a case study of villages in Oyo State' (Department of Agricultural Extension, University of Ibadan, unpublished memoir).

Feacham, R. *et al.* (1978), *Water, health and development* (London, Tri Med Books).

Feldman, R. (1981), *Employment problems of rural women in Kenya* (Addis Ababa, ILO–JASPA).

Floor, W. M. (1977), *The energy sector of the Sahelian countries* (The Hague, Policy Planning Section, Ministry of Foreign Affairs, mimeo).

*Focus* (1975), 'Africa's food producers: the impact of change on rural women' (London, International Defence and Aid Fund for Southern Africa), Vol. 25, No. 5, January–February.

Fordham, P. (1973), *Rural development in the Kenya highlands*. A report of Geographical Field Group Regional Studies No. 17 (Nottingham).

Fortes, M. (1949), 'Time and social structure: an Ashanti case study', in M. Fortes (ed.), *Social structure* (New York, Russell and Russell).

Fortmann, L. (1981a), 'The plight of the invisible farmer: the effect of national agricultural policy on women in Africa', in R. Dauber and M. L. Cain (eds), *Women and technological change in developing countries* (Boulder, Colo., Westview Press).

Fortmann, L. (1981b), *Women's agriculture in a cattle economy* (Gabarone, Ministry of Agriculture, May).

Foster, G. M. (1962), *Traditional culture and the impact of technological change* (New York, Harper).

Fox, R. H. (1953), 'A study of energy expenditure of Africans engaged in rural activities', PhD thesis, presented to the Human Nutrition Research Unit, Medical Research Council (University of London).

Fox-Genovese, E. (1982), 'Placing women's history in history', *New Left Review* (London, New Left Review Ltd.), Vol. 133, May–June, pp. 5–29.

Gaisie, S. K. (1980), *Demographic trends in Ghana and world population plan of action* (Legon, University of Ghana).

Germain, A. (1975), *Women's role in agricultural development* (New York, Agricultural Development Council, draft).

Germain, A. (1976), *Women's role in Bangladesh development: A program assessment* (Dacca, Ford Foundation).

German Foundation for Developing Countries (1972), *Development and dissemination of appropriate technologies in rural areas*. Report on an international workshop held in Kumasi, 17–18 July 1972 (Kumasi, mimeo).

Ghana National Council on Women and Development (1980), *The first women's co-operative gari factory* (Accra).

Goody, J. R. (1976), *Production and reproduction* (Cambridge, Cambridge University Press).

Government of India (1973), *Rural Labour Enquiry, 1963–65: final report* (Simla, Ministry of Labour, Labour Bureau).

Government of India (1979), *Rural Labour Enquiry 1974–75: final report on wages and earnings of rural labour households* (Chandigarh, Ministry of Labour, Labour Bureau).

352 *Technology and Rural Women*

Government of India (1980), *Rural Labour Enquiry 1974–75: summary report on wages and earnings, and employment and unemployment of rural labour households* (Chandigarh, Ministry of Labour, Labour Bureau).
Government of India (1981), *Rural Labour Enquiry, 1974–75: final report on employment and unemployment of rural labour households* (Chandigarh, Ministry of Labour, Labour Bureau), Part I.
Government of Nigeria (various dates), *Annual abstract of statistics,* several issues (Lagos).
Government of Nigeria (1981), *Fourth National Development Plan, 1981–85* (Lagos).
Government of Sierra Leone (1970a), *Statistical Bulletin, Vol. 17* (Central Statistics Office).
Government of Sierra Leone (1970b), *Agricultural survey report* (Ministry of Agriculture and Natural Resources).
Government of Sierra Leone (1971), *Statistical Bulletin, Vol. 19* (Central Statistics Office).
Government of Sierra Leone (1972), *Household surveys of the rural areas of the provinces,* July 1969–January 1970 (Central Statistics Office).
Government of Sierra Leone (1974), *1974/75–1978/79 Five-Year Plan* (Ministry of Development and Economic Planning).
Government of Sierra Leone (1977), *Annual Statistical Digest* (Central Statistics Office).
Government of Sierra Leone (1978), *National nutrition survey report.*
Government of Sierra Leone (1979), Paper presented at Workshop for Trainers and Planners on Village Technology (Sierra Leone, Co-operative Department).
Government of Sierra Leone (1980), *Household surveys* (Central Statistics Office, unpublished).
Government of Sierra Leone/UNCSTD (1978), *Report on Subregional Seminar* (Freetown, July).
Greeley, M. (1981), *Rural technology, rural industries and the rural poorest: the case of rice processing in Bangladesh.* Paper presented at the post-harvest technology workshop (New Delhi, Indian Agricultural Research Institute, January).
Griffin, K. (1972), *The Green Revolution: an economic analysis* (Geneva, UNRISD).
Griffin, K. (1974), *The political economy of agrarian change, an essay on the Green Revolution* (London, Macmillan).
Gulati, L. (1978), 'Profile of a female agricultural labourer', *Economic and Political Weekly, Review of Agriculture* (Bombay), March.
Gutto, S. B. O. (1976), *The status of women in Kenya: a study of paternalism, inequality and underprivilege* (University of Nairobi, Institute of Development Studies, Discussion Paper No. 235, April).
Guyer, J. (1978), *Women's work in the food economy of the cocoa belt: A comparison* (Boston University, African Studies Center, working papers).
Hagan, G. P. (1976), 'Divorce, polygamy and family welfare', *Ghana Journal of Sociology* (Accra), Vol. 10, No. 1.
Halpern, P. (1978), *Labour displacement among rural women in Bangladesh*

(University of Sussex, Institute of Development Studies).

Hanger, J. and Moris, J. (1973), 'Women and the household economy', in R. Chambers and J. Moris (eds), *Mwea: an irrigated rice settlement in Kenya* (Munich, Welforum Verlag).

Hardiman, M. (1974), 'A preliminary study of the role of women in some Akan rural communities', in C. Oppong (ed.), *Legon family research papers* (University of Ghana, Institute of African Studies).

Hardiman, M. (1977), *Women farmers of the Akwapim hills*. Paper presented to the British Sociological Association Development Study Group (London, mimeo).

Harrel Bond, B. E. and Rijnsdorp, U. (1976), 'The emergence of the "stranger permit marriage" and other new forms of conjugal union in rural Sierra Leone', *Africana Research Bulletin* (University of Sierra Leone, Fourah Bay College), Vol. 6, No. 4.

Harris, J. (1940), 'The position of women in a Nigerian society', *Transactions of the New York Academy of Sciences*, Series II, Vol. 2, No. 5, pp. 141–148.

Harris, O. (1981), 'Households as natural units', in K. Young, C. Wolkowitz and R. McCullagh (eds), *Of marriage and the market* (London, CSE Books).

Harriss, B. (1977), 'Paddy-milling: problems in policy and the choice of technology', in B. H. Farmer (ed.), *The Green Revolution? Technology and change in rice-growing areas of Tamilnadu and Sri Lanka* (London and Basingstoke, Macmillan).

Harriss, J. (1979), *Capitalism and peasant farming: a study of agricultural change and agrarian structure in Northern Tamilnadu*, Monographs in Development Studies, No. 3 (School of Development Studies, University of East Anglia, February).

Harrod, R. F. (1948), *Towards a dynamic economics* (London, Macmillan).

Hart, G. P. (1978), 'Labor allocation strategies in rural Javanese households', PhD dissertation (Ithaca, New York, Faculty of the Graduate School of Cornell University, August).

Hay, M. Jean (1976), 'Luo women and economic change during the colonial period', in N. Hafkin and E. G. Bay (eds), *Women in Africa: studies in social and economic change* (Stanford, Calif., Stanford University Press) pp. 87–109.

Hayami, Y. and Ruttan, V. W. (1971), *Agricultural development: an international perspective* (Baltimore, Md, Johns Hopkins Press).

Hemmings-Gapihan, G. (1981), 'Baseline study for socio-economic evaluation of Tangaye Solar site', in R. Dauber and M. Cain (eds), *Women and technological change in developing countries* (Boulder, Colo., Westview Press).

Hevi-Yiboe, L. A. P. (1979), *Smoke in rural Ghanaian kitchens* (Accra, Arakan Press).

Heyer, J. (1975), 'The origins of regional inequalities in smallholder agriculture in Kenya, 1920–73', *Eastern Africa Journal of Rural Development* (Makerere University, Uganda) Vol. 8, Nos 1/2, pp. 142–181.

Heyer, J. and Waweru, J. K. (1976), 'The development of small farm areas', in J. Heyer, J. K. Maitha and W. M. Senga (eds), *Agricultural development in Kenya (an economic assessment)* (Nairobi, Oxford University Press), pp. 187–221.

Heyer, J., Maitha, J. K. and Senga, W. M. (1976), *Agricultural development in Kenya (an economic assessment)* (Nairobi, Oxford University Press).

Heyzer, N. (1980), 'From rural subsistence to an industrial peripheral work force: an examination of female Malaysian migrants and capital accumulation in Singapore', in *Rural women in waged work* (Geneva, ILO).

Heyzer-Fan, N. (1981), *A preliminary study of women rubber estate workers in peninsular Malaysia* (ILO, Geneva; mimeographed World Employment Programme research working paper; restricted).

Hicks, J. R. (1932), *The theory of wages* (London, Macmillan).

Hill, F. (1979), *Women agricultural producers: industrial and non-industrial societies*. Paper prepared for USAID for the UN/FAO World Conference on Agrarian Reform and Rural Development (Rome, FAO).

Hill, P. (1963), *Migrant cocoa farmers of Southern Ghana* (Cambridge, Cambridge University Press).

Himmelweit, S. and Mohun, S. (1977), 'Domestic labour and capital', *Cambridge Journal of Economics* (London, Academic Press), Vol. 1, pp. 15–31.

Holtermann, S. (1979), *Intermediate technology in Ghana: The experience of the Kumasi University's Technology Consultancy Centre* (London, Intermediate Technology Group).

Hostettler, E. (1978), 'A comparison of the sexual division of labour in Norfolk and Northumberland', unpublished manuscript.

Humphries, J. (1977), 'Class struggle and the persistence of the working class family', in *Cambridge Journal of Economics*, Vol. 1, No. 3.

Hussain, A. (1980), 'The impact of agricultural growth on changes in the agrarian structure of Pakistan with special reference to the Punjab Province: 1960–1978', PhD dissertation (Department of Economics, University of Sussex).

Illo, J. F. I. (1983), *Wives at work: patterns of labour force participation in two rice farming villages in the Philippines*. Paper presented at the conference on Women in Rice Farming Systems, Los Banos, Philippines, 26–30 September (Los Banos, International Rice Research Institute).

International Labour Office (1966), *Plantation workers: conditions of work and standard of living* (Geneva, ILO).

International Labour Office (1970), *Conditions of work of women and young workers on plantations* (Geneva, ILO, Committee on Work on Plantations, Sixth Session).

International Labour Office (1972), *Employment, incomes and equality: a strategy for increasing productive employment in Kenya* (Geneva, ILO).

International Labour Office (1976a), *Kenya country study on rural employment promotion* (Geneva, ILO; mimeographed World Employment Programme research working paper; restricted).

International Labour Office (1976b), *Growth, employment and equity: a comprehensive strategy for the Sudan* (Geneva, ILO).

International Labour Office (1978a), *Options for a dependent economy: development, employment and equity problems in Lesotho* (Addis Ababa, Jobs and Skills Programme for Africa).

International Labour Office (1978b), *Towards self-reliance: development, employment and equity issues in Tanzania* (Addis Ababa, Jobs and Skills Programme for Africa).

International Labour Office (1978c), *Employment, growth and basic needs: a one world problem* (Geneva, ILO, second edition).

International Labour Office (1980a), *Tarkwa women's income-generating activities: Draft report of evaluation mission* (Geneva, ILO).

International Labour Office (1980b), *Rural technology centres* (Geneva, ILO Technology and Employment Branch, February, mimeo).

International Labour Office (1980c), *Women in rural development – critical issues* (Geneva, ILO).

International Labour Office (1981), *Women at work* (Geneva), No. 1, p. 22.

Jackson, A. F. J. (1978), 'The potentials of indigenous and appropriate technology in national development', Report, UNCSTD Subregional Seminar (Freetown, mimeo).

Jain, L. (1976), *Measurement of household activities in India.* Paper for Agricultural Development Council Workshop on Household Studies (Singapore, Sonta).

Janelid, I. (1975), *The role of women in Nigerian agriculture* (Rome, FAO, Human Resources Institution and Agrarian Reform Division).

Jannuzi, F. T. and Peach, J. T. (1977), *Report on the hierarchy of interests in land in Bangladesh* (Washington, DC, USAID).

Jedlicka, A. D. (1977), *Organisation for rural development* (New York, Praeger).

Johnston, B. F. and Kilby, P. (1972), *Inter-relations between agricultural and industrial growth.* Paper presented at the International Economic Association Conference on the Place of Agriculture in the Development of Underdeveloped Countries (Bad Godesberg, Germany).

Jones, S. Kurz (1977), 'Domestic organisation and the importance of female labor among the Limbu of Eastern Nepal', PhD dissertation (New York State University).

Jones, W. O. and Akinrele (1976), *Improvement of cassava processing and marketing.* Recommendations and report prepared for International Institute of Tropical Agriculture (Ibadan, Nigeria, IITA).

Jonston, R. (1969), 'Co-operatives and agricultural production in Sierra Leone', *Rural Africana* (East Lansing, Michigan State University).

Kabede, H. (1978), *Improving village water supply in Ethiopia: a case study of the socio-economic implications* (UNECA, African Training and Research for Women, ECA/SDD/ATRCW/VTWATER/78).

Kaberry, P. M. (1952), *Women of the grassfields: a study of the economic position of women in Bermenda, British Cameroons*, Research Publication No. 14 (London, Colonial Office).

Kabir, K. Ayesha and Chen, A. (1976), *Rural women in Bangladesh: exploding some myths* (Dacca, Ford Foundation).

Kagan, B. (1970), *Fish processing in Ghana: possibilities of improving traditional processing* (Accra, FAO Food Research and Development Unit).

Kalecki, M. (1976), *Essays on developing economies* (London, Cambridge University Press).

Kaniki, M. (1980), 'Economical technology against technical efficiency in the palm oil industry of West Africa: development and change', *SAGE* (London and Beverly Hills), Vol. 2, pp. 273–284.

Kayongo-Male, D. and Walji, P. (1977), *The value of children in rural areas: parents' perceptions and actual labour contributions of children in selected areas of Kenya* (University of Nairobi, Department of Sociology, Seminar Paper No. 27).

Kershaw, G. (1975/6), 'The changing roles of men and women in the Kikuyu family by socio-economic strata', *Rural Africana* (East Lansing, Michigan State University), Winter, No. 29, pp. 173–194.

Khan, S. Anwar and Bilquees, F. (1976), 'The environment, attitudes and activities of rural women: a case study of a village in Punjab', *Pakistan Development Review* (Islamabad), Vol. 15, No. 3.

Khatun, S. and Rhani, G. (1977), *Bari-based post-harvest operations and livestock care: some observations and case studies* (Dacca, Ford Foundation).

Kilby, P. (1969), *Industrialisation in an open economy: Nigeria 1945–66* (London, Cambridge University Press).

Killick, A. (1978), *Development economics in action: a study of economic policies in Ghana* (London, Heinemann).

Killick, A. and Szereszewski, R. (1969), 'The economy of Ghana', in P. Robson and D. A. Lury (eds), *The economics of Africa* (London, Allen & Unwin).

King, E. (1976), *Time allocation in Philippine rural households*, Discussion paper No. 76–26 (Los Banos, Institute of Economic Development and Research, School of Economics, University of Philippines, August).

Kitching, G. (1980), *Class and economic change in Kenya (the making of an African petite bourgeoisie, 1905–70* (New Haven, Conn., Yale University Press).

Klingshirn, A. (1971), 'The changing position of women in Ghana', doctoral dissertation (University of Marburg/Lahn).

Klingshirn, A. (1978), *Investment of women in co-operatives in Zaire and Ghana* (Rome, United Nations Fund for Population Activities/FAO).

Knowles, J. C. and Anker, R. (1981), 'An analysis of income transfers in a developing country: the case of Kenya', *The Journal of Development Economics* (North Holland, Amsterdam), Vol. 8.

Konadu, O. (1980), 'A study of a rural industry: the Adinkra industry in the Kwabre district of Ashanti', MA thesis (Legon, University of Ghana, Department of Sociology).

Kongstad, P. and Mönsted, M. (1980), *Family, labour and trade in Western Kenya* (Uppsala, Scandinavian Institute of African Studies).

Kula, W. (1976), *An economic theory of the feudal system*, translated from

Polish by Lawrence Garner (London, New Left Books).

Landes, J. B. (1977/8), 'Women, labor and family life: a theoretical perspective', *Science and Society* (New York, John Jay College), Winter, pp. 386–409.

Lawson, R. and Kwei, E. (1974), *African entrepreneurship and economic growth: a case study of the fishing industry of Ghana* (Accra, Ghana Universities Press).

Lefaucheu, M. (1962), 'The contribution of women to the economic and social development of African countries', *International Labour Review* (Geneva, ILO), Vol. II.

The Legon Society on National Affairs (1980), *The Legon Observer*, 19 September – 2 October (Accra, Liberty Press).

Leith-Ross, S. (1952), *African women: a study of the Ibo of Nigeria* (London).

Lele, U. (1979), 'A revisit to rural development in Eastern Africa', *Finance and Development* (Washington, DC, International Monetary Fund), Vol. 16, No. 4, December.

Levi, S. S. and Oruche, C. B. (n.d.), *Some inexpensive improvements in village scale gari making*, FIIR Research Report, No. 2 (Lagos, Federal Institute of Industrial Research).

Lewis, W. A. (1967), *Reflections of Nigeria's economic growth* (Paris, OECD).

Lim, L. Y. C. (1978), *Women workers in multinational corporations in developing countries: the case of the electronic industry in Malaysia and Singapore*, Occasional paper No. 9 (University of Michigan, Women's Studies Program).

Lindenbaum, S. (1974), *The social and economic status of women in Bangladesh* (Dacca, The Ford Foundation, No. 30).

Little, K. L. (1948), 'The changing position of women in Sierra Leone Protectorate', *Africa* (London, Africa Journal Ltd), Vol. 17.

Longhurst, R. (1980a), *Rural development planning and the sexual division of labour: a case study of the Moslem Hausa village in Northern Nigeria* (Geneva, ILO; mimeographed World Employment Programme research working paper; restricted).

Longhurst, R. (1980b), *Work and nutrition in Nigeria* (University of Sussex, Institute of Development Studies, mimeo).

Loose, E. (1979), *Women in rural Senegal: some economic and social observations*. Paper presented at the Workshop on Sahelian Agriculture (West Lafayette, Indiana, Department of Agricultural Economics, Purdue University, February).

Loutfi, M. (1980), *Rural women: unequal partners in development* (Geneva, ILO).

McCall, D. (1961), 'Trade and the role of wife in a modern West African town', in A. W. Southall (ed.), *Social change in modern Africa* (London, Oxford University Press).

MacCarthy, F. (1974), *The status and conditions of rural women in Bangladesh* (Dacca, Ministry of Agriculture).

MacCarthy, F. E., Sabbah, S. and Akhtar, R. (1978), *Rural women workers*

*in Bangladesh: problems and prospects* (Dacca, Ministry of Agriculture, Planning and Development Division, Women's Section).

MacCormack, C. (1976), 'The compound head – structure and strategies', *Africana Research Bulletin* (University of Sierra Leone, Fourah Bay College), Vol. 6, No. 4.

McDonough, R. and Harrison, R. (1978), 'Patriarchy and relations of production', in A. Kuhn and A. M. Wolpe (eds), *Feminism and materialism (women and modes of production)* (London, Routledge & Kegan Paul).

McDowell, J. and Hazzard, V. (1976), 'Village technology and women's work in Eastern Africa', *Assignment Children* (Geneva, UNICEF), No. 36, October–December, pp. 53–65.

McInerney, J. P. and Donaldson, G. F. (1975), *The consequences of farm tractors in Pakistan* (Washington, DC, IBRD, Staff working paper no. 210, February).

McIntosh, M. and Barrett, M. (1980), 'The family wage', *Feminist Review* (London), No. 6.

McLean, K. (1968), *Fufu preparation machinery* (Accra, FAO Food Research and Development Unit).

Macpherson, G. and Jackson, D. (1975), 'Village technology for rural development', *International Labour Review* (Geneva, ILO), Vol. 3, No. 2, February.

Mamdani, M. (1972), *The myth of population control: family, caste and class in an Indian village* (New York, Monthly Review Press).

Manners, R. A. (1962), 'Land use, labor and the growth of market economy in Kipsigis country', in P. Bohannan and G. Dalton (eds), *Markets in Africa* (Evanston, Ill., Northwestern University Press), pp. 493–519.

Manuaba, A. (1979), 'Choices of technology and working conditions in rural areas', in *Technology to improve working conditions in Asia* (Geneva, ILO).

Martius von Harder, G. (1975), *Women's participation in rice processing with special reference to HYVs.* Paper presented to the BARD–Ford Foundation Seminar on the Socio-economic Implications of Introducing HYVs of Rice (Comilla, Bangladesh Academy for Rural Development).

Marx, K. (1977), *Capital*, Vol. I, (New York, Vintage Books).

Matsepe-Casaburri, I. F. (1980), *Changing roles and needs of women in South Africa and Namibia.* Paper presented to the World Conference for the UN Decade for Women, Copenhagen 14–30 July 1980 (Copenhagen, mimeo).

Max-Forson, M. (1979), *Progress and obstacles in achieving the minimum objectives of the world and Africa plans for action: a critical review* (Addis Ababa, UNECA, November).

Mbilinyi, M. J. (1972), 'The state of women in Tanzania', *Canadian Journal of African Studies* (Canadian Association of African Studies, Carleton University, Ottawa, Ontario), Vol. 6, No. 2.

Mbithi, P. M. and Mbula, J. (1981), *Socio-economic factors influencing technical farm development in the arid/semi-arid lands* (Kenya Government,

Co-operative Research Project, Ministry of Agriculture).

Mbula, J. (1981), *Women and the family*. Study prepared for the Ministry of Transportation and Communications, Roads and Aerodromes Department (Nairobi, Government of Kenya).

Mellor, J. W. (1969), 'The subsistence farmer in traditional economies', in C. R. Wharton Jr, *Subsistence agriculture and economic development* (Chicago, Aldine), pp. 209–227.

Mernissi, F. (1978), *Country reports on women in North Africa* (Addis Ababa, UNECA).

Mickelwait, D., Riegelman, M. and Sweet, C. (1976), *Women in rural development* (Boulder, Colo., Westview Press).

Millet, K. (1971), *Sexual politics* (London, Hart-Davis).

Mitchnik, D. A. (1972), *The role of women in rural development in the Zaire* (Oxford, Oxfam, July, mimeo).

Mock, P. R. (n.d.), 'The efficiency of women as farm managers: Kenya', unpublished paper (Teachers' College, Columbia University).

Molyneux, M. (1979), 'Beyond the domestic labour debate', *New Left Review* (London, New Left Review Ltd), No. 116, July–August, pp. 3–27.

Monstead, M. (n.d.), *The changing division of labour within rural families in Kenya* (Copenhagen, Centre for Development Research).

Mullings, L. (1976), 'Women and economic change in Africa', in N. Hafkin and E. Bay (eds), *Women in Africa: studies in social and economic change* (Stanford, Calif., Stanford University Press).

Nadia, H. Y. (1978), *The interrelationship between the division of labour in the household, women's role and their impact upon fertility*. Paper presented at the Informal Workshop on Women's Role and Demographic Research Programme (Geneva, ILO).

Nag, M. *et al.* (1977), 'Economic value of children in two peasant societies', in *International Population Conference: Mexico, 1977, Vol. 1* (Liége, Belgium, International Union for the Scientific Study of Population).

Nash, J. (1977), 'Women in development: dependency and exploitation', *Development and Change* (The Hague), Vol. 8, No. 2, April, pp. 161–182.

Nath, K. and Thomas, A. T. (1976), *Indicators of regional development*, National Development Planning paper no. 11/39 (Freetown, mimeo).

Nelson, N. (1979), *Why has development neglected rural women? A review of South Asian literature* (Oxford, Pergamon Press).

Nerlove, M. (1974), *Economic growth and population perspectives of the 'new home economics'* (New York, Agricultural Development Council reprint).

North, J., March, J., Mickelwait, D. and Street, C. (1975), *Women in national development in Ghana* (Accra, USAID).

Norwegian Agency for International Development (NORAD) (1980), *Aid to fisheries at Lake Turkana – evaluation and recommendations*. Report by an advisory group appointed by NORAD, September 1980 (Oslo).

Nukunya, G. K. and Boateng, E. O. (1979), *An evaluation/study of water utilisation behaviour and its related socio-economic impact* (Institute of

Statistical, Social and Economic Research, University of Ghana).

Oboler, R. Smith (1977a), *Work and leisure in modern Nandi: preliminary results of a study of time allocation*, WP 324 (University of Nairobi, Institute of Development Studies, September).

Oboler, R. Smith (1977b), *The economic rights of Nandi women*, WP 328 (University of Nairobi, Institute of Development Studies, November).

Okali, C. (1976), 'The importance of non-economic variables in the development of the Ghana cocoa industry', unpublished PhD thesis (Legon, Accra, University of Ghana).

Okali, C. and Mabey, S. (1975), 'Women in agriculture in southern Ghana', *Manpower and Unemployment Research in Africa* (Montreal, Quebec, McGill University), Vol. 8, No. 2.

O'Kelly, E. (1973), *Aid and self-help* (London, Charles Knight).

O'Kelly, E. (1978a), *Rural women: their integration in development programmes and how simple intermediate technologies can help them* (London).

O'Kelly, E. (1978b), *Simple technologies for rural women in Bangladesh* (Dacca, UNICEF).

Okoth-Ogendo, H. W. O. (1976), 'African land tenure reform', in J. Heyer, J. K. Maitha and W. M. Senga (eds), *Agricultural development in Kenya (an economic assessment)* (Nairobi, Oxford University Press).

Olin, U. (1977), *Integration of women in development: programme guidelines* (New York, United Nations Development Programme).

Ollennu, N. A. (1966), 'Aspects of land tenure', in W. Birmingham, I. Neustadt and E. N. Omaboe (eds), *A study of contemporary Ghana* (London, Allen & Unwin).

Oluwasanmi, H. A. (1973), 'West African agricultural development in the 60s', in I. Ofori (ed.), *Factors of agricultural growth in West Africa* (Legon, Institute of Statistical, Social and Economic Research).

Opare, K. D. (1979/80), *The impact of agricultural extension services on rural development.* Paper prepared for Population Dynamics Programme Seminar on Population and Development (Legon, New Year School).

Oppong, C. (1974), *Marriage among a matrilineal elite* (London, Cambridge University Press).

Oppong, C. (1980a), *Seven roles and the status of women* (Geneva, ILO).

Oppong, C. (1980b), *Changing roles of women in urban households: action-oriented research on economic opportunities for women and demographic change* (Geneva, ILO).

Oppong, C. (1982), 'Family structure and women's reproductive and productive roles: some conceptual and methodological issues', in R. Anker, M. Buvinic and N. H. Youssef, *Women's roles and population trends in the Third World* (London, Croom Helm), pp. 133–150.

Oppong, C., Okali, C. and Houghton, E. (1975), 'Women power: retrograde steps in Ghana', *African Studies Review* (Brandeis University), Vol. 18, No. 3.

Ottenberg, P. V. (1959), 'The changing position of women among the Afikpo Ibo', in *Continuity and change in African cultures* (University of Chicago).

Ottenburg, S. (1983), 'Artistic and sex roles in a Limba chiefdom', in C. Oppong (ed.), *Female and male in West Africa* (London, Allen & Unwin).

Oyenuga, V. A. and Opeke, L. K. (1957), 'The value of cassava rations for pork and bacon production', *West African Journal of Biological Chemistry* (University of Ibadan), April.

Pala, A. O. (1976a), *African women in rural development: research trends and priorities*, Overseas Liaison Committee Paper No. 12 (Washington, DC, American Council on Education, December).

Pala, A. O. (1976b), *A preliminary survey of avenues for and constraints on women's involvement in the development process in Kenya*, Discussion paper No. 218 (University of Nairobi, Institute of Development Studies).

Pala, A. O. (1978), *Women's access to land and their role in agriculture and decision making on the farm: experiences of the Joluo of Kenya*, Discussion paper No. 263 (University of Nairobi, Institute of Development Studies).

Pala, A. O. (1980), 'Notes on changes in the role of women and in family welfare', in *Korean Agriculture*, Project Impact Report No. 12 (Washington, DC, Agency for International Development, December).

Pala, A. O., Reynolds, J. E., Wallis, M. A. and Browne, D. L. (1975), *The women's groups programme in the SRDP*. Occasional Paper No. 13 (University of Nairobi, Institute of Development Studies).

Palmer, I. (1975a), *Women in rural development* (Geneva, ILO, mimeo).

Palmer, I. (1975b), *The new rice in the Philippines*, Studies on the 'Green Revolution', Report No. 10 (Geneva, UNRISD).

Palmer, I. (1976), *The new rice in Asia: conclusions from four country studies* (Geneva, UNRISD Report No. 76. 6).

Palmer, I. (1977), 'Rural women and the basic needs approach to development', *International Labour Review* (Geneva, ILO), Vol. 115, No. 1, January–February.

Palmer, I. (1978), *Women and Green Revolutions*. Paper presented to the Conference on the Continuing Subordination of Women and the Development Process (Sussex, Institute of Development Studies, mimeo).

Palmer, I. (1979), *The Nemow Case: case studies of the impact of large-scale development projects on women: a series for planners* (Falmer, Sussex, mimeo).

Palmer, I. (1980), 'Notes on changes in the role of women and in family welfare', in *Korean Agriculture*, Project Impact Report No. 12 (Washington, DC, Agency for International Development, December).

Palmer, I. and Buchwald, U. von (1980), *Monitoring changes in the condition of women: a critical review of possible approaches* (Geneva, UNRISD).

Papanek, H. (1977), 'Development planning for women', in the Wellesley Editorial Committee (eds), *Women and national development: the complexities of change* (Chicago, Ill., University of Chicago Press).

Parker, R. N. (1973) *Agriculture in south-east Ghana* (University of Reading, Department of Agricultural Economics and Management), Vol. 1.

Parker, R. N. (1978), 'Catchment systems for rural water supplies', in G. E. Dalton and R. N. Parker (eds), *Agriculture in south-east Ghana* (University of Reading, Department of Agricultural Economics and Management), Vol. II.

Paterson, D. (1980), *Coping with land scarcity: the pattern of household adaptation in one Luhya community*, WP 360 (University of Nairobi, Institute of Development Studies, January).

Paulme, D. (ed.) (1971), *Women of Tropical Africa* (Berkeley, Calif., University of California Press).

Pearse, A. (1974), *The social and economic implications of large-scale introduction of new varieties of food grain: summary of conclusions of the global research project* (Geneva, UNRISD Report No. 74).

Pilgrim, J. (1968), 'Social aspects of agricultural development in Sierra Leone – II technical development', *Sierra Leone Studies* (Freetown).

Posnansky, M. (1980), 'How Ghana's crisis affects a village', *West Africa* (London), 1 December.

Quizon, E. K. and Evenson, R. E. (1978), *Time allocation and home production in Philippine rural households* (Yale University, mimeo).

Quraishy, B. B. (1971), 'Land tenure and economic development in Ghana', *Présence africaine* (Paris, Nouvelle Société Présence Africaine), No. 77, 1st quarterly.

Randhawa, I. Kaur (1975), 'An experiment in farm management', *Indian Farming* (New Delhi, Indian Council of Agricultural Research), Vol. 25, No. 8, November.

Rapp, R., Ross, E. and Bridenthal, R. (1979), 'Examining family history', *Feminist Studies* (Women's Studies Program, University of Maryland, College Park), Vol. 5, No. 1.

Reish, I. (1978), 'Contribution of women to rural development with special emphasis on Africa'. Paper presented at the Seminar on Problems in Rural Areas Considering the Role of Radio in Development Process (mimeo).

Republic of Ghana (1951), *Development plan, 1950 to 1960* (Accra, Government Printer).

Republic of Ghana (1959), *The second development plan: 1959 to 1964* (Accra, Government Printer).

Republic of Ghana (1963), *The seven-year development plan, 1963/64 to 1969/70* (Accra, Government Printer).

Republic of Ghana (1977), *The five-year development plan, 1975/76 to 1979/80* (Accra, Government Printer).

Republic of Ghana, Central Bureau of Statistics (1960), *Population census of Ghana*, all volumes (Accra, Government Printer).

Republic of Ghana, Central Bureau of Statistics (1970), *Population census of Ghana* (Accra, Government Printer).

Republic of Kenya (1974), *Bee-keeping in Kenya* (Nairobi, Ministry of Agriculture).

Republic of Kenya (1977), *Integrated rural survey 1974–5* (Nairobi, Central Bureau of Statistics, Ministry of Finance and Planning).

Republic of Kenya (1978a), *Women in Kenya* (Nairobi, Central Bureau of

Statistics, Ministry of Finance and Planning).

Republic of Kenya (1978b), *Report of the planning workshops on the transfer of village technology through women's groups in Kenya* (Nairobi, Women's Bureau, Ministry of Housing and Social Services).

Republic of Kenya (1979), *Development plan for the period 1979 to 1983*, Parts I and II (Nairobi, Ministry of Economic Planning).

Republic of Kenya (1980a), *Statistical abstract* (Nairobi, Central Bureau of Statistics, Ministry of Economic Planning and Development).

Republic of Kenya (1980b), *A baseline study of rural access roads in Kenya* (Nairobi, Ministry of Transport and Communications, Roads and Aerodromes Department).

Res, L. (1983), *Changing labour allocation patterns of women in rice farm households: a rainfed village, Iloilo Province, Philippines*. Paper presented at the conference on Women in Rice Farming Systems, Los Banos, Philippines, 26–30 September (Los Banos, International Rice Research Institute).

Ricardo, D. (1951), *Principles* (Cambridge, Cambridge University Press).

Roberts, P. (1979), 'The integration of women into the development process: some conceptual problems', *IDS Bulletin* (Brighton, Sussex), Vol. 10, No. 3.

Robinson, J. V. (1956), *The accumulation of capital* (London, Macmillan).

Rowbotham, S. (1973), *Women's consciousness, man's world* (Harmondsworth, Middx, Penguin Books).

Sai, F. (1977a), *Food, population and politics*, International Planned Parenthood Federation Occasional Essay No. 3 (Washington, DC, International Planned Parenthood Federation).

Sai, F. (1977b), *Defining family health needs, standards of care and priorities*, International Planned Parenthood Federation Occasional Essay No. 4 (Washington, DC, International Planned Parenthood Federation).

Sajogyo, P. (1983), *Impact of new farming technology on women's employment*. Paper presented at the conference on Women in Rice Farming Systems, Los Banos, Philippines, 26–30 September (Los Banos, International Rice Research Institute).

Salter, W. E. G. (1960), *Productivity and technical change* (Cambridge, Cambridge University Press).

Sarpong, P. (1974), *Ghana in retrospect: some aspects of Ghanaian culture* (Accra, Ghana Publishing Corporation).

Savane, M. A. (1979), Interview to *Daily Nation* (Nairobi), 2 May, p. 6.

Schofield, S. (1979), *Development and the problems of village nutrition* (London, Croom Helm).

Schultz, T. W. (1964), *Transforming traditional agriculture* (New Haven, Conn., Yale University Press).

Schumacher, E. F. (1973), *Small is beautiful* (London, Blond and Briggs).

Scott, J. W. and Tilly, L. A. (1980), 'Women's work and the family in nineteenth century Europe', in A. H. Amsden (ed.), *The economics of women and work* (Harmondsworth, Middx, Penguin Books), pp. 91–139.

Seidman, A. (1981), 'Woman and the development of "underdevelopment": the African experience', in R. Dauber and M. L. Cain (eds), *Women and*

*technological change in developing countries* (Boulder, Colo., Westview Press).

Sen, A. (1975), *Employment, technology and development* (Oxford, Clarendon Press).

Shanin, T. (ed.) (1971), *Peasants and peasant societies* (Harmondsworth, Middx, Penguin Books).

Simmons, E. B. (1976), *Economic research on women in rural development in Northern Nigeria*, Overseas Liaison Committee Paper No. 10 (Washington, DC, American Council on Education).

Sinha, J. N. (1972), 'A rational view of the census economic data', *Indian Journal of Industrial Relations* (New Delhi, Shri Ram Centre for Industrial Relations and Human Resources), Vol. 8, No. 2, October.

Smock, A. Chapman (1977), *Women's education and roles in Kenya*, WP 316 (University of Nairobi, Institute of Development Studies, July).

Spencer, D. S. C. (1976), *African women in agricultural development: A case study in Sierra Leone*, Overseas Liaison Committee Paper No. 9 (Washington, DC, American Council on Education, June).

Spencer, D. S. C. (1979), 'Labour market organisation, wage rates and employment in the rural areas of Sierra Leone', in *Labour and Society* (Geneva, IILS).

Spurgeon, D. (1979), *A woman's work*, Action for Development No. 58 (London, Centre for World Development Education, January).

Sridharan, S. (1975), 'In Chatera', *Indian Farming* (New Delhi, Indian Council of Agricultural Research, November).

Stamp, P. (1975/6), 'Perceptions of change and economic strategy among Kikuyu women of Mitero, Kenya', *Rural Africana* (East Lansing, Michigan State University, African Studies Center), No. 29, Winter, pp. 19–43.

Staudt, K. (1975/6), 'Women farmers and inequities in agricultural services', *Rural Africana* (East Lansing, Michigan State University, African Studies Center), No. 29, Winter.

Staudt, K. (1978), *Women and participation* (Washington, DC, USAID).

Stevens, Y. (1981), *Technologies for rural women's activities – problems and prospects in Sierra Leone* (Geneva, ILO, mimeographed World Employment Programme research working paper WEP. 2-22/WP 86).

Stewart, F. (1978), *Technology and underdevelopment* (London, Macmillan).

Sticher, S. (1975/6), 'Women and the labor force in Kenya 1895–1964', *Rural Africana* (East Lansing, Michigan State University, African Studies Center), Winter, pp. 45–67.

Stoler, A. (1977), *Class structure and female autonomy in rural Java* (New York, Department of Anthropology, Colombia University, mimeo).

Stolke, V. (1981), 'Women's labours: the naturalisation of social inequality and women's subordination', in K. Young, C. Wolkowitz and R. McCullagh (eds), *Of marriage and the market* (London, CSE Books).

Sudarkasa, N. (1973), *Where women work: a study of Yoruba women in the market place and in the home* (East Lansing, Mich., University of Michigan).

Tadesse, Z. (1979), *Women and technological development in agriculture: an*

*overview of the problems in developing countries*, Working Paper Series No. 9 (Vienna, UNITAR, Science and Technology).

Tadesse, Z. (1982), 'The impact of land reform on women: the case of Ethiopia', in L. Beneria (ed.), *Women and development: the sexual division of labor in rural societies* (New York, Praeger).

Thomas, K. (1978a), 'Collective responsibility for discovering Africa's vanished traditional techniques'. Paper presented at the International Conference on Appropriate Technology in Rural Societies (Freetown, Fourah Bay College).

Thomas, K. (1978b), Keynote address at the International Conference on Appropriate Technology in Rural Societies (Freetown, Fourah Bay College).

Timmer, C. Peter (1973), 'Choice of technique in rice milling in Java', *Bulletin of Indonesian Economic Studies* (Canberra, Australian National University), Vol. 9, No. 2.

Tinker, I. (1976), 'The adverse impact of development on women', in I. Tinker and M. B. Bramsen, *Women and world development* (Washington, DC, Overseas Development Council), pp. 22–34.

Tinker, I. (1977), 'The adverse impact of development on women', *Peace Corps Program and Training Journal* (Washington, DC, Peace Corps Times, US Peace Corps), Vol. 4, No. 6.

Tinker, I. (1981), 'New technologies for food-related activities: an equity strategy', in R. Dauber and M. L. Cain (eds), *Women and technological change in developing countries* (Boulder, Colo., Westview Press).

Tinker, I. and Bramsen, M. B. (1976), *Women and world development* (Washington, DC, Overseas Development Council).

Twumasi, P. A., *et al.* (1977), *A sociological study of rural water use*. A project report for Ghana water supply and environmental health (Legon, Government of Ghana).

UNCTAD/GATT (1977), *Cassava export potential and market requirements* (Geneva).

UNECA (1963), *Women in the traditional African societies*, Workshop on Urban Problems (Addis Ababa).

UNECA (1967), *The status of and role of women in East Africa*, Social Welfare Services in Africa, No. 6 (Addis Ababa).

UNECA (1972), 'Women: the neglected human resources for African development', *Canadian Journal of African Studies* (Ottawa, Ontario, Canadian Association of African Studies, Carleton University), Vol. 6, No. 2.

UNECA (1975), *Employment of women in the Sudan*. Paper contributed by the United Nations Economic Commission for Africa for the ILO Comprehensive Employment Mission to Sudan (Addis Ababa, January).

UNECA (1976), *Women population and rural development in Africa* (Addis Ababa, UNECA/FAO Women's Programme Unit).

UNECA/ATRCW (1975a), *New international economic order: what roles for women?* (Addis Ababa, UNECA).

UNECA/ATRCW (1975b), *Women of Africa: today and tomorrow* (Addis Ababa, UNECA).

UNECA/ATRCW (1975c), 'Women and national development in African countries', *The African Studies Review*, Vol. 18, No. 3, December.

UNECA/ATRCW (1977), *The new international economic order, what roles for women?* (Addis Ababa, August).

UNECA/ATRCW (1978), *Improving village water supplies in Ethiopia* (Addis Ababa, UNECA).

UNECA/FAO Women's Programme (1974), *The role of women in population dynamics related to food and agriculture and rural development in Africa* (Addis Ababa, UNECA).

UNECA/FAO/Netherlands Government (1973), *Report of 5 workshops for trainers in home economics and other family-oriented fields* (Addis Ababa, UNECA).

UNICEF (1974), *The young child: approaches to action in developing countries* (New York, E/ICEF/L).

UNICEF (1978a), *Simple technologies for rural women in Bangladesh* (Dhaka, Bangladesh Women's Development Programme).

UNICEF (1978b), *Technologies villageoises en Afrique de l'Ouest et du Centre (Etude en Afrique de l'Ouest et Afrique Centrale)* (Geneva, UNICEF).

UNICEF (1979), *Appropriate village technology for basic services. A catalogue of devices displayed at the UNICEF/Kenya Government Village Technology Unit, Nairobi* (Nairobi, UNICEF).

UNICEF (1980), *Appropriate technology for basic services. A report of a UNICEF-sponsored inter-regional workshop on Appropriate Technology for Basic Services, 19–26 March* (Nairobi).

UNICEF (1981), *Kenya 1981 country profile* (Nairobi, UNICEF, Eastern Africa Regional Office).

United Nations (1977a), *Appropriate technology for developing countries and the needs of rural women* (New York, UN Advisory Committee on the Application of Science and Technology to Development).

United Nations (1977b), *Women in food production, food handling and nutrition (with special emphasis on Africa)* (New York, UN Protein–Calorie Advisory Group).

United Nations (1980), *Rural women's participation in development.* Evaluation Study No. 3 (New York, United Nations Development Programme).

United Nations (1981), *Promoting and accelerating women's participation in development in the Caribbean among technical co-operation agencies for developing countries* (New York, Technical Co-operation among Developing Countries).

United Nations Research Institute for Social Development (1977), *Strategy and programme proposals* (Geneva, WP2/Rev. 1/Nov.).

University of Ife (n.d.), 'The gari report, a socio-economic and technological investigation' (Ife, unpublished).

University of Sierra Leone/Sierra Leone Institution of Engineers (1978), *Summary report* of the International Conference on Appropriate Technology in Rural Societies (Freetown).

USAID (1979a), *Kitale maize (an impact evaluation)* (Washington, DC, mimeo).

USAID (1979b), *Women and security of land use rights*. Special briefing paper for the UN/FAO Conference on Agrarian Reform and Rural Development (Rome).

USAID (1979c), *Women's rights to inherit and claim land*. Special briefing paper for the UN/FAO Conference on Agrarian Reform and Rural Development (Rome).

USAID (1980), *The potable water project in rural Thailand*. Project Impact Evaluation Report No. 3 (Washington, DC, Agency for International Development, May).

US National Academy of Sciences (1976), *Energy for rural development* (Washington, DC, US National Academy of Sciences).

Vanek, J. (1980), 'Time spent in housework', in A. H. Amsden (ed.), *The economics of women and work* (Harmondsworth, Middx, Penguin Books).

Vellenga, D. (1977a), 'Differentiation among women farmers in two rural areas in Ghana' in *Labour and Society* (Geneva, IILS), Vol. 2, No. 2, April.

Vellenga, D. (1977b), *Draft report* of study seminar on role of women in rural development (University of Sussex, Institute of Development Studies, mimeo).

Vercruijsse, E. (1983), 'Fishmongers, big dealers and fishermen: co-operation and conflict between the sexes in Ghanaian canoe fishing', in C. Oppong (ed.), *Male and female in West Africa* (London, Allen & Unwin).

Visaria, P. and Visaria, L. (1983), *Indian households with female heads: their incidence, charcteristics and level of living*. Paper presented at a workshop on Women and Poverty, Calcutta, 17–18 March (Calcutta, Centre for Studies in Social Science).

Vletter, F. de (1978), *The rural homestead as an economic unit: a case study of the Northern Rural Development Area* (University of Swaziland).

Wagenbuur, H. T. M. (1972), *Labour and development (an analysis of the time budget and of the production and productivity of lime farmers in southern Ghana)*, Social Studies Project, Research Report Series No. 17 (Ghana, University of Cape Coast).

Wallis, M. A. H. (1975), 'Case study: Mbere', in A. O. Pala *et al.*, *The women's groups programme in SRDP*. Occasional Paper No. 13 (University of Nairobi, Institute of Development Studies), pp. 62–69.

Ward, B. (1970), 'Women and technology in developing countries', *Impact of Science on Society* (Paris, UNESCO), Vol. 20, No. 1.

Wharton, C. R. (1968), 'The infrastructure for agricultural growth', in H. M. Southworth and B. F. Johnston, *Agricultural development and economic growth* (Ithaca, New York, Cornell University Press), pp. 107–142.

Whitcombe, E. (1972), *Agrarian conditions in northern India: 1860–1900*, Vol. I (Berkeley, University of California Press).

White, B. (1976), *Population, involution and employment in rural Java* (Bogar, Indonesia, Agricultural Development Council, mimeo); also in G. E. Hansen (ed.), *Agricultural development in Indonesia* (Ithaca, New York, Cornell University Press).

White, B. (1983), *Women and the modernisation of rice agriculture: some general issues and a Javanese case study*. Paper presented at the conference on Women in Rice Farming Systems, Los Banos, Philippines, 26–30 September (Los Banos, International Rice Research Institute).

White, G. F., Bradley, D. J. and White, A. U. (1972), *Drawers of water* (Chicago, Ill., University of Chicago Press).

Whitehead, A. (1978), *Women and the household; themes arising from a North-East Ghana example*. Draft paper presented to the Conference on the Continuing Subordination of Women and the Development Process (Sussex, Institute of Development Studies).

Whitehead, A. (1979), 'Notes on the subordination of women', *IDS Bulletin* (University of Sussex, Institute of Development Studies), Vol. 10, No. 3.

Whitehead, A. (1980), 'A conceptual framework for the analysis of the effects of technological change on rural women' (draft Ms).

Whitehead, A. (1981a), 'I'm hungry, mum: The politics of domestic budgeting', in K. Young *et al.* (eds), *Of marriage and the market* (London, CSE Books).

Whitehead, A. (1981b), *A conceptual framework for the analysis of the effects of technological change on rural women* (Geneva, ILO, mimeographed, World Employment Programme research working paper WEP. 2-22/WP.79; restricted).

Whitehead, A. (1984), 'Solidarity and divisions of interest among women', *IDS Bulletin* (University of Sussex, Institute of Development Studies), April.

Whythe, R. O. and Whythe, P. (1982), *The women of rural Asia* (Boulder, Colo., Westview Special Studies on Women in Contemporary Society).

Wilde, J. C. de (1967), *Experiences with agricultural development in tropical Africa. Vol. 1, the synthesis* (Baltimore, Md, Johns Hopkins Press).

Williams, B. (1978), *Background paper: UNCSTD sub-regional seminar* (Freetown, mimeo).

Willis, J. (1967), *A study of the time allocation by rural women and their place in decision making*. Research paper (Makerere University College, R.D.R. 44).

Wipper, A. (1975/6), 'The underside of development', *Rural Africana* (East Lansing, Michigan State University, African Studies Center), Winter, pp. 1–18.

Woodman, G. (1966), 'The development of customary land law in Ghana', PhD thesis (Cambridge University).

World Bank (1973), *Agricultural sector survey, Kenya*, 2 vols (Washington, DC).

World Bank (1979), *Recognising the 'invisible' woman in development: the World Bank's experience* (Washington, DC, October).

World Bank (1980), *Population and development in Kenya* (Washington, DC, Development Economics Department).

World Bank (1982), *World Development Report 1982* (Oxford, Oxford University Press).

Wright, O. A. (1979), 'Economics of cassava processing in selected villages

of Oyo State', unpublished MSc thesis (University of Ibadan, Department of Agricultural Economics, September).

Young, K. (1978a), 'Modes of appropriation and the sexual division of labour: a case study from Oaxaca, Mexico', in A. Kuhn and A. Wolpe (eds), *Feminism and materialism* (London, Routledge & Kegan Paul).

Young, K. (1978b), 'Changing economic roles of women in two rural Mexican communities', *Sociologia Ruralis* (Netherlands, European Society for Rural Sociology), Vol. 18, Nos 2/3.

Young, K., Wolkowitz, C. and McCullagh, R. (eds) (1981), *Of marriage and the market: women's subordination in international perspective* (London, CSE Books).

Youssef, N. (1974), *Muslim women and agricultural production: are they undercounted or actually dispensable?* (University of South California, Population Research Laboratory, Department of Sociology, mimeo).

Youssef, N. and Hetler, Carol B. (1984), *Rural households headed by women: a priority concern for development* (Geneva, ILO; mimeographed World Employment Programme research working paper; restricted).

Zeidenstein, S. (1975), *Socio-economic implications of HYV rice production on rural women in Bangladesh* (Dacca, mimeo).

Zeidenstein, S. and Zeidenstein, L. (1973), *Observations on the status of women in Bangladesh* (Dacca, Ford Foundation).

# Index

*abusuapanyim*, head of lineage (Ghana) 221
access to credit or loans for women, discrimination against 177, 248
Adjetey ovens for fish smoking 235
Advisory Services of Technology, Research and Development (ASTRAD) 315
Africa: beer brewing by women 17
  food sharing 76
  high workload by women 72
  labour rights between husband and wife 45
  marriage contracts between families 55
  mechanisation in agriculture 11
  modernisation, effects of 103-8
  technologies to assist women 123
  training for women 149
  unequal distribution of household costs 112
  women's duties 117
African: agrarian systems, women in 55
  agriculture, low labour-land ratio 79
  polygamous family units 79
African Sahel, firewood gathering 71
Agricultural Development Bank (Ghana), lack of service to women 219
  extension services, unequal sharing 148
  functions of 221
  labour in Asian households (Tables 4.6-4.9), 91-9
  force of women 146-7
  households, increase of in India 91
  households, wage decline in 98
  labourers, wage earning 97, 98
  mechanisation, labour displacing effects of 113
  in Sierra Leone 286
  modernisation, categories of 79, 80
  effect on rural women 8, 10
  tasks, participation, distribution by sex and crops (Table 6.4), 156, 187
  waste for fuel 319
agriculture: and female labour 3
  impact of technical change 78
  major responsibilities of women 146
  women and technological change in 67-114
*akara* from dried beans 306

Algeria, female workforce 69-70
alternative technologies in *gari* processing (Nigeria) 270
Altona oven for fish smoking 235
analysis and concepts of technical change 27-64
Andhra Pradesh: decline in wage earnings 97
  factors in higher productivity 87
  introduce irrigated rice cultivation 100
  labour time and operation (Table 4.1), 82
  paddy-growing farm 81
  wage annual earnings (Table 4.9), 98
  women agricultural workers 91
  farm labour characteristics (Table 4.3), 86-7
animal rearing and household tasks, distribution of participation (Table 6.5), 188, 189
Appropriate Technology Unit of the Faculty of Engineering, work on fuel cookers 319-20
appropriate technology 195
  advantages to women 197
*asanka*, earthenware bowl 230
Ashanti women farmers 222
Asia: food sharing 76
  introduction of HYVs 80
  marriage contracts 55-6
  mechanisation displacing labour 96
  women as plantation workers 38
Asian: agriculture, monogamous family units 79
  high labour-land ratio 79
  evidence of technical change 90-1
  farms, harvesting and threshing labour 95
  households and agricultural modernisation 80, 81
  men responsible for family subsistence 75

Bafodea chiefdom 288
*baimbay*, basket fishing net 309
*bandas*, for sun drying 300, 301
Bangladesh: agricultural wage decline 98
  female work displacement 332
  food for work programme 111
  household women seek wage

370

employment 102
introduce irrigated rice production 100
marriages of convenience 38
mechanisation displacing female labour 96
paddy processing, HYVs in 33-4
rice milling 31
  affecting women's livelihood 112
women, and household income 110
  labour 34-6
  on pump maintenance 150
  spending 75
  tasks 327
  work for family income 111
Bank of Sierra Leone help to small farmers 318
*bari* (homestead) paddy processing 33-5
*Baseline study of households* (Kenya) 174
beans, processing and use of 306
bee-keeping in Kenya 140
beer brewing: a non-farm activity of women 17, 18
  technological changes in 17-18
beliefs and taboos affecting use of improved technologies 234-42
benniseed, use of 305
Beti: cocoa farming 41, 56
  women, labour of 38
biochemical inputs in Asia 81
biogas for cooking 320
blacksmiths and new technologies for women 245
black tumbler (*dialium guineense*) wood 295, 296
Bo district, pedal-operated rice threshers 298
Bondo female secret society 284, 288
Botswana: agricultural responsibility of women 148
  livestock ownership 148
Brazil, coffee plantation work by women 38
Brazilian type *gari* cooker 272
bridewealth (Kenya) 164
broadloom, reason for non-participation of women in 239, 240
Brong Ahafo women farmers 222
bullock ploughs, women's non-use of 239
Bundu, female secret society 284
by-products, utilisation of 340

Cameroon flour mill co-operatives 113
Cameroon, United Republic of, corn mill scheme 132
  grinding mill success 130
capital formation: and credit, access to (Kenya) 178
  women excluded from (Kenya) 158

capital-output ratio and technical change 16, 17
cash: control of by male head of household 106
  women deprived of 104
  cropping in Asia 80
    in Ghana 215-16
    disadvantage of 107
    impact of 105-8
    increasing women's work burden 107
  crops, high-value in small-farm agriculture 159
  input by women 146
  men control income from 75
  income necessity in Kenya 158
  spending of 74-5
  women's control and consumption 78, 127
cassava: bread production, improved technology (Table 9.1), 292, 305
  fermentation, plastic containers for 270
  flour (*kobonte*) 225-6
  *gari* processing 225
  roots processed, source (Table 8.2), 256
  processing, *gari* and *fufu* production, improved technology for (Table 9.1), 292
  shortages affecting production of *gari* 279
  as staple food 253
casual labour: increase with HYVs (Table 4.4), 87
  time increase of labour 90
cattle: herding by children 185
  touching taboo for women 239
Central African Republic working hours 72
charcoal: for cooking 295, 296
  making (Ghana) 233
Chayanov's theory of family peasant farming 36-7
child: care, need for education 250
  labour in Andhra Pradesh (Tables 4.1, 4.2), in Kenya 183
children: care of (Sierra Leone) 185
  care of cattle (Kenya) 185
  female, greater demands on 120
  malnutrition and lack of care for 123
class-based inequalities denying women access 333
class system and land access 59
coal pots for cooking 295, 296
cocoa: cultivation, men take over cash crop 106
  farming, low output (Ghana) 216
  farm owners (Ghana) 216
  growing (Nigeria) 253

harvesting by women 38
coconut: oil production (Table 9.1), 293, 305-6
production from 139
coffee: harvesting by women 38
planting, women deprived of training in 149
Colombian land reform law 53
combine harvesters displacing casual labour 96
commercial: banks, stipulations 318
mills uneconomical for women 143
commercialisation, effect on women's work 32
communical (chiefdom) ownership of land (Sierra Leone) 285
communal technologies, need for training women in 150
community projects, women's participation 118
concert system to disseminate technology 245
*congoo* from groundnuts 306
contractual inferiority of small farmers 60, 61
convection crop driers 322
cooking: impact of improved technology on (Table 9.2), 316
methods (Ghana) 229-30
improved (Table 9.1), 290
'three-stone' (Sierra Leone) 295
oil processed by women 226
co-operation of sexes in farming (Sierra Leone) 285
Co-operation of American Relief Everywhere (CARE) 297
co-operatives: benefit South Asian countries 113
and credit facilities, women denied use of 136
access to essential 150
encouraged to acquire tools 243
formation for marketing 283
organisation and factory processing 273-4
problems for women's ventures 113-14
sex discrimination in 113
Third World 113
Co-operative Department and repayment of loans 288
corn mill: hand-operated 130
societies 130-1
costs and returns of traditional processing of *gari* (Tables 8.11, 8.12), 264
cotton: growing by women 286
weaving 43
taboo for women (Ghana) 231
credit: for farming, sources of 318

women lose access to 108
and loans, repayment rates 151
women's lack of access to 61, 138, 145-6, 219
policies for technologies 179-80
crop: driers, improvement needed 322
processing, Africa 128
devices 135
production, access to credit for 124-5
new technologies 134-5
cultivation and food production of females (Kenya) 165
custom miller 34

dairy production and modernisation displaces women 333
dehusking and winnowing rice 298, 299
Dempster deep well hand pumps 297
*dheki* technique 34, 35
diesel oil rising costs, effect of 143
discrimination against women 333-4
diseases from water collection and storage 297
disembodied technological change 17
dissemination of technologies, shortage of 309
dissolution of marriage, women's rights 173
distance: from farms to village, disadvantage of 219
travelled to markets (Table 8.21)
divorce affecting work programme 44
domestic: chores of women in Ghana 213, 226-7
economy, Mexico 42
and market production 191-2
drama groups and dissemination of technology 245
drudgery: in productivity 202, 203
technology to reduce, problems of 202-3
in women's work 252
duties and roles of Kenyan women 157
dwarf HYV rice post-harvest crushing by women 100 n.
dye-stuff, preparation of 306

earning income, technologies to assist 123
East Africa, women vegetable growers 138
economic and educational opportunities (Kenya) 167
education: fees payment of 182
by sex areas of access, men and women (Table 5.2), 146
women excluded from (Kenya) 158
of women (Sierra Leone) 287
Elmina use improved sun-drying racks 236

embodied technological progress 17
employment: alternative for rural
    women 180-4
  of females by occupation on a rural-
    urban basis 1970 215
  study of Kenyan family employment
    168—9
Engineering Faculty of the University of
    Science and Technology (Ghana)
    improve kilns 238
Engleberg Steel roller mill 299
equipment: beneficial to rural women
    120-2
  institutions with facilities for
    manufacture 315
  women's lack of control over 144, 145
  women maintain 150
Ethiopia: children's duties 119
  methane stoves 134
  water collection 71, 118
  women time saving 127
exploitation of women 7
extension: advice, proportion of male-
    and female-headed households
    receiving (Table 5.4), 148
  services 248
  importance of access to 148
  sexual bias (Table 5.4), 148-9

Fabrication and Production Company
    (FABRICO) 270, 272
factor: market, equality in 62
  imperfections in rural areas 333
  price distortions and labour
    displacement 331-2
factors requiring access 333
Faculty of Engineering, Fourah Bay
    College 323
  AT unit 320
  test solar crop drier 322
family: feeding, women's responsibility
    125
  labour 37-8
    and income 39
    unremunerated 43
  pursuit of survival 109
  responsibilities (Kenya) 163
  spending of household income 74-5
*fanna*, used for dehusking and
    winnowing rice 299
farm(s): co-operatives own grinding
    mills 129
  limit of size for women 59
  not using family women 87
  women manage (Sierra Leone) 287
farmers: and cash income 58
  and extra wives for harvests 38
farming: equipment, owning and
    sharing 125
  impact of improved technologies on

rural women (Table 9.2), 317
  implements for women, low quality of
    (Ghana) 216
  improved technology for (Table 9.1),
    290
  rice processing, improvements needed
    321-2
  role of Ghanaian women 214
farming: tasks shared 163
  tools used by women 216, 298
Fasola: storage of *gari* 276-7
  study of *gari* processing in 253-4
Federal Institute of Industrial Research
    (FIIR) 270-1
female: casual labour time 90
  family labour, characteristics (Table
    4.3), 86-7, 89
  farmers, expense of land cleaning and
    felling 219
  heads of households in Africa 148,
    173
  lack of support for 77
  labour, in Andhra Pradesh (Table
    4.1), 82
    displacement, mechanisms causing
      31, 331-3
    effect of HYVs on (Tables 4.2,
      4.4), 82, 87
    effect of mechanisation on 95
    in food production 182
    influenced by male migration 165-6
    input, institutional basis of 329-30
    in self-employment (Ghana) 213
    technologies to assist 123
    unpaid 38
firewood fetching: distances to walk 71
  women's responsibility 198
firewood shortages in Mwea villages 104
fish: industry in Ghana 224
  oil production 181
  preservation (Ghana) 223-4
  smoking, improved ovens for (Ghana)
    235
  smoking in Sierra Leone 301
  sun drying of (Ghana) 236
  wives, frustration of 249
food: farming, production by women
    220
  intakes for men and women,
    differences in 76-8
  preservation 300-1, 322-3
    improved technology for (Table
      9.1), 291
    impact on rural women (Table 9.2),
      316
  processing, loans and assistance for
    132-2
    in Ghana 223
    and preservation (Sierra Leone)
      286, 391-2

technology, improvements needed
  323
fuel: for cooking 229
  fetching, tools for 229
  shortages 73
  supplies 133-4
  technologies to improve 122
  wastage 341
*fufu* 303
  cooking 295, 304, 305
  made from cocoyam or yam 230
funerals of women, male directors for
  (Sierra Leone) 287
future research, areas for 330-41

Gambia: household production 44
  study on food sharing 76
*gara*: balls 306-7
  dyeing, improved technology 286,
    (Table 9.1), 293
  (tie-dye) production, impact of
    improved technology on rural
    women (Table 9.2), 317
*gari* making 236-7
  comparison of time spent on
    traditional and mechanised
    processing 263 (Table 8.10)
  methods of transportation 274 (Table
    8.20)
  processing, in Ibadan 253
    index of the effect 277-8 (Table
      8.25)
    index of high innovative effect
      278-9
    index of effect on women 277
      (Table 8.25)
    mechanised 253, 258, 261, 269, 270
      (Tables 8.17, 8.18)
      cost and returns 270
      time spent on 263 (Table 8.9)
  production 304
  sources of help for respondents 278
    (Table 8.19)
  technology of 255-8
  traditional 225-7, 255, 258-61
    (Tables 8.3, 8.4, 8.8)
    time spent on 258 (Tables 8.5-8.7)
  storage 276 (Tables 8.5-8.7)
Gbangi male secret society 284
gender: as a system of inequality and
  hierarchy 30, 62
  in costs and access for women 57-62
gender-based inequalities and
  discrimination 2, 3, 334
Gezira region tenants adopt new lifestyle
  105
Ghana: activities of women 230-4
  cocoa cash controlled by men 75
  cultivation 106
  currency 232 n.

domestic chores of women 226-30
economic: crisis, effect on women's
  work 232
  problems 10
farming, traditional manner of 220
  food processing 225
  insect and pest control, lack of 220
  land tenancies 222
  methods to disseminate new
    technology 242-7
  ownership of farms by women 146,
    216
  population censuses 213
  technological improvements in
    activities of rural women 213-34
  technology assistance 139
  women's knowledge of cash crop
    farming 148
  women labour 72
    low farm output, reason for 219
    roles in Northern sector 215
  work time of farming households 72
Ghana/IDRC Rural Fishery Research
  and Development Project low cost
  sun-drying equipment 236
Ghana National Assembly of Women
  247
Ghana National Council for Women and
  Development xiii, 238, 242, 247
  encourage co-operatives 243
  grants and loans for ovens 235, 237
  provide credit 243
girls, opportunities for, factors affecting
  183
grain: grinding in Third World
  countries 70
  pounding 123
  by women and by mills 128-3
Grains Development Board (Ghana) 237
Green Revolution 38, 44, 81, 330
  benefits and burdens 102
  employment losses 208
  programme 283
  studies 57
  technology and male domination 330
  and women in agriculture 40
grinding: commercial mills in Africa
  128-9
  ownership 129
  payment for services 128-9
  stones for milling 304
groundnuts: labour of men in 45
  processing 306
  shelling domestic production 196
group approach advantages 244
groups and co-operatives of women
  needing labour-saving devices 152

Haiti, fuel shortages 73
handicrafts: impact of improved

technologies on rural women
(Table 9.2), 317
improved technology of (Table 9.1),
294
improvements needed 324
of women (Sierra Leone) 308
co-operatives for sale of 308
hand-operated: palm oil presses 302
screw presses 302
small equipment, preference for 151
harvesting, mechanised, and
involuntary unemployment 21
Haryana, water carrying 71
work time 73
heads of household, distribution by sex
(Table 6.1), 174
health, effect of women's work and 127
high cots, effect on use of technology
325
highlife songs for dissemination of
technology (Ghana) 245-6
high-yielding variety HYV technology
30
holding operations: by residence,
distribution of (Table 6.2), 175
by province (Table 6.2), 175
home cleanliness, technologies for 123
homecrafts in Kenya 181
Home Extension Unit (Ghana) 220
home improvement technologies 137
home tasks, small-scale technologies for
194-5
honey production in Kenya 140-1
hours worked by women and men in
Third World 71
housecleaning tasks, sexual division of
188
household-based enterprises 36
household: differentiation, factors in
178
duties, children and 183
food sharing 76-8
income, control of and sharing 74-6
females provide 109-10
in Sierra Leone 285
labour 37-8, 40
landless and small cultivator, high
workload of 70
production (Gambia) 44-5
subsistence by part-time trading 182
as a unit of analysis 331
unit of production (HUP) 192-4
female activities in 193
labour processes in 194
human factors and new technologies 202
HYV-irrigation packages: in Asia 81
causing tenant eviction 100
effect of 33, 112
on female labour (Table 4.2), 82,
85

on production and incomes 85, 86
on women in small cultivator
households 100
innovation requirements 58
and labour input 86
male dominance in 36
and mechanisation, effects of (Table
4.7), 93, 94
unemployment from 99
use of in Tamil Nadu (Table 4.4), 87

Ido Co-operative Farming and Produce
Marketing Society, objects of 254,
273
Ilaju *gari* factory 253, 254
income(s): class distribution of 15
defining 18
distribution 18
inequality (Kenya) 158
for use of HYVs 86
functional distribution of 15
household 39
rural women and 5, 7, 9
and time, impact on technological
change 22, 23, 26
women's independence needed 151
income-earning constraints against
women 335
income-generating: activities,
improvements needed 324
activities of women (Sierra Leone)
286
technology for 137-42
schemes, lack of planning 144
India: agricultural, labour households,
increase of 91
modernisation, effect of 91-2
annual real earnings (Table 4.9), 98
average daily real wage earnings
(Table 4.8), 97
employment of agricultural labour
households 1964/5 and 1974/5
(Table 4.7), 93
employment and unemployment,
1964/5 and 1974/5 (Table 4.6),
91
harvesting labour 96
mechanisation displacing labour 96
plantation work 38
rent rises 99
women agricultural workers 91
women marketing fish 332
Indian Punjab, effect of HYV irrigation
package on 99, 100
India-specific empirical results of
mechanisation 81
individualisation of title to land (Ghana)
222
indivisibilities of scale 201
Indonesia: change to male labour 95

effect of HYV-irrigation package on
94, 100
on tenants 99
female wage labour displacement 332
industrial revolution and women's work
190
inequalities in agrarian structure 334
infrastructures in *gari* processing 274,
282
inheritance rights under Islamic law 53
innovation, women and development in
*gari* processing (Nigeria)
270-9
innovations, diffusion of 334-6
innovatory inputs: purchasing 58
public provision 58
Integrated Fisheries Development
Programme
fish processing displaces women
333
International Institute of Tropical
Agriculture (IITA) 254
International Labour Office report on
plantation workers 38
Tarkwa Project, use of radios 246,
247
World Employment Programme xii,
xiii
International Technology Transfer Unit
244
intra-household distribution of work,
income and consumption 69-78
investment: in cash crops, factors
affecting 44
in cassava production 274
iron hoes, introduction of (Kenya) 166
irrigation: leading to cash crops 101
schemes in Asia 80, 81
Islamic law and women's inheritance
rights 53
Ivory Coast: cash crops, effect on family
income 107
Ixtapa-Zihuatanejo laundries employ
men 190

Java: decline in real wages 98, 109
family work for household income
110
household tasks for women 71
rice milling affecting women's
livelihood 31, 112
rice hullers displace landless women
96
rice mills overcapacity 332
technical innovations 41
women as traders 109
job opportunities, education and 183

Kakamega district household survey 176
*kanya*: from groundnuts 306

rice bread 300
Karnataka introduce irrigated rice
cultivation 100
Karnataka study of rural caloric intake
76-7
*kedokan* payments system 94-5
*kenkey* processed from maize 226, 237
Kenya: agrarian structure 159
agricultural improvements 166
production, commercialisation 171
alternative technologies for rural
women 184-205
children water carrying 119
education levels, male and female
182-3
expansion of education system 120
irrigation scheme at 103
male dominance in agriculture 167
modernisation, production
organisation of rural women
157-210
poor job prospects 158
pre-colonial male activities 165
rural women 9-10
school attendance 183
sexual balance of labour 168
small farm equipment 179
social differentiation and technical
change 165-171
transformation of 164
use of group approval to technologies
244
use of herbicides and knapsack
spraying 207
wage employment 141
water and firewood collecting 117
women farmers, discrimination
against 177
in part-time employment 172
headed rural households 119
in self-help labour 118
tasks of 184-92
time on farm work 117
Kenya Land Commission Report assess
use of hoes and ploughs 166
Kenya Women's Bureau technology
assistance 140
Kerala (India) study of family food
intake 76
kerosene stoves for cooking 296
Keta Lagoon salt mining 230-1
Kikuyu: crops grown by males 163
women's property rights 173
kiln, improved 238-9
kinship status and land system 53, 54,
55
Kipsigis water mills for grinding 166
Kisii women, property rights 173
*kobonte*, dried cassava flour 225
*kokodoma* (soap) 231

*kokonte* sundrying of (Ghana) 236
Kokrobite use new fish-smoking ovens
	243
	village acquire loans for ovens 235-6
Korea: rice wages controlled by men 74
Kpompo village: study of 242
	water fetching 227
Krobus, ethnic groups, no access to
	lineage land 222
Kwamoso: kiln at 238
	village farming in 221

labour: allocation in household
		production 36-7
	costs in *gari* processing 268, 269
	division of, between men and women
		(Table 5.1), 120
	division of, class specific 119
	hired, increase of in India 94
	income and consumption allocation
		strategies 41
	increase: in agricultural householders
		91
		in HYV use in Tamil Nadu 87
	innovations affecting 79
	and production processes 328-9
	productive and unproductive 3
	productivity, women's lack of
		resources 184
	sexual division of 33, 41, 146, 151,
		163-5, 171
	tasks, men and women 30
	time, female head as manager of 199
		reallocation of 197-201
	use of in Andhra Pradesh (Tables 4.1,
		4.2), 82, 83
	wages on smallholdings 179
	workloads of women in Third World
		70-5
land: access to (Ghana) 221
	allocation on social criteria 61
	investment in, women's rights 53
	and labour, women's difficulties of
		access to 107
	mechanisation 31
	occupation, discrimination against
		women (Ghana) 221
	ownership in Third World 54
	preparation and crop care (Table 6.3),
		185-6
	tenure system 221, 248
	title held by men 146
landless households: high workloads of
		70
	women's role in 69
	population in Asia 79
	women in HYV technology 31-2
landlessness and poverty, increase of in
		Bangladesh 98
landowners, class status in 60-1

landownership increase from HYV-
		irrigation packages 99
large cultivator households, effect of
		HYV-irrigation packages 102
Larteh, study of 245
Latin America: food sharing 76
	low status of women 75 n.
laundry soap making, improved
		technology for (Table 9.1), 294
leisure time, technology change and
		23-4
	increase in earning rate 24
Lesotho:household dependence on
		women 119
	and maintenance of equipment 143
	road building by women 118
	women's agricultural work time 117
Liberia: crop production technologies
		135
	rice planting taken from women 108
Libya, female workforce 69-70 n. 1
limited access of women to technology
		144, 145-9
limited dissemination of technologies
		144
local groups and dissemination of
		technology 245
low-income female-headed rural
		household problems 206-7
*lubi*: and 'black' soap production (Sierra
		Leone) 307, 308
	improved technology for (Table 9.1),
		293
	preparation 308
	uses for 307-8
Luo women, property rights 173

Machakos district, plough used 166
machinery, impact on working class 15
Mafi-Kumasi, *gari* making 237
maize: cultivation, improved seeds for
		(Ghana) 237-8
	women's reluctance to use 237-8
	grinding and shelling, effect on
		income 132, 201
	and groundnut shelling, impact of
		improved technology on rural
		women (Table 9.2), 201, 317
	processing 306
maize-sheller, handheld 136
male(s): cash crop farming (Ghana) 216
	children on European farms 167
	contributions to household expenses
		(Kenya) 182
	control over cash 114
	dominance in Africa 108, 144
	farmers in agricultural extension
		service 147
	greater shares of food 76-8
	housecleaning for Europeans 188

labour, in Andhra Pradesh (Table 4.1), 82
effect of HYV on (Table 4.4), 87
force reduced by technology 207
migration (Kenya) 165-6, 168-9
burden for women 118, 119
women's role in 168-9
participation in farming (Ghana) 214
priority for agricultural equipment 124-5
replaces female labour 31
male-female labour relations 35-6
status differentiation in households 77
male-headed household domination 174
Malawi: labour input 146
workloads by women 72
Malaysia: plantation work 38
wage control by men 79
Mali, family dependence on women 118
malnourishment of females 336
manual work, women and 85, 90
marketing of crops, participation in 188
market production replacing domestic production 157
Marx on technological change 15
Masai women's property rights 173
Masanki palm oil 302
mass media, use of to disseminate new technologies 245
maternal mortality rate (Sierra Leone) 287
mechanical cassava graters, ownership 273
mechanisation: a disadvantage to women 207
effect on female employment 208, 95-6
of farming 178-9
displacing women 31, 330
negative implication for women 102
selective for agriculture 280
men: deprive women of finance 104
groundnut growing 73
lack of responsibility 176
manage labour at Mwea 104
owning grinding mills 128
sharing housework 109-10
and women, working house 70-5
*See also* male
methane gas for cooking and lighting 122
Mexico, use-rights of men 56
millet processing 306
milling: grains, vegetables and spices 303
impact of improved technologies on rural women (Tables 9.1, 9.2), 291, 317
Ministry of Agriculture and improved seeds (Ghana) 237

Ministry of Social Welfare and Rural Development with UNECA, design presses 302
mobile cinema vans to show new technologies 245
monetised and non-monetised tasks, sexual division in 188
money-earning projects for women 151
money-lenders, interest rates 318
Morocco, low female participation 70 n.1
Morogoro male predominance in agricultural training 147
mortar and pestle milling 303
Muslim low female participation 69-70 n.1
Mwea: irrigation settlement scheme, impact of 104
new villages, women's work in 103
rice growing by women 75
weeding workload increased 207

Nandi: men refuse to cut roads 185
peasant workloads 170
National Co-operative Development Bank 318
National Council on Women and Development 139
assist marketing 243
National Development Bank scheme for small borrowers 318
National Maize Project (NMP) in Tanzania 147
male and female participation (Table 5.3)
National Workshop 315, 318, 320
small hand tools 321
neem for soap making 239
Nepal: rural households, work time 72
shortage of fuel 73
net protein utilisation of food (NPU) 224
New Household Economics School 36, 37
new seeds, Luo and Kowe, women develop 177
new technology design, consultation with women 151-2
new technology, policy changes, 150
Niala Oil Centre hydraulic press 303
Nigeria: cash crops 253
food intake, women and men 76
hand-operated oil presses 131-2
household consumption 126
innovation and rural women 252-83
palm oil mills 143
problems of rural women 10
women demonstrate against new mills 131
women's land rights 55

position in agriculture 279
workload by women 72
Nigerian Institute of Social and
  Economic Research (NISER) 254
Nigerian working hours for women 72
non-farm: activities 181
  employment, women excluded from
    158
non-monetised tasks, projects to
  introduce 197
nutrition survey of 1978 286
Nyanza, beer brewing 181

occupation: of employed people in
  agriculture (Ghana) 1970 (Tables
  7.2, 7.3), 217, 218
  of women (Kenya) 159
off-farm: activities 41
  self-employment 181
*ogi* porridge 306
*ogiri*: preparation 305
  production, improved technology for
    (Table 9.1), 293
*olele* from dried beans 306
overemployment of women in Sierra
  Leone 287
Oyo State: study of *gari* processing 253
Oyo State Ministry of Agriculture 254
Oyo State Ministries of Agriculture and
  Natural Resources encourage
  mechanisation of *gari* processing
  274

paddy processing 33-4
paddy-growing states in India 81
Pakistan: effect of HYV-irrigation
  package on tenants 99
  low female participation 70 n.1
Pakistan Punjab: effect of HYV-
  irrigation package 100
  tenant eviction 100
  work time 72
palm: fruit production, increase needed
  328
  kernel oil processing, impact of
    improved technologies on rural
    women (Table 9.2), 317
  kernel oil production 303
    improved technology for (Table
    9.2), 291
  oil, comparison of traditional methods
    of production (Sierra Leone) 302
    processing methods 301-2
    production, improved technology
    for (Table 9.1), 291
    scarcity in Ghana 239
    use of in Ghana 231
Papua New Guinea, women trained at
  workshops 150
parboiling and drying rice 299

patriarchal society, pre-colonial Kenya
  103-4
Peace Corps technicians for water
  collection 297
peasant: household, production 36
  unremunerated labour 37-8
  household, technological innovation
    and women's work 36-51
  household yam cultivation 106
  householders, commercialising 42
  women, employment of 32
pedal threshers 135-6
*peppe stone*: for milling 304
*pikin* 304
Philippines: change to male labour 95
  effect of HYV-irrigation package on
    94, 95, 99, 100
  family labour in 39
  rural households, working hours 72
  threshers displace hired labour 96
  women, work time 72
pipe-borne untreated water (Sierra
  Leone) 284
ploughs 166, 174
plum wood (*prunus domestica*) for
  cooking 295, 296
polygamy in Sierra Leone 288
post-harvest mechanisation displacing
  female labour 96
pottery, women produce 231-2
poverty and landlessness weakening
  bonds of obligation to family 110
pre-colonial Kenya, patriarchal society
  163-5
processing establishment schemes 139
Produce Marketing Board 318
Product Development Agency
  (PRODA) 270, 272
production and commercialisation, scale
  of 332-3
productivity, measure of 30-1
projects for women, problems of 304
property rights of women in Kenya 173
Punjab, wage earnings 97
pyrethrum and cotton, female
  participation 188
  production by women 138

radios, use of in Ghana 246
rainwater collection 297-8
refrigeration for health clinics 123
regional variations in activities (Ghana)
  248
relationship of operator to holder,
  distribution of (Table 6.2), 175
released time: and gainful employment
  25-6
  use of 21
reproductive work 42
research and development ideas, lack of

funds for 315
research and development (R&D)
 institutions, new technologies 240
rice: employment of males in 96
 growing and processing 38
 harvesting by women 135
 hullers, diesel- and power-operated
  299
 male responsibility (Sierra Leone) 285
 milling 33-4
 mills displacing female labour 332
 payments for women's work 104
 processing (Sierra Leone) 298-300
  impact of improved technologies on
   rural women (Table 9.7), 317
  improved technology for (Table
   9.1) 290
  by women 286
 threshing 298
 women cultivate 45
Rift Valley beer brewing 181
rivers and streams, contamination of
 297
roads, cutting, women's work 185
role of women: and the division of
 labour (Table 5.1), 117-20
 lack of understanding 149
'rough rice' 300
rural: areas, women in production and
 labour force 115
 associations, training of leaders 244
 family members' time, use of (Table
  7.4), 227
 households, time allocation study 170
 poverty, cause of 206
 and urban differences in economic
  activities 214
 women, access to modern production
  171
  activities of (Sierra Leone) 285, 286
  and the agrarian structure in Kenya
   172-8
  alternative technologies for 184-205
  assist in design of new equipment
   237
  chronic ailments of 230
  duties of male protector of 287
  effect of technological changes on
   unpaid work 21
  employment alternatives 180-4
  food farmers in Ghana 216
  groups in Sierra Leone 288
  household activities 20
  impact of technological change on
   19
  in labour-intensive sectors 4
  lack of literature for 320-5
  leisure time 22
  in modern Kenya 177-84
  problems and prospects in Sierra

 Leone 284-326
  and social acceptability of change
   25-6
  technologies for: impact and
   dissemination 115-22
  welfare 7
 *See also* women
Rural Labour Enquiries (RLE) 91

*sagod* system and payment to labour 94
sale of crops, use of income from 125
salt mining (Ghana) 230-1
Sande female secret society 284, 288
scythes: problems of using 135
 with pedal threshers 135, 136
secret societies in Sierra Leone 284
seeds, improved, women's reluctance to
 use 237-8
Senegal: grain grinding 128
 rice planting taken from women 108
 rice transplantation training 149
 women's work 143
sesame processing 306
sexual: bias in business affairs 108
 division of labour, affecting
  household income 109
  in Ghana 42, 43, 45, 214
  in Kenya 185
  research for needed 338
sex-sequential labour processes,
 technological change needed 328
shallow water fishing 309
sharecropping in Java 39
shea oil, uses of 231
shifting cultivation, mode of traditional
 farming 222
Sierra Leone: ethnic groups 284
 female technologies 11
 hand-operated presses 132
 improved technologies for
  (Table 9.1), 284-326
 mud stoves 134
 problem of generation, production
  and diffusion of improved
  technologies 315-19
 rural economy 284
 sexual division of labour 289
Sierra Leone Produce Marketing Board
 (SLPMB) threshing machines 299,
 303
small cultivator households: high
 workload 70
 impact of HYV-irrigation package 99
 women, effect of withdrawal from
  field work 101
small-farm agriculture (Kenya) 158-9
 women's role 172
smallholders: and food consumption 182
 hired labour for 180

smallholdings, sexual division of labour 185
smoking ovens, improvements needed 322-3
soap making 139-40, 238, 239
   in Ghana 231
   improvement needed 324
social: acceptability of technical change 25-6, 240
   production, women in 161, 190-1
   responsibility of the biological role of women 205
Social Welfare Department and child care 250
socioeconomic: classes, classification 338
   studies of technology design 311, 312
   variables, direction of change (Table 8.25)
'soda' soap preparation 308
Sokko, male secret society 284
solar: crop driers 138-9, 322
   energy for cooking 320
      uses of 122
   reflective cookers, problems of 133, 145
   water pump 320
*sondee*, farming tool 298, 301
sorghum production, male labour for 45
South Asia, effect of HYV-irrigation package 99-100
South Gujarat, wages 74
South India: paddy-growing 81
   rice milling 31
South Pacific Appropriate Technology Foundation (SPATF) 150
Sri Lanka: plantation work 38
   rice milling 31
starch production from cassava 305
*stool*, chief's of office (Ghana) 221
storage of *gari* 274 (Tables 8.22–8.24)
stoves, improved designs 133
subordination of women 112
succession, women's right to 53
Sudan, water carrying 70-1
Sudanese women withdraw from fields 105
sugar-growing, earnings from 141
sun-drying: fish in Ghana 224
   of fish and cassava 236
   for food preservation 300-1
superstitions: affecting rural women 335
   and new technology 239
survival, forms of 108-11
swamp rice, women's work 73
Swaziland: family dependence on women 118-19
   lack of male migrant support 119
   rubbish disposal 137
   sanitation methods 137

Tamil Nadu: decline in wage earnings 97
   employment and unemployment 93
   and female family labour (Table 4.5), 89
   female casual labour (Table 4.4), 87
   paddy-growing farm labour 81
   women agricultural workers 91
Tanzania, United Republic of: 127
   extension services 147
   new tenure systems 108
   workloads of women 72
Tarkwa Women's Project (ILO) and pottery making 232-3
tasks: female, commercialised for men 190
   identification of male or female 209
technological change:
   analytical framework 19-25
   cost of 26
   effect on women 78
   impact on income and time 15, 16, 22, 23
      on rural women, 2, 8, 10
   nature of 194-7, 339
technological improvements in women's activities, constraints 234-42
technological innovations: in agriculture 79
   capital and labour using 16
   classified 16-17
   for *gari* processing 272-3
   *See also* technology
technology(ies): in agriculture (Nigeria) 280
   awaiting dissemination 242
   conditions for adoption of improved 309-10
   diffusion, strategies of (Ghana) 242-7
   flow chart for introduction of (*Fig. 9.1*), 312-15
   high cost of 241
   impact and dissemination 124-5, 143
   to improve labour of women 120-2, 122-5, 289-309
   improved, analysis of impact on women (Table 9.2), 316
      examination of (Table 9.2), 315, 212, 239-40 (Table 7.5)
   phases for 152
   for traditional methods (Table 9.1), 290-4
   to increase production, relieve boredom and save time 319-24
   inappropriate effect on women 143
   lack of understanding of 142
   planning and designing 309
   and welfare 336
   *See also* technological
Technology Consultancy Centre

(Ghana) 239, 240
assists with loans 243, 246
tenants, use of family labour 39-40
thatching, a Kikuyu women's task 191
Third World: agricultural
    modernisation 79
  food sharing 76-8
  household workloads 70-5
  rural economies 63
  women in agriculture 8, 67
    land rights 54, 55, 63
  women's work in 30, 38, 118
threshers, use of in India 96
tie-dyeing, improvement needed 324
Tikonto Agricultural Extension Centre
    (TAEC) 315, 318, 320, 321
time disposition a constraint to income
    earning 335
Togo type *gari* cooker 272
tools: improved, reasons for
    non-acceptance 234
  lack of in Ghana 223
  problem of purchasing 201
tractors, use of in Africa and Asia 80,
    81, 95, 99
trading by women (Sierra Leone) 286
traditional: agriculture, transforming
    281-2
  analysis, relevance of 15
  macroeconomic theories 327
  processing of *gari, see gari*
training: opportunities for men only 208
  women 132
transport 122
  costs, East Africa 128
Tropical Africa, women lose land rights
    107-8
Tropical Product Institute (TPI) 136
Tsito, women and use of new seeds
    237-8
tubewell investment in Asia 80
Tunisia: female workforce 69-70 n.1
  water-carrying 71

Uganda: use of herbicides and knapsack
    spraying 207
  women's work 72
underground water, diseases caused by
    297
unemployment of family members 39
United Nations Conference on Science
    and Technology for Development,
    1979 xii
United Nations Research Institute for
    Social Development 30
unpaid housework, effect of technology
    on 20, 21, 23
Upper Volta: cost of commercial milling
    129

grinding mills, lack of maintenance
    130
  wells, inadequacy of 126
  women's duties 118, 143
USAID: hand pumps for villages 297
  supply tractor for cassava growing
    237
Uttar Pradesh 91
  increase in wage earnings (Table 4.9,
    97-8

village technology, improved 195
vitamin supplement in *gari* 270

wage(s): control of by men 74
  employment, female participation
    141, 142
  depressed by rice mills 332
Wande, male secret society 284
water:carrying, distances 70-1
  catchment systems 242
  collection, impact of improved
    technologies (Table 9.2), 316
  and storage, improved technology for
    (Table 9.1), 290, 296
  diesel pumps deprive women of
    income 127
  fetching by women and children
    (Ghana) 227-8
  irrigation scheme, farmers and 59
  lifting, improvements for 122, 123
  problems (Sierra Leone) 284, 320
  pumps, use of 297, 320
  purification, need for 298
  storage and purification 321
  supplies and collection, women's task
    126-7, 198, 199, 200
    governmental effort 228
    technologies for 121-2
  systems, breakdown of 143
  transmitting diseases 228
  utilisation in Ghana 228
weaving, a male activity (Ghana) 231
weeders, hand-held, failure 135
weeding: African males refuse to work
    for European farmers 186
  payment for 94
  women and 188
welfare 23
  implications 19
  indices of 21-2
wells (Africa) 126
West Africa: labour processes 42
  oil extraction by women 131
  women and rice surplus 138
West Bengal, decline in wage earnings
    97
West Javanese family labour 39
West Malaysia, displacement of labour
    by combine harvesters 96

Western Nigeria Agricultural
  Investment and Industrial
  Development Corporation loan 274
wheelbarrow and carts, women use 321
wife, unremunerated, labour of 37-8
Winneba fishing industry 225
winnowers, hand operated 136
winnowing rice 299
wives and household income 39
woman day (year) time component
  19-20
women: access, areas needed in 160
  to technology (Kenya) 158
  in agriculture 30-1, 125, 167, 216
  of agricultural households, concern
    for 91
  biased by males in agriculture 176
  contractual inferiority 334
  denial of status 60
  denied credit or loans 274, 325
  desert husbands in Mwea scheme 104
  in development (Nigeria) 281
  economic position, deterioration of
    109
  economically better-off, domination
    113
  education 145, 281
  effect of mechanisation of gari
    processing 274
  establish separate farms 106-7
  factors against farming 219-20
  factors handicapping progress 208-9
  factory 18, 19
  as family labour 40
  farmers (Ghana) 221
  in fish preservation 223
  form own co-operative (Sierra Leone)
    288
  and instruction, social constraints 177
  land rights 53-4
  low rural status 108, 145
  and new technologies, payment for
    314-15
  organisation, activities of (Sierra
    Leone) 288

processors of gari in Ibadan district
  (Table 8.1), 254
productivity, problem of enhancing
  203
rights in the use of land 53-4, 56,
  172-3
self-employed 18, 19
selling labour 167
supervisory function in households
  330
support of by husband's family 55-6
and technical change in agriculture
  67-114
training: groups 132
  lack of time for 138, 143, 144, 145,
    152
  necessary for 209
  as wage labourers 45
work: burden and control of income
  69, 70-5
  intensification of 41-51, 182
  working time 141
  workloads of 70
  replaced by new technologies 191
  and technical innovation 36-51
  working in field, economics of
    128-9
wood: grinding board and bottle 304
  used in cooking 295
World Conference of the United
  Nations Decade for Women xii

Yoruba: cocoa farming 41, 56
  families, lack of support from male
    migrants 119
  remuneration of wives 45
  women, labour of 38

Zaire: water carrying 71
  water supply 198
  women's worktime 117
Zimbabwe: increased demand for labour
  330
  women's work 72